The
Sydney
Modern
Project

Introduction: transforming the Art Gallery of New South Wales

Michael Brand

Whereas the original building once shunned the morning glow, the north-easterly aspect of the new building recalibrates the historic sandstone palace. Now, across the full arc of a typical Sydney day, the new cultural campus is animated by the sun. On its 'new' geologic podium, where speeches, songs, dances and feasts have doubtless taken place century after century during the unending time of the Eora, the Art Gallery's campus presents a ceremonial ground where Sydneysiders and visitors can commune to investigate and celebrate the cultural as well as the natural forces that activate Sydney's multifarious society.

So we have arrived at this promising moment. On this ancient ground, the staff of the Art Gallery of New South Wales have the chance to nurture the continuing emergence of an art history that is both *Sydney* and *modern*. Such an art history will be globally aware and influential while being locally founded and endemically energised too. With its policies, programs and special projects, the Art Gallery has the chance to bring fresh acknowledgement and animation to the stretch of Country that hosts it.

Now that I have used this foreword to focus chiefly on the architecture of SANAA's new building, the chapters that follow in this book will detail the expanded museum's policies, projects and programs. If I were to suggest that the architecture can be construed as the hardware of the project, then the policies, projects and programs might be the software. However, as soon as I make this analogy, I want to bring more warmth to our imagining of the activities that will animate the expanded cultural campus where the new building now glistens. More than software, as the chapters in this book demonstrate, the policies, projects and programs can bring zest and connective verve to the harbour-shore, such that the Sydney Modern Project might earn the right to be construed, over time, as an amplifier of an unstinting 'kara' force that is coursing through the effervescent city.

In this hopeful light, while never denying that shadows of ignorance and unsettled debts still darken the city's colonised ground, a beckoning stage is now set. Here in this special tract of Sydney Country, the stage is set for something distinctively modern, bright and stintless to bloom out of time, out of this vivacious place.

that reveal the shape and tempo of the present, the staff in a modern art museum must always be aware of the histories and the possible futures that are being brought to light in every moment. In maintaining such vigilance, one hopes that the staff can also reveal and assess the value of histories that are being obscured or suppressed. In this latter role, a watch for justice can be kept.

So, having settled on our definition of the keyword, we come back to the question: what is notably modern in the Sydney Modern Project? The question returns us to the pavilions of the new building that address the harbour-shore. The designers are the prized Japanese studio SANAA. Virtuosi of contemporary engineering that is glass-predominant, vista-rich and naturally illuminated, SANAA have produced many of the most distinctive cultural sites of the past two decades. To name just three: the 21st Century Museum of Contemporary Art in Kanazawa, Japan; the New Museum of Contemporary Art in New York City; and the Louvre Lens campus in France. (All this is in addition to SANAA co-director Ryue Nishizawa's work on the Teshima Art Museum, one of the most inspiring place-making exercises of the past hundred years.) Plainly, SANAA buildings are always *à la mode*. But they usually refer to the past also. The pavilions of the new building, for example, are inspired by centuries of Japanese shelter-design and garden-layout. Revering and revamping traditional motifs from their own heritage, the architects readily embrace rather than reject old forms. In this way they are attuned to the best impetus in contemporary art practice: they construct every present intention and action by analysing how the present can inherit strong momentum from the past as every lived moment leans into the future.

So here it is, ready to invigorate the cityscape: the Sydney Modern Project. The transformed Art Gallery of New South Wales and the city are well placed to harmonise because they share fundamental qualities. Energetic, speculative and attuned to ever-adjusting contexts, the city and the new campus both project outward, creatively curious about everything that is coming over the horizon.

Although it began as a fort town, Sydney transformed quickly into a port town. In a comparable way, the Art Gallery's expanded campus is no gated bastion. Perhaps the art museum is transforming from 'fort', to 'port', too. The imposing old edifice of the Art Gallery's original building has been warmed and softened by its adjacency to the radiant new pavilions.

vividly and governed avidly for thousands of generations. A contemporary mode of thinking – the architectural analysis of the affordances of terrain, informed by consultation with Indigenous advisors – has arrived at a worldview that might be aligned, in good faith, to some of the teachings in Eora wisdom.

No doubt, a distinctively *Sydney* characteristic has been brought to light in the cascading pavilions of the Sydney Modern Project's new building. But what of the second half of the venture's name? How is the new museum especially *modern?*

In answer, we must first define 'modern' by picking one specific meaning from the several different connotations that the word generally carries. In our context – namely, our appreciation of the role that museums can play in a city's culture and identity – we should start by comparing the condition of being modern to the condition of being modernist.

Something that is modernist has a philosophical impetus and a stylistic palette related to an international art movement that is at least a century old and that waned, in most places, sometime during the 1970s. By contrast, when something is understood to be modern, we perceive it to be an object or an event that we know is fashioned right now in a duel between the dictates of the immediate past and the options that are poised to spring forth in the next instant of the future. A modern phenomenon is distinguished by its novelty, by the way it outmodes the context from which it has arisen. Of course, with the relentless lapse into obsolescence that innovation produces, most modern phenomena sooner or later become prosaic, if not forgotten. But some special items become recognised as 'classic' and thus abide in everyday experience. In fact, museums of modern art play a significant role in the sorting of phenomena along a spectrum between the dross of valueless clutter and the gloss of the enduring classic. It follows that a successful art museum will always evolve through its day-to-day existence. The primary task of the staff in a modern museum is the attentive engagement with contemporary artists. Tracking and showcasing productive artists year after year, decade after decade, a successful modern art museum makes and leaves traces of its own history while constantly displaying and examining new artistic interpretations of the ever-unfolding present.

In this process, the challenge is to be modern but not modish. While they go about the daily work of constructing exhibitions and programs

compiled in Sydney during the first years of the takeover, there are several words that commence with the prefix 'kara'. Here are just a few:

karaga – to yell or call

karamung – a swelling

karangan – fingernails, growing out from the body

karadigan – a doctor, someone who manages the strengthening force of healing

karaign – to cough

karagadyera – a block which one throws out in front so that companions can aim at it when playing or practising how to hunt

karabi – the screeching cockatoo, the bird with the sulphur swoosh of head-plumage that can fan out in a bright instant, the bird that flies off in screeching mobs that take over the sky.

Evidently the 'kara' prefix refers to an expansive vigour that courses within the Eora world. Across the millennia, 'kara' words must have been uttered countless times along the ancient shoreline. Then it came to pass that more than two centuries of colonialism assailed the Eora vigour. Which brings us to the present moment when a new architectonic openness projects its own verve across the artfully connective landscapes fanning out toward the harbour-glamour.

What to make, in modern times, of the 'kara' force? At this auspicious moment in the history of the harbour-shore, might we envisage a time when the site of the Art Gallery of New South Wales – so aesthetic, so energetic – can become an ever more auspicious place? A place where knowledge might grow. Might the museum earn the right, in time, via sustained ingenuity and beneficial actions, to be understood and enjoyed by everyone as a kara-place? First a learning place, then a healing place.

Now, I need to be clear: the fact that the architecture of the new building can be linked to the notion of the 'kara' force does not mean that this time-tested Indigenous concept has been explicitly referenced or appropriated by the architects. But I can affirm that, by analysing the distinctive qualities imbuing the site, the Art Gallery of New South Wales, the architects and the advisory teams have used their own expertise and methods to notice and to highlight, in the layout and the material radiance of the new campus, some of the same qualities that the Eora have known

account, they were inextricable and mercurial, mutually energised and jeopardised.

Illustrating this point, Dawes wrote of a day when he was visiting the Eora at the harbour shore, a day when he learnt about the power of language whenever *singing* was involved. The incident started innocently and playfully. In that gleaming scene beside the water, Dawes was so moved by affection for his Eora companions that he broke into song, addressing his fond audience directly. The after-effect was not what he anticipated. There was no commendation of his performance. Indeed at least one member of the audience became angry. Perplexed, Dawes sought an explanation from his teacher and friend, the brilliant young Eora woman named Patyegarang, who seems to have been authorised by Eora elders to transact with Dawes so as to investigate the intentions of the white men. From the cryptic review of his own performance, which he jotted in his notebook, we can infer that he learnt how singing – agitating the air with projected vocal force – was an activity so powerful that it could distort a setting if the song was ignorantly performed.

Let's remember that in most languages the notions of 'breath' and 'spirit' are synonymous. With the Eora, it seems that singing required great care because, in the moment of its expiration, the projected breath of an unsanctioned song might dispirit the world. Singing must be done well, in the right place and right time, by the right people, for the right reasons. An injudicious song might decompose the world or bring inclement spirit-weather. It seems every Eora present at the scene of Dawes' faux pas was aware of a delicate dynamism in the Country, aware that the projection of unruly sounds and inappropriate rhythms can distort the relationship between people and their habitat. I tell this story because it helps us understand more about that defining 'Sydney' quality, the brio that I mentioned earlier. To say it better, the defining 'Sydney' quality is a fecundity – or perhaps it is an elemental *élan* – which is always ready to bloom in the harbour-country. Human actions within Sydney's natural domain can result in a burgeoning world or a festering one, depending on the commission or omission of protocols that govern the Country's elemental force. To say it best, the Aboriginal language of Sydney has a term for the *élan*. In the vocabulary lists that Dawes and several other colonists

David Moore *Sydney Harbour from 16,000 feet*
1966, printed later. The Sydney Modern Project
site is situated centre left.

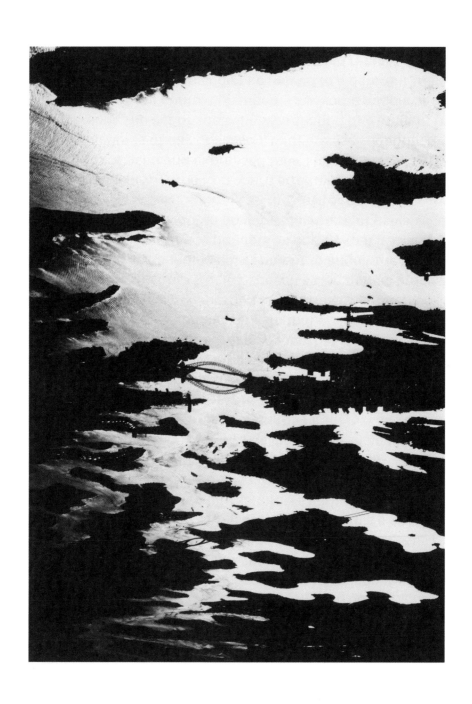

The centrepiece of the Sydney Modern Project is a new building comprised of several lustrous, flat pavilions that fan out down a sunny verge easing into the inner reaches of Sydney Harbour. The glassy new galleries are like polished skim-stones that have been cast at the water. From top to bottom of their stepped assemblage, luminance shuttles down through each element, as if gravity-drawn, toward the scintillations of the harbour. Sheen and sparkle meet and redouble there. Thus the radiance and centrifugal layout of the architecture mimic a special quality of Sydney: the way the spangled city shimmers with a projective verve and always seems to be on the *increase*. In the gleaming cascade of the pavilions, some of the city's brio has been materialised.

The verve of harbourside Sydney has long been acknowledged. It was noted in 1790–91, for example, when the First Fleet astronomer William Dawes cast his focus earthward after spending two years observing the gyring constellations. Studying the local language, Dawes heard how the Eora (custodians of the southern shoreline for millennia) routinely bore witness to an outbursting vigour that is sprung in their Country. This vigour is an everyday animism that charges each of the earth's entities with an assigned portion of potentiality. Immersed in their animated world, the Eora treated speech as a dynamic process that draws force from the surrounding environment to engulf the speaker; at the same time every utterance projects an energy that is likely to rearrange its setting. Dawes noted how the environment galvanised the speaker while the speaker galvanised the environment.

This would explain why the Eora were attentive to their milieu whenever they composed and expressed their statements. At particular places, at specific times of day or season, with precisely identified ranks of people in earshot, the act of speaking was shaped by stringent rules and responsibilities. If the context changed – say some people of a new rank joined to listen, or the audience moved to a different tract of Country – then to reiterate the same message would require different grammar and vocabulary, perhaps even different speakers. And if the rules governing expression were flouted, then the interwoven social, natural and spiritual order could fray. The language spoken along the shoreline was governed by the encompassing world; and concomitantly, that world was susceptible (for good and bad) to the force of the proclamations. Language and the world, culture and nature: by Dawes'

Foreword

Ross Gibson

The Sydney Modern Project

Transforming the Art Gallery of New South Wales

Edited by Michael Brand

Contents

From here. For all.

This has been the guiding principle for the Art Gallery of New South Wales as we planned the Sydney Modern Project to be not only a physical expansion but also an opportunity to *transform* our state art museum in Sydney. Or, as Ross Gibson has put it whimsically in his foreword to this book, to move forward purposely with our 'assigned portion of potentiality'. To become a beacon for what is essential in both art and community.

'Here' is Gadigal Country. That's where the Art Gallery stands in Sydney, overlooking Woolloomooloo Bay on the southern shores of one of the world's most beautiful harbours. And that is why all events at the Art Gallery begin with an acknowledgement that the Gadigal of the Eora Nation have been custodians of these lands and waters for countless generations over thousands of years. This is a central tenet of who we are as an Australian institution.

The 'all' is the broad audience we aim to engage in an open and inclusive manner, and bring along with us on a journey through art. While our main focus will always be on the direct encounter with works of art on our Sydney campus, we are strongly committed to our online audiences, whether they are connecting with us from regional New South Wales, from elsewhere in Australia or internationally.

How we made this transformation a reality by creating new art experiences within our two buildings and throughout our expanded campus in Sydney is the subject of the essays that follow. But this book is not only a record of the goals of the Sydney Modern Project, it is also a record of the multiple voices that have come together to drive this institutional change – a transformation that has taken place against a backdrop of huge global change. Executing these plans and bringing them to life for our audiences has been, and will continue to be, the work of every single member of our staff. While some issues referenced here are particular to this 150-year-old art museum in Sydney, many others are shared by art museums around the world as we navigate an era with as many challenges as there are opportunities.

The historical moment in which the transformation has taken place must be recognised: the #MeToo movement against the sexual abuse and harassment of women and a related awareness of gender inequity within art museums; the catastrophic bushfires in Australia during the summer of 2019–20 that underscored the dangers of climate change; the Black Lives

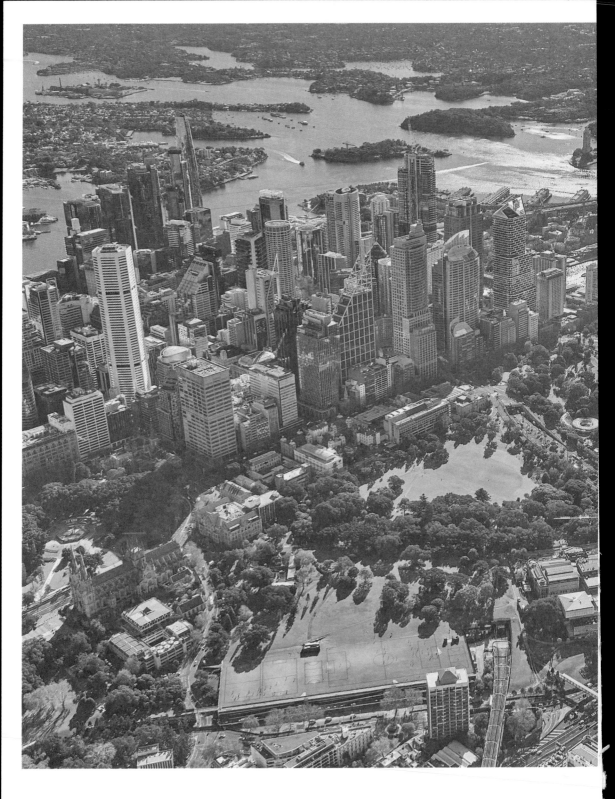

The Art Gallery of New South Wales campus (lower right),
with the original building to the left and new building
construction site on the right

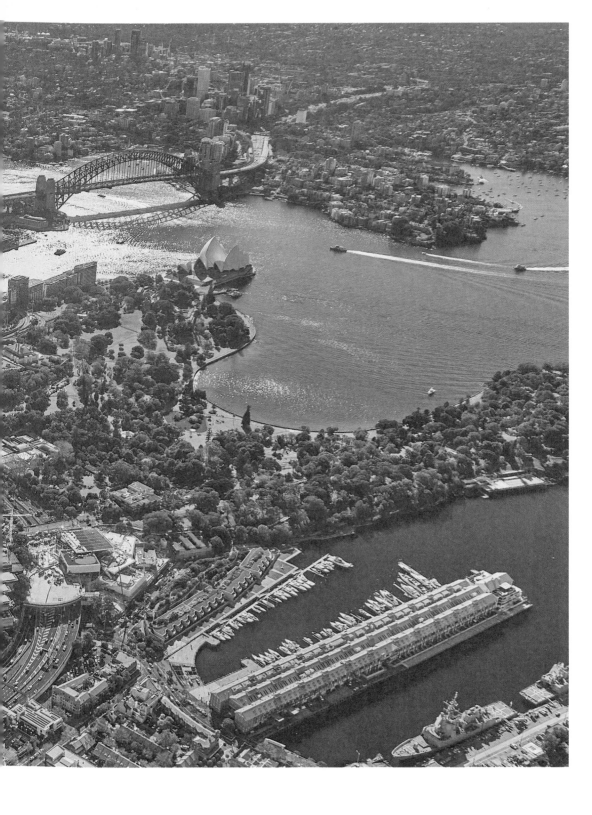

Matter movement that started in the United States but also refocused attention on the shocking record of Indigenous deaths in custody in Australia; and the COVID-19 pandemic that shut down large segments of the world during much of 2020, and then through much of 2021 and into 2022.

This introduction gives an insight into how, over the past decade, we set out to forge an even brighter future for our much-loved art museum as we expanded our building footprint for the first time in over thirty years. It's about place, history and potential. The process started out with a recognition of the uniqueness of our location in Sydney, the layering of its histories and its role as a portal between Australia and the rest of the world, along with a deep respect for Indigenous histories, learnings and practices. This involved looking back into our institutional past to better understand how we had evolved since our foundation in 1871. At the same time, we contemplated our potential for change and speculated on what creative role we wanted to play in the future. In doing so, we have sought to refine an authentic institutional voice that allows us to speak out using the language of art to unite, illuminate and motivate.

* * *

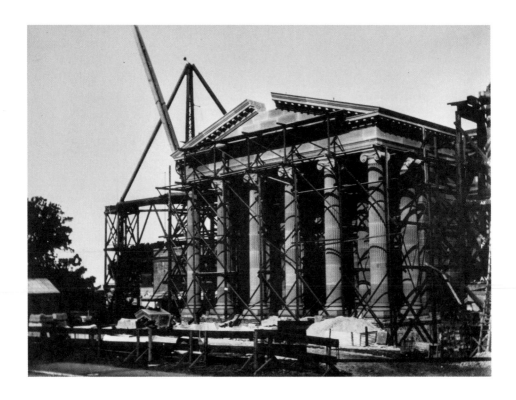

My vision has been for the Sydney Modern Project to transform the Art Gallery of New South Wales into an art museum campus with seamless connections between art, architecture and landscape. And an art museum that believes the art of the past is crucial to understanding the art of our own times. Through the project, our original building, whose earliest wing dates back to the very end of the nineteenth century with subsequent additions from 1972, 1988 and 2003, has benefited from an additional series of upgrades, including the allocation of twice as much space for twentieth-century art. The new building, whose creation is the subject of the following chapter, has almost doubled our total exhibition space and, with a more porous connection between indoors and outdoors, delivers new types of spaces for new thinking and new forms of art. The landscape linking the two buildings allows us to offer the physical experience of magnificent gardens and a metaphorical exploration of the Indigenous concept of 'Country'.

Perhaps with the exception of *national* galleries, all public art museums are unique in the way they both represent and serve the city in which they are located. Of this relationship, the former director of Tate, Sir Nicholas Serota, has said:

> A gallery should be fundamentally rooted in its community –
> it should grow out of that community and reflect that community –
> and if you parachute in, I think it's extremely difficult to achieve. You
> can make a visitor attraction, but it's very, very difficult to create
> something that really grows out of the soil.[1]

There is no single art museum paragon for all institutions to emulate. Each museum will inevitably reflect, for better or worse, its own city's or state's form of government, its economy, its trade relations, the structure of its society, its art history, the generosity of its philanthropy and the desire, and ability, of its citizens to freely express themselves. It is the challenge of each art museum to absorb and channel these realities – and then inspire its communities to nurture the museum's dual role as a repository of shared cultural heritage and a home for those driven to think and act creatively.

Our view of art is from the perspective of Sydney. As we reflect and explore many ways of seeing from our own place in the world, it is first essential to understand something of the nature of this young city with such an old history.

The keystone about to be placed in the sandstone pediment of the original Art Gallery of New South Wales building designed by Walter Liberty Vernon, 24 March 1902

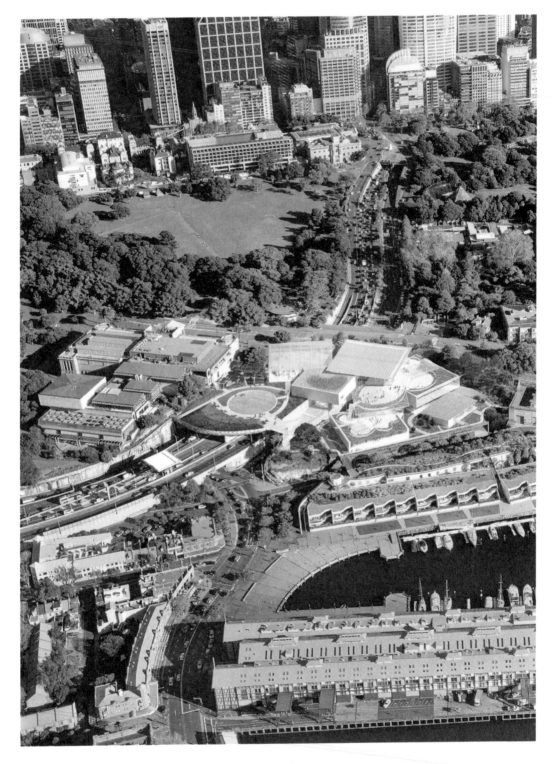

Aerial view of the Art Gallery with Woolloomooloo in the foreground;
the original building centre left; a render of the new building designed
by Kazuyo Sejima + Ryue Nishizawa / SANAA centre, with the Domain,
Royal Botanic Garden and city beyond

Sydney was where the Aboriginal people of our island continent first encountered the expansionist forces of European colonialism, in the person of Captain James Cook, who landed at Kamay (which he named Botany Bay) in 1770, just 15 kilometres south of where the Art Gallery stands today. In 1788 Sydney was the site where Europeans first established a settlement on this Aboriginal land at Warrane, now known as Sydney Cove or Circular Quay, barely a kilometre to our north-west. This new colony became known as New South Wales.

Sydney was therefore Australia's first gateway city. By the time New South Wales federated with the other colonies in 1901 to form the modern nation of Australia, Sydney already had a flourishing maritime trade with cities around the globe. It also had a nascent art museum that would play a leading role in how Sydney came to define itself throughout the remainder of the twentieth century, and into the twenty-first.

The development of Sydney as a place of culture parallels that of the even younger Australian nation: first ignoring, and then championing, the art of Indigenous Australians that is now recognised as part of the world's oldest continuous living culture. This sense of continuous evolution, and the moral obligation brought with it, is well summed up by the celebrated Australian author David Malouf on a bronze plaque at Circular Quay: 'Australia is still revealing itself to us. We oughtn't to close off possibilities by declaring too early what we have already become.'[2]

I believe our chief artistic 'possibility' derives from the coexistence of multiple cultural traditions, from those of Indigenous Australians, which can be dated back up to sixty-five thousand years, to those of the long series of migrant arrivals: primarily British and Irish settlers (including convicts) from the end of the eighteenth century; Chinese speculators drawn by the gold rushes of the mid nineteenth century; a massive wave of migrants from Europe and the Middle East immediately before and after the Second World War (including many Jews fleeing Nazi persecution); and then, more recently, those from the Asia-Pacific region.

While the core, and chief strength, of our collection will always be what is perhaps too neatly described as 'Australian art', we recognise that this term has become increasingly less useful in an ever more fluid and interconnected world. We have no wish to prioritise any notion of a distinct national culture anchored to one particular spot between the South Pacific and Asia. Instead, we are redoubling our efforts to find points

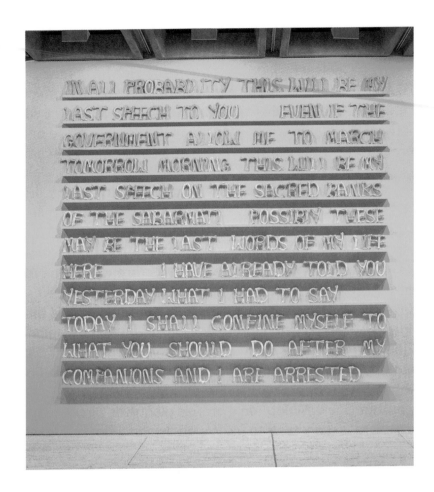

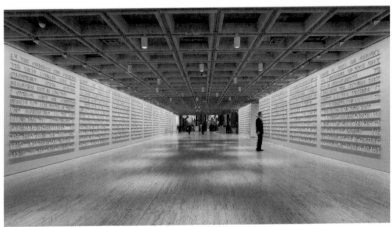

Jitish Kallat's *Public notice 2* 2007 in the entrance
court of the original building; the vast installation
reproduces Mahatma Gandhi's historic Dandi
March speech from 1930 in its entirety

Introduction

of commonality with art and artists beyond our shores, and to recognise the way Australian artists have always mediated the flow of ideas and forms in both directions.

As the Sinologist Pierre Ryckmans (who was a great friend of the Art Gallery) reminds us:

> Culture is born out of exchanges and thrives on differences. In this sense, 'national culture' is a self-contradiction, and 'multiculturalism' a pleonasm. The death of culture lies in self-centredness, self-sufficiency and isolation. (Here, for instance, the first concern – it seems – should not be to create an Australian culture, but a cultured Australia.)[3]

I believe a cultured Australian art museum should be cosmopolitan by nature. The 'local' will always be nurtured and cherished but, equally, new ideas must be welcomed and new bridges to the world beyond must constantly be built. The need to resist choosing one focus over the other has been deftly described by the philosopher and cultural theorist Anthony Kwamé Appiah:

> The most common idea about cosmopolitanism – that claiming world citizenship is repudiating local commitments – is also the most mistaken. For, at the heart of the cosmopolitan tradition is a pair of thoughts. First, that each of us has places where we belong; but second, that all of us can profit from conversations (in the broadest sense) with places where we do not belong. It is as absurd to deny that you can be a citizen of both a country and the world as it is absurd to deny that you can be a citizen of both a city and a country. In our responses to human creativity too, the cosmopolitan insists on the double claim. Yes, there are artworks and spaces that are yours through your local identity, but spaces and artworks elsewhere can also become central to who you are.[4]

Sydney is not just an Australian city. It is an Asian-Pacific city open to the world beyond. It can also be seen as part of a global set of port cities that currently serve as conduits of international trade and culture rather than as political capitals: think of Hong Kong, Shanghai, Mumbai, Istanbul, Barcelona, Amsterdam, Cape Town, Rio de Janeiro, New York and, finally,

Los Angeles, lying 12,000 kilometres directly to the north-east of Sydney across the Pacific Ocean.

Port cities such as Sydney also anchor the coastal littoral of their landmasses, and thereby serve to bring the benefits of trade and cultural diffusion to their inland regions. And, as our name strongly states, we are an art museum that serves not only the city of Sydney but also the whole state of New South Wales. Though little known as a separate entity outside of Australia, this state is considerably bigger than both the largest member of the European Union (France) and the largest mainland state of the United States (Texas); and has more than twice the landmass of Japan.[5] All this territory, it must always be noted, is unceded Aboriginal land.

Art museums in Australia did not initially recognise the creative agency of the Indigenous custodians of this land: in 1897, for example, our Art Gallery trustees twice declined to purchase a group of drawings, possibly those displayed at the Columbian World Exposition in Chicago in 1893, by the Aboriginal artist named Mickey of Ulladulla (a small town on the South Coast of New South Wales).[6] However, from the late 1950s, we became leaders in Australia in the acquisition and display of Aboriginal art as *art*.[7] We established the nation's first curatorial department for Aboriginal art in 1979; appointed the first Indigenous curator of Aboriginal art in 1984; created our Yiribana Gallery for Aboriginal and Torres Strait Islander art in 1994; and curated a series of groundbreaking exhibitions over many decades, including *Papunya Tula: Genesis and Genius* that coincided with the 2000 Olympic Games held in Sydney.[8] In 2018, we created an Indigenous Advisory Group, chaired first by artist Tony Albert (who also became the first Indigenous member of our Board of Trustees in 2020) and then by art historian Stephen Gilchrist.

'Our paintings are our memories for future relatives.'[9] Thus artist Tommy Watson (c1935–2017), one of eight Indigenous Australian artists whose work features permanently on the architecture of the Musée du Quai Branly in Paris, describes the importance of Indigenous art collections. Preserving links between generations is one of our prime duties as a keeping place for Aboriginal and Torres Strait Islander culture. We also have a special responsibility to ensure that multiple voices are heard. As the Māori writer Linda Tuhiwai Smith has noted in a broader First Nations context:

Clifford Possum Tjapaltjarri and Tim Leura
Tjapaltjarri *Warlugulong* 1976, a key painting
included in the Art Gallery's *Papunya Tula:
Genesis and Genius* exhibition in 2000

Indigenous people want to tell our own stories, write our own versions, in our own ways, for our own purposes. It is not simply about giving an oral account or a genealogical naming of the land and the events which rage over it, but a very powerful need to give testimony to and restore a spirit, to bring back into existence a world fragmented and dying.[10]

All art museums are ultimately judged by their collections. Throughout the planning, designing and fundraising phases of the architectural side of the Sydney Modern Project, the Art Gallery continued to develop its collection, which is the basis not only of our displays but also our public programs. It is in collection-building where art museums need to make the most profound choices. In addition, our temporary exhibition program aims to illuminate links and build bridges between both individual artists, and works of art, and the broader currents of art history worldwide.

All along, we have strived to assert our leadership in the field of contemporary art, and to further develop our significant collections of historical Australian, Asian and European art. We aim to reflect the continuing evolution of the visual arts in the twenty-first century alongside the development of new channels of global communication that increasingly transcend national boundaries. Our new art acquisition policy, ratified in 2019, is committed to gender equity and diversity, which had already become a characteristic of the Art Gallery's recent collecting. The Sydney Modern Project includes nine site-specific commissions, five of which are featured in the new building. As always, and especially since we lost state government art acquisition funds in 1991, it has been private philanthropy that has allowed us to aim high for new works. In particular, the Art Gallery of New South Wales Foundation made an early commitment to fund major acquisitions over the five years leading up to the completion of the Sydney Modern Project.

The following essays introduce fifteen of my senior creative colleagues at the Art Gallery. Our goal has not been to produce a highlights book, but to reveal the ways in which we have taken advantage of new or reconceived spaces to change the way we engage our audiences with art: What will our new art displays be like? What stories will we be telling? What will a visit be like? In other words, how has each writer transformed their thinking as part of the Sydney Modern Project?

New technologies in the digital, rather than physical, domain and the new skills we have learnt while connecting with audiences during the pandemic lockdowns of 2020 and 2021, such as our online Together In Art social project, form a significant part of this matrix of creative possibilities. In 2021 we introduced a new digital experience platform that supports all our digital content and our widening range of online interactions. This book, however, is mainly focused on the experience of art in the physical spaces of our expanded campus.

It was decided early on that gallery spaces in the new building would not be allocated to individual curatorial departments – with one exception. Nothing has been timelier than moving our Yiribana Gallery for Aboriginal and Torres Strait Islander art from the lowest level of our original building to the entrance level of our new building. Indigenous art will also be included in other displays throughout both buildings and the landscape. Our project to Indigenise some of our labels will provide a deeper insight into the extraordinary relationship between Indigenous Australians and Country. It will also give visitors surprising and beautiful new ways of looking at some of our non-Indigenous works. These multiple intersections are critical for achieving a fuller understanding of how this artform operates on its own terms. As Hetti Perkins wrote in an earlier Art Gallery publication:

> The advent of contemporary Indigenous visual arts from Australia as a unique presence in world art is a phenomenon that runs against the grain of Western modernism. At odds with a premise of modernity – to erase the old with the new – is the apparent conundrum of the world's oldest continuous culture being the wellspring of a dynamic contemporary art movement. Australian Indigenous art resists interpretation outside of its historicity and continues to elude definition in terms relevant to Western art theory.[11]

Our planning for the new art installations began with three assertions. Firstly, that we collect and display both historical and contemporary art – and believe the two are inextricably linked. As Picasso noted: 'there is no past or future in art. If a work of art cannot always live in the present it must not be considered at all.'[12] There is no hard and fast chronological dividing line between the two buildings, but we respect

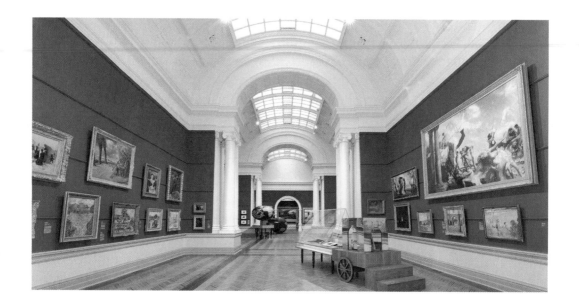

their different personalities. We see the character of the original building as being the historical inflected with the contemporary, while the new building conversely represents the contemporary inflected with the historical. This allows us to highlight the many ways chronology can loop and embrace multiple perspectives, through some thoughtful insertions of works out of chronological order.

Secondly, we wish to break from traditional Australian art museum practice which, except in the field of contemporary art, generally displays Australian art separately from that of 'international' artists. The Art Gallery started following this course over a century ago but for a different reason: to show that our homegrown artists were not *British* artists. What we mean now is: Australian artists *are* international artists. For the first time in a major Australian art museum, collections of Australian and international modern art of the twentieth century are displayed together. We aim to show how Australian artists interacted with their international peers so productively, from the late nineteenth century in the lead-up to Federation, right through an increasingly globalised twentieth century. International works – Asian works in particular – will be selected that resonate with Australian art and its historical movements as well as bringing their own perspectives to the conversation.

Installation view of the historical Grand Courts in the original building that first opened in 1897, showing the 2022 reinstallation featuring Brook Andrew's sculptures collectively titled *Tombs of thought* 2017–18

Introduction

Finally, we believe the Art Gallery has a special reason to focus on depictions of the individual. We are an art museum with portraiture as a central element of our institutional DNA. In 1916, the founding editor of the *Bulletin*, Jean-François Archibald, established an endowment for the Art Gallery to create an annual prize for portrait painting to be judged by our Board of Trustees. Each year since 1921, the art exhibition that perhaps has the broadest and most diverse audience of any in Australia, and which unquestionably receives the most extensive media coverage, encourages visitors to look into the faces of contemporary Australia. During periods when abstraction was dominant over figuration, a visit to the Archibald Prize exhibition to revel in portraiture was regarded by some as a guilty pleasure. We see painting the human individual as an essential activity that strengthens our ability to know not just each other, but also the world around us. As the writer Zadie Smith has so powerfully articulated:

> Having this experience of other people ... is an annoyingly persistent habit of actual humans, no matter how many convincing theoretical arguments attempt to bracket and contain the impulse, to carefully unhook it from transcendental ideas, or simply to curse it by one of its many names: realism, humanism, naturalism, figuration. People will continue to look at people – to listen to them, read about them, or reach out and touch them – and on such flimsy sensory foundations spin their private fantasias. Art has many more complex pleasures and problems, to be sure, but still this consideration of 'souls' should be counted among them.[13]

* * *

In our search for organising narratives, we have avoided the standard notion of art history in the singular and have explored a number of art histories. The various thematic gallery installations in the original building follow a loose chronology. Within this rubric, the works we have highlighted in our inaugural display include 'anchor works' that help guide viewers through our architecture (and out again), new acquisitions, works that might not have been seen for many years (some re-emerging after specialised treatments by our conservation team), and many more works by women artists that help us in our continuing goal to achieve gender

balance. Another desire has been to incorporate more moving image, performance and music into our art displays, facilitated by the creation of new positions for curators in each of these three areas.

From the completion of the Sydney Modern Project onwards, the temporary exhibition program will continue to provide a balance between big projects attracting large audiences and smaller ones introducing lesser-known artists, practices or themes. There will be a strong commitment to staging monographic exhibitions of Australian artists. What will be totally new is an annual program of highly ambitious commissioned installations in the Tank, a unique space at the lowest level of the new building. The Art Gallery will remain as a founding host of the Biennale of Sydney, and a leader with our sister institutions in Sydney in continuing to develop *The National* as a biennial of Australian art.

Our overarching interpretive strategies have been formulated to ensure that all these experiences resonate with our audiences in the most inspiring manner possible. We aim to be concise and not to overwhelm works of art with words. On all platforms, whether physical labels or digital content, our writing aims to be inclusive and provoke curiosity. It can be as unexpected as it is well informed. In both cases, the quality of the underlying scholarship is essential. We do not shy away from discussing some of the key social and political issues of our times, especially those of race, gender, migration and the environment; artists past and present demand this of us, as does our audience. We encourage forms of interpretation beyond the written word, including performances that will help illuminate the art on display through song, dance and the spoken word. This also allows us to bring languages other than English into the experience of art throughout our campus and online. In all cases, our goal is to invite a closer viewing of, and reflection upon, the actual works of art. In this approach I continue to draw inspiration from the American writer Andy Stefanovich, with whom I helped run creative-thinking programs for business leaders when I was director of the Virginia Museum of Fine Arts in the United States. His credo is remarkably simple: 'Look at more stuff and think about it harder.'[14]

In May 2020, while the Art Gallery was still closed to the public during our first pandemic lockdown, we organised a workshop with writer, filmmaker, poet and academic Ross Gibson, who has contributed the foreword to this book. We were looking for new ways of creating

Hoda Afshar's film *Remain* 2018, acquired by
the Art Gallery in 2020, featuring asylum seekers
Behrouz Boochani and Edris Nikghadam near their
former detention centre on Manus Island

Michael Brand

narratives in an art museum. It took the form of a mock writers' room, the creative space where TV series are conceived and scripted. We spoke first about uncertainty and opportunity in the time of COVID-19. Then, we intentionally left behind the safety of traditional museum practice and speculated on how the Art Gallery might distinguish itself from its peers by adopting some of the creative tools more commonly used in film and drama: setting, character, plot and intrigue, mood and tone along with the theme and values of the compelling idea. Gibson concluded the workshop by reminding us that performance is most compelling to an audience when the artist is working at the level of a virtuoso but still taking risks.

Through a willingness to take creative risks while pursuing excellence, all art museums have the potential to transform themselves as art and society evolve in tandem. The outcome at each institution will reflect its own sense of place and history as well as its own art collection and architectural spaces. The goal of our transformation at the Art Gallery of New South Wales has been to create a unique art campus on Gadigal Country overlooking Sydney Harbour.

From our dazzling new stage, we strive to offer art experiences worthy of our location, our history, the many who have contributed to our development over the past 150 years and the many who will look to us for joy, inspiration and insight in the coming decades. It has taken a large team and a huge commitment from all involved to expand our impact as a self-aware and outward-looking international art museum. It is through a series of creative transformations – such as the centrality of the Indigenous Australian voice indoors and outdoors across our campus, SANAA's elegantly restrained but technically complex design for our new building, site-specific commissions from some of the leading artists of our time, and new cultural juxtapositions in the display of art in both buildings – that we now come together to better connect the voices of artists past and present with our audiences. And to be a generous host for those who arrive with an open mind, sharply focused eyes and a sense of visual adventure.

From here. For all.

Charlotte Moorman performing Mieko Shiomi's *Cello sonata* 1972 on the roof of the Art Gallery of New South Wales in 1976 for the fifth Kaldor Public Art Project

Introduction

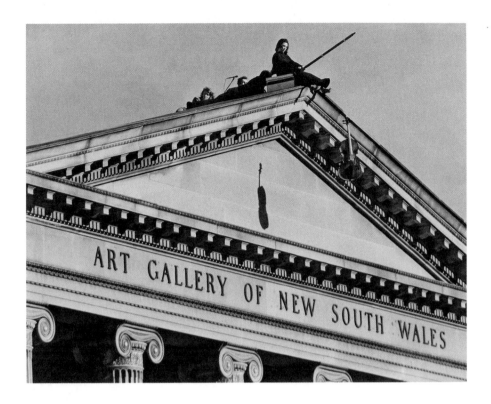

Notes

1 Nicholas Serota quoted in Jane Morris, 'Nicholas Serota looks beyond Take Modern: Tate director rules out overseas satellites to carry on serving a broad public at home', *Art Newspaper,* 14 Jun 2016.

2 Text on Sydney Writers Walk plaque, excerpted from David Malouf, 'Lugarno postscript', *Notes and Furphies*, no 3, Oct 1979.

3 Pierre Ryckmans (under his pseudonym Simon Leys), quoted in Julian Barnes, 'People will hate us again', *London Review of Books*, vol 39, no 8, 20 Apr 2017.

4 Anthony Kwamé Appiah, 'Cultural identity: a cosmopolitan view', in Andres Lepik (ed), *Architecture in dialogue: Aga Khan Award for Architecture* 2019, Architangle, Berlin, 2019, pp 104–05.

5 New South Wales is 801,150 square kilometres; France is 643,801, Texas 695,662 and Japan 377,915.

6 Steven Miller, *The Exhibitionists: a history of Sydney's Art Gallery of New South Wales*, AGNSW, Sydney, 2021, p 17.

7 The Art Gallery's collection of Aboriginal and Torres Strait Islander art began with the 1947 acquisition of the watercolour *Amulda Gorge* by Edwin Pareroultja (8017), followed by sculptures by Nora Nathan (8079 and 8080) and Linda Craigie (8078.a-b) gifted by the artist Margaret Preston in 1948. In the 1950s acquisitions increased with 24 works from the American–Australian scientific expedition to Arnhem Land in 1956 and numerous gifts from Stuart Scougall, who worked in tandem with former Art Gallery deputy director Tony Tuckson from 1957 onwards.

8 *Papunya Tula: Genesis and Genius* was curated by Hetti Perkins, then curator of Aboriginal and Torres Strait Islander art at the Art Gallery. See Hetti Perkins & Hanna Fink (eds), *Papunya Tula: genesis and genius*, AGNSW, Sydney, 2000.

9 Tommy Watson, quoted in a note about his work *Walpu* 2004, AGNSW website, artgallery.nsw.gov.au/collection/works/128.2005/

10 Linda Tuhiwai Smith, *Decolonizing methodologies: research and indigenous peoples*, Zed Books, London / New York, 2012, p 28.

11 Hetti Perkins, 'One sun one moon: Aboriginal art in Australia', in Hetti Perkins & Margie West, *One sun one moon: Aboriginal art in Australia*, AGNSW, Sydney, 2007, p 11.

12 Pablo Picasso, 'Statement to Marius de Zayas', 1923, cited in Alfred Barr, *Picasso*, New York, 1946, pp 270–71.

13 Zadie Smith, 'A bird of few words', review of show by Lynette Yiadom-Boakye, *New Yorker*, 19 Jun 2017.

14 Andy Stefanovich, *Look at more: a proven approach to innovation, growth, and change*, Jossey-Basse, Hoboken, NJ, 2011.

The Sydney Modern Project:
the making of an art campus

Michael Brand

'The Sydney Modern Vision was intentionally ambitious and carried a name that highlighted how we intended to embrace the future from the city of Sydney with an unashamedly modern, outward-looking perspective.'

1

THE TRANSFORMATION OF AN ART MUSEUM requires a finely articulated balance of the architectural and the museological – along with a touch of the entrepreneurial. New spaces must be conjured and linked through circulation paths and sightlines. Existing spaces must be reconsidered or renewed. Collections must be augmented and reimagined as new artforms are explored and embraced. The nature and purpose of exhibitions must be challenged and reconceived as the notion of art programming is expanded to include new platforms for new audiences. And all of this must first be costed and then funded. In our case, that means a public–private partnership that will create more art experiences for more people while celebrating the continuing role of the artist within society.

Starting out along this path has required the Art Gallery of New South Wales to first gain a fuller understanding of both our foundation and our subsequent history. To mark our 150th anniversary in 2021, our senior archivist Steven Miller wrote a comprehensive history of the Art Gallery.[1] Even so, it is important here to give at least a brief introduction to the spirit with which we were founded, and to consider how the physical evolution of our institution brought us to the ambition of the Sydney Modern Project, before discussing how those plans have been brought to fruition.

* * *

Our institution started in 1871 as the New South Wales Academy of Art, with the purpose of 'promoting the fine arts through lectures, art classes and regular exhibitions'.[2] Its first standalone home was the modest Fine Arts Annexe designed by William Wardell and built adjacent to the mammoth Garden Palace that housed the Sydney International Exhibition in 1879.[3] After that event concluded, our name was changed to the Art Gallery of New South Wales. This was upgraded to the National Art Gallery of New South Wales in 1883 and it remained that way right past Federation in 1901 until the word 'National' was finally dropped in 1958. Our four foundational leaders from the 1870s were a cosmopolitan group, with two of them born on Caribbean islands. This helped set the tone for the rest of our history, during which the Art Gallery has continually sought to balance a responsibility to Australian artists and audiences with a parallel duty to link Sydney creatively with the rest of the world.

Born at Basseterre on the island of St Kitts in 1802, Sir Alfred Stephen took over as the second president of the Academy in 1873 and continued as president of the Art Gallery from 1876 until 1889.[4] Eliezer Levi Montefiore, born in 1820 in Barbados the son of a Jewish merchant from Belgium (he received a Belgian knighthood in 1883), was our first vice-president and then president from 1889 to 1892, and our first director from 1892 until his death in 1894. Frederick Eccleston Du Faur, born in London in 1832, served as secretary and treasurer until 1886 and then president from 1892 until 1915. Edward Combes, born in England in 1830 but trained in Paris, was a member of the New South Wales Parliament who began as an active Academy

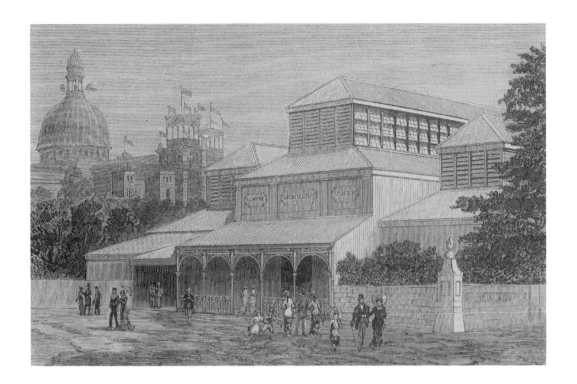

Exterior view of the Fine Arts Annexe to the Garden Palace housing the Sydney International Exhibition 1879, in what is now the Royal Botanic Garden adjacent to the Art Gallery of New South Wales campus

councillor before serving as director of the art section at the 1879 Sydney International Exhibition. Like Montefiore and Du Faur, he was fluent in French. It is not surprising, then, that one of the topics of discussion at the Academy's first official function in 1871 had been the damage inflicted at the Louvre during the Paris Commune that same year.[5]

From 1874 on, the New South Wales colonial government provided limited art acquisition funds. Despite the best lobbying efforts of the Art Gallery's leaders, the government's allocation was never enough to match their ambitions. For this reason, it was decided early on to focus the collection on the work of living artists rather than try to amass an 'encyclopaedic' collection. Our first art acquisition was a landscape watercolour commissioned in 1874 from the London-born Conrad Martens (1801–78) (see p 40), who had arrived in Australia after a stint on the second voyage of the HMS *Beagle*, during which he started a lifelong friendship with Charles Darwin. The famed Australian impressionist Arthur Streeton (1867–1943) later commented that we were the first art gallery in Australia to recognise 'Australian artists and to purchase their pictures'.[6]

Despite the shortage of funds, the Art Gallery was still resolutely international in its outlook. The first international art acquisition was made in 1875, using that year's entire funding grant for the purchase of *Chaucer at the court of Edward III*, painted by Ford Madox Brown between 1847 and 1851 (see p 128). This and other such acquisitions at the time were based on the recommendations of art advisors in

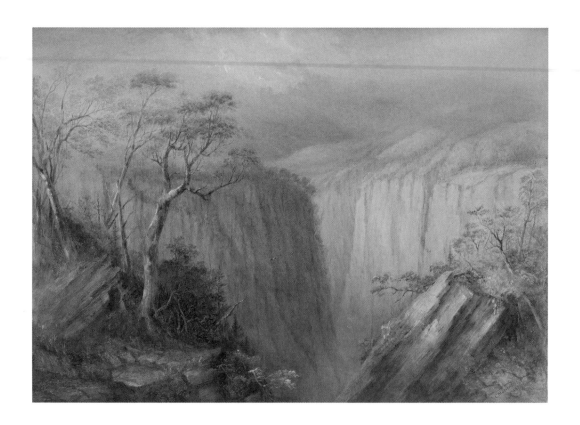

London and Paris (including Montefiore's brother Édouard). Among the earliest donations of art to the Art Gallery was a significant group of ceramics and bronzes gifted by the Japanese government after the Sydney International Exhibition closed in 1879. This was the beginning of our collection of Asian art.

The Art Gallery was soon attracting a growing number of international visitors. Among names in the VIP Visitors' Book are those of Archduke Franz Ferdinand, heir presumptive of the throne of Austria-Hungary whose assassination in 1914 was the most immediate single cause of the First World War, and the Sāmoa-based Robert Louis Stevenson, both in 1893; and the American Mark Twain in 1895. French artist Paul Gauguin would presumably have visited the Art Gallery during stops in Sydney on his trips to Tahiti in 1891 and 1895 – but was not, in any case, invited to sign the VIP book.[7] If he did visit, he would have been disappointed to find not a single Impressionist painting from France.[8] It would take quite some time for truly modern art to find a home at the state art museum in Sydney.

The Art Gallery was legally incorporated by an Act of Parliament in 1899, with the mission of 'using works of art for educational and other beneficial purposes', under the management of thirteen trustees, at least two of whom had to be knowledgeable and experienced in the visual arts. The Act was signed into place by Lord Beauchamp, who served briefly as Governor of New South Wales between 1899 and

Conrad Martens *Apsley Falls* 1874, the first Australian work to be acquired by the Art Gallery

The Sydney Modern Project

1901.[9] It took quite a deal longer to establish an appropriate physical structure for the fledgling art museum.

The Canadian-born, Boston-trained architect John Horbury Hunt (1838–1904), who had already designed the Sydney home of Frederick Eccleston Du Faur in the North American shingle style, was commissioned to design a new art museum building not far from the original Art Annexe in the Domain. His three successive grandiose designs were, however, deemed too expensive. As a compromise, he designed a very basic temporary building with a saw-tooth roof that was constructed in 1884 and soon dubbed the 'art barn' by critics.[10]

In 1890, the English-born architect Walter Liberty Vernon (1846–1919) met with Art Gallery trustees to discuss an alternative design strategy, but his first design was rejected too. He had proposed using his preferred neo-Gothic style, but the trustees wanted something more neoclassical, and eventually he followed their recommendation to use William Playfair's National Gallery of Scotland in Edinburgh as a model. Vernon's design was built in four stages from 1896 and the construction was finally completed in 1909 – or at least half of it was. Hunt's 'temporary' structure remained hidden behind the facade of the incomplete northern wing and was demolished only in 1968. What was built included two dedicated galleries for Australian art alongside those for British and 'Foreign' art,[11] all of which now comprise our Grand Court galleries behind the southern stretch of Vernon's facade. So proud were the stonemasons who clad the new building in glorious Sydney sandstone that they featured an image of it on the banner of their union, the first in the world to win the eight-hour working day.[12] The technology within was not so advanced, however, with electric light introduced into these galleries only in 1954.

A proposal to further expand the Art Gallery in the 1930s was thwarted by the Great Depression so this is how the building remained until the late 1960s when the state government was looking for ways to celebrate the 1970 bicentenary of the arrival of Captain Cook in Sydney. The Latvian-born Andrew Andersons (b1942) was appointed as the project architect shortly after completing his master's degree in architecture at Yale University in 1966. Apart from his first-hand experience of Louis Kahn's Yale University Art Gallery, Andersons had also visited other new art museum buildings such as Marcel Breuer's Whitney Museum of American Art in New York and Jørgen Bo and Wilhelm Wohlert's Louisiana Museum outside Copenhagen. Hal Missingham had been the director responsible for planning the new wing over many years, but he retired just before it opened in 1972, a year before Jørn Utzon's Sydney Opera House. With this 1972 extension, the Art Gallery finally had spaces suitable for its growing collection of modern and contemporary art as well as for major exhibitions. Andersons was invited back to design the Art Gallery's next expansion, this one timed to coincide with the 1988 bicentenary of the British settlement of Sydney. This included, among other features, a gallery for Asian art, an outdoor sculpture

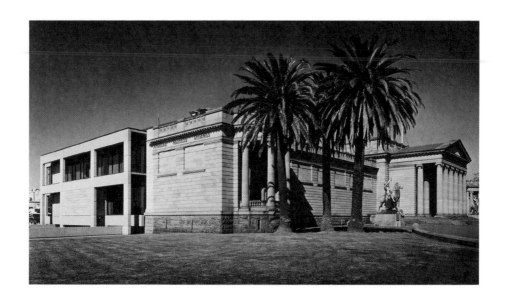

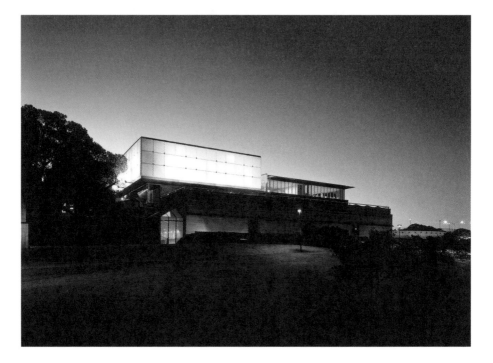

Top: The junction between the 1972 extension designed by Andrew Andersons and the northern facade of the original building designed by Walter Liberty Vernon in the 1890s

Above: A night view of the Asian Lantern gallery designed by Richard Johnson above the 1988 extension designed by Andrew Andersons, July 2003

The Sydney Modern Project

terrace and the Belgiorno-Nettis Family Galleries, which have since housed so many groundbreaking exhibitions of contemporary art.[13]

The final stages of the Art Gallery's architectural evolution took place between 2003 and 2011. First, an additional gallery for Asian art designed in the form of a rectangular glass lantern by Richard Johnson (b1946) at Johnson Pilton Walker was added, along with another temporary exhibition gallery and a new conservation studio. Not long afterwards, Andersons was again invited back to create new galleries from a storage area within his earlier 1972 extensions. They were to house the gift of the John Kaldor Family Collection of two hundred works of contemporary art and opened in 2011, along with a new offsite art storage facility. The Brett Whiteley Studio in Surry Hills – former workplace and residence of one of Australia's most celebrated artists – had come under Art Gallery management in 1995, with full title to the building being transferred in 2010.[14]

Even before these new galleries opened, the Art Gallery realised there was absolutely no more space for art to be eked out of its building. In order to plan for an even more successful future, a Strategy and Development Committee of the Board of Trustees was formed in 2008, comprised of then-president Steven Lowy, trustees Guido Belgiorno-Nettis and David Baffsky, the director Edmund Capon (who served a remarkably long and productive term from 1978 to 2011 and had overseen the 1988 and 2003 expansions) and deputy director Anne Flanagan. In 2011, a three-volume masterplan was completed that set forth how much new space the institution would need over the coming decades and where such a structure should be sited. The committee's finding was unequivocal: while the Art Gallery remained one of Australia's leading art museums, and punched well above its weight, it was woefully ill-equipped for the twenty-first century in terms of scale and space, and lagged well behind its peers in this regard.

* * *

This is the masterplan I was fortunate to inherit, along with a collection that had grown to number thirty-five thousand works of art by the time I returned to Australia in June 2012 to become the ninth director of the Art Gallery of New South Wales. It was the platform from which Steven Lowy and I launched the Sydney Modern Vision in March 2013 with a very simple message: 'Sydney needs this new museum and Sydney deserves this new museum'. The Sydney Modern Vision was intentionally ambitious and carried a name that highlighted how we intended to embrace the future from the city of Sydney with an unashamedly modern, outward-looking perspective. It had to be an art museum that could take its place in what had become known as the Asian century, in a more interconnected and digitised world in which a fuller range of visual arts, including film, music and performance, would be integral to the visitor experience.

The chosen location for the new building, immediately to the north of our original building, would make use of land underutilised by the public: two giant concrete slabs, one a land bridge over the Eastern

Distributor expressway and the other the roof of two disused Second World War oil tanks. The new building would, for the first time, allow the Art Gallery to display the full richness of our collection and increase our ability to establish creative partnerships and stage extraordinary exhibitions. But success, as I noted in my speech at the Vision launch, would not be evaluated by attendance figures alone (and nor would we be tempted to use that well-worn phrase 'largest in the Southern Hemisphere'). I wanted to focus more on the question of relevance, both national and international. We also recognised that a higher level of entrepreneurship would be required to achieve our ambitions and to earn the respect and financial support of both the state and private benefactors. Financial resources would have to be augmented by expanding revenue streams and revitalising fundraising activities, while ensuring that public funding from the NSW state government continued to provide the underpinning of our daily operations, which includes free entry for all.[15]

The first creative steps we took were to establish an international architecture competition for the Sydney Modern Project in February 2014 and undertake a thorough new technical survey of our site, funded by a generous state grant. The brief was developed with my colleagues Suhanya Raffel, then our deputy director and director of collections,[16] and Sally Webster, who would shortly thereafter be appointed head of the Sydney Modern Project, with external advice provided by architect Graeme Dix, who knew our original building well from his work at Johnson Pilton Walker.

We settled on an invitational model for the competition due to the complexity of the site. In the first phase of work, an Architects Advisory Panel selected around fifty Australian and international architectural practices for further consideration by the seven-member competition jury, which I had the honour of chairing. The other members were: Kathryn Gustafson, landscape architect with Gustafson Guthrie Nichol (Seattle) and Gustafson Porter (London); Michael Lynch, then CEO of the West Kowloon Cultural District Authority in Hong Kong and former CEO of the Sydney Opera House; Toshiko Mori, the Robert P Hubbard Professor in the Practice of Architecture, Harvard University Graduate School of Design; Glenn Murcutt, Sydney-based architect and recipient of the Pritzker Architecture Prize in 2002; Juhani Pallasmaa, Helsinki-based architect, professor emeritus and widely published writer; and Hetti Perkins, Sydney-based member of the Eastern Arrernte and Kalkadoon Aboriginal communities and a filmmaker, author and former senior curator of Aboriginal and Torres Islander art at the Art Gallery. The new president of our Board of Trustees, Guido Belgiorno-Nettis, attended all meetings as an observer.

The jury selected twelve architectural practices to participate in Stage 1 of the competition. These firms were sent one simple box containing an iPad loaded with the brief and all the necessary technical information about the site and the institution. Their entries were judged anonymously in January 2015 in the high-rise office of our legal firm Herbert Smith Freehills, overlooking a full sweep

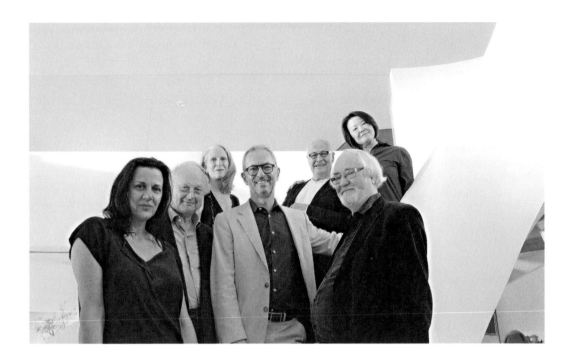

The Sydney Modern Project architecture competition jury in January 2015; from left: Hetti Perkins, Glenn Murcutt, Kathryn Gustafson, Michael Brand, Michael Lynch, Juhani Pallasmaa, Toshiko Mori

of Sydney, from the Harbour Bridge and the Opera House across to the Royal Botanic Garden and the Art Gallery, and then eastwards to the harbour and the Pacific Ocean beyond. Five architectural practices were shortlisted for Stage 2: Kengo Kuma (Tokyo), Kerry Hill (Perth and Singapore), Rahul Mehrotra (Boston and Mumbai), SANAA (Tokyo) and Sean Godsell (Melbourne). Their submissions were assessed by the jury in April 2015 after a site visit and a presentation to the jury.

The jury resolved unanimously that SANAA, led by Kazuyo Sejima and Ryue Nishizawa, be recommended as the preferred architect for the Sydney Modern Project, and this was announced publicly on 27 May 2015. SANAA was then best known for its design of the 21st Century Museum of Contemporary Art in Kanazawa (2004), the New Museum in New York (2007) and the Louvre satellite museum in Lens in northern France (2012). For the Sydney Modern Project, SANAA selected Sydney-based firm Architectus as executive architect, under the leadership of CEO Ray Brown and principal Luke Johnson; and McGregor Coxall as landscape architect, led by Adrian McGregor.

SANAA's work exhibits a clear elegance on the outside that masks brilliantly complex structural dynamics. As Harvard professor Eve Blau noted in a commemorative essay when SANAA was awarded the Pritzker Architecture Prize in 2010:

> The structural organization of Sejima and Nishizawa's buildings – from small houses to museums to large institutional

buildings – operates in terms of an inherently contradictory (double) spatial logic that is predicated on combining the maximum independence of parts with the closest possible interrelation among them.[17]

The jury's comments on SANAA's Stage 2 entry for the competition show how the architects had kept in balance our dual goals of expansion and transformation:

> [It] responds to the beauty of the competition site through a series of pavilions that reach out to the Domain and the Royal Botanic Garden as they cascade down to Sydney Harbour and Woolloomooloo. The low profile of the pavilions complements and preserves both the integrity and importance of the existing Art Gallery building and creates spaces to bring people together and foster a sense of community, imagination and openness.

> Its lightness of form speaks to the new century while respecting the architecture of the previous centuries to create a harmonious and inspiring new public space for Sydney. The scheme is futurist in its thinking about art museums and the visitor experience and will be transformative for the Art Gallery. The scheme elegantly places Aboriginal and Torres Strait Islander art at its heart.

> This is a twenty-first century concept that has the full potential when developed to be an environmentally sensitive art museum. The scheme starts to deconstruct the classical art museum and offers opportunity for further development of new types of spaces for the display of a variety of artforms, both existing and new.

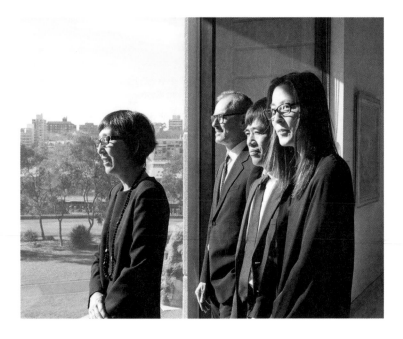

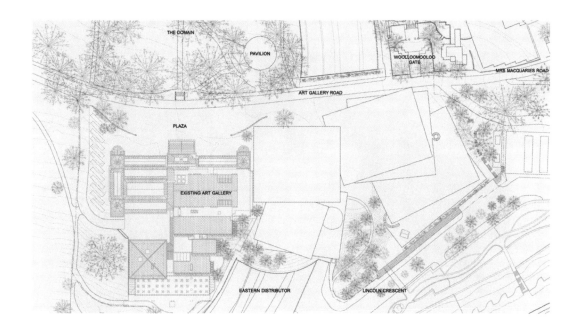

The design offers what the architects describe as 'a clean palette' for displaying art and staging cultural events. The scheme will invite artists to experiment and provide a curatorial challenge for the Art Gallery which would be profoundly invigorating for an institution transforming itself into a twenty-first-century art museum.

The Art Gallery team soon joined with SANAA's team to commence the further development of their concept. What followed was a series of over twenty design workshops in Tokyo and Sydney and, in between, numerous conference calls taking advantage of the cities' similar time zones. The first workshop was held in September 2015 at SANAA's studio in Tokyo.[18] At the end of the workshop we made a quick visit with our new Japanese colleagues to the Naoshima 'art island', incorporating side trips to Sejima-san's projects on Inujima Island and Nishizawa-san's Teshima Museum on Teshima Island for further inspiration.

SANAA's Tokyo studio is located on an island of reclaimed land near where the Sumida River flows into Tokyo Bay. The studio (since rebuilt) was an old warehouse with a single open space holding the entire group of around fifty architects, divided into three zones by shoulder-high bookshelves (temporary structures prone to toppling over during stronger earthquakes). The main meeting space was at the far end of the studio overlooking a canal. All workshop

Opposite: Kazuyo Sejima (left), Ryue Nishizawa (centre), Yumiko Yamada and Michael Brand overlooking the Sydney Modern Project building site on the morning of the competition announcement in May 2015

Above: SANAA's site plan from Stage 2 of the architectural competition in 2015, showing the pavilions of the new building cascading down towards Woolloomooloo. In this early iteration, the new building is shown spanning the land bridge over the Eastern Distributor.

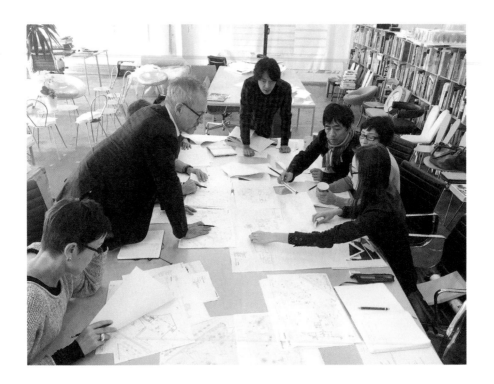

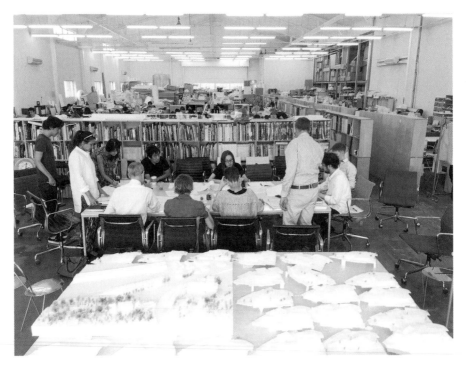

Design workshops at SANAA's Tokyo studio in 2015, with an array of models for the Art Gallery's new building in the foreground of the lower image

The Sydney Modern Project

discussions were structured around physical, three-dimensional models. During one workshop, a typhoon hit Tokyo and when we opened the sliding glass windows to get a better look at the conditions outside, the dramatic change in air pressure sent scores of cardboard models flying through the air.[19] Computer work took place behind the wall of bookshelves. Between the conference table and the windows were other tables full of models for their various projects, along with casually placed potted orchids and the occasional prototype of a SANAA-designed chair.

Apart from Sejima and Nishizawa, key members of the SANAA Sydney Modern Project team were Yumiko Yamada, one of the firm's three partners; Asano Yagi, who would later be based in Sydney during the construction phase; Hysun Soo and Ichio Matsuzawa, the latter often playing the role of pinch-hitting problem-solver. Sejima-san was the most active when it came to physically manipulating the cardboard models as we evaluated options. Discussions would sometimes continue over dinner, and also during car trips to architectural sites around Tokyo.

While many details were changing, the concept of the multiple 'floating' pavilions that had so appealed to the competition jury gained added strength. The actual configuration of the pavilions evolved continually, but the way the pavilions were locked into the landscape within the tree line meant views up from Woolloomooloo towards the city were preserved along with connectivity to the Royal Botanic Garden. At the same time, SANAA worked with various engineers, especially Atelier 10 and WSP | Parsons Brinckerhoff, to ensure the most effective response to sustainability principles. This would result in a maximum 6-star Green Star design rating from the Green Building Council of Australia, the first art museum in the country to achieve this.

Early 2016 marked a major point of transition for the Sydney Modern Project. After his nine-year term limit as a trustee expired, Guido Belgiorno-Nettis, who had served as board president for his final two years, was replaced by David Gonski, who returned for his second appointment as president, having previously served in that role from 1997 until 2006. A preliminary business case concerning both the projected operating costs of the expanded art museum and an estimation of economic benefits to the state had been submitted to the government in late 2015 under the leadership of our then chief operating officer John Wicks. Now, the new president needed to ensure we obtained sufficient funding to bring the full quality of SANAA's design to life. He immediately sought a review of the potential funding for the project, from both public and private sources.

Based on this review, it was decided to slightly reduce the footprint of the new building by removing the structure that was to be built on the land bridge, including a concourse gallery that would have provided an internal link between the original and new buildings. This contraction of the pavilions was a blessing in disguise since it allowed a tighter configuration of the pavilions with a single vertical transit axis through all levels, along with better pathways and sightlines. Most

significantly, it meant that the land bridge between the two buildings could become part of the Sydney Modern Project as a space in its own right: what we initially dubbed the 'third element'. This led to us describing the combination of the three distinct but contiguous places as a campus, the first of its kind for an art museum in Australia, as we took inspiration from such institutions as the Getty in Los Angeles; the Clark Institute in Williamstown, Massachusetts; and the Louisiana Museum of Modern Art near Copenhagen.

We named the third element an 'art garden', hoping to create a unique public space for Sydney that would be a work of art itself: a garden that would honour the history of the site on which the Art Gallery stands while taking inspiration from both the present and our envisioned future; a flexible space that would offer an experience of immersion in the natural and built environment while hosting a wide diversity of people and uses. In order to achieve this goal, we brought in Kathryn Gustafson as the landscape artist for the art garden and initiated discussions with Sydney-based Wiradyuri and Kamilaroi artist Jonathan Jones about creating a major art commission within this landscape. Gustafson had worked in Sydney previously and been a member of the architecture competition jury for the Sydney Modern Project while Jones had previously worked as a public program officer at the Art Gallery as well as having artworks in our collection. Having created a masterplan for the art garden, Gustafson's own landscape design eventually expanded to focus on creating a garden forecourt uniting our whole frontage along Art Gallery Road, while Jones's art commission also expanded in ambition and scale to encompass almost the entire eastern zone of the art garden. During Gustafson's masterplanning process, the Art Gallery obtained major philanthropic support for this part of the project from the Hong Kong–based Lee family to honour the late Pearl Lee and her husband, Ming Tee.

In February 2017, our new deputy director and director of collections Maud Page travelled with the Art Gallery team for her first Tokyo workshop as we started conceiving how we would install, or reinstall, art across our expanded campus; and how we might add to our collection with that goal in mind. This was a moment when the emerging architectural designs were inspiring new ways of curatorial thinking as much as the designs themselves were being informed by our curatorial vision.

One of the most consequential workshops took place in Sydney in September 2017 when several members of the SANAA team were able to make their first visit into the underground oil tank that was to be preserved in their design for the new building. Having descended the temporary scaffolding stairs into the tank, with its floor still covered by a shallow layer of water, they immediately decided to abandon plans to add a mezzanine over part of this cavernous space and,

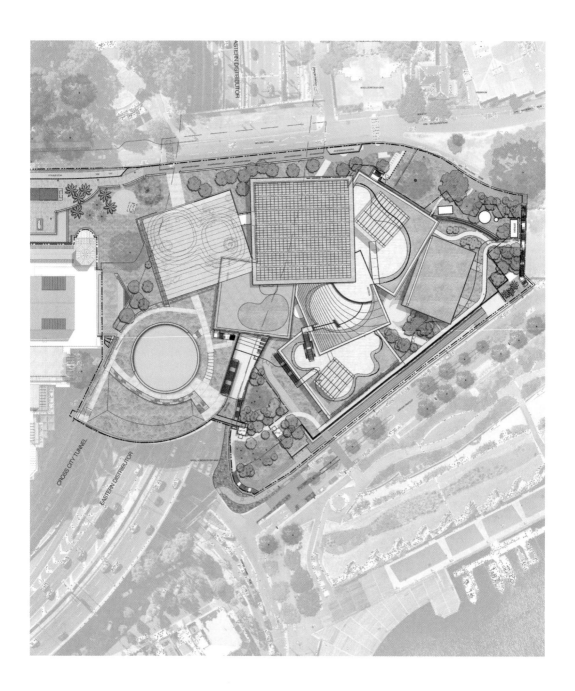

Detail of a landscape site plan produced
by McGregor Coxall, including Kathryn
Gustafson's masterplan for the art garden
connecting the original and new buildings

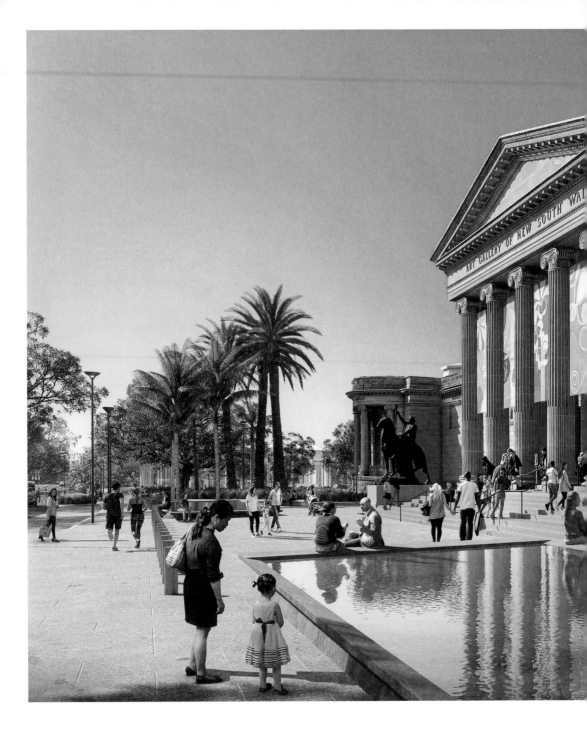

Architectural render of the forecourt and reflection
pools in front of the original building, designed by
renowned landscape architect Kathryn Gustafson and
Seattle firm GGN, with the new building to the rear left

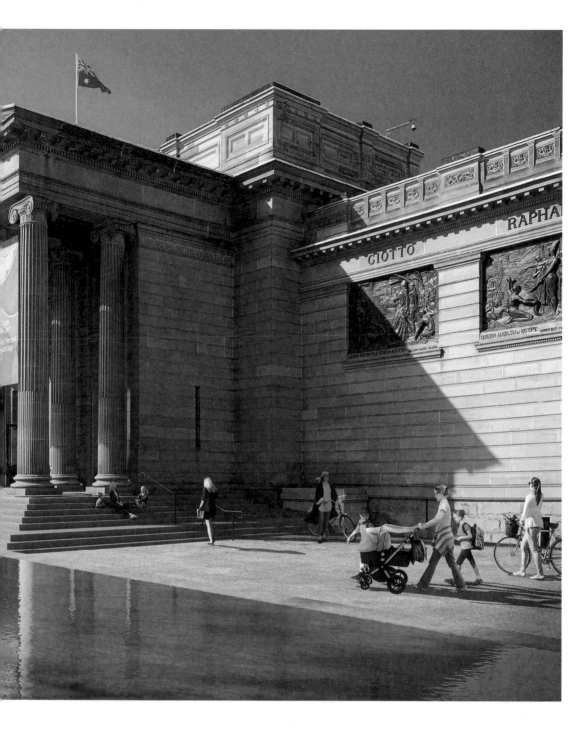

instead, chose to preserve the tank in its entirety as what they described as 'Sydney's treasure'. A remarkable moment came in November that year when we were able to take our first virtual-reality tour of the new building design at the Sydney offices of Architectus. At first, we moved through the spaces together watching on a large screen. Then we were able to don headsets individually and navigate ourselves around the building. We were extremely excited by what we experienced and felt even more certain the design was matching our vision. The following month, we were joined at a Tokyo workshop by Kathryn Gustafson and Jonathan Jones, to formally discuss the development of the art garden, that 'third element' which would drive the broader development of the campus landscape.

The individual personalities of the three large stone-clad pavilions, one for each of the above-ground levels, continued to evolve. The new Yiribana Gallery for Aboriginal and Torres Strait Islander art on the entrance level was provided with a glazed loggia overlooking the art garden and a large north-facing window that linked it with the waters, lands and skies of Sydney; one level down, the four columns originally incorporated within the Isaac Wakil Gallery were removed

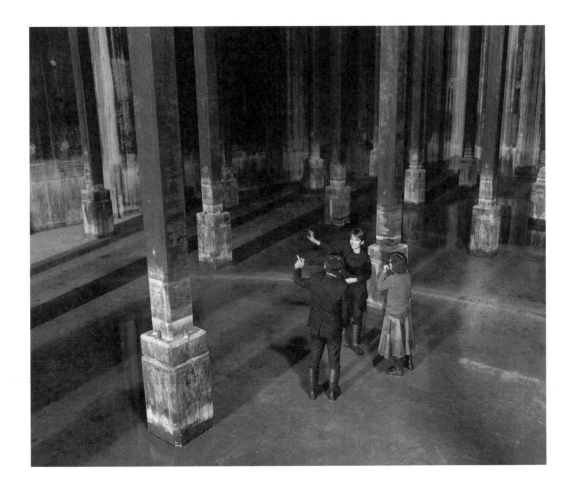

The Sydney Modern Project

to provide a spectacular column-free space for contemporary art with a wall of glass overlooking the harbour; and the Ainsworth Family Gallery for major exhibitions, one further floor down and resting on top of the Tank space, was designed to provide 50 per cent more floor space than the existing area for this function in the original building. Each pavilion achieved a ceiling height of 5.5 metres.

Another significant design breakthrough occurred with the development of SANAA's extraordinary glass canopy soaring as much as seven metres above the Welcome Plaza between our two buildings. The 'arches' of the wave-form profile of the huge glass panels perform a structural function, alleviating the need for steel beams joining the slender columns on the east–west axis. A fritting pattern was added to the panels to deflect solar heat and improve climate conditions under the canopy. By continuing to bend roof-forms (one of the benefits of those flexible cardboard models), SANAA was eventually able to design an exterior pathway down across the upper three levels of the building that provides spectacular views of the city and harbour.

The ambitious scale of our creative vision required unprecedented levels of funding. The Sydney Modern Project is the largest public–private partnership in the arts to date in Australia. During the first two years of design development, board president David Gonski continued to lead negotiations with the state government regarding its support of the project's capital costs. At the same time, another criterion of public support for the Sydney Modern Project was becoming very apparent: the success of our private fundraising. The Board of Trustees created a Capital Campaign Committee as soon as the architecture competition concluded in May 2015, with then board vice-president Mark Nelson appointed as chair, working with our director of development John Richardson. The extraordinary success it achieved in its 'quiet phase', before its public launch two years later, played a significant role in gaining government support. At an event in the Art Gallery in June 2017, the then state Minister for the Arts, the Hon Don Harwin, announced $244 million of state funding for the project, contingent on the Art Gallery raising $100 million from private sources. The Art Gallery used this event to formally announce the Sydney Modern Project capital campaign, with $70 million already pledged. Of that amount, $20 million had come from the Susan and Isaac Wakil Foundation and the Art Gallery was proud to announce that this lead gift was from a couple who had both come to Australia as refugees: Susan (1933–2018) having been born in Romania and Isaac in Iraq. Other early donors included then trustee Geoff Ainsworth and his family as well as Sydney-based property developer Aqualand and Gretel Packer. The full $100 million target was surpassed in June 2018.

With the design process in full swing and government capital funding secured, there were still further processes to be completed. The State Significant Development Application for the design of the new building was submitted to the Department of Planning in November 2017 and the final business case was submitted to the state

SANAA architects viewing the empty oil tank in rain boots to fend off the residual water. From left: Ryue Nishizawa, Asano Yagi, Kazuyo Sejima.

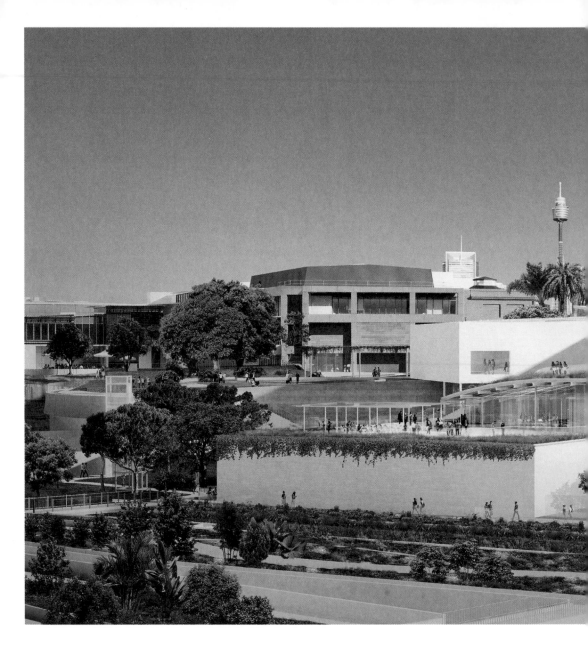

Architectural render of the new building designed
by Kazuyo Sejima + Ryue Nishizawa / SANAA,
viewed towards the west from Woolloomooloo,
with the city in the background

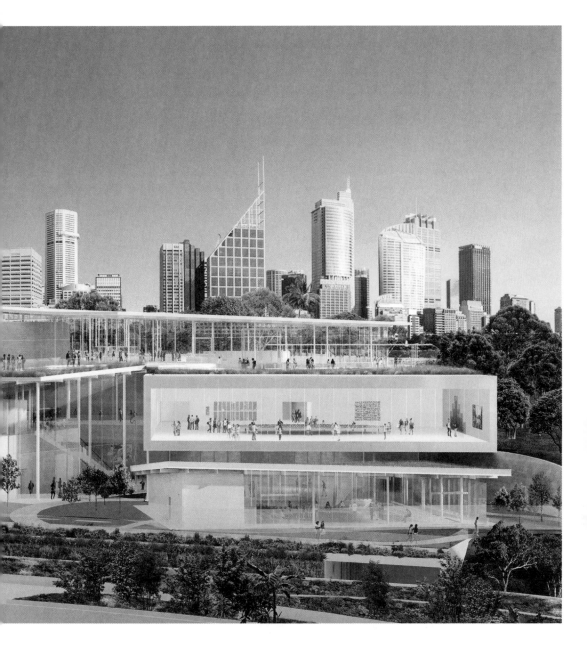

government the following month, with a highly positive 1:6 Cost Benefit Ratio. Work on developing a full operating budget for the expanded art museum continued under the leadership of new chief operating officer Hakan Harman. The development application was approved in November 2018,[20] and this allowed the Art Gallery to start the tendering process through Infrastructure New South Wales. A contract was signed with Richard Crookes Constructions in October 2019 and, with this in hand, Andrej Stevanovic commenced as our new project director, taking over from Nicholas Wolff, who served in this role during the pre-construction phase after the initial project director John Gale. It was confirmed that the new building would open by the end of 2022.

On a scorching hot day at the beginning of November 2019 – the Black Summer bushfires had started in September – the groundbreaking ceremony for the Sydney Modern Project on top of the oil tanks commenced with a moving, multi-generational Welcome to Country introduced by our Girramay, Yidinji and Kuku-Yalanji artist trustee Tony Albert. While highlighting the importance of the project for the state, the then premier of New South Wales, the Hon Gladys Berejiklian, congratulated SANAA for its design of the new building and the Art Gallery for the success of its capital campaign to obtain private philanthropic support for the project. A special thank

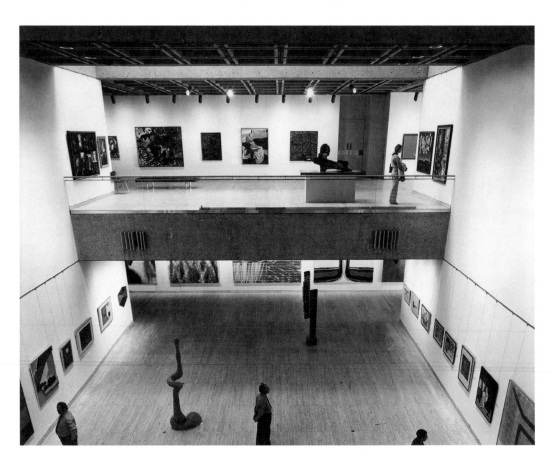

you was extended to the ninety-two-year-old Isaac Wakil, who sat in the audience. This would prove to be the last trip from Tokyo to Sydney for the SANAA team before the COVID-19 pandemic took hold in March 2020 and severe travel restrictions were put in place by the Australian Government. Fortunately, SANAA's project architect, Asano Yagi, had just taken up residence in Sydney in order to provide direct access to the Tokyo studio throughout the construction period. A day of work was lost in the first week of construction due to smoke from the bushfires then circling Sydney but, almost miraculously, construction continued unabated during the COVID-19 pandemic until a two-week stoppage in July 2021.

Significant funds were also allocated for revitalising the Art Gallery's original building, restoring some design features that had been altered in attempts to create more space and relocating some functions based on changing needs and priorities. This was a key element in our plan to create an art museum campus with two equally impressive buildings, one contemporary and the other dating back to the late nineteenth century. In December 2019, Tonkin Zulaikha Greer was appointed as architect for this part of the project, under the leadership of Peter Tonkin. Its main tasks were to renovate the original Grand Courts (including new lighting and the removal of an internal stairway cut through the floor of one court in 1972); reopen the balconies overlooking the double-height gallery in the 1972 wing; expand the Edmund and Joanna Capon Research Library and National Art Archive into the space on lower level 3 in the 1988 extension, freed up when the Yiribana Gallery for Aboriginal and Torres Strait Islander art moved up to the entrance level of the new building; double the size of our Members Lounge next to the new library and turn the library's previous location into an 'atelier' office space. As the project continued to evolve and the capital campaign went from success to success, other features were added such as a children's library and a new dedicated space for our volunteers.

Initial construction work on this part of the project started not long after we celebrated our 150th anniversary in April 2021 and continued into mid 2022 in tandem with the reinstallation of all the original gallery spaces. Construction of the new building was completed at the same time and the installation of art then began. Ten years after I had taken on the role of director of the Art Gallery and was charged with expanding and transforming the state art museum, the Sydney Modern Project was brought to completion and our new building opened to the public in December 2022.

As part of an identity project under the leadership of our director of public engagement Miranda Carroll, a new visual identity was provided by Dominic Hofstede from the Melbourne office of Mucho (who also designed this book). The choice of the word 'campus' to describe the physical extent of the expanded Art Gallery was carefully considered as part of our new identity. In Australia, it is almost exclusively used with respect to schools and universities. This is company we are happy to keep. Around our central focus on the work of art we can now spin a sense of the movement of both people

A 1972 interior view by photographer Max Dupain of one of the two original balconies in the extension designed by Andrew Andersons, reopened as part of the Sydney Modern Project

and ideas through buildings and landscape. Art and performance are encountered in a veritable history of art museum architecture, from the capacious top-lit spaces of the neoclassical nineteenth-century picture galleries through the modernist additions of 1972, 1988 and 2003 to SANAA's non-hierarchical pavilions of the new building emerging like a lotus flower from the murky depths of the repurposed industrial space of the Tank. The landscape brings experiences from the formal to the evocative and the downright conceptual. The existing spaces bring their history with them while the new spaces stand ready to inspire both artists and viewers from current and future generations. This is how we think of our new campus at the Art Gallery. This is where we work with art. And this is what we share in this book marking the completion of our Sydney Modern Project transformation.

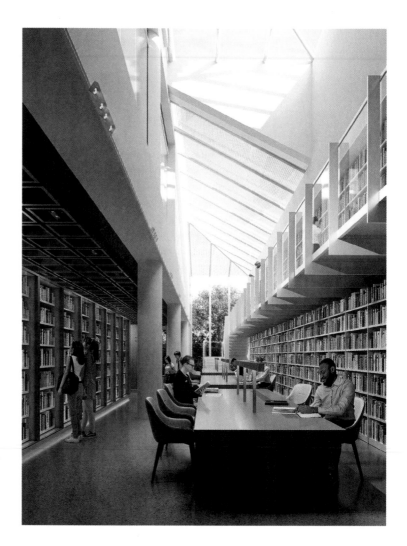

Right: Architectural render of the new reading room as part of the relocated library and archive designed by Tonkin Zulaikha Greer Architects

Overleaf: Photographs of the Art Gallery's new building under construction by Rory Gardiner

The Sydney Modern Project

1 Steven Miller, *The Exhibitionists: a history of Sydney's Art Gallery of New South Wales*, AGNSW, Sydney, 2021.

2 *New South Wales Academy of Art first annual report*, Sydney, 1872, p 1.

3 William Wardell was a pupil of Augustus Pugin and the architect of the nearby St Mary's Cathedral, to which Pugin made some extensions.

4 Stephen had previously served as chief justice of New South Wales from 1844 to 1873, and then as vice-president of the state's commissions for both the 1878 Paris Universal Exhibition and the 1879 ney International Exhibition, and ident of the commission for the Colonial and Indian Exhibition ndon.

tefiore and Combes were acclaimed artists. In the *tin*, 23 April 1881, p 1, Combes described as the 'best teur painter in Sydney and vonder [is] … that the prosy echanical engineer can find to indulge in the "seraph asy" of a pictorial ideal'.

ur Streeton's art', *Sydney ning Herald*, 21 Nov 1931, quoted ller 2021, p 116. In 1890, our ees had purchased Streeton's *glides the stream, and shall for glide'*, painted earlier that year he was just twenty-two years nd the first of his works to a public collection in Australia.

uin did however sign the rs' book at the Auckland Art ry Toi o Tāmaki on 26 August see Auckland Art Gallery ve, EH McCormick Research ry, RC2015/5/5/1

rst example of French ssionism, Pissarro's *Peasants s, Éragny* 1887, was purchased n 1935. Du Faur's comments a six-month trip to Europe in hat he found 'little evidence ty youth among the younger s' but rather 'a lifelessness that suggests impoverished blood' suggest he was not looking in the right places in Paris.

9 Beauchamp subsequently maintained a lifetime link with Sydney where, hinting at the way the city would embrace its LGBTQI+ community in the future, he was able to live quite openly with his male lover before his disapproving brother-in-law, the Duke of Wellington, forced him into exile. For a fuller telling of this story, part of which provided inspiration for Evelyn Waugh's novel *Brideshead Revisited*, see Miller 2021, pp 149, 151.

10 'We have a fine painting of it in our Art Barn – I beg pardon – Gallery in the Domain.' HS, 'A time-honoured little vice', *Sydney Mail*, 26 Jan 1884, p 150.

11 See map and information, p 142.

12 The Operative Stonemasons Society banner, Miller 2021, p 93.

13 The galleries were named for the Belgiorno-Nettis family in honour of a major gift in 2008. Franco Belgiorno-Nettis founded the Biennale of Sydney in 1973 and the Art Gallery has served as one of its venues ever since the second iteration in 1976.

14 In June 2022, it was announced that the Art Gallery and the Brett Whiteley Foundation would become joint recipients of the promised Wendy and Arkie Whiteley Bequest, which will be one of Australia's greatest cultural gifts and the largest bequest in the Art Gallery's history. See *Sydney Morning Herald*, 20 Jun 2022, pp 1, 4.

15 Paid tickets are required for major temporary exhibitions.

16 Suhanya Raffel served in this role from July 2013 to September 2016, when she was appointed as director of M+, then under construction in Hong Kong.

17 Eve Blau, 'Inventing new hierarchies', The Pritzker Architecture Prize essay on Kazuyo Sejima and Ryue Nishizawa, 2010 laureates, The Hyatt Foundation/The Pritzker Architecture Prize, Chicago, 2011, pritzkerprize.com/2010/essay

18 The Art Gallery team joining me for this critical meeting comprised Suhanya Raffel, Sally Webster, the newly appointed project director Nicholas Wolff, along with Luke Johnson from Architectus.

19 Typhoon Mindulle struck Tokyo in August 2016.

20 Three modifications were approved between 2019 and 2021.

Errata

pp44, 61n16
Anne Flanagan served as deputy director from 2010 until the completion of the architecture competition in May 2015, when then director of collections Suhanya Raffel took on this additional role.

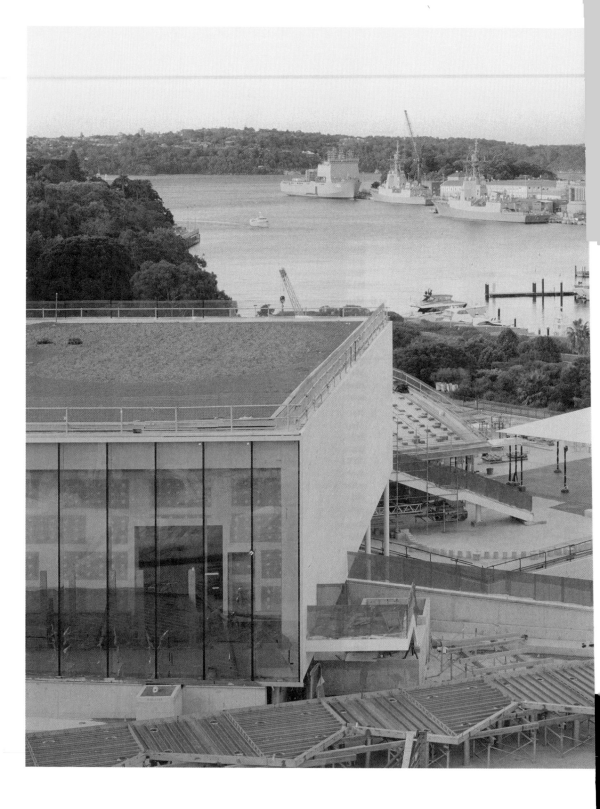

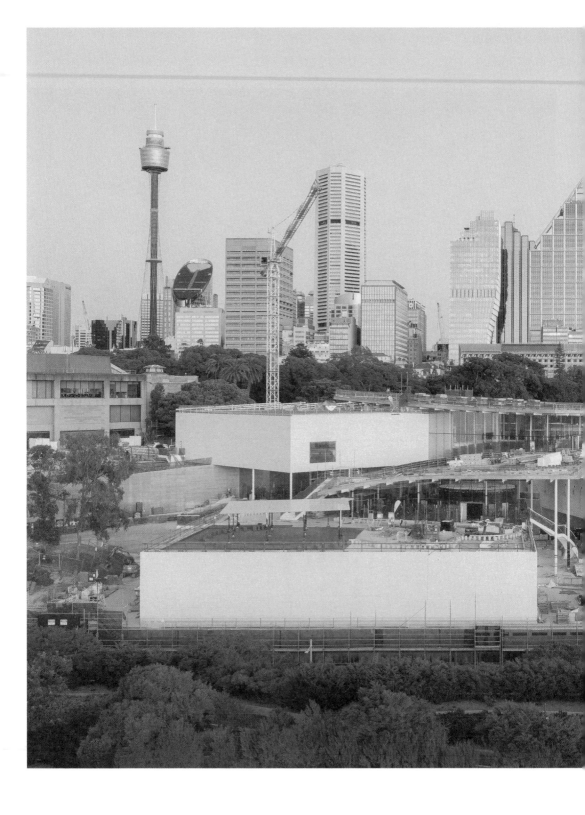

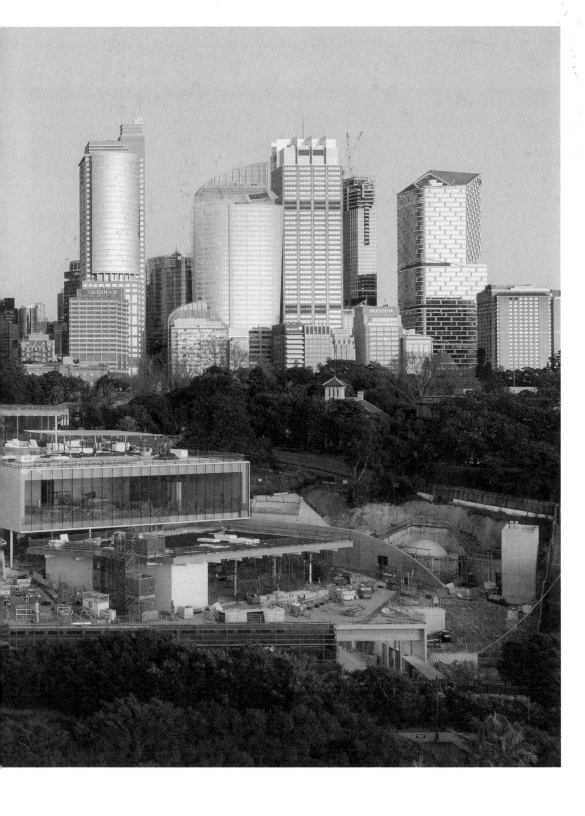

The commissioning pulse

Maud Page

'Commissions are sought, shaped, nurtured and chosen for what they can say about an institution at a particular point in time. They are like signposts marking a museum's character that also signal a shift, a change in mood or purpose.'

2

Tell stories Filled with Facts. Make People Touch and Taste and KNOW. Make People FEEL! FEEL! FeeL!

—Octavia Butler[1]

A COLLECTION TELLS THE HISTORY OF AN INSTITUTION. It speaks of the audacious and the droll, small and large triumphs, awkward pauses and poignant moments, capital T truths and, sometimes, little lies. Its artworks trace chronologies of fluctuating aspirations and shifting tastes, shaped by the individuals who created and acquired them.

Collections are born of opportunity and availability, while commissions are developed to a different pulse. Commissions are sought, shaped, nurtured and chosen for what they can say about an institution at a particular point in time. They are like signposts marking a museum's character that also signal a shift, a change in mood or purpose.

Nine artists have been commissioned for the Sydney Modern Project – Lorraine Connelly-Northey, Karla Dickens, Simryn Gill, Jonathan Jones, Yayoi Kusama, Lee Mingwei, Richard Lewer, Lisa Reihana and Francis Upritchard. Each has been variously chosen to respond to our collection, to SANAA's lyrical architecture or to simply document the building site.

Their works resonate with, and sit within, the strong and continuous Aboriginal history of this place. They variously humour, confront, prod and delight, drawing on a myriad of narratives, from sci-fi to particular histories from this part of the world. A number of them privilege Aboriginal and Pacific histories and knowledge. Asian voices also loom large, as do, of course, Australian perspectives. Their art is polyphonic but also precise. Many of the commissions engage with urgent social issues: migration, displacement, labour value and climate change. They are as aesthetically varied as they are rigorous, and powerfully herald new art histories to be written from here.

Over 450 individuals excavated earth, engineered, welded, plastered, scaffolded and much more during the two-and-a-half years of constructing the Art Gallery's new building. Richard Lewer's suite of paintings pays tribute to this human element of the project. His aim was to record some of the many people who created this quietly intelligent yet highly complex structure that gently cascades down a headland jutting into Sydney Harbour, known as Yurong before the arrival of European settlers. He painted Glenn Baldwin, the work health and safety officer from Richard Crookes Constructions, who had to juggle his roles of caring for the personnel on the building site and for his daughter, who has no mobility, at home. Another portrait depicts Charmoon Tumupu (aka Sharkboy), Luke Hollard and Liam Fearn, who made the formwork for the steel spiral staircase that leads down into the repurposed oil tank and who cajoled Richard Lewer to 'paint them good'. They shared their lunch with him and told him that Jo-Anne (Jo) McDonald-Singh, the 'lollypop' site traffic controller, gives them love advice. The lead SANAA architect on the project, Asano Yagi, lived alone in Derrawunn/Potts Point during this time,

far from family and firm in Tokyo. She was the sharp brain with a soft touch. And Andrej Stevanovic, the 'boss' of the project, consumed a lot of chocolate from the dispensary and had energy to burn, treating no problem as unsolvable – piecing together the working team like Tetris, he ensured that everything was purposeful, fast and coordinated.

Lewer, with his usual insight and close attention to poignant details, has captured some of this recent human history of this site. Of his nine painted panels, the first shows the campus site before excavation, looking back from a grassed-over concrete area towards the existing Art Gallery building. The empty space with its curved brick wall echoes the original sandstone escarpment that encircles the building, as well as the sweeping rammed-earth walls that form the distinctive foundations of the SANAA building. Lewer's oil portraits painted on black steel will hang on one of these walls.

In another portrait Lewer also captures a glimpse of the Tank, the jewel of the new building. Here Dave Robins, who has worked for the construction company for twenty-seven years, leans on a skip bin. He is lit by daylight coming through the circle cut into the high roof that would later become the entry point for the magnificent circular staircase into this unique space. It is worth remembering the workers who laboured to build the two oil tanks on the Sydney Modern Project site. Constructed in the 1940s as part of the fearful strengthening of Australia's defence following the fall of Singapore, the tanks, now decommissioned but still bearing an oil patina, have only the handsome mouldings of the seven-metre-high columns remaining as a trace of the many hands that built them.

Richard Lewer in his Melbourne studio working on his portrait commissions for the Sydney Modern Project

The commissioning pulse

In addition to its long history as a gathering place for the Gadigal, the Art Gallery's campus lies adjacent to the two-hundred-year-old Botanic Garden on the Domain that slopes down to Woolloomooloo, a place of Indigenous gathering that has seen comings and goings for tens of thousands of years. Woolloomooloo's more recent history is marked by the construction of the Finger Wharf in the 1910s, the world's longest timber-piled wharf, where ships departed for war and migrants arrived after the Second World War from Europe, the Americas and the Pacific. These arrivals later populated the area, benefiting from the local fish market and proximity to city factories.[2]

For her commission, Lisa Reihana drew on this ebb and flow of labour to point to Sydney's histories with the Pacific, specifically Aotearoa New Zealand. Reihana is an artist of Māori descent and her panoramic moving-image work *GROUNDLOOP* uses a humble account of weaving and logging to evoke greater seismic and cosmological stories. Its 19 x 5 metre digital screen overlooks the new building's central atrium and carries the momentum of the ocean swell it depicts. The film skims the waters of the Tasman Sea between Australia and Aotearoa, with the harbours of Sydney and Hokianga in New Zealand's far north looming into view as if being encountered for the first time. This narrative of discovery is countered by the to-and-fro of waka (canoe) journeys that dip deep to the ocean floor and soar high into the skies, alluding to shared traditional navigational tools that draw upon the Milky Way and the Emu Dreaming. This layered traversing enables Reihana to disrupt chronology and narrative sequence. *GROUNDLOOP* is a kind of Polyfuturism – as Māori say, '*Ka mua, ka muri*', 'walking backwards into the future'.

The film is anchored by Reihana's deep respect for Australian First Nations cultures, built over three decades of relationships with Aboriginal people. As with her 2015 video *in pursuit of Venus [infected]*, Reihana drew her collaborators from across both countries and beyond, forming an intergenerational cast of actors, performers, artists, designers, animators, navigators and technical crew to create vignettes elucidating specific aspects of Indigenous knowledge. *GROUNDLOOP* commemorates the recent passing of waka builder, captain and mentor Lilo Ema Siope, who is invoked through Jahra Wasasala's lead role as *kaiwhakatere* (navigator) of the futuristic waka that travels between Sydney and Hokianga harbours.[3] Both women deftly navigate Pacific knowledge systems through different creative means. Reihana is a member of the Ngā Puhi tribe and the ancestors Tuki Tahua and Ngāhuruhuru, also from New Zealand's Northland, were the first recorded Māori to enter the British colony of New South Wales in 1793. These master *tohunga* (artists, knowledge men and chiefs) were brought (some say kidnapped) to Norfolk Island by Lieutenant Philip King, later the third colonial governor of New South Wales, to teach female convicts how to weave flax into garments, even though, as men, they didn't really know how to process flax or weave. In the end pedagogy gave way to commercial interests, with the two *tohunga* mapping the abundant timber and flax crops of Hokianga Harbour while hosted by King in the first Government House. This

Production stills of Lisa Reihana's *GROUNDLOOP* 2022

led to an ongoing trade with Māori businesses. *GROUNDLOOP* is also a document of this little-known history.[4]

Reihana, though, is most interested in looking to the future. Originally *GROUNDLOOP* was proposed as a cli-fi film based on the eruption of the volcano Whakaari/White Island and Māori having to flee their land to join forces with Indigenous Australians, but, eerily, the actual island erupted after this initial concept.[5] And this event was followed in Australia and New Zealand by a series of unusual earthquakes, tornados, devastating bushfires and deadly floods. The urgency, then, is not in imaging dystopian climate carnage but in seeking ways we might survive it.

Indigenous knowledge and philosophy are finally gaining wider recognition at a moment when the colonial legacies of industrialisation and rampant capitalism are causing environmental implosion. Within the commission series, artists are leading this conversation by bringing Indigenous practices and thinking to physically change our Art Gallery. These ideas have also informed our collection displays. Cara Pinchbeck, who leads the Art Gallery's Indigenous team, has chosen to work with the idea of 'burbangana', a word from the Aboriginal language of Sydney meaning 'to take hold of my hand and help me up', as the curatorial rationale for the Yiribana Gallery, which has been elevated from the lowest level of the original building to the entrance level of the new building (see further p 90). Gentle leadership, support and generosity are implicit in burbangana; an invitation to share knowledge.

Set in a place of quiet sanctuary within the fabric of the new building's external rammed earth wall, Lee Mingwei's sculpture is built on the idea of reciprocity, on what it means to offer or receive a gift. What do visitors take with them when they leave our spaces? What do they remember and what makes them return?

Lee recounts the story of pausing before a Chinese sculpture of the Buddha from the Sui dynasty (581–618 CE) in the Art Gallery's collection while visiting Sydney in 1999. Standing over two metres tall, this Buddha is remarkable for its powerful presence, even though its head, hands and feet are missing. Rather than evoking loss or the ravages of time, the sculpture – with its translucent patina, the flowing marble pleats of the Buddha's robe, and cavities where its hands once were – generates great empathy in those who encounter it.[6] Indeed, this is what Lee experienced: his pause became a plea to the Buddha for guidance through a difficult juncture in his life. Many years later, he returned to the Art Gallery and once again stood before the Sui Buddha. Remembering his plea, he felt gratitude and hoped that its spirit would guide another. This profound and very personal experience was the foundation for Lee's sculpture *Spirit House* 2022. He worked with SANAA architects to house it, creating a domed space made of rammed earth that appears as if it is dug out of the building's sweeping wall. Visitors can enter the dome from one of the internal gardens, to encounter Lee's bronze seated Buddha within. Once a day its upturned palms offer a rattan-covered stone, to be taken by a visitor if they choose.

Lee Mingwei with the clay model
Buddha for his *Spirit House* installation
and rattan-wrapped stone created by
Shizu Designs

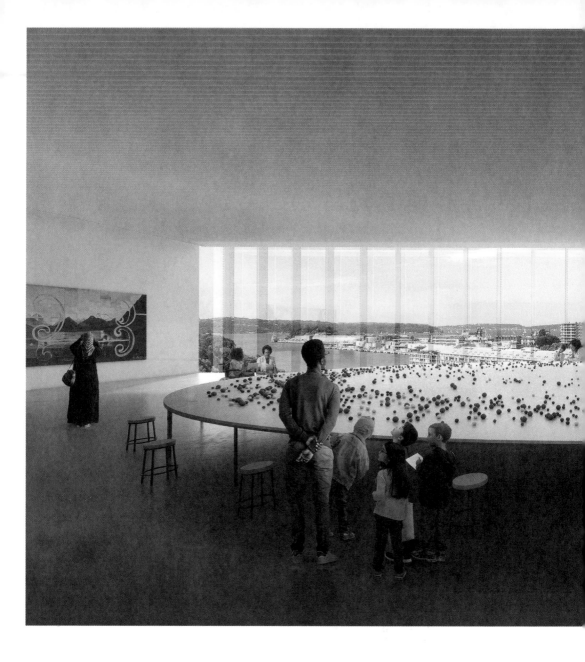

Rendition of the Sydney Modern Project building
produced by Kazuyo Sejima + Ryue Nishizawa /
SANAA, featuring Kimsooja *Archive of mind* 2017
(centre), Imants Tillers *Counting: one, two, three*
1988 (left), and Rodel Tapaya *Do you have a rooster,
Pedro? (Adda manok mo, Pedro?)* 2015–16 (right)

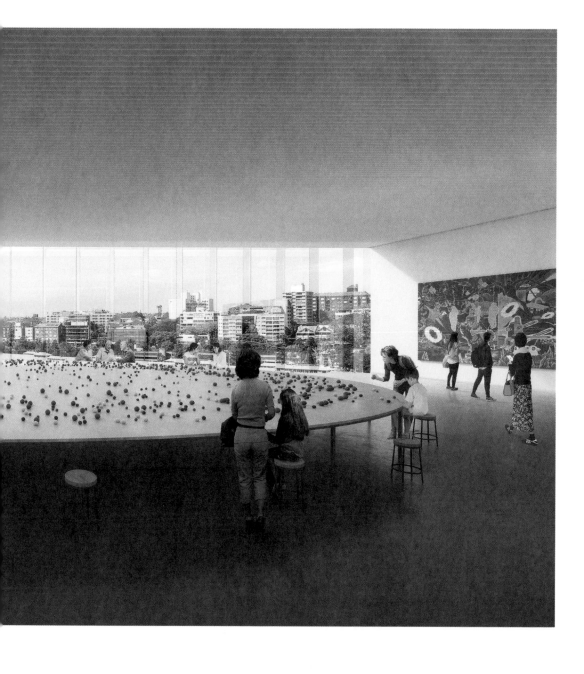

Lee does not overdetermine his artworks: he offers suggestions, but never expectations. The gift of a stone could trigger a journey like the one Lee undertook under the guidance of the Sui Buddha, with the possibility that the person who received the stone could return it once their hardship is over. An archive will be created for those who want to share, but the primary intention is that visitors feel something beyond a passing viewing experience – that they make a personally impactful and long-lasting connection to the artwork, whether they see it as a sculpture or a deity. The stone catalyses a physical and emotional encounter that can be rare in a museum. Lee's commission resonates with Kimsooja's *Archive of mind* 2017, which will be placed within sight of *Spirit House* as part of the inaugural installation of the large new gallery above, with its wall of glass overlooking the harbour. In Kimsooja's work, visitors are invited to shape a lump of clay into a sphere, feeling the materiality of the earth through a repeated and meditative gesture. The clay spheres gradually accumulate on a long wooden table, tracing the presence of multiple, individual actions. The simple gesture of forming clay in one's hand or caressing a stone quietly challenges the common perception of established institutions as overly cerebral and pedagogical.

Francis Upritchard was one of five artists invited to respond to SANAA's Welcome Plaza, for a work to be situated under its majestic glass canopy. Her sculptural trio was chosen for its imaginative

The commissioning pulse

composition and for the compelling materiality of the figures – a kind of intimacy that belied their massive size.

Upritchard's six-metre-tall figures seem to have just wandered in from the neighbouring Royal Botanic Garden. Their impossibly long limbs appear to be made of organic material rather than the bronze they are. Their flesh is gnarly and appears folded; with their knobbly knees and thickened knuckles they might have been fashioned from clay, breathed to life and then frozen while performing amorphous tasks. The visceral materiality of the figures is derived from Upritchard's process of manipulating balata – a type of rubber harvested sustainably in the Amazon. She heated the hardened balata underwater, then worked it into a dough-like substance, stretching it to make forms that retain their unexpected folds, imprints and elastic textures before casting them into bronze. Such markings add to the sense of vulnerability these anti-heroic giants have. Their mundane yet ambiguous actions are laced with humour, pathos and tenderness: each sculpture is actually a pair, in which one figure balances its partner's deficiencies. The shorter figures are carried by long-legged partners who, in turn, rely on their long arms. One long-armed figure reaches to stabilise itself by holding on to a SANAA column, cupping its hand on the ground so that children may cocoon within it.

The figures in one duo are consumed by balancing boulders on top of each other. Is this action laborious or one of mindless delight? We might imagine that these figures could make use of the Waradgerie artist Lorraine Connelly-Northey's giant narrbong-galang (many bags) visible through the Yiribana Gallery window nearby. Or that they might choose to pluck Yayoi Kusama's *Flowers that bloom in the cosmos* 2022, which blossom bright on the top terrace overlooking Woolloomooloo Bay. Kusama's exuberant sculpture is unequivocally recognisable, its maker adored and revered for the boldness of her spotted vision.

Upritchard has also placed tiny critters in between toes and winding across the feet and along the arms of her figures, which are inspired by a myriad of visual references, including the mischievous and elusive *yōkai* (spirit being) Ashinaga-tenaga (Long Legs Long Arms) in Japanese folklore, Quentin Blake's illustrations in Roald Dahl's book *The BFG*, and the sinuous roots of the Moreton Bay fig tree. The phrase and title of her commission, *Here Comes Everybody* 2022, is key to its narrative provocation. Upritchard says, 'My work is never about an accurate rendition of a known form but an exploration of bodily experiences and gesture, plants and geology.'[7]

While Upritchard squished, thumb-stroked, smoothed and pinched wet balata gum into forms that didn't exist prior to her imagining, Simryn Gill inked and repeatedly rubbed existing organic forms to trace their presence and memory. Gill was commissioned to record the transformation of the Art Gallery's campus. Initially she was drawn to the web of gum-tree roots that had grown through the roof of the oil tank and sprawled down to the ground, taking advantage of a layer of water that had accumulated there. Her rubbings of these otherworldly and slightly menacing roots extend

Francis Upritchard working
on *Here Comes Everybody*
2022 in Italy

across ten metres, capturing all their visceral, entangled beauty. The marks are like a fury on paper: billowing, scratchy and swirling, they evoke the resilience of plant forms, with their ability to propagate, seek nourishment and, some say, communicate.[8]

Alongside her recording of this previous occupant of the oil tank, now a space named 'the Tank', Gill made a frottage of a Canary Island date palm at the Art Gallery that was being relocated to make way for construction. The row of palms that flanked the Art Gallery's facade were for some years a feature of the Art Gallery's branding.[9] Former government botanist and director of the Botanic Garden Joseph Maiden had popularised these palms in Sydney in the early 1900s, planting them throughout the city to beautify and make tropical a landscape that many still don't appreciate. As it happened, the palm destined for relocation was infested with coconut weevils and could not be replanted. What had begun as a record of a site in transition became a shroud. Gill's twenty-six-metre rubbing of the palm's trunk and wispy fronds, *Clearing* 2022, is now shown in the original building in the context of the Art Gallery's collection. What began as a form of documentation for Gill became a deeper questioning of how we think about trees, whether introduced or not.

For his commission, *bíal gwiyúŋo (the fire is not yet lighted)* 2023, Jonathan Jones has developed a living artwork in which the institution is genuinely only the caretaker and custodian. Aboriginal knowledge

Simryn Gill creating a graphite rubbing of a Canary Island date palm outside the Art Gallery for *Clearing* 2022

The commissioning pulse

and cultural practices are inseparable from the physical work, which is linked to programs, traineeships and fellowships at the Art Gallery to establish new understandings about our relationship to Country.

In this work, a seasonal 'fire garden', Jones is creating a piece of Country. Located between the original and new buildings, his garden-scape is tiered across approximately 3000 square metres, responding directly to the site's history and the magnificent landforms of south-east New South Wales, particularly sandstone escarpments and cliff faces. The title of the work refers to a phrase spoken by Eora woman Patyegarang and recorded by the early colonist William Dawes in the early 1790s.[10] It evokes possibility and positions fire as regenerative. Jones will work with local Aboriginal communities to do a cultural burn of the garden in different seasons. Admonishing settler society's deep fear of fire, Jones emphasised in his proposal that over 70 per cent of Australia's indigenous plants depend on fire, plants that have nourished Aboriginal people for over sixty-five thousand years.

From a central circular gathering space, the garden fans out in angular bursts that recall Gadigal patterns found on shields.[11] These forms, created from local sandstone, envelop the three plant species Jones has chosen: gadi (*Xanthorrhoea* or grass trees), watanggre (*Banksia serrata*) and báamoro (*Themeda triandra* or kangaroo grass). Each has a specific narrative that cascades thunderously through our colonial history resulting in a multifaceted and ever-expanding picture of what is around us, of what is Sydney, and of what is Australia. Author and Aboriginal Elder Bruce Pascoe has methodically shown through historical records how Aboriginal people had a thriving agricultural practice that sustained both people and Country, with kangaroo grass having a central function.[12] Pervasive throughout Australia, the grass gave the land its warm golden colour when colonists first arrived, and was a food staple, with ancient grindstones found throughout the country, some dating back thirty thousand years.[13]

The seasonal burns will blacken the garden, dramatically countering conventional ideals of beauty and expectations that landscape has to be luscious and abundant. At this point in the cycle, the energetic sandstone patterning will be most visible: the work takes on a new life and aesthetic phase while the green shoots bud and grow, eventually covering the entire garden again. Jones is renowned as a sculptor working with light, and this garden is a decisive continuation of his practice on a large, public scale, using the new medium of fire. The artwork is lit at night and visible from the Art Gallery's buildings as well as from neighbouring Potts Point and city skyscrapers.

Every detail of this expansive living artwork has been meticulously considered, from its connections to the establishment of a new building for the Art Gallery in the late nineteenth century, the result of a fire, right up to Muŋgurrawuy Yunupiŋu's painting referencing Gurtha (fire) that was among the first works acquired from Yirrkala in the Northern Territory's Top End.[14] The Garden Palace was built in 1879 to house the Sydney International Exhibition. The devastating fire that destroyed it in 1882 was used as a rationale to develop a bespoke

One of Jonathan Jones's collaborators, Oliver
Costello, undertaking a cultural burn of dorrabbee
grass on Bundjalung Country in New South Wales

Artist's impression of Jonathan Jones *bíal gwiyúŋo
(the fire is not yet lighted)* 2023, developed in consultation
with Aunty Julie Freeman, Uncle Charles Madden and
Oliver Costello, designed and created with DCG Design,
image by Alessandro Mucci

building to house art and led to the relocation of the Art Gallery of New South Wales to its present site in the Domain. This incident also formed the impetus behind Jones's extraordinary project *barrangal dyara (skin and bones)* 2016, which traced the original footprint of the palace in ghostly white shields in the grounds of the Royal Botanic Garden.[15] Like that earlier project, Jones's commission at the Art Gallery arises out of deep thinking about the site on which we sit, our collection, and what is needed to keep the institution relevant and connected to new thinking and possibilities.

We are living in a time when young people leave their classrooms to protest about the world they will be left with. Others take to the streets to implore governments to ensure social justice and reappraise colonial histories. Conversely, some withdraw further and further from the world, as pandemics and computer screens and the consequent lack of human touch produce a profound emptiness. Our commissioned artists address these aspirations and fears. Showing alongside our 150-year-old collection, their commissioned works declare their position, acutely conscious of what has come before. They remind us what it is to be human today. To borrow the words of the celebrated science-fiction writer Octavia Butler, who has inspired so many artists, what institutions need to do today is 'make people FEEL! FEEL! FeeL!'

Notes

1 Octavia E Butler, notes on writing, 'Tell stories filled with facts ... ', c1970–95, The Huntington Library, Art Collections, and Botanical Gardens.

2 Helen B Armstrong, 'Cultural pluralism within cultural heritage: migrant place making in Australia', PhD thesis, University of NSW, Sydney, Jul 2000. See unsworks.unsw.edu.au/fapi/datastream/unsworks:35331/SOURCE01?view=true

3 Lilo Ema Siope was recognised as a Sāmoan master navigator. See Anna Marbrook's *Loimata, the sweetest tears*, a documentary on Siope that won the Grand Prix du Jury at Tahiti's Festival International du Film Documentaire Oceanien (FIFO), 2021. Jahra Wasasala is a cross-disciplinary artist best known for her performances.

4 See Maarama Kamira, 'Maori trade and relations in Parramatta', City of Parramatta, 2016, historyandheritage.cityofparramatta.nsw.gov.au/sites/phh/files/field/media/file/2020-07/trade-and-relations-maori-in-parramatta.pdf, accessed 27 Oct 2022.

5 Whaakari/White Island is an active stratovolcano island in north-east Aotearoa New Zealand. It erupted in December 2019 killing twenty-two people and injuring many more.

6 To view this Buddha visit artgallery.nsw.gov.au/collection/works/432.1997

7 Francis Upritchard, artist proposal to AGNSW for the Welcome Plaza commission, 2021, np.

8 For more information refer to Bruce Albert, Hervé Chandès, Isabelle Gaudefroy et al, *Trees*, exh cat, Fondation Cartier pour l'art contemporain, Paris, 2019.

9 The Art Gallery's branding changed in 2020 from iconic palm trees outside the entrance to three angular lines in Whiteley blue, designed by Mucho.

10 See *William Dawes' notebooks on the Aboriginal Language of Sydney*, Hans Rausing Endangered Language Project and SOAS Library Special Collections, School of Oriental and African Studies, London, in association with the Darug Tribal Aboriginal Corporation, dnathan.com/eprints/dnathan_etal_2009_dawes.pdf, accessed 25 Mar 2022.

11 See Jonathan Jones exhibition *untitled (transcriptions of country)* at Palais de Tokyo, Nov 2021, and at Artspace, Sydney, 2023. Having pored through drawings from the Nicolas Baudin expedition in 1801–03 – drawings that, tragically, are the most comprehensive record of Gadigal cultural material, with most actual items having been lost or destroyed – Jones was able to bring that culture's bold, patterning into the design of the fire garden.

12 See Bruce Pascoe, *Dark emu: Aboriginal Australia and the birth of agriculture*, Magabala Books, Broome, WA, 2018.

13 See for example, 'Wailwan grindstone' in the Australian Museum collection, australian.museum/learn/first-nations/unsettled/unsettled-introduction/wailwan-grindstone, accessed 27 Mar 2022.

14 See Muŋgurrawuy Yunupiŋu *Lany'tjung story no 3* 1959, artgallery.nsw.gov.au/collection/works/IA62.1959

15 Jonathan Jones's *barrangal dyara (skin and bones)* 2016 was conceived for the 32nd Kaldor Public Art Project and was donated to the Art Gallery by John Kaldor and the artist in 2017. See artgallery.nsw.gov.au/collection/works/334.2017

Yiribana ... this way

Cara Pinchbeck

'Yiribana has been a focal point through which staff have developed ways of working within a historically Eurocentric institution that prioritise Indigenous methodologies and celebrate Aboriginal and Torres Strait Islander peoples, perspectives and cultural knowledge.'

3

YIRIBANA MEANS 'THIS WAY' in the Aboriginal language of Sydney and it was the name given to the Art Gallery's dedicated space for the display of Aboriginal and Torres Strait Islander art when it opened in November 1994. Yiribana acknowledges the location of the Art Gallery on Gadigal Country and since its establishment it has been home to diverse exhibitions and collection displays that highlight the strength and dynamism of art practice across Indigenous Australia. Just as importantly, Yiribana has become a space for people – for coming together and exchanging ideas. Following the directional intent of its name, Yiribana has been a focal point through which staff have developed ways of working within a historically Eurocentric institution that prioritise Indigenous methodologies and celebrate Aboriginal and Torres Strait Islander peoples, perspectives and cultural knowledge.

While Yiribana began as an exhibition space and, relocated within the new building, remains as such within the Art Gallery's expanded campus, it can also be considered a catalyst for change, as approaches embedded within Yiribana have been more widely embraced across the institution over recent years. This change has been incremental and has echoed the shift from displaying works in the Aboriginal and Torres Strait Islander collection principally within the dedicated space of Yiribana to including them in a range of contexts and spaces. This encourages dialogue across collection areas and allows nuanced consideration of points of connection, rather than perpetuating difference. Of course, this approach does not ignore difference, or the uniqueness of Aboriginal and Torres Strait Islander art and culture, but rather foregrounds our belonging in the wider world and the humanity of shared experiences.

Another word from the Sydney language, 'burbangana', means to 'take hold of my hand and help me up'.[1] Burbangana is an invitation, and it is a concept that is fundamental to Yiribana. Through Yiribana artists have shared their art and knowledge to inspire understanding. And staff have worked to develop greater equilibrium between artists and the Art Gallery. Yiribana has encouraged change and invited the wider institution to embrace Indigenous knowledge, perspectives, culture and, most importantly, people.

While it is now the norm in Australian state art museums, in 1994 it was a major development to dedicate space and resources to Aboriginal and Torres Strait Islander art. It also signalled a momentous shift in thinking, given earlier displays had been in what was known as the 'Tribal' or 'Primitive Art Gallery': the passion project of then deputy director Tony Tuckson that opened in 1973.[2] Likewise, the early collection was defined as 'primitive' through the prefix of 'P' within accession numbers, until this was altered to 'IA' for 'Indigenous Australian' by curator Hetti Perkins in the early 2000s. The legacy of this history is difficult to extinguish, and much of the work undertaken by Aboriginal staff since the initial appointment of Djon Mundine as curator in the field in 1984 (the first appointment of its kind in Australia) has been to counteract

outdated societal attitudes and encourage alternate viewpoints that value Indigenous people, perspectives and knowledge.

The selection of Yiribana as the name for the gallery was a clear assertion of change. In opposition to the 'primitive', by which notion Aboriginal people are located in some seemingly distant past, separate from 'modern' Australia, Yiribana was an assertion of presence that respected the ongoing connection of the Gadigal to the land on which the Art Gallery stands. Implied within the naming was the creation of a space for Aboriginal and Torres Strait Islander people by Aboriginal and Torres Strait Islander people, with local relevance.

Acquisitions associated with the opening of Yiribana expanded the collection considerably as the Art Gallery more consciously reflected its national remit. With the acquisition of works by Destiny Deacon in 1993 and Ellen José in 1994, identified Torres Strait Islander artists were represented for the first time.[3] Closer to home, numerous works by Sydney-based artists, including Michael Riley, Bronwyn Bancroft, HJ Wedge, Aunty Elaine Russell and r e a, entered the collection in 1993 and 1994, greatly increasing the representation of local artists with cultural connections across New South Wales. Significantly, the realities of lived experiences are captured in many of these works

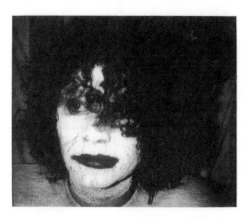

Destiny Deacon *Dreaming in urban areas* 1993

Above: Elaine Russell
Inspection day 1994

Opposite: Jack Yarunga and
Laurie Nelson Mungatopi
with Bob Apuatimi working on
Pukumani posts at Milikapti,
Melville Island, 1958. From
left: filmmaker Bill Dalzell, Bob
Apuatimi, Jack Yarunga, Dr Stuart
Scougall, Tony Tuckson, Laurie
Nelson Mungatopi.

and issues of concern are foregrounded: stereotypes are questioned
in Bancroft's *You don't even look Aboriginal* 1991, the politics of race
are highlighted in r e a's *Highly coloured: my life is coloured by my
colour* 1994 and Deacon confronts perceptions of authenticity while
validating the diversity of Indigeneity in *Dreaming in urban areas* 1993.

In acquiring these works the Art Gallery signalled its intent
to engage with current issues and to give voice to Aboriginal and
Torres Strait Islander peoples. Historically, a lack of agency has been
afforded to Indigenous peoples within government institutions. From
the outset Yiribana has been a platform for discussion. In the early
years a daily performance program enabled Sean Choolburra and
Adam Hill (aka Blak Douglas), among others, to engage directly with
audiences. More recently, dedicated positions have been established
for Aboriginal staff to deliver free daily tours of the collection,
prioritising Indigenous voices and presence within the institution
while guiding conversations with Art Gallery visitors.[4]

Whether intentional or not, in its early days the Art Gallery
contributed to impressions of an absence of Aboriginal people and
culture in Sydney. When the watercolour by BE Minns of the Yuin

Yiribana ... this way

men Merriman, Coonimon and Droab was acquired in 1894, the Art Gallery founders considered Aboriginal people as a dying race to be documented before an eventual demise.[5] Informed by theories of evolution, this thinking drew on notions of racial purity. When the Art Gallery began to collect Aboriginal works in a concerted manner from the late 1950s, it focused not on local art but on art from northern Australia, as that area was considered by many to be untainted by external influences and therefore home to authentic artforms. Indeed, in correspondence to Tuckson regarding *Pukumani grave posts* 1958, the benefactor Stuart Scougall comments: 'I think such an exhibit ... would be of great historical value and should be made before white influence becomes apparent.'[6]

The notion of Indigenous culture being 'authentic' only at a fixed point in time, with any external influences negatively impacting traditions, does not allow for the dynamic nature of culture. It also points to inappropriate systems of value being placed on certain groups of people: for some groups change is considered development while for other groups it is seen as dilution. Somewhat ironically, the communities of Yirrkala and Milingimbi in northern Australia, from which much of the early collection derives, had embraced external influences for generations, annually welcoming people from Makassar – in what is now Indonesia – to collect trepang, and both communities had been home to Royal Australian Air Force bases during the Second World War.

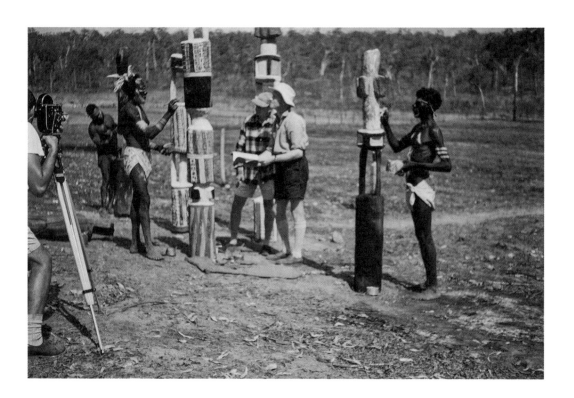

Aboriginal and Torres Strait Islander culture has developed and been maintained over countless generations. It is deeply embedded within Country, within communities and within people.[7] And cultural practices, including the making of art, are enmeshed within obligations and responsibilities: change is mediated and managed.[8]

One of the most beloved works in the collection, Lin Onus's *Fruit bats* 1991, featured in the inaugural exhibition in Yiribana. In many ways this work is analogous to Yiribana itself – a reminder of the presence of Aboriginal culture in our own backyards. In this sculpture a colony of flying foxes has taken up residence on a suburban Hills Hoist clothesline – hanging at rest, but alert and looking outward. The flying foxes' wings are painted with rarrk (crosshatching) and their guano is laid out on the floor underneath the clothesline, with the painted design on individual droppings echoing the flowers from which they draw nectar. Onus was a Yorta Yorta man and after spending time in Maningrida with Djinaŋ artist Djiwut Jack Wunuwun and Ganalbiŋu artist John Bulunbulun, he was given permission to use these designs. Similar designs are evident in the work of Milingimbi-based Djambarrpuyŋu artist Binyinyuwuy Djarrankuykuy, who inherited the right to paint this Ganalbiŋu design for flying foxes through his maternal grandmother.[9]

Flying foxes are often considered a pest in Sydney, as they create a mess following their evening meals on available fruits and flowers. However, for Binyinyuwuy and within a Ganalbiŋu worldview, flying

Above: Russell Smith entertaining an audience as Ngununy, the cheeky fruit bat, in front of Lin Onus's sculpture *Fruit bats* 1991

Opposite: Binyinyuwuy Djarrankuykuy *Trees and flying fox camp* c1950s

Yiribana ... this way

foxes imbue the water below with power as they fly over paperbark forests after feeding on nectar. This thinking acknowledges the importance of ecosystems and the role of flying foxes in pollinating flowers and dispersing seeds over large distances to enhance the gene pool and health of native forests.

Yiribana has been crucial in strengthening the depth and diversity of the collection, and sharing this through exhibitions that emphasise the multifaceted, ever-changing nature of art while profiling Indigenous knowledge systems. Through the convergence of works within Yiribana, connections are established and explored, highlighting intricate webs of relatedness rather than simplistic definitions that categorise and separate. Too often art from the north of Australia has been defined as 'traditional', and the artists 'remote', with art from Sydney- or Melbourne-based artists becoming 'contemporary' and 'urban'. These restrictive categorisations are not necessarily mutually exclusive and do not allow for the complexities of artistic practice and artists' lives.

Exhibitions and projects connected to Yiribana seek to offer nuanced insights that are directly informed by artists and their communities. Fostering self-determination, this approach values collaboration and a willingness to be responsive. In 2003 the Art Gallery worked with Warmun Arts Centre and Jirrawun Aboriginal Art Corporation on *True Stories: Art of the East Kimberley,* an exhibition which garnered deep insights into regional practice and established connections between artists that were both familial and

artistic. The exhibition was strengthened through the artists' decision that a DVD be produced to allow unmediated documentation of their true stories, including personal accounts of conflict on the colonial frontier.[10] The Art Gallery had previously filmed interviews with artists, but this project initiated more widespread use of film to ensure the primacy of artists' voices within its resources, including the major publication *One sun one moon: Aboriginal art in Australia* 2007, the documentary *Art + soul* 2010 and numerous short films online.[11] Hetti Perkins was central to these projects, and her commitment to filmed interviews in the artist's preferred language led to the development of a rich audiovisual archive which complements other material from individual artists and arts professionals in our National Art Archive.

Patrick Mung Mung and the late Rusty Peters are among the artists featured in *Art + soul*. When they were invited to contribute to the weekend program celebrating the accompanying exhibition in Yiribana, they decided to perform the Junba, broadly known as the Gurirr Gurirr, in Sydney for the first time. The generosity of this offering was inspired by personal connections established during *True Stories* and strengthened during the filming of *Art + soul*. Mung Mung, Mabel Juli and the late Phyllis Thomas and Betty Carrington led the fourteen performers who enacted the Junba over three consecutive days within the Art Gallery's entrance court. The paintings central to the performance, by Mung Mung, Thomas, Juli, Peters, Mary Thomas and Charlene Carrington, were subsequently purchased for the collection.[12]

Reciprocity is reflected in these events, which also highlight the value of sustained connections over time. This can be challenging for institutions that move from one distinct project to the next. However, cultural authority over art is continuous and does not diminish

Above: (left to right) Gija artists Mary Thomas, Shirley Drill, Peter Thomas, Owen Thomas, Jane Yalunga and Blandina Barney performing the Junba with Mary Thomas's *Dawoorrgoorrima* 2010 during the *Art + Soul* exhibition in 2010

Opposite: Shari Lett, former archivist of Aboriginal and Torres Strait Islander art, speaking in front of Reko Rennie's *No sleep till Dreamtime* 2014 in the exhibition *Murruwaygu: Following in the Footsteps of Our Ancestors*, 2015

when a work enters an institutional collection. The Art Gallery has long worked with leaders like Pedro Wonaeamirri, who has been instrumental regarding the display of *Pukumani grave posts*, acquired in 1959. This work has moved to different spaces over recent years as the Art Gallery has sought to display Australian art more inclusively.[13] With each move the context, formation and interpretative content are determined in discussion with Wonaeamirri, evidencing the institution's transition from a possessor of cultural material to a caretaker valuing guidance.

In the process of making this shift, old institutional narratives have been reconsidered. Much has been written of Tuckson working with Scougall to acquire major works which laid the foundations for the Aboriginal collection. However, these accounts tend to simplify the actions of those involved, and the artists – Laurie Nelson Mungatopi, Bob Apuatimi, Jack Yarunga, Don Burakmadjua and Charlie Kwangdini – are largely forgotten. While archival records related to *Pukumani grave posts* are devoid of Tiwi voices, the artists' role is evident if the documents are considered with alertness to their contribution. The artists actively participated in the collecting process, consciously deciding what they would share and how, in conversation with Scougall and Tuckson.[14] It was very much a collaboration and acknowledging the agency of the artists affords greater respect to all. As Canadian Métis curator David Garneau has written: 'Indigenous curation is a curation of people rather than

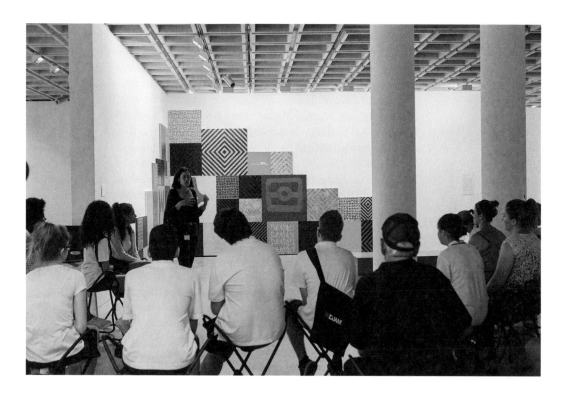

things ... Indigenized curators heal the estrangement between people and their belongings, they restore and re-story.'[15]

Home: Aboriginal Art from New South Wales was held in Yiribana in 2012 as the Art Gallery began to more expressly focus on exhibitions dedicated to artists with cultural connections to New South Wales.[16] *Home* provided an overview of practice and led to the development of an education resource for an expansive school program that enables students to connect to art and artists from their local area.[17] Artists including Lorraine Connelly-Northey, Lorraine Tye, Roy Kennedy, Reko Rennie and Karla Dickens have been instrumental to this program over numerous years. A subsequent exhibition, *Murruwaygu: Following in the Footsteps of Our Ancestors*, curated in 2016 by artist Jonathan Jones, considered the use of line by male artists from south-east Australia. The exhibition reclaimed unattributed works and established connections between generations of artists to emphasise cultural continuity. This idea, rarely considered in connection to art from New South Wales, informed later projects such as the Barkandji canoe workshops led by Uncle Badger Bates in Wilcannia in 2020 (see p 232), and Andrew Snelgar's making of shields in response to currently unattributed historical works in the collection in 2021.[18]

Collection items with incomplete cataloguing details are a reminder of past times when Indigenous people were considered by some to be too insignificant to name. One of the main intentions of the exhibition *Art from Milingimbi: Taking Memories Back* was to restore as much information as possible to works in the Milingimbi collection. Through active engagement with the families of artists and the wider community over several years this was achieved – all paintings were attributed, and all artworks titled. The knowledge that the community generously shared is captured in the related publication, which community leader Keith Lapulung Dhamarrandji feels is akin to 'a bible' for future research.[19] The project was a starting point for continuing collaboration, and aligned with the aspirations of the Milingimbi Makarrata of 2016, which I attended on behalf of the Art Gallery, taking with me collection works to signal the Art Gallery's desire to be more open and outward looking.[20]

When Binyinyuwuy's work entered the collection in 1962 (see p 95) his daughter Judy Lirririnyin was a young child. She had not seen his work until preparations for the Milingimbi exhibition began. Lirririnyin now draws upon her father's art in her own practice and is among the Milingimbi artists whose work has been acquired in recent years as art activity has strengthened following the Makarrata.[21] Weaving, in particular, has attracted increased attention and one of the artist-driven projects supported by the Art Gallery in 2021–22 at Milingimbi fostered intergenerational exchange and knowledge sharing among women weavers. Related projects that offered artists autonomy rather than predetermined outcomes saw the creation of Ku' (dogs) by artists at Wik and Kugu Arts Centre in Aurukun, Grace Lillian Lee's sculptural forms, and ceramics by artists at Hermannsburg Potters.[22]

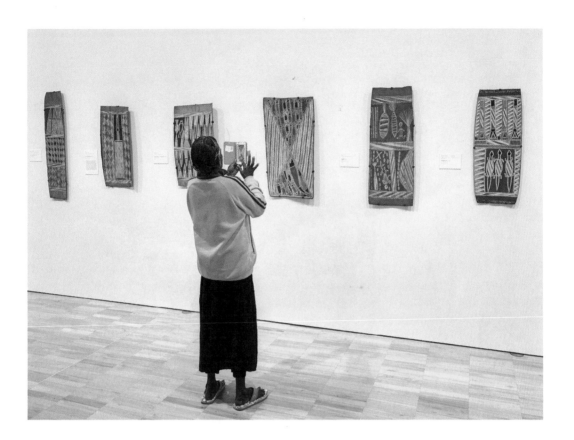

Art from Milingimbi was one of numerous exhibitions held throughout the Art Gallery as Aboriginal and Torres Strait Islander art became more widely embraced within the institution. Other major exhibitions have marked important occasions in Sydney: *Papunya Tula: Genesis and Genius* was part of the Sydney 2000 Olympics Arts Festival and *Illuminate*, a project by Euraba Artists and Papermakers (Boggabilla) with Jonathan Jones, was part of Corroboree Festival 2013. In addition, many distinguished guests of the Art Gallery have requested tours of the collection in recognition of this unique aspect of Australia's cultural inheritance, including His Holiness the 14th Dalai Lama in 1996 and former United States president Barack Obama in 2018.[23] The Art Gallery has been pivotal in encouraging and supporting this growing interest, and building it through the display of Aboriginal and Torres Strait Islander art in ever-expanding contexts.

The 2016 exhibition *When Silence Falls* heralded a desire to 'open fresh sightlines through the collection, revealing unexpected connections between one artwork and another and from there to the world beyond'.[24] Aboriginal artists were included throughout the exhibition alongside artists from the wider Australian and international collections, highlighting shared concerns between artists across cultures, countries and time. This inclusive approach is now embraced within the Art Gallery, and was paramount in the curatorial

Judy Lirririnyin viewing works by her father Binyinyuwuy Djarrankuykuy in the exhibition *Art from Milingimbi: Taking Memories Back* 2016

Cara Pinchbeck

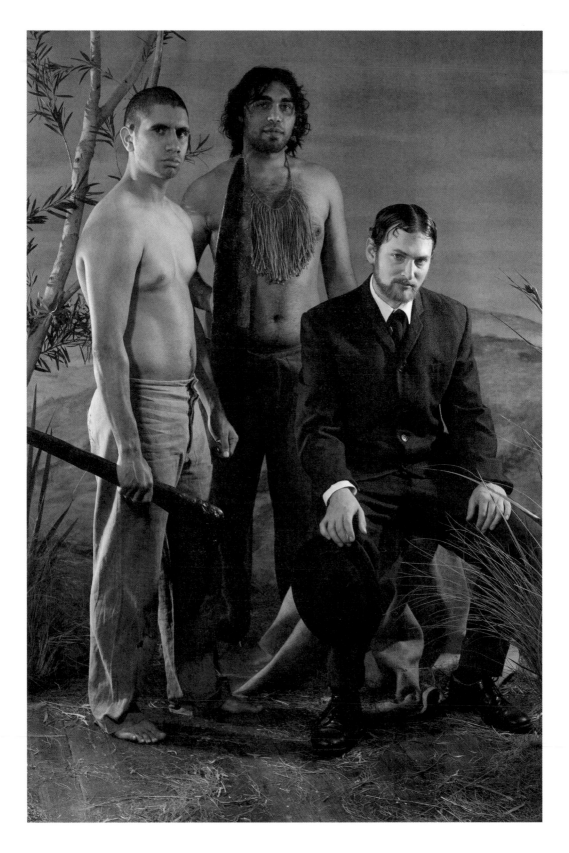

Yiribana ... this way

rationale for the new collection displays of 2021–22 in the original building, which more adequately reflect contemporary Australia and the divergent influences that shape the here and now, while recognising the essential importance of Indigenous art.

A relational rather than an oppositional approach has been employed as divisions between collection areas erode and Indigenous art is increasingly displayed in dialogue with non-Indigenous art. In the nineteenth-century Grand Courts, for example, the aim is to Indigenise rather than to reverse the colonial gaze. Pairing Brook Andrew's *AUSTRALIA VI theatre and remembrance of death* 2014 with Frederick McCubbin's *On the wallaby track* 1896 (see p 109) shows the fundamental human need for companionship while prompting consideration of connection to Country. Recontextualising Minns's watercolours of 1894 by showing them alongside Genevieve Grieves' *Picturing the old people* 2005 highlights the agency of ancestors who determinedly persisted in the hope of improving circumstances for subsequent generations. Applying an Indigenous lens to the interpretation of colonial works can enrich understanding. Similarly, employing Indigenous placenames acknowledges deep history while dual naming ensures the transparency of complex histories – presenting both is an invitation to consider things more holistically.

In response to the Art Gallery's historical exclusions, works by Aboriginal artists in the 2021–22 rehang of the colonial Grand Courts are exclusively from Australia's east, and major works realised for the opening of the expanded campus are by artists with cultural connections to New South Wales. Commissions by Karla Dickens, Lorraine Connelly-Northey and Jonathan Jones are publicly accessible at all times of the day and night, signalling the Art Gallery's intent to be more locally relevant, outward facing and welcoming. To complement this local emphasis, the inaugural display in the new Yiribana Gallery reaches out across the country, across time, media and subject matter to profile moments of burbangana – generosity, responsiveness and reciprocity – and encourage understanding and connection between people. This is extended across the globe, as the interconnectedness of Indigenous, Australian and international art is foregrounded in integrated displays of the modern and contemporary collections.

As Yiribana settles into a new home, its philosophies, and the Aboriginal and Torres Strait Islander collection, permeate the institution. Yiribana's 'this way' has become multidirectional, creating webs of connectivity across the campus that are not defined nor restricted, but imbued with potentiality. The gene pool of the Art Gallery is strengthened and the personality of the institution is redefined, as the humanity of burbangana, an invitation to *see* and *do* things differently, takes hold.

Genevieve Grieves *Picturing the old people* 2005 (video still)

Cara Pinchbeck

Brook Andrew's *AUSTRALIA VI theatre and remembrance of death* 2014 is included in the revitalised Grand Courts alongside nineteenth-century Australian paintings of Country

Notes

1 The word 'burbangana' was documented by William Dawes in his manuscript 'Vocabulary of the language of N.S. Wales, in the neighbourhood of Sydney, Native and English', c1790–92, and is listed in Jakelin Troy, *The Sydney language*, Australian Institute of Aboriginal and Torres Strait Islander Studies, Canberra, 1994, p 72.

2 Works from the Aboriginal collection had been displayed in various locations within the Art Gallery prior to 1973. However, Tuckson's display of 1973, realised in part by his wife Margaret Tuckson following his death, focused on the Aboriginal and Pacific collections.

3 A mask considered to be from the Torres Strait Islands was acquired in 1976. However, the artist is not currently known, see artgallery.nsw.gov.au/collection/works/169.1976

4 Two part-time positions were established in December 2019. They were generously funded by the Nelson Meers Foundation until the end of 2021, when the positions became full-time and permanent.

5 Steven Miller, *The Exhibitionists: a history of Sydney's Art Gallery of New South Wales*, AGNSW, Sydney, 2021, p 14.

6 Dr Stuart Scougall correspondence to Tony Tuckson, 10 Oct 1957, National Art Archive, AGNSW. *Pukumani grave posts* 1958 were commissioned by Scougall in discussion with the artists at Milikapiti, Melville Island, NT, in 1957 and Tony Tuckson in Sydney. Scougall donated the works to the Art Gallery in 1959.

7 To Aboriginal people and Torres Strait Islander people, Country is more than land, it is sentient and all-encompassing.

8 The management of change differs across the country. Cultural leaders are key to determining what is and isn't appropriate.

9 Cara Pinchbeck, 'Binyinyuwuy', *Art from Milingimbi: taking memories back*, AGNSW, Sydney, 2016, p 46, see also artgallery.nsw.gov.au/collection/works/IA10.1962

10 *True stories: art of the East Kimberley*, 2003, dir Hetti Perkins and James Marshall, DVD, 25 min, AGNSW, Sydney, 2003. The small brochure by Ken Watson, *True stories: art of the East Kimberley*, AGNSW, Sydney, 2003, np, also accompanied the exhibition. The exhibition *True Stories* was curated by Hetti Perkins, Ken Watson and Cara Pinchbeck.

11 Hetti Perkins and Margie West, *One sun one moon: Aboriginal art in Australia*, AGNSW, Sydney, 2007, published in partnership with Museum and Art Gallery of the Northern Territory and the Holmes à Court Collection. The three-part documentary series *Art + soul* 2010 was a partnership between AGNSW and Hibiscus Films for ABC TV, directed by Warwick Thornton, presented by Hetti Perkins and produced by Bridget Ikin and Jo-anne McGowan.

12 To see these works search by accession number (299.2010, 301.2020, 302.2010, 509.2010, 510.2010 and 511.2010) on artgallery.nsw.gov.au/collection. The Gurirr Gurirr was originally conceived by Rover Thomas in the mid 1970s following a series of dream visitations by the spirit of an elderly woman who died following a car accident on a road flooded by Cyclone Tracy. This was translated into a Junba by Thomas, Paddy Jaminji and George Mung Mung. The Junba performed at the Art Gallery in October 2010 was sung by Patrick Mung Mung, Mabel Juli and the late Phyllis Thomas and Betty Carrington. The dancers were Gabriel Nodea, Owen Thomas, Andrew Daylight, Peter Thomas, Jane Yalunga, Mary Thomas, Shirley Drill, Lorraine Daylight, Blandina Barney and Johnie Echo.

13 Historically, Aboriginal and Torres Strait Islander art was largely excluded from these displays.

14 For further details see Cara Pinchbeck, 'To be cultured', *Tuckson*, AGNSW, Sydney, 2018, pp 165–87.

15 David Garneau, 'From artefact necropolis to living rooms: Indigenous, and at home, in non-colonial museums', unpublished paper, 2016, np.

16 Other exhibitions include:
La Per: An Aboriginal Seaside Story,
16 Jul – 10 Oct 2010; *Illuminate*,
16 Nov 2013 – 16 Mar 2014; *Reko
Rennie: No Sleep Till Dreamtime*
28 Jun – 30 Nov 2014; and *Mervyn
Bishop*, 24 Jun – 8 Oct 2017, and
subsequent tour throughout NSW
and ACT.

17 Amanda Peacock and Jonathan
Jones, *Home: Aboriginal art from
New South Wales*, education kit,
AGNSW, Sydney, 2013, developed
into a partnership with Wagga
Wagga Art Gallery, Wagga Wagga
Aboriginal community and the
Arts Unit of the Department of
Education in 2015. It has expanded
to an online resource connected
to multiple regional galleries and
communities, see artgallery.nsw.gov.
au/artboards/home/home-program

18 The canoe project began in 2019 as
part of the Djamu regional program
developed by the Art Gallery in
collaboration with Broken Hill
Regional Art Gallery and Wilcannia
Central School. Search accession
numbers 124.2021 and 125.2021 on
artgallery.nsw.gov.au/collection
for works by Snelgar. While the
historical shields are currently
unattributed it is hoped that
further research will refine details.

19 Personal email from Louise Hamby
to Cara Pinchbeck, 16 May 2019.
Lapulung has used the publication
when researching painted skulls for
repatriation.

20 The Milingimbi Makarrata was held
in August 2016 and was attended by
invited participants connected to
institutional collections of material
from Milingimbi. The ceremony
marked a time where past actions
or tensions were dissolved, and
new collaborative partnerships
were established. For further
information see Cara Pinchbeck,
'Taking memories back', *Art from
Milingimbi: taking memories back*,
AGNSW, Sydney, 2016, pp 12–17, and
Louise Hamby and Lindy Allen, *The
Milingimbi Makarrata: resolution,
signing, outcomes*, Louise Hamby,
Canberra, 2020. The Art Gallery is
a signatory to the resolution. The
collection works IA129.1962, *Djali
(armband)* c1950s and IA131.1962.b,
Djambarrpuyngu dhawundu
(pendant) c1950s, were taken
to the Makarrata.

21 The development of the Djalkiri
digital archive of artworks from
Milingimbi within Milingimbi Art
and Culture has also played a major
role, allowing the community easy
access to their cultural inheritance
and inspiring a younger generation
of artists to engage with art.

22 At the time of writing these
projects are in development, so
details such as all artists' names
cannot be provided.

23 His Holiness the 14th Dalai Lama
visited Yiribana in 1996 and was
welcomed by performer Sean
Choolburra. AGNSW director
Michael Brand gave former
United States president
Barack Obama a tour in 2018.

24 Michael Brand, 'Foreword',
When silence falls, AGNSW, Sydney,
2015, np. The selection of artists
within this exhibition and across
collection areas was supported and
encouraged by head of international
art Justin Paton.

Littoral zones: transforming ideas about nineteenth-century Australian art

Denise Mimmocchi

'The Australian Grand Courts are envisaged as meeting spaces, where the colonial collections are considered within a wider context and where new and vital meanings emerge.'

4

THE DISPLAYS OF THE NINETEENTH- and early-twentieth-century Australian collections at the Art Gallery of New South Wales occupy the two central Grand Courts of architect Walter Liberty Vernon's classically designed galleries.[1] In 2021, the year of the 150th anniversary of the Art Gallery, we took the opportunity to reflect on the role of the museum's history in driving its present transformation and to consider both the traditions and the renewed curatorial approaches in interpreting and displaying Australian art in these spaces.

At the centrepiece of Vernon's galleries, 'heroic' works of a much-mythologised period of Australian nineteenth-century art have featured the work of men that established, according to Bernard Smith's history of Australian art first published in 1945 and echoing a view earlier expressed in William Moore's *The story of Australian art*, 'the first authentic vision of the country'.[2] Smith refers to artists Tom Roberts, Arthur Streeton, Charles Conder and Frederick McCubbin, whose works, featuring in his chapter on the 'genesis' of Australian art, have remained on near-permanent display since the Grand Courts opened in 1897, reinforcing this art-historical narrative.

Through their enduring presence, these works have developed a symbiotic connection with the architectural character of the galleries, whose neoclassical references, commonplace at the time in British and colonial architecture, implied the triumphant continuation of the ideals of ancient empires, and the epitome, in imperial terms, of the Western cultural values they enshrined. Within a lofty brief to make it 'as strictly classical as possible', using the National Gallery of Scotland as a guide, Vernon created an inspired suite of galleries.

The displays of the Australian collection occupy the two central Grand Courts: one divided into three internal spaces, in which colonial-era works have traditionally been displayed in a loose chronology; and the other a vast, unbroken space of nearly 380 square metres, in which a grand tradition of nineteenth-century Australian painting was claimed. The culminating display of such works at the architectural centre of the Grand Courts has upheld the notion of the triumphant emergence of this 'authentic' Australian school of painting as an Anglo and largely masculine pursuit.[3]

If, as the authors of *Australian art exhibitions* (2018) have asserted, exhibitions serve 'as the public face of art history', then it is the displays of state art museum permanent collections that are the mainstays by which people primarily 'encounter and derive meaning from Australian art histories'.[4] Art museums manufacture meaning in our cultural histories. The sesquicentenary of the Art Gallery, leading into the completion of the Sydney Modern Project, offered a rare occasion to reconsider the curatorial premise for our nineteenth-century displays, to expand on perceptions of art of this period and highlight the silent spaces in cultural histories left by absences in the Art Gallery's collection. The new displays incorporate a series of changes that have been implemented over recent years, among them the inclusion of works by First Nations

Top: Frederick McCubbin *On the wallaby track* 1896

Above: Arthur Streeton *'Still glides the stream, and shall for ever glide'* 1890

artists, Indigenising labels as part of interpretative material, and addressing the absence of female artists in the collection. Such changes formed part of a greater cohesive transformation of the Art Gallery.[5]

The need for change was sharpened by contemporary events while working on the new installation of the collection over 2020 and 2021. Curators began planning for the new displays at the time of the catastrophic Black Summer bushfires in the Australian summer of 2019–20. The long-predicted climate emergency had become immediate and epic, fuelling the need to address the legacies of colonialism, the impact of which remains shamefully present in Australia, particularly for First Nations people.

These crises urged a greater critical appreciation for how art histories connect with our present. Artworks are not historical documents, but they register cultural histories and are open to reconsideration. As historian of colonial Australia Grace Karskens states: 'embedded in artistic construction are memories of a deeper human history'.[6] In questioning colonial legacies, this pivotal notion of larger human statements – of how art may creatively envisage relationships between humans and the world – became a crucial driver of the rehang and its interpretive strategy.

A guiding theme to direct the installation and draw together these considerations was applied: the littoral zone, the ever-shifting tidal margin where land meets sea. The littoral can simply refer to the condition of Australia as an island nation, and Gadigal Country as bordered by water, and Sydney as a harbour city. These geographies contribute to the distinctiveness of Australian art and to an artistic experience of place that diverges from the more celebrated bush landscapes. In the Grand Courts the idea of the littoral was applied more broadly – as a generative metaphor implying a site where different states encounter and reshape one another. Hence the two central courts are envisaged as meeting spaces, where the colonial collections are considered within a wider context and where new and vital meanings emerge. The idea of littoral space is used to move away from metanarratives such as nationhood and instead we reflect on the deeper human, sensory experiences of place through artworks that express how people inhabit, interact with, and exploit their environments. This recalibrates the ways we see and invest meanings in the art of our past, in our present.

The entrance of the first Australian court is now marked by a group of Aboriginal shields from south-east Australia, including examples dating from the early to mid nineteenth century. They are encountered before the familiar early colonial landscapes and portraits and introduce the cross-cultural intention of the new installation. While traditionally excluded from the histories enshrined in these galleries, the new shield display references the fact that First Nations cultures, predating and enduring British invasion, are deeply embedded in the layered histories of place as represented in Australian art.[7]

Southeast region artist
Sydney shield 1800s

A program of Indigenising interpretative texts, undertaken with the curators of Aboriginal and Torres Strait Islander art, ensures that First Nations perspectives weave throughout the galleries.[8] They are a crucial feature of renewal, as they expand on the appreciation and contextualisation of well-known works through the lens of Indigenous knowledge. They alert us to the inherent complexities of colonial representation. The act of restoring original names for Country in labels offers a greater understanding of our nation, while acknowledging the fact of Indigenous custodianship of the unceded lands represented in colonial painting. Thus, for example, to refer to the subject of Eugene von Guérard's *A fig tree on American Creek near Wollongong, NSW* 1861 as Dharawal Country is to register a more nuanced story than that of the colonial invention of place (it may also alert us to the cross-cultural references within the painting's title itself, which combines an Italian-derived name for a country of the 'new world', an Aboriginal placename and one that pays homage to a European country).

Denise Mimmocchi

The new installation of this Australian court offers a series of episodic encounters with early colonial art through selective moments of alignment with contemporary works. While there is now a certain orthodoxy to introducing contemporary art into historical displays, the connections here are intended to destabilise the meanings of colonial art and stress the significance of historical works within a continued cultural dialogue. For example, colonial portraiture is approached through questions around presence and absence: who was represented in colonial art and how were they portrayed? The politics of colonial representation are enmeshed in questions of identity in the present day, and we include works from across cultures and times, so that recent faces, such as those in Genevieve Grieves' *Picturing the old people* 2005, stare back and challenge the absence of real people in imaged histories (see p 100).

The littoral theme also allows us to explore the artistic engagements between people and the natural world in nineteenth-century art, knowing that the way nature was regarded in colonial

Eugene von Guérard *A fig tree on American Creek near Wollongong, NSW* 1861

Littoral zones

cultures carries deep implications for the present. This invariably turns to the subject of landscape, a central artistic motif of these histories. For many of the painters of the early colonial era, travel, often in the pursuit of nature's 'wild spaces', was a condition of their art. The experiences of transnational and cross-cultural movement (albeit within an overarching European worldview) are embedded in their works and distinguish them from their European precedents.[9] The Austrian-born Eugene von Guérard, for example, roamed astounding distances for the subjects of his art.[10] He painted the revelations of new environments, in all their physical and scientific detail, and as sensual encounters with place. *Sydney Heads* 1865, von Guérard's only Sydney subject painted in oil, depicts the scene with topographical accuracy while also reinforcing the ambience of the harbour's light-filled waters. In his later painting of an Aotearoa New Zealand landscape, *Milford Sound, with Pembroke Peak and Bowen Falls* 1877–79, the artist conveys his marvel at a soaring fjord carved by glacial time through reverence to the overpowering sensory experience of being immersed in nature's forms, witness to shadowed light and almighty silence.

The littoral theme incorporates the marine and the terrestrial – atmospheres, skies and underlands – in alignment with the expanded understanding of the natural world as reflected in nineteenth-century art. Artists travelled further, and deeper, into the world, and underground terrains offered new artistic challenges. Painting at Burragalong Cavern (now known as the Abercrombie Caves) near Bathurst, NSW, in 1843, Conrad Martens experimented with a style departing from his well-versed picturesque mode, to describe encounters with a world where space and time operated differently: slow, silent and darkly secretive.[11]

While underlands fuelled creative imaginations they were simultaneously being disturbed and exploited. Lands were turned inside out, and environments irrevocably destroyed in the quest to mine gold and other minerals from the first gold rush of 1851.[12] In a turn away from the sublime apprehensions of subterranean encounters, goldmining formed a new heroic subject in Australian painting, monumentally espoused by Julian Ashton's life-sized portrait *The prospector* 1889.[13] The new installation disrupts the artistic heroics that represent goldmining as an all-male, predominantly European pursuit (the prevailing approach in the art of the nineteenth-century mining boom) by including artworks alluding to the impact of mining on the land and inscribing the culturally diverse reality of the times. At times the display will also include works of calligraphy or contemporary interventions that inscribe the presence of the Chinese diaspora, and Marlene Gilson's painting of the Ballarat goldfields on Wadawurrung Country reminds of the enduring First Nations presence in Country within a period of expanding multicultural migration (see p 265).

The new display also reflects a shift in nineteenth-century presentations of nature from sublime environments to haunting pictures of environmental damage. By the late nineteenth century

artists revealed, often unwittingly, traces of the incalculable ecological damage wrought during the colonial era, and the terrible facts of the dispossession of First Nations people from Country. Such works invoke the destructive patterns that have fed into our present climate crisis. From allegories on the death of nature envisaged through local fauna, such as Margaret Fleming's *The cockatoo* 1895, to paintings depicting savaged ecologies, including Oswald Brierly's *Whalers off Twofold Bay, New South Wales* 1867, these works contribute to a larger picture of incalculable loss. Paintings of dry, drought-stricken lands (Louis Buvelot's *Goodman's Creek, Bacchus Marsh, Victoria* 1867 is one example), once celebrated as exemplars of the Australian pastoral lexicon, now reveal alarming visions of deforestation and destructive agricultural practices.

Central to this grouping is WC Piguenit's *The flood in the Darling 1890* 1895, based on a flood of the Darling River – known as Paawan to the Ngiyampaa and Baaka to the Barkandji – that consumed the township of Bourke in north-west New South Wales. What once registered as a sublime marker of the forces of nature, today appears as an elegiac image, a vision of a once-mighty river system that has now been diminished immeasurably due to water theft, farming practices and climate change.[14] At the time it was painted, and after colonial failures to learn from First Nations knowledge of the cycle of floods and droughts, the Murray–Darling river system was already the subject of charged debate around a water conservation management plan in the dry west. Alert to this context, Piguenit may have painted his masterpiece with a moral subtext. By the time he

Above: WC Piguenit *The flood in the Darling 1890* 1895

Opposite: Jessie E Scarvell *The lonely margin of the sea* 1894

Littoral zones

exhibited the painting in 1895 it reflected a past event, but stood as, and remains, an inspirational image for the future.

Nationalism and impressionism were ideas that informed Australian painting in the late nineteenth century, particularly in the lead-up to Federation in 1901, and their association with the art of that period has become commonplace in subsequent art histories.[15] Impressionism has long been saddled with the rhetoric of nationhood, and by 1945 Bernard Smith had noted that the popularity of such practices had rapidly become a 'national vice'.[16] Recent exhibition histories of Australian art, while presenting more nuanced accounts, suggest this remains the case.[17] The reinstallation of the Australian courts was an occasion to disentangle the nineteenth-century collections from this singular association, and rethink their display through the flux and change offered by the concept of littoral zones.

Notwithstanding the significance of impressionism in late-nineteenth-century Australian painting, the Art Gallery's collections offer the means to explore greater artistic terrains and present an expanded view of cultural histories. Given the symbiotic relationship between written art histories and the process of collection building that encouraged a broad acceptance that it was indeed men who authored the 'authentic' vision of nation, it can be taken as read that the works in these Grand Courts are still predominantly by male artists. There were, however, moments of rare triumph – that we now recognise and which reorient the new display – when works by nineteenth-century artists including Mary Stoddard, Emily Meston, Jessie Scarvell and Annie Dobson were acquired for the Art Gallery collection at the time they were first exhibited.

In 1929 Stephanie Taylor registered frustration at Arthur Streeton's published account of an Australian school of painting,

E Phillips Fox *Art students* 1895

Hugh Ramsay *A lady in blue* 1902

noting that in his 'artistic paradise there is apparently no room for women artists'.[18] This was not a new sentiment even then, but it was not until a later period of feminist activism in the 1970s that art historians and curators embarked on the ongoing process of retrieving names lost, and restoring and building artistic reputations to broaden the picture of art practices at this time. The Art Gallery, like other institutions of its type, was (at best) slow to respond to this awakening,[19] but in recent years has acquired major works by Violet Teague, Florence Fuller, Ethel Carrick and Jane Sutherland, which are among those that hold a new, defining presence and weight in the Grand Courts. The current commitment to transforming the collections embraces the Art Gallery's long-term plan to expand the representation of work by women artists across all eras.

Even if works by women artists are scarce, the Art Gallery's collections do reflect the centrality of symbolic representations of women in late-nineteenth-century art, both in local practices and that of expatriate artists working in Europe. To consider the importance and complexity of women as subjects alters traditional assumptions about the nineteenth century as a 'masculine' epoch of Australian art. The question of how constructed female subjects manufacture meaning in late-nineteenth-century artistic culture became crucial to the planning of this new display and led to further questions about the biases of our art histories.

To illustrate this, the previous pages present two collection paintings in which female subjects offer insights into different cultural influences. E Phillips Fox's *Art students* 1895, considered a masterpiece of late-century naturalism, positions women as active participants in Melbourne's art world. Fox has closely cropped and tilted the composition to focus on the toil of the artists. Their studio space is unrefined, littered with the debris of the art-making on which the students are fully focused. Their art school world is an all-female space (notwithstanding the implied presence of their instructor, the artist) that speaks to a reality of the nineteenth century that persists today. Women overwhelmingly made up the numbers of art school enrolments, but the professional art world revolved around the work of men.

Opposite Fox's work is Hugh Ramsay's *A lady in blue* 1902, where an enigmatic woman who emerges from darkness in a numinous blue dress embodies a kind of dream state. She appears physically close while psychologically distant, aligned to the hypnotically detached women who regularly appeared in turn-of-the-century Symbolist-inspired art to signify mysterious inner realms, at a time of a deeper scientific mapping of the subconscious.

These works picture the oscillating artistic domains of naturalism and artifice; of realism and dream worlds. They suggest how artists negotiated these ideas through the female form, and in their feminised subjects made women a key driver of meaning in this period of cultural history. There is a profusion of feminised meanings in late-nineteenth-century art: the 'feminine Arcady' of Rupert Bunny's belle epoque, Bertram Mackennal's sculpted allegorical

figures, the strange gestural theatres of George Lambert's painting. All would have this era renounce its masculine shackles and declare it a women's epoch.

But the examples cited here of female form are not identities created by women. The 2017 acquisition of Violet Teague's *Margaret Alice* 1900 (see p 178), a Federation-era portrait of grand scale, adds a distinct note to this feminised mapping of culture. Margaret Alice is depicted as a sportswoman in the (now unimaginable) sportswear of the day, tennis racquet in hand – a feminist portrait from a time when suffragettes were campaigning for women's health and greater physical mobility.[20] Notwithstanding the subject's moment of repose, she signals an active sense of change in an age of greater self-determination for women.

Extending from questions of national imaging, this period of art opens toward a more cosmopolitan view of practices that were operating in the vibrant cultural mix of nineteenth-century art. This frames a renewed approach to works of the now legendary *9 by 5 Impression* exhibition in 1889, a venture led by Tom Roberts, Arthur Streeton and Charles Conder. Long considered a landmark in heralding impressionism in Australia, this exhibition could more accurately be described as one of experimental stylistic crossover: with impressionist traits surely, but also with influences of Aestheticism, Symbolism and art-nouveau styling in the mix. Travel remained a condition of artistic experiences in late-nineteenth-century Australia – the regular movement of artists between Australia and Europe and the circulation of ideas that this brought to local culture is revealed in the wide set of influences operating in Australian art at this time.

To present the wider context of these hybrid influences and the authorship of artistic experimentation beyond Roberts, Streeton and Conder, we have taken the panels from the *9 by 5 Impression* exhibition out of the cabinets in which they had been displayed in isolation and installed them on a specially cladded section of one court,[21] in the broader company of works by other artists, of different stylistic emphasis. Paintings by Fred Leist, for example, another artist creating 'impressions' of the landscape, hang here, as do panels by Mortimer Menpes, complete with lavishly designed frames. Menpes was an Adelaide-born artist who travelled to Japan in 1887 to experience first-hand the culture that so inspired the Aesthetic movement. He also worked closely with James McNeill Whistler (who had not been to Japan). The *9 by 5 Impression* exhibition was itself staged as a Whistler-inspired Aesthetic event, an artful environment that integrated fine arts, decoration and design.[22] The Sydney-based artist Constance Roth was influential in promoting the values of Aestheticism and was known to Roberts, Conder and Streeton. One of her few extant works, *Apples* 1890, which she used to demonstrate crossovers between painting and ornamental design, is also displayed in this new grouping.

The novelist Ada Cambridge noted that after the 1880 Melbourne International Exhibition, which had included a Japanese court of

Littoral zones

ornamental objects and design, Victoria's middle classes became 'rapidly Aesthetic'.[23] The appeal of Japanese art had similarly increased in Sydney after the 1879 International Exhibition, from which the Art Gallery acquired a series of Japanese bronzes and ceramics. This established the Asian art collection, and a selection of these works is included in the new display to emphasise their impact. There is also a strong emphasis in this display on the role of Aestheticism in prompting cultural and artistic connections. Charles Conder's cosmopolitan view of Sydney in *Departure of the Orient – Circular Quay* 1888 (acquired in the year of its making) reveals how Aestheticism encouraged artists to imagine cultures beyond their own while remaining committed to picturing their homelands. The 1890s panel paintings are now exhibited alongside the Art Gallery's rich collection of Arts and Crafts material from this period, mainly works by female practitioners, including ceramics, jewellery, miniature paintings and book designs.

Another defining transformation in this display is the inclusion of films from the Corrick Collection, which has UNESCO heritage listing as a culturally significant archive of early cinema.[24] The Corricks were an Australian-based family of itinerant entertainers, responsible for screening early films from Europe and the United States across Australia. The inclusion of this hitherto largely undeclared influence on Federation-era culture sees the dancing nymphs of Sydney Long's enchanted Australian arcadian scenes in the company of morphing nymphs in director Gaston Velle's *The flower fairy* (1905, Pathé, France).

The Grand Courts remain true to nineteenth-century conditions for presenting art. In contrast to the 'white cube' of the modern gallery, the original salon railing-systems make attempts to pre-design displays with any precision redundant. Features of historical works themselves, such as the fragility and varying sizes of frames, also guide their presentation. History remains stubbornly present in these galleries, in a wholly satisfying way.

To live without a sense of cultural history is to exist in a state of amnesia. The transformation of the Grand Courts as part of the Sydney Modern Project imprints a sense of history as a condition of experiencing the present moment. But the notion of history is not static. Rather than presenting a conclusive statement, this new installation invites questions and ideas that will prompt further consideration and re-examination of how we present our collections. Our littoral metaphor suggests art histories as networks of interconnection that are forever expanding and reshaping.

Opposite, from top:
Charles Conder *Departure of the Orient – Circular Quay* 1888

Mildred Lovett *Vase with pastoral design of dancing figures by Sydney Long* 1909

The renewed display of Australian art
in the Grand Courts in 2022

Littoral zones

Notes

1 The Grand Courts were constructed and launched in a staggered rollout between 1897 and 1901. The largest of the two central courts was one of the original spaces launched in 1897.

2 Bernard Smith, *Place, taste and tradition: a study of Australian art since 1788*, Oxford University Press, Melbourne, 1979 (1945), p 146.

3 While recent Australian art scholarship and curating have envisaged a nuanced account of historical narratives, the Art Gallery's presentations of works have tended to support a more traditional vision.

4 Joanna Mendelssohn, Catherine De Lorenzo, Alison Inglis and Catherine Speck, *Australian art exhibitions: opening our eyes*, Thames & Hudson, Port Melbourne, Victoria, 2018, p 16.

5 The 2020 rehang developed out of collaborative discussions between the author and colleagues Cara Pinchbeck, senior curator of Aboriginal and Torres Strait Islander art, Isobel Parker Philip, senior curator of Australian contemporary art, Anne Ryan, curator of Australian art and Ruby Arrowsmith-Todd, curator of film. I also acknowledge the efforts of Wayne Tunnicliffe, head of Australian art, in driving a program of change in these collection galleries.

6 Grace Karskens, *The colony: a history of early Sydney*, Allen & Unwin, Sydney, 2009, p 7.

7 This is not the first time that Aboriginal and Torres Strait Islander art has featured in these courts. In 1959, the spectacular group of Tiwi Island *Pukumani grave posts*, a collaborative commission led by senior artists Laurie Nelson Mungatopi, Bob Apuatimi and Jack Yarunga, were first displayed in the Grand Courts along with a series of commissioned bark paintings from Yirrkala in north-east Arnhem Land. These works stood in alluring distinction to the inscribed values of European traditions of these hallowed artistic halls, offering richly different notions of cultural heritage to what was then known to Art Gallery audiences.

8 This program was led by Erin Vink and Cara Pinchbeck, curator and senior curator of Aboriginal and Torres Strait Islander art, AGNSW.

9 This counters the reductive claim made by Bernard Smith in 1945 that the art of this period was purely imitative of English traditions of painting (omitting mention of a significant painter of this period, Eugene von Guérard who was Austrian), Smith 1979, pp 112–13.

10 As evocatively visualised by curator and art historian Ruth Pullin in the exhibition *Eugene von Guérard: Artist-traveller*, Art Gallery of Ballarat, Victoria, 24 Mar – 27 May 2018. See also Ruth Pullin *The artist as traveller: the sketchbooks of Eugene von Guérard*, Art Gallery of Ballarat, Ballarat and State Library of Victoria, Melbourne, 2018, and Ruth Pullin and Michael Varcoe-Cocks, *Eugene von Guérard: nature revealed*, National Gallery of Victoria, Melbourne, 2011.

11 Ron Radford and Jane Hylton, *Australian colonial art 1800–1900*, Art Gallery Board of South Australia, Adelaide, 1995, pp 49–50.

12 Bathurst, in central west New South Wales, was one of the sites of the Australian gold rush of 1851.

13 Julian Ashton was a trustee of the Art Gallery at the time this work was purchased. In the new display, a work by Japanese artist Kubota Beisen is presented alongside *The prospector*, offering a new cultural inflection to this well-known image. Beisen published his own 'aesthetic' illustration of Ashton's painting when he saw it at the World's Columbian Exposition in 1893.

14 At the time of writing, Piguenit's painting had become an eerily familiar scene as towns were submerged in the catastrophic floods across eastern Australia – a further devastating outcome of climate change.

15 As referred to in numerous art-historical accounts, but succinctly stated in Daniel Thomas, 'In the burning fiery furnace: Streeton's *Fire's on* 1891', *Artlink*, vol 33, no 4, Dec 2013.

16 Smith 1974, p 143.

17 For example, the National Gallery of Victoria held *Australian Impressionism* in 2007, which was followed up with *She-Oak and Sunlight: Australian Impressionism* in 2021. More recent major exhibitions of impressionist artists include Frederick McCubbin (2007), Tom Roberts (National Gallery of Australia 2016) and Arthur Streeton (Art Gallery of New South Wales 2020). And in the story of global movements of Impressionism *Australia's Impressionists* was exhibited at the National Gallery in London in 2017.

18 Stephanie Taylor, letter to the editor, 'Women as Australian artists', *Argus*, 26 Nov 1929, p 19.

19 Former senior curator of Australian art Deborah Edwards and former education officer Linda Slutzkin should be acknowledged here as two of the professional feminist voices who campaigned for, and inspired, change at the Art Gallery of New South Wales.

20 Victoria Hammond, *A century of Australian women artists 1840s–1940s*, Deutscher Fine Art, Melbourne, 1993, p 15.

21 The heritage conditions of these galleries prohibit drilling into walls, and works are installed on traditional hanging rails. This has made it difficult to exhibit small works, such as the *9 by 5 Impression* panels, outside of cases, and thus specialised cladding of walls was introduced for this display.

22 See, for example, 'Preparing for the Impressionist exhibition', *Table Talk*, Melbourne, 16 Aug 1889, p 6, or Viva, 'Melbourne gossip', *Sydney Mail and New South Wales Advertiser*, 31 Aug 1889, p 6.

23 Ada Cambridge, cited in Humphrey McQueen, *Tom Roberts*, Macmillan, Sydney, 1996, p 85.

24 The films presented in the Grand Courts are curated by Ruby Arrowsmith-Todd, curator of film, AGNSW.

Denise Mimmocchi

Past and present: the place of historical European art in Sydney

Peter Raissis

'The stories old master pictures tell are actually universal ones, probing the fundamental questions of what it is to be human.'

5

Tradition is not to preserve the ashes but to pass on the fire.

—Gustav Mahler

WHAT DO THE ACQUISITIONS made during the Art Gallery's formative years – especially the spectacular examples of British Victorian and French Salon painting – say about the way those entrusted with building a public collection in Sydney thought about art and the role it would play in the lives of people who visited the Art Gallery? What do they suggest of the convictions, premises, even prejudices, that carried the fledgling institution forward to build the bedrock of what trustees expected to be a major art collection? And what are we to make of this legacy today?

The Sydney Modern Project not only invites reflection on the Art Gallery's past, it also compels us to revisit our age-old collections through a new lens and to address the way our experience of historical works can be expanded and enriched through reinvigorated displays that embrace a diversity of perspectives. Fidelity to the skills, knowledge and (as far as possible) the intentions of the makers of the artworks we care for is a traditional role of many museums. Our challenge with respect to the responsibilities we have to our collections and our audiences is twofold: how to balance these concerns without pigeonholing objects and ideas into narrow parameters, and how to encourage access to the multiple histories and meanings which can be advanced and sustained about great works of art.

When the New South Wales Parliament voted in 1874 to transfer £500 originally intended for the Australian Museum 'towards the formation of a Fine Art Gallery'', trustee JH Thomas outlined in a lofty paper the principles upon which the proposed gallery should be established. It is the closest document we have to a founding charter.[2] 'A national gallery,' Thomas argued, 'should illustrate what is truly great in art; should set before the public pictures that are the works of master minds, or good copies of them.' He discussed the acquisition of culture through familiarity with 'the noblest examples', with 'what is beautiful and what is exalted', advancing art as a force which 'breaks through all dividing barriers of sect [and] of bigotry', allowing its adherents to 'esteem one another as fellow-scholars of humanity'.

This was no fanciful idea. The moral implications of art and aesthetics, and their relationship to society, were topics of sustained inquiry by major cultural theorists of the Victorian age. Intellectual luminaries such as Matthew Arnold and John Ruskin were confirmed in their conviction that art is an intrinsic part of life rather than some sort of desirable extravagance. Arnold's definition of culture as 'the best which has been thought and said in the world' and Ruskin's notion of museums as 'places of noble instruction' helped determine the ethos not only of the future Art Gallery of New South Wales but of the Victorian museum movement at large.[3] A consensus arose that there were civic benefits to be reaped from cultural institutions, and that their 'civilising influence' – in the words of the trustees – was a sign of progress and prosperity.[4] The health of a civil society demanded that people be permitted to contemplate beauty.

The Art Gallery of New South Wales was dreamt as a *national* gallery. Indeed, as early as 1883 it was officially named the National Art Gallery of New South Wales.[5] The name indicates at least some desire that the institution model itself on the national art collections in London or Edinburgh, as opposed to the municipal museums which were emerging in Britain and its colonies in the second half of the nineteenth century.[6] Architecturally, the Sydney and Edinburgh galleries are sister institutions, the Ionic portico of our building based directly on that of the Scottish National Gallery. However, the ideal of a national collection was one which placed as much value on the great masters of the past as on the art of the present. As Ruskin and Arnold understood, to engage with the highest expressions of human culture also means, by necessity, exposure to the art of earlier ages. This was an idea which was to be emphatically proclaimed on the exterior of our building in the frieze of names of great European artists from Praxiteles to Gainsborough.

However, to fulfil that dream in the nineteenth century was far beyond Sydney's resources. Trustees lacked the competence to acquire old master paintings. Not only were the paintings associated with aristocratic taste, the market was also perceived to be difficult, riddled with fakes and dubious attributions. And old masters were expensive. As JH Thomas had noted in his address, a Murillo could go for £23,000. By contrast, the first major European painting bought by the Art Gallery – Ford Madox Brown's youthful magnum opus, *Chaucer at the court of Edward III*, exhibited in 1851 – cost a mere £500, the entire acquisitions budget for 1876!

Given the dismally insufficient funds at their disposal, the trustees resolved to display old masters not through originals but painted copies. However, this decision was soon repealed following a controversy launched by trustee EL Montefiore, who held that watercolours by living artists were preferable to old master copies because 'the study of watercolours is very largely followed by art students in Sydney'.[7] While 'Mr Montefiore was willing to sit at the feet of our good British masters', observed the *Sydney Mail*, 'Mr Thomas would fain worship at the shrine of the great dead painters of Italy'.[8] Although the Art Gallery would later acquire painted copies of Italian Renaissance and Baroque art with the donation of Sir John Nodes Dickinson's collection in 1899, the influence of old masters in shaping the collection during the Art Gallery's early history was negligible.[9] Despite continuing debate at this time over the lack of paintings from the period between the Renaissance and the eighteenth century, Sydney's foray into this field of collecting would have to wait until the next century.[10]

Watercolours were seen as highly appropriate for emerging colonial galleries since they met the specific educational needs of students and aspiring artists. Fashionable, affordable and quintessentially British, they were also perceived as democratic and domestic, capable of being appreciated by audiences of widely differing social and educational backgrounds. Avidly acquired by the Art Gallery between 1875 and 1906, modern British watercolours were

Ford Madox Brown *Chaucer at
the court of Edward III* 1847–51

Past and present

prized permanent exhibits, presented in gold frames and glamorous mounts to show them to advantage.[11] People who had never seen a loch, or a dale, or a fen, and never would, were beguiled, brushstroke by painstaking brushstroke, into believing that nature, in its Edenic state, was British.

Soon artworks other than watercolours also began to form the nucleus of the collection. Early displays were arranged by medium: sculpture and casts, ceramics, drawings, prints and autotypes, and oil paintings. By 1883 the collection was deemed substantial enough to warrant the publication of an official general catalogue, and new editions appeared in rapid succession recording its growth: in 1884, 1886, 1888, 1891, 1893, and 1899. With the exception of oil paintings, which addressed the Art Gallery's 'high art' aspirations, the bulk of the collection was intended to fulfil a practical, pedagogical purpose.

By the mid 1880s the range of the collection was such that one trustee could confidently write to the editor of the *Sydney Morning Herald*, 'there is plenty in the building to gratify tastes instructed and not instructed'.[12] He also noted the paintings with 'sound moral lessons for those who have patience to study the story told, and eyes to perceive it'. The quote reminds us yet again of the widespread belief that great art was deemed to have power over the very moral substance of its audience. This was not to do with knowledge of art history but rather the experience of those viewing the painting, which for a Victorian audience meant empathising with the story. As Anna Jameson, the prolific nineteenth-century writer on museums, opined, 'in the fine arts, as in many other things, knowledge comes after love'.[13]

Until well into the twentieth century the Art Gallery looked primarily to Britain for its major acquisitions. These were contemporary and predominantly British paintings. The reason for this focus rests on the history of colonisation. In the nineteenth century, Australia was so imbued with the imperial ethos that its practices and precepts went unquestioned, influencing even the way paintings at the Art Gallery were classified and displayed by national school: 'Australian' and 'British and Foreign' (ie European).[14] As early as 1874 a 'London selection committee' of overseas advisors was appointed to make purchases, and shortly afterwards a committee was also set up in Paris. The first individuals appointed were Nicholas Chevalier and Colin McKay Smith in London, artist and critic respectively, and Édouard Montefiore in Paris. Advisors tended to be expatriate Australians with formidable social and political connections, often with successful artistic careers behind them.[15] Although the Art Gallery's very first purchase had been a locally commissioned watercolour, the growth of the Australian collection was gradual. It was not until the 1930s that Australian oil paintings exceeded British ones in number.[16]

Colonial gallery trustees favoured paintings which edified the mind rather than appealed to the senses. It is no accident that the first oil painting to be purchased abroad was Ford Madox Brown's *Chaucer at the court of Edward III* 1847–51. Created early in Queen

Victoria's reign, the painting was already considered old-fashioned when it was purchased in 1874, but it contained uplifting sentiments. Arguably, what mattered more than its Pre-Raphaelite credentials was its status as a grand history painting, replete with patriotic meaning and celebratory of past English cultural achievements. Read at the time as a statement of imperial unity and shared identity, it shows the father of English literature reading lines from *The Canterbury tales* to the king who first championed the English language over French. Upon its acquisition trustee Edward Combes described the painting to the Minister of Public Instruction as a 'magnificent example ... as a work of art this grand picture would hold its own in any gallery in the world'.[17]

Military paintings were also a popular presence in every colonial Australian gallery. In an age when nations were thought to be forged on the battlefield, patriotic themes which strengthened imperial resolve were often expressed through imagery of exemplary male death and the slaughter of war. Alphonse de Neuville's *The defence of Rorke's Drift 1879* 1880 was purchased from London's Fine Art Society in 1882 shortly after it had completed a successful nationwide tour of the United Kingdom. It became so well known in Australia that the painter Tom Roberts could breezily write in the Melbourne *Argus*, 'to describe [*The defence of Rorke's Drift 1879*] is not needed, for has not everyone seen the photogravures?'[18]

A famous episode in the Anglo-Zulu War of 1879, the battle of Rorke's Drift is one of the most celebrated stories of tenacious defence against overwhelming odds in British military history.[19] The painting was seen to combine contemporary history with an exemplary moral dimension. One Art Gallery trustee high-mindedly evoked the heroic battles of ancient Greece when enumerating its virtues: 'It is the story of a deed', he wrote, 'as noble as the stand of Leonidas and the 300 Spartans against the Persians at Thermopylae.' Recounting de Neuville's spectacle of an outnumbered garrison under attack while evacuating wounded men from a burning hospital, the writer continues: 'To do and to dare for others is as good a lesson in our day as it was of old, and I for one am glad that we have such a living teacher in our gallery.'[20]

Long after its acquisition, the canvas was exhibited with one, then three large labels explaining the battle's episodes and the personalities involved, as well as a pair of annotated watercolours illustrating the topography of Rorke's Drift.[21] They were joined by a photograph of a letter from the commanding officer of the company of men stationed there, Lieutenant Gonville Bromhead VC.[22] The display of the painting alongside such contextual material is an interesting early instance of the use of archives in the public presentation of an artwork. Celebrated as a triumphalist, eyewitness account of British pluckiness, *The defence of Rorke's Drift 1879* and its supporting documents presented only a fragment of a more complex and troubling colonial history in South Africa – a version of a defensive rather than offensive empire, told exclusively from the European perspective.

Alphonse de Neuville
*The defence of Rorke's
Drift 1879* 1880

Beyond the name of the Zulus' commander, Prince Dabulamanzi
kaMpande, and the fact that the British press of the time treated
them with considerable respect, we know little about the Zulu
position because the story was never told. Our challenge today
is to acknowledge this asymmetry of reportage and to show the
painting in ways which do not privilege one side. If *Rorke's Drift,* or
any imaginative work for that matter, should continue to lay claim
to our time, feelings and thoughts, interpretation must go on. In its
most recent installation, *Rorke's Drift* has been separated from its
usual company of late-nineteenth-century salon pictures to allow
us to explore how aesthetic, historical and moral issues intersect
around the painting, and to pursue a different set of questions than
was possible in earlier displays. Our exploration of the picture is
in two parts and takes two approaches, one historical, the other
contemporary. The first focuses on the painting's historical display at
the Art Gallery and its critical and popular reception in nineteenth-
century Sydney. The second, bringing together works by southern
African artists associated with the Rorke's Drift Art and Craft Centre
in the later twentieth century, such as John Muafangejo and Sam
Nhlengethwa, addresses the painting from the viewpoint of a world
that has changed and is changing especially fast in our lifetime.[23] As
museums have to be responsive to the new needs of a newly defined
community, the approach is revisionary, and considers alternative,
marginalised histories which have been hidden from view in the
legacy of colonialism. Because paintings cannot be constrained or
limited by prosaic directness, the stories they harbour are many,
their meanings not unchanging but evolving, and it should be our

Peter Raissis

irresistible compulsion to try to demonstrate the plurality of these for our audience.

Nor should we overlook the fact that paintings such as *Rorke's Drift* are integral parts of a collection which is itself an organic entity, possessing a particular character and history of its own. Following the major success of its acquisition, the Art Gallery went on to secure other impressive examples of contemporary art at the time: Frederic Leighton's *Wedded* in 1882, Luke Fildes's *The widower* in 1883, John William Waterhouse's *Diogenes* in 1886, Edward Poynter's *The visit of the Queen of Sheba to King Solomon* in 1892, and Édouard Detaille's immense *Vive l'Empereur!* in 1893. These are the nineteenth-century pictures which remain on display in the Art Gallery's Grand Courts, an imposing enfilade of originally sky-lit galleries, which opened in stages between 1897 and 1901, one of the most coherent ensembles of late Victorian art in its original setting outside the United Kingdom. The art-historical context of these paintings has also been broadened by subsequent purchases and donations, particularly from passionate collectors of Victorian art such as John Schaeffer.

However, not all acquisitions made in the nineteenth century fared so well. By 1894 president Frederick Eccleston Du Faur already felt compelled to ask his fellow trustees whether 'second class' paintings should remain in the collection.[24] Overseas advisors had rarely looked beyond the circles of the Royal Academy and, to a lesser extent, the Paris Salon – the establishment tastemakers. The

coveted letters RA (royal academician) or ARA (associate) after an artist's name seemed to be validation enough of artistic merit when considering future acquisitions. But in later years the predominance of stock regional gallery subjects like 'figures in a landscape' seemed to indicate that the contemporary art of one generation does not necessarily serve as the historical art of the next. Many pictures fell victim to deaccessioning in the 1940s and 1950s, when Victorian art reached the nadir of unfashionability.

The Art Gallery of New South Wales might have been called 'National', but it was provincial British in all but name. Although trustees limited their acquisitions to artists in the current market, they showed little interest in progressive, contemporary art. 'Boudoir work' was decidedly off limits.[25] They eschewed the 'fleshly school' of Rossetti and his circle, the aestheticism of Whistler, and indeed anything that might expose the public to the excessively sensual, the decadent, the erotic. Most examples of Pre-Raphaelitism, for example, came into the collection only from the mid twentieth century. Similarly, influential European movements were paid scant attention. When the Paris Committee asked in 1894 about the desirability of purchasing Impressionist pictures, the reply was brisk: 'The trustees are of the opinion that they should be avoided.'[26] It was not until 1935 that the Art Gallery purchased its first Impressionist painting, Camille Pissarro's *Peasants' houses, Éragny* 1887. A gradual shift was taking place towards a circumspect acceptance of works in the modern French tradition embodying aesthetic criteria that had emerged beyond the sway of the academy. Around the same time, the critic Frank Rutter commended the Art Gallery's recent acquisitions

Opposite: Edward John Poynter
The visit of the Queen of Sheba to King Solomon 1881–90

Above: Camille Pissarro
Peasants' houses, Éragny 1887

Peter Raissis

of Corot, Boudin and Fantin-Latour because they demonstrate 'improved taste and greater knowledge', in contrast to 'the costly errors of the past' (essentially every major nineteenth-century work in the Art Gallery bar the Ford Madox Brown), which he dismissed in an outburst of anti-Victorian invective.[27] Another promoter of Impressionism and British modernism, DS MacColl, had expressed a similar opinion to the director some years earlier in his capacity as keeper of the Tate Gallery: 'The great masters of the [nineteenth] century are absent, and their place is taken by the favourites of a passing fashion.'[28]

It was also in the 1930s that the Art Gallery took serious steps to build up a collection of old masters. The trustees appointed Harold Wright of Colnaghi's, initially to purchase prints, and from 1946 also to purchase old master paintings. It is to his expertise that we owe our significant graphic holdings by such artists as Mantegna, Dürer and Rembrandt, among others.[29] The fuller story of Sydney's old masters will need to be given in another context. However, mention must be made of the paintings added to the collection in the 1990s, including those by Niccolò dell'Abate, Domenico Beccafumi and Bronzino, all representative of Italian art of the sixteenth century in various guises. It was then that an astoundingly generous series of gifts by James Fairfax transformed the focus and potential of the Art Gallery's European collection completely, with examples of

sixteenth- and seventeenth-century Flemish, seventeenth-century Dutch, and eighteenth-century French and Italian painting, not to speak of an important group of old master drawings. To this tradition of philanthropy, we add Kenneth Reed, whose donations of paintings and promised gift of eighteenth-century European porcelain and Italian Renaissance majolica have enhanced our collections and invigorated our displays in exciting and unforeseen ways.

'Why old masters?' is a question which I sometimes hear people ask in Sydney. Old master paintings depict subjects and express ideas and feelings that some might believe alien or at worst antithetical to those of contemporary life. Their meanings lie deep in the crevices of their own European traditions, in mythology, philosophy, theology, folklore ... Such cavilling overlooks the enormous complexity of the imaginative contrivance that is great art. The stories old master pictures tell are actually universal ones, probing the fundamental questions of what it is to be human. The works of the great artists of the past are conduits through which we can explore our own personal and shared experience, and the significance they hold can never be static.

The Art Gallery's most recent old master acquisition, a painting representing Aesop by the Spanish Baroque artist Jusepe de Ribera, is a good example of the way meanings, both historical and contemporary, can freely cohabit in a great work of art. Painted sometime between 1625 and 1631 in Naples where the artist had made his home, the work is one of Ribera's very first depictions of so-called

Opposite: Claude Lorrain *Pastoral landscape* 1636–37, gift of James Fairfax AC 1992

Above: Installation view of the James Fairfax Galleries in the Grand Courts, 2022

Peter Raissis

Jusepe de Ribera *Aesop* c1625–31

Past and present

'beggar philosophers'. Although we do not know the identity of Ribera's model (or if indeed he used one) it seems plausible, given the work's jolting immediacy and psychological presence, that he was someone known to the painter.

Aesop was a legendary ancient Greek storyteller whose fables (a kind of philosophy which can teach lessons about the world) used talking animals to make a sharp critique of human foolishness. He was said to be a strikingly ugly slave whose cleverness and wit eventually secured his freedom. Ribera's painted version suggests someone rendered wise through the hardships he has suffered. However, it is not certain Aesop existed at all. His life is an elaborate study in myth. And as with Aesop himself, the origins of the Greek fables are also lost to history. They have, nevertheless, become not only one of the most enduring literary traditions of European culture but also one of the oldest and best-known collections of stories in the world. The fables began as part of a culture that relied on oral, not written, transmission. They have been told for thousands of years, undergoing revision as they passed from one teller to another, and transcribed into dozens of languages, including those of Asia.

Throughout its 400-year history, Ribera's *Aesop* has moved between private collections in Italy, Spain, France and America. In Sydney, at its destination in an art museum on Gadigal Country, the picture will invariably assume new meanings and elicit new resonances. Ultimately, Aesop and his fables serve to remind us that storytelling, from the very beginning an oral tradition, has been critical to our sense of humanity. Like the extraordinary oral literature traditions of Indigenous Australians, the original storytellers of this country, whose songs and poetry have been carried continually through millennia, Aesop also speaks of the power and importance of ancestral storytelling to us all.

1 New South Wales Academy of Art, minutes, 17 Jul 1874, p 16; New South Wales Parliament, *Votes and proceedings of the legislative assembly during the session of 1873–74*, vol 2, Thomas Richards, government printer, 1874, p 473.

2 A version of Thomas's address was later delivered to students of the New South Wales Academy of Art, and it was afterwards published. See JH Thomas, 'On art and culture', *Athenaeum* (Sydney), vol 1, no 17, 23 Oct 1875, pp 197–99; no 18, 30 Oct 1875, pp 212–13; no 19, 6 Nov 1875, p 225.

3 Matthew Arnold, *Culture and anarchy*, ed J Dover Wilson, Cambridge University Press, Cambridge, UK, 1986 (1869), p 6; John Ruskin, quoted in ET Cook and Alexander Wedderburn (eds), *The works of John Ruskin*, 39 vols, Library Edition, George Allen, London, 1903–12, vol XXVIII, letter 59, Nov 1875, p 450. In 1881 the trustees approved the purchase in England of a number of books by John Ruskin for the Art Gallery.

4 *Catalogue of the Art Gallery of New South Wales, with 94 illustrations, drawn by EL Montefiore, Esq*, John Sands, Sydney, 1893, p viii.

5 In pre-Federation Australia, New South Wales was a 'nation'. Although this name became anachronistic after the federation of the Australian colonies in 1901, it nevertheless continued in use until 1958 when 'National' was dropped.

6 See Giles Waterfield, *The people's galleries: art museums and exhibitions in Britain 1800–1914*, Yale University Press, New Haven, 2015.

7 AGNSW Board of Trustees, minutes, 23 Jul 1874.

8 'Fine arts. Our National Gallery', *The Sydney Mail and New South Wales Advertiser*, 30 Jan 1875, p 135.

9 Supreme Court judge Sir John Nodes Dickinson (1806–82) was the first to propose the founding of an art gallery in Sydney in 1873. Thirty-five painted old master copies from his collection were presented to the Art Gallery of New South Wales by his daughter, Helen Mary Dickinson, in 1899. The paintings were part of the Art Gallery's permanent display until at least the mid 1930s.

10 When *The defence of Rorke's Drift 1879* was purchased in 1882 for £2000, the prominent critic WJ Loftie lamented, 'the Sydney Gallery might have bought a couple of genuine Sir Joshuas, and a good Gainsborough, and two or three representative Italian pictures', 'Art in Australia', *The Magazine of Art*, vol 9, 9 Jan 1886, pp 174–75.

11 See Peter Raissis, *Victorian watercolours from the Art Gallery of New South Wales*, exh cat, AGNSW, Sydney, 2017.

12 A trustee, 'Art in Sydney – to the editor of the Herald', *Sydney Morning Herald*, 10 Mar 1887, p 4.

13 Anna Jameson, *A handbook to the public galleries of art in and near London*, John Murray, London, 1842, p 14.

14 This system of displaying paintings at the Art Gallery of New South Wales appears to have started by 1899 and lasted until at least the 1920s. Previously, all paintings had been integrated.

15 Édouard Montefiore, a banker and amateur artist, was the brother of Eliezer Levi Montefiore, a trustee and later the Art Gallery's first director. He was followed by Charles Ephrussi and Philippe Burty. The principal advisors in London following Chevalier and Smith were Sir Oswald Brierly; Thomas Lane Devitt; George Howard, 9th Earl of Carlisle; Arthur H Greening; Sir Alfred East; Sir John Longstaff; AG Temple; Sir George Frampton and Sir Frank Brangwyn. The London committee was disbanded in 1921 only to be reconstituted in 1925. The Art Gallery depended on the advice of overseas advisors for purchases of European art (which from 1946 included old master paintings) until about 1970.

16 The preference for imported contemporary art as opposed to locally produced art became a topic of heated debate, with *The Art Journal* noting in 1885 'considerable soreness just now in the minds of local artists at Sydney' when no works were purchased with modest sums allocated for the purpose. The writer proposed that Australian artists would be best assisted by the Art Gallery acquiring 'examples not only of contemporary but of ancient art, irrespective of nationality'. 'Art notes', *The Art Journal*, vol 47, 1885, p 228.

17 Letter from Edward Combes to Joseph Docker, 11 Feb 1876, National Art Archive, AGNSW, CF 39/1876.

18 Tom Roberts, 'The national Art Gallery of New South Wales, *Argus*, 31 Oct 1891, p 4.

19 A fighting force of fewer than 150 men withstood the assaults of an army of around 4500 Zulu warriors when they crossed from Isandlwana into the neighbouring British colony of Natal and descended on the virtually defenceless field hospital and storehouse established at Rorke's Drift.

20 A trustee, 'Art in Sydney – to the editor of the Herald', *Sydney Morning Herald*, 10 Mar 1887, p 4.

21 Lieutenant-Colonel Henry James Degacher made the drawings, *Rorke's Drift post* and *Barricade at Rorke's Drift* in 1879, while campaigning in the Anglo-Zulu War.

22 Bromhead is shown in the centre of the composition wearing a white helmet and pointing to the right. He was memorably portrayed by Michael Caine in the 1964 film *Zulu*. The painting was used as a source for the set of the film.

23 The Evangelical Lutheran Church Art and Craft Centre at Rorke's Drift, established in 1962, attracted students from across southern Africa, many of whom went on to become influential artists and teachers. A reproduction of de Neuville's painting was used as a teaching aid at the school, and students often made their own interpretation of the scene.

24 AGNSW Board of Trustees, minutes, 8 Dec 1894.

25 Letter from TL Devitt to EL Montefiore, National Art Archive, AGNSW, 15/1894.

26 AGNSW Board of Trustees, minutes, 20 Jan 1894.

27 Frank Rutter, 'Art in Australia. New purchases for Sydney, errors of the past', *Sunday Times*, 24 Sep 1933, p 12.

28 Letter from DS MacColl to GVF Mann, National Art Archive, AGNSW, BF7/19111.

29 See Peter Raissis, *Prints and drawings: Europe 1500–1900*, exh cat, AGNSW, Sydney, 2014.

Peter Raissis

Between here and there: collecting and displaying modern and contemporary international art

Nicholas Chambers

'The Art Gallery has moved towards a view of international art as a relational collection area – acquiring works less as representative examples of particular places, styles or periods than for their ability to animate points of connection between different cultural and historical contexts.'

6

ON A FIRST VISIT TO AN ART MUSEUM, we typically look for a gallery map. Variously printed in a brochure or displayed on a wall, it gives us the lie of the land, highlights points of interest, and assists with navigation. Its intent seems entirely functional; however, contained within the map we can also begin to discern the institution's worldview. It concisely describes priorities and omissions and, moreover, reveals much about how the museum sees itself and the art of its place in relation to the rest of the world. One such map, held in the archives of the Art Gallery of New South Wales, depicts the building's layout a century ago.[1] In the northern wing, it indicates a series of galleries devoted to Australian art while, in the central and southern wings, it shows the location of 'British' and 'Foreign' art, shorthand at the time for 'not British'. It is a map that underscored the Art Gallery's highly deferential attitude towards Great Britain and its highly differentiated regard for everywhere else.

In the second half of the twentieth century, the organisation of the Art Gallery's collections began to reflect an expanded and more nuanced sense of what might count as art from *here*. Following extensions in 1972, 1988 and 2003, the Art Gallery boasted spaces designated for Aboriginal and Torres Strait Islander art, for non-Indigenous Australian art, and for Asian art – all of which constituted a broader and more inclusive notion of the local. Over the same period, the Art Gallery's terminology for art from *there* shifted – from 'Foreign' in the aforementioned map, to 'European', to 'Western', to 'international', the last being a collection area seemingly defined by a lack of geographic or cultural specificity.

Progressively, the Art Gallery has moved towards a view of international art as a relational collecting area – acquiring works less as representative examples of particular places, styles or periods than for their ability to animate points of connection between different cultural and historical contexts. It has become, in keeping with the meaning of the word's prefix 'inter-', a category of art situated 'between' *here* and *there*.

The 2021–22 refurbishment and reinstallation of the collection galleries, which now present Australian and international art in dialogue, has provided an opportunity to reflect on our own history of collecting and display. We have reconsidered the place of modern and contemporary international art through focusing on works that reveal the richness and complexity that exists in the spaces between art from different places and times.

World echoes
The oldest display spaces at the Art Gallery, the Grand Courts, are like a time machine. Designed by Walter Liberty Vernon in the 1890s when (it is worth being reminded) New South Wales was a British colony, they are populated by numerous works of art that have remained on continuous display since their acquisition more than a century ago. The history of the courts is inscribed into their architecture, creating an environment that transports visitors to a pre-cinematic moment when art galleries offered the best visual spectacle available. Early acquisitions, such as Sir Edward John Poynter's monumental *The visit of the Queen of Sheba to King Solomon* 1890, reveal the extraordinary synergy between the Grand Courts' design and the contemporary art of its day. The image of Solomon's court refers not only to a fantastical vision of the material culture of the Middle East but also to the architecture of classical antiquity. Furthermore, the architectural references extend beyond the picture plane, to be reprised in the Poynter's ornate frame and echoed in the galleries themselves, in the columns, architraves and dado of Vernon's interior. In instances like this, the art and architecture of the Grand Courts create their own ecosystem, reflecting an amalgam of Victorian interests from ancient Greece and Italy through to the Middle East while, from a contemporary perspective, inviting questions about the significance of this set of interests, and what it says about Victorian aesthetics and Britain's worldview in the nineteenth century.

In the new installation of the John Schaeffer Gallery, which houses the Art Gallery's most important Victorian pictures, Poynter's painting is seen in relation to an artwork by Cameroonian artist Pascale Marthine Tayou (see pp 144–45).[2] Titled *Colonnes Pascale* 2012, Tayou's sculpture comprises five elegantly undulating columns which draw the eye upwards and have the effect of enhancing the drama and artistry of the Grand Courts. Made from stacks of ceramic vessels, this work makes a playful, even precarious, counterpoint to the heroics of Vernon's architecture and Poynter's painting. Found by Tayou in North Africa, the vessels are decorated with patterns

A plan of the Art Gallery's ground floor, 1926

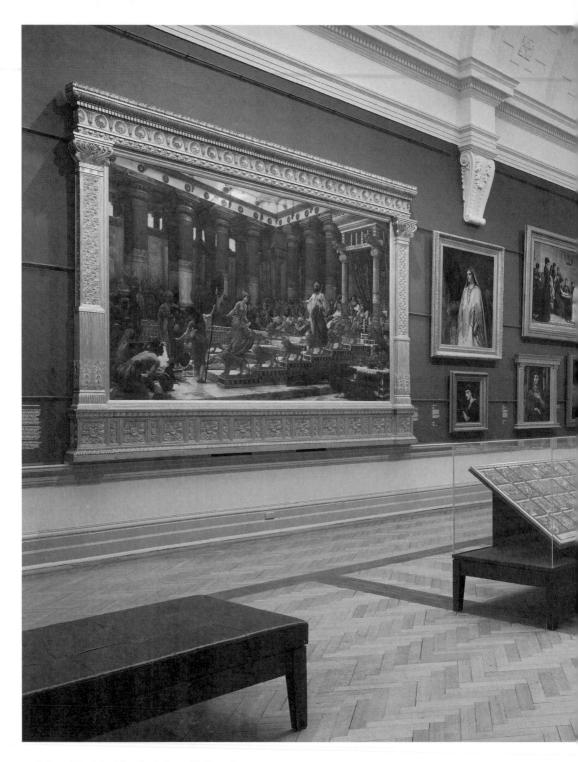

A view of the John Schaeffer Gallery with Edward
John Poynter's *The visit of the Queen of Sheba to
King Solomon* 1881–90 on the left and three columns
of ceramics (from a total of five) from Pascale
Marthine Tayou's sculpture *Colonnes Pascale* 2012
in the centre

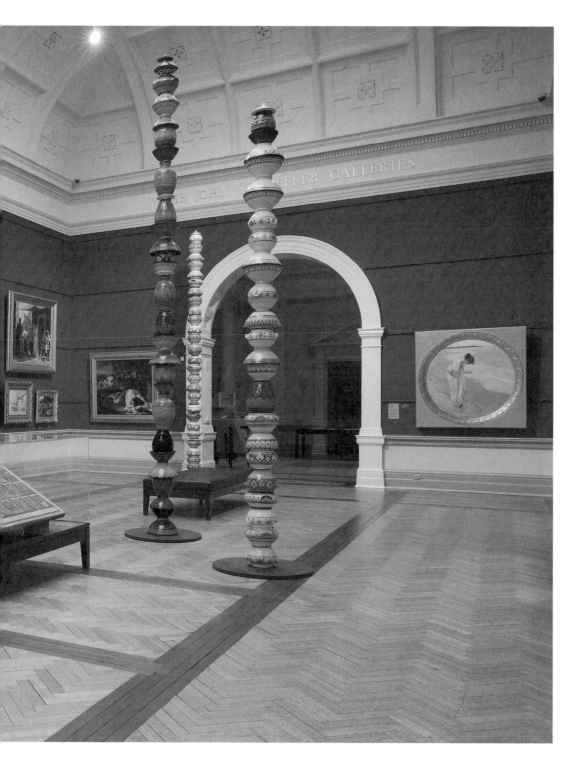

that reveal their origins in the Arab world, while their occasional chips and imperfections, intentionally left visible by the artist, point to the ceramics' individual stories of use and exchange. Massed together and comprising more than 200 vessels in total, they draw attention to a world of accelerated production and to global narratives of colonisation and trade (contemporary and historical). Poynter's orientalist painting, replete with cultural forms borrowed from North Africa and the Middle East is, of course, a product of these narratives. However, the effect of Tayou's sculpture is not to simply 'call out' colonialist attitudes but to meditate on the various ways in which places are intertwined through their material cultures. It is a strategy that evokes Édouard Glissant's neologism *échos-monde*, which he used to refer to a world of cultural and aesthetic resonances.[3] *Colonnes Pascale* unsettles the relations between the subject and object of the colonial gaze and, instead, focuses attention on points of transfer between cultures, speaking *through* the colonial project in order to amplify the processes of sampling and hybridisation already at work in so many of the Victorian pictures that surround it.

Related to Glissant's concept of *échos-monde* is the term 'créolisation', which he used to describe the capacity for seemingly disparate ideas to collide and produce new ones. It is a process that we can see unfold in the Grand Courts where a contemporary painting by Canadian Cree artist Kent Monkman shares a space with seventeenth- and eighteenth-century European paintings and ceramics, etchings by Jacques Callot and colonial Indian Company School miniature paintings. Framed in a reproduction-period frame and integrated into a salon presentation that also includes landscapes by Claude Lorrain, John Constable and Jacob van Ruisdael, Monkman's contemporary painting could, at a casual glance, be mistaken for a work from an earlier century. In it Monkman draws upon a diverse range of references, tracing a thread from the seventeenth century to the modern period, to draw attention to the place (and absence) of Indigenous, female and queer perspectives in the standard narratives of European art.

Monkman's title provides us with a jumping-off point. *The allegory of painting* 2015 reminds us of Vermeer's and Boucher's famous paintings of the same subject, both of which portray the figure of 'painting' as female, despite the almost complete occlusion of women from the ranks of seventeenth-century professional artists. And, more pointedly, it invokes Artemisia Gentileschi whose own version, in a political act of self-assertion, took the form of a self-portrait that declared 'I am painting'. In Monkman's take on this subject, it is his own gender-fluid alter ego Miss Chief Eagle Testikle who assumes the role and is depicted confidently and declaratively in the foreground.

The composition of Monkman's painting, however, brings us to the nineteenth century. It reprises, with extraordinary detail, a Hudson River School painting, *Shandaken Range, Kingston, New York* c1854 by Asher Durand, in the collection of the New-York Historical Society. Durand's painting is emblematic of colonial landscapes produced in Australia, North America and elsewhere which imaged

Opposite, from top:
John Constable *Landscape with a goatherd and goats (after Claude)* 1823

Kent Monkman *The allegory of painting* 2015

Between here and there

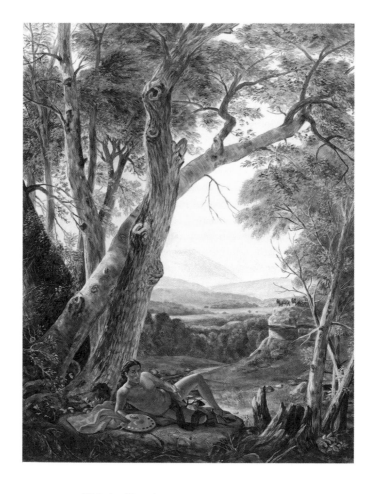

Nicholas Chambers

occupied lands in the manner of seventeenth-century Romantic European landscapes. Eugene von Guérard's *A fig tree on American Creek near Wollongong, NSW* 1861, installed in an adjacent court, gives us an Australian example. In a manner that bears comparison to Daniel Boyd's appropriation and reworking of images associated with Australia's colonial history,[4] Monkman adopts the idiom of the Hudson River School to assert the ongoing Indigenous presence in New York's Hudson Valley.

And, in peeling back a further layer, we may note that the figure of Miss Chief is depicted painting a distant herd of buffalo on a rock. Her painting references the millennia-old pictographs at Áísínai'pi (Writing-on-Stone, Milk River, Canada), while also raising the spectre of early European modernism's appropriation of Indigenous artistic forms. In this instance, Monkman has in mind the figure of Pablo Picasso. 'I take Picasso's bull,' he wrote, 'a deliberately constructed symbol of his male virility – and reclaim it through Miss Chief's depiction of the buffalo, matriarchal beings recognised as kin to Plains Indigenous people.'[5]

The works by Tayou and Monkman animate a conversation not only between different cultures but also across time, revealing the historic environment of the Grand Courts to be one in which different time periods are overlaid and in which distant places are brought into proximity. As Monkman stated in a 2017 interview, 'I want to make the contemporary feel historic and the historic feel contemporary.'[6]

Modernism and mobility

In the Art Gallery's early years, international acquisitions were predominantly British and to a much lesser degree French, academic paintings. European modern art would follow in the 1920s, but this typically happened in a sporadic manner, or was at times opportunistic. Camille Pissarro's *Peasants' houses, Éragny* 1887, for example, the first modernist painting to enter the collection, was acquired not from France but from a 1935 exhibition in Sydney organised by the Society of Artists.[7] Similarly, it was the 1939 *Herald Exhibition of French and British Art*, organised by Keith Murdoch, father of the media tycoon Rupert Murdoch, at the David Jones Gallery (and infamously decried as an exhibition of art by 'degenerates and perverts'[8]), which facilitated the purchase of modern paintings by French artists Charles Camoin (thought to be by Paul Gauguin at the time of its acquisition), André Derrain and Albert Marquet,[9] and by British artists George Leslie Hunter, Philip Wilson Steer and Henry Tonks.

While artworks like these may have constituted the beginnings of the Art Gallery's modern international collection,[10] the expedient nature of their acquisition reflected an attitude of detached distance from the rest of the world that contrasted starkly with the practices of many contemporary artists. By the early twentieth century, the idea of artistic exchange between different, and sometimes disparate, places increasingly became a matter of lived experience. Of particular

Grace Crowley *Portrait of Lucie Beynis* 1929

significance for the development of modern painting in Sydney are the examples of Dorrit Black, Grace Crowley and Anne Dangar, who in the late 1920s all studied cubism in Paris at the Académie André Lhote.

As was the case in so many parts of the world, cubism proved to be highly conducive to new forms of artistic experimentation in Australia. In the decades following the 1912 publication of the manifesto *Du 'Cubisme'* the movement became an international phenomenon. For many artists it provided a gateway to modern ideas, and its central tenets were readily transmitted around the world and adapted in response to local aesthetic traditions. While Lhote is often neglected in his native France,[11] the movement's international mobility was due in no small part to the student body at his academy, which was predominantly made up of women from countries other than France. Over the course of the academy's three decades, it accepted students from Brazil, Argentina, Mexico, United States, Sweden, Finland, Serbia, Turkey, Iran, Egypt, India, Japan and Australia – an extraordinary international cohort at a time prior to the advent of mass air travel.

Nicholas Chambers

The new installation of the modern collections is seen across the two floors of the Art Gallery's 1972 extensions designed by Andrew Andersons, whose rational, modular interiors stand in contrast to the ornamentation of the Grand Courts. Refurbished to Andersons' original design, these galleries again feature a central atrium, now installed with Ken Unsworth's *Suspended stone circle II* 1974–77 to emphasise the visual connection between the ground floor and the level below. A beloved work in the Art Gallery's collection, in this location it also functions as an 'anchor work' that helps guide viewers around the building's various architectures.

The ground floor display, which integrates Australian and international works, elucidates the cosmopolitan environment of the early twentieth century and presents a picture of modernism as a story of mobility and exchange. Emblematic of this approach is the display of newly acquired works by Lhote and Tunisian modernist Yahia Turki, which are seen in dialogue with early breakthrough works by Crowley, Black, Dangar and other Australian artists.

Lhote painted *House in Tunis* (*Maison à Tunis*) 1929 not in Paris but in the Tunisian town of Sidi Bou Said, where he had travelled to present a lecture at the invitation of the Société des écrivains de l'Afrique du Nord. It is an unusually reductive composition for the artist, featuring large planes of bright colours, almost approaching abstraction, and presumably influenced by the low-rise, planar

André Lhote *House in Tunis*
(*Maison à Tunis*) 1929

Between here and there

architecture of the town and the Islamic geometric ornamentation that featured in its buildings. It is notable that the painting was made at the time of the French occupation of Tunisia. While it was academic painting, even in 1929, that was championed by the colonial administration, local artists nevertheless created platforms for progressive art in North Africa and developed networks with artists from other parts of the world.

At the time of Lhote's visit to Tunisia, Turki, who had been studying in France, was returning home to exhibit at the Salon Tunis. In Paris he had become close to Albert Marquet, among other artists, whose late-1920s painting *The Pont Neuf in the snow*, acquired by the Art Gallery from the aforementioned *Herald* exhibition, would have been executed at the time of their friendship. Whether Turki attended Lhote's lecture in Tunis is a matter of speculation, but the correspondences between the Frenchman's *House in Tunis* and the Tunisian's *The blue door Sidi Bou Said*, both painted in Sidi Bou Said in 1929, are plainly apparent. Their subjects, colouration and composition bear striking similarities. Unsurprisingly, however, Turki's painting betrays a deep sense of connection to the site and reveals the artist's desire to synthesise modernist principles with his deep knowledge of and sensitivity to Arabic culture. Through paintings like this, Turki asserted a modern North African identity within a colonial context and laid the foundations for the

Yahia Turki *The blue door Sidi Bou Said* 1929

Nicholas Chambers

establishment of the École de Tunis – a centre for North African modern art of which he became president following Tunisia's declaration of independence in 1956.

The year 1929 was also a turning point for Crowley. Her painting *Portrait of Lucie Beynis* 1929 (see p 149), installed adjacent to the works by Lhote and Turki, was executed shortly before she returned to Sydney, where she would soon establish a new art school influenced by the ideas encountered in the cosmopolitan environment of Lhote's academy.[12] Installed together, these three works from 1929 by a Frenchman, a Tunisian and an Australian present a picture of early modern art as a complex and mobile field of practice. They help to develop a picture of modernism not only as a remarkable set of formal innovations but also as a platform for international dialogue and exchange.

New narratives for the late modern
The new installation of the late-twentieth-century collection galleries downstairs begins, predictably enough, with a group of colourful abstract paintings. Among the various strands of 1960s and 1970s abstraction in Australia, two narratives loom large: one relating to the exhibition *The Field*, which in 1968 surveyed early-career Australian artists working in the international idiom of colour field painting and geometric abstraction;[13] and the other concerning the establishment of the Papunya Tula Artists cooperative in 1972, which saw the adaptation of ancient, sacred designs for the medium of acrylic paint on canvas.[14] Considered retrospectively, it is easy to regard their approximate coincidence as a metaphorical handing-over of the baton – of 1968 representing the zenith of modernist abstraction in Australia, and 1972 heralding the arrival of a new story of Australian art that would become the nation's most successful artistic export, ever. As art historian Charles Green put it, 'the global lineage of abstract painting was at this moment about to shift, unseen, from New York to Central Australia'.[15]

The differences between these two approaches to painting are manifold. It is arguable, however, that they are most profound not in the works themselves, nor in the motivations of the artists, but in the discourses that surround them. In the case of high modern abstraction, the dominant discourse privileged formal innovation, medium specificity and self-reflexivity, while downplaying art's capacity for narrative and its relationship to the world of events, places and people.

The discourse around Australian Western and Central Desert painting, on the other hand, regarded abstraction, place and storytelling as completely entangled. What's more, their entanglement was readily recognised not only by specialists but also by general audiences who took it as a given that the non-figurative images made by Aboriginal artists were the carriers of stories. A pointed illustration of these contrasting discourses can be found in Anmatyerr artist Emily Kame Kngwarreye's encounter, at the Art Gallery, with a work by Australian abstract painter Tony Tuckson.

When Kngwarreye was shown the work, it was explained in relation to its formal qualities, with her guide pointing out 'Tuckson's painting process and his interest in mark-making and action painting, hoping she would see some connection. Kngwarreye responded in language: "Oh poor fella, he got no story. No dreaming."[16]

What we should take from this anecdote is not the absence of story in late modern abstraction but, rather, its omission from the conventional discourses. It is often the case, in fact, that artists resisted the reductive nature of formalist discussions of their works by using allusive titles that evoked other places and times. For example, the titles of Frank Stella's *Khurasan Gate variation II* 1970 (see pp 154–55) and Sydney Ball's *Transoxiana* 1967, exemplars of late modern hard-edge abstraction and installed adjacent to each other in the galleries, transport viewers to Iran and Central Asia. Their arrangements of curved and straight bands of colour evoke the decorative patterns of Islamic design, while their titles invoke the ancient names of regions lying either side of the river Amu Darya: Khurasan to the west (encompassing parts of present-day Iran and Turkmenistan), and Transoxiana to the east (encompassing present-day Uzbekistan and Tajikistan). This frame of reference for the Stella and Ball is underlined in the galleries by their juxtaposition

Kamrooz Aram *Nocturne 3 (departing nocturne)* 2019

with a painting by contemporary Iranian artist Kamrooz Aram. In his *Nocturne 3 (departing nocturne)* 2019 (see p 153), an underlying grid nods to the legacy of American formalist abstraction while also providing a compositional scaffold for a series of curved forms that variously echo written Farsi, the ornamentation of Persian architecture and the reach of the artist's arm. Together, the three works prompt reflection on processes of homage, inspiration and appropriation between the East and West, contemporary and historical.

Elsewhere in these galleries, we find William Turnbull's *8-1965* 1965, a green monochrome divided vertically by a wavy, hard-edge stripe. Turnbull's title, which matter-of-factly tells us that it was the eighth painting he created that year, would appear to place the work firmly within a self-reflexive late modern framework. There are, however, additional interpretative layers that can be surfaced and which are animated by the work's juxtaposition with paintings by Papunya Tula artists Timmy Payungka Tjapangati, Kaapa Tjampitjinpa and Charlie Tjungurrayi – works in which we can readily infer a relationship to the lands of the Western Desert. An opening is created through this juxtaposition to privilege a story related by Turnbull's son,[17] who described the painting's dense field of green in relation to a topographic view of Southeast Asia, with

Frank Stella *Khurasan Gate variation II* 1970

Between here and there

the wavy stripe representing a river meandering through dense forest. What's more, this reading of the work relates to the artist's experiences as a pilot and his flights over Southeast Asia with his wife, Singaporean artist Kim Lim, whose work also features in the twentieth-century galleries. What this example illustrates, along with the Stella and Ball, is the multivalence of late modern abstraction wherein resolutely non-representational formal considerations are able to coexist with an interest in places, people and narrative.

From here

One of the most profound stories of artistic influence in the Art Gallery's collections is between the work of American conceptual artist Sol LeWitt and Australian Central Desert painting. Thanks to the gift of the John Kaldor Family Collection, the Art Gallery holds 34 works by LeWitt, spanning 1969 to 2003, making it one of the most important museum collections of his work anywhere in the world. LeWitt first visited Australia in 1977 to produce Project 6 in the Kaldor Public Art Project series in Sydney and Melbourne, and returned for a second project in 1998, Project 11, just in Sydney. On that second visit he encountered the work of Kngwarreye and began to collect works by her and fellow Anmatyerr artist Gloria Petyarre, swapping acquisitions made on his behalf by Kaldor for his own works

on paper. The correspondences between Central Desert painting and LeWitt's so-called 'loopy-doopy' and 'tangled bands' works from the late 1990s are striking and were openly acknowledged by LeWitt, who wrote to Kaldor after receiving a new work by Kngwarreye: 'I feel a great affinity for her work and have learned a lot from her work.'[18] The connections were also reportedly noted by Kngwarreye who asked, after encountering LeWitt's work of the late 1990s, why *he* painted like *her*.[19]

In the Art Gallery's 2014 LeWitt survey, *Your Mind Is Exactly at That Line*,[20] it was a display juxtaposing works by LeWitt, Kngwarreye and Petyarre that garnered the most critical discussion. It demonstrated the ways in which the appreciation of a canonical international artist, one studied by undergraduate art-history students worldwide, can be substantially altered through its relationship to the local. We learn, in revisiting that exhibition, that a work by LeWitt is able to signify something quite different in Sydney than it might in New York, London or Tokyo.

The new collection displays, as part of the Sydney Modern Project, aim to foreground and animate exactly these kinds of generative intersections between works of art from different times and places, and to develop an understanding of how our place informs our regard for the rest of the world. It is an approach to display that, above all else, follows the lead of artists, whose diverse perspectives transcend borders and relate complex, open-spirited and international stories of art.

View of the twentieth-century galleries, featuring (from left) Kaapa Tjampitjinpa *Wartunuma (Flying ants)* 1977, Michael Johnson *Anna* 1965 and William Turnbull *8-1965* 1965

Between here and there

1 *National Art Gallery of New South Wales illustrated catalogue*, AGNSW, Sydney, 1926, p 2.

2 Tayou, it should be noted, curated an exhibition at the Art Gallery in 2000: *Fun Five Fun Story: Five International Artists from Africa*, organised by Tony Bond.

3 See Édouard Glissant (translated by Betsy Wing), *Poetics of relation*, University of Michigan Press, Ann Arbor, 1997.

4 For example, *Untitled (FS)* 2016 in the Art Gallery's collection is derived from a photograph of two Indigenous Australians. Boyd's reworking of the image, which he found in an institutional archive, imbues it with a sense of intimacy and foregrounds his personal connection to the land depicted.

5 Kent Monkman, email to the author, 1 Nov 2019.

6 Kent Monkman, cited in Dakshana Bascaramurty, 'The modern touch of an old master', *Globe and Mail* (Toronto), 1 Dec 2017, theglobeandmail.com/arts/inside-the-process-behind-kent-monkmans-art/article37126241, accessed 23 Feb 2022.

7 *Society of Artists Annual Exhibition*, Education Department Gallery, Sydney, 6 Sep – 4 Oct 1935.

8 See Eileen Chanin and Steven Miller, *Degenerates and perverts: The 1939 Herald exhibition of French and British contemporary art*, The Miegunyah Press, Melbourne, 2005.

9 One of the more experimental French works in this exhibition, Fernand Léger's *The bicycle* 1930, was purchased by Dr HV Evatt and donated to the Art Gallery in 1966 by Mrs HV Evatt in her late husband's memory.

10 These international acquisitions also laid the groundwork for more ambitious and strategic purchases that would follow with the support of donors. Particularly notable are the establishment of the Mervyn Horton Bequest and the Art Gallery of New South Wales Foundation in 1983.

11 For example, André Lhote's work was not included in the Centre Pompidou's 2018 survey of the cubist movement, *Le Cubisme*, 17 Oct 2018 – 25 Feb 2019.

12 In 1932, Crowley established the Crowley–Fizelle School with fellow artist Rah Fizelle. The school closed in 1937.

13 *The Field* was one of the inaugural exhibitions at the National Gallery of Victoria's St Kilda Road building, where it was displayed from 27 April until 26 August 1968. It subsequently toured to the Art Gallery of New South Wales where it was displayed from 30 October until 24 November 1968. It is also notable that in May 1968, American critic Clement Greenberg visited Australia to give the inaugural John Power Lecture in Contemporary Art at the University of Sydney.

14 The Papunya Tula Artists cooperative was organised and run by Aboriginal artists. It was Australia's first Aboriginal arts company.

15 Charles Green, 'The discursive field: home is where the heart is', *Fieldwork: Australian art 1966–2002*, National Gallery of Victoria, Melbourne, 2002, p 12.

16 Margo Neale, 'Emily Kame Kngwarreye: the impossible modernist', *Artlink*, vol 37, no 2, Jun 2017, viewed online 31 Jun 2021.

17 Johnny Turnbull, conversation with the author, 26 May 2020.

18 Sol LeWitt, fax to John Kaldor, 7 Jun 2001.

19 Neale 2017, in *Artlink*.

20 Curated by Natasha Bullock, *Your Mind Is Exactly at That Line* brought together works by LeWitt donated to the Art Gallery by John Kaldor with additional loans from the LeWitt estate.

Nicholas Chambers

From here, south is north:
Asian art in Sydney

Melanie Eastburn

'Without being Australia-centric, how should we consider
the objects from this vantage point, where South and
Southeast Asia are north and what was once termed the
Far East is geographically near?'

It is the shift in our own vantage point that changes the way we see the world.

—Reena Saini Kallat, 2020[1]

IN EDO (TOKYO) IN 1866, TSUKIOKA YOSHITOSHI designed the only known Japanese print of the period to show what is almost certainly Sydney.[2] His vision is one of neoclassical and Georgian architecture under an expanse of blue sky, horse-drawn carriages, excited children, a Chinese man, women in Victorian-era dress, and a black ship in the distant harbour. Yoshitoshi never left Japan which, until 1853, had essentially closed itself to international influence for over two hundred years. His sources are unknown, but the image suggests awareness of nineteenth-century migration from China to Australia. Coincidentally, Yoshitoshi's Sydney was imagined during the period leading up to the planning for the Art Gallery of New South Wales, which now stands as a neoclassical structure by the harbour.

Also thinking about the southern hemisphere, in 2018 Reena Saini Kallat worked in her Mumbai studio to create *Woven chronicle*. A monumental map of the world, it uses electrical wires and circuit boards to trace complex threads of human migration, movement and communication. The map is flipped, with Australia towards the top and just right of centre. The orientation relates to *McArthur's universal corrective map of the world*, a subversive south-up map published by Australian Stuart McArthur in 1979. It takes a moment to adjust to the view in *Woven chronicle* but, beyond convention and power, is there any reason the Mercator projection established in the sixteenth century continues to dominate?[3]

From here, south is north

These two works of art, made more than 150 years apart, have consistently come to mind while planning a significant new presentation of the Asian collection at the Art Gallery of New South Wales. The reinstallation encompasses the two levels of the Asian Lantern galleries, with works from the Asian collection also incorporated into displays throughout the original building and exhibitions in the new building designed by Japanese architects SANAA.

For the Asian Lantern galleries, the curatorial team worked with art historian Chaitanya Sambrani from the Australian National University as advisor. The project inspired reflection on the development and interpretations of the collection over time and raised many questions. The Art Gallery now holds over 4200 objects from across Asia – from Indonesia to Mongolia and Japan to Iran. Without being Australia-centric, how should we consider the objects from this vantage point, where South and Southeast Asia are north and what was once termed the Far East is geographically near? Importantly, how can we most engagingly communicate with contemporary audiences through the collection?

Opposite: Tsukioka Yoshitoshi *Picture of the country of New Holland South Wales (Shin Oranda Minami Waruresukoku no zu)* 1866

Above: Reena Saini Kallat *Woven chronicle* 2018

The collection began with a gift of Japanese vessels in bronze, ceramic and cloisonné enamel from the Japanese Commissioners for the 1879 Sydney International Exhibition. Once re-engaged with international trade, Japan's rulers were committed to demonstrating the country's modern sophistication. One avenue was through

international expositions, or world fairs, officially beginning with Vienna in 1873, then Philadelphia in 1876 and Paris in 1878 before Sydney in 1879.[4] International fascination with Japan was intense, as was Japan's interest in the rest of the world.

The social histories, politics and population of Australia today are far removed from those of the 1870s, as is our understanding of Asia. The Asian continent covers about 30 per cent of the world's landmass and is home to over 60 per cent of global population. In contrast, Europe makes up less than 10 per cent of world population and North America under 5 per cent.[5] Through diverse diasporas, the cultures of Asia are spread across the globe. Over 3.5 million Australians out of a population of 25 million identify as having Asian heritage.[6] Asia is everywhere.

While the pace of change has increased, the intricate web of consumer demand, market preferences, manufacturing, greed and international transport networks in today's world are nothing new. Intra-Asian trade flourished long before active European engagement in the region. Its traces survive, for instance, in Indian textiles traded to Egypt in the ninth century, and in the wrecked remains of trade ships carrying ceramics, gold and silver.[7] Every

Matsumoto Hōen *Jar with design of sea creatures* 1870s

From here, south is north

object tells its own story. The Art Gallery's collection includes a dragon-shaped ewer made in Vietnam's Hong River delta in the fifteenth century. It was recovered from a wreck of a ship holding a cargo of more than three hundred thousand ceramics destined for markets across Southeast Asia. The ship had sunk off the coast near Hội An soon after departure.[8]

Closer to Australia, Makassan traders from South Sulawesi in Indonesia are known to have interacted with Aboriginal people of the Kimberley and Arnhem Land in northern Australia for centuries. The traders often spent several months of the year in Australia and Aboriginal people travelled to, and sometimes settled in, Sulawesi. The engagement officially ended in 1906–07 when the Australian Government began to deny the visitors fishing licences, but the connection between the Yolŋu people of north-east Arnhem Land and the Makassan people continues, including in art.[9] A history of recording these stories continues into the twenty-first century in works such as the 2006 linocut *The Macassan prahu* by Dhuwarrwarr Marika from Yirrkala in north-east Arnhem Land. The print shows a ship with large sails, people on deck and a cargo loaded with trepang (sea cucumbers), rice and weapons.[10]

Vietnam, Hội An
Dragon ewer mid 1400s

Melanie Eastburn

Just as people, things and ideas have never stayed still, an object's journey is not complete once it enters a museum collection. The ways objects are interpreted, valued and shown continue to change according to research and display contexts. New presentations from the Asian collections across the Art Gallery's expanded campus demonstrate the dynamic potential of inanimate things enriched by layers of storytelling in diverse voices, especially those of artists. In the words of art historian Kavita Singh, 'a museum is not a lack of context, it is another context, and it is our context for our encounter with works of art'.[11]

Formative collecting and exhibitions

It is often assumed that little happened in Asian art at the Art Gallery of New South Wales in the years between the Sydney International Exhibition in 1879 and the 1978 appointment as director of Edmund Capon, an English specialist in Chinese art with a passion for the arts of Asia. A review of that century, however, reveals that there were very few years without Asian acquisitions or exhibitions. Although early collecting and exhibitions tended to arise through opportunity rather than planning, in retrospect some have proved pertinent.[12]

In line with values and tastes of the period, early additions to the collection established the Art Gallery's focus on art from Japan and China. Gifts include a gold lacquer Japanese vase inlaid with blossoms in mother-of-pearl, presented in 1902 by Henry C Dangar, who was on the council of the Art Gallery's precursor, the Academy of Art, and a large gilt-bronze Chinese figure of a Ming dynasty Buddhist guardian from Australian naval Captain Francis Hixson in 1905. The sculpture is believed to have been souvenired in Peking (Beijing) in 1900 and given to Hixson. Looting of objects during times of conflict was common at the time but now raises strong ethical concerns around the circumstances of the sculpture's procurement in China.[13]

Other important additions came in the form of collections amassed by naval captain GW Eedy (c1865–1921) in 1921; Charles Binnie (1864–1946), who gave more than ninety Japanese and Chinese ceramics between 1924 and 1939; and Sydney Cooper (d1980), who in 1962 gave 162 Chinese ceramics and ink paintings.[14] Between 1961 and 2003 a further 145 objects, mostly ceramics, were donated from the collection of John Hepburn Myrtle (1911–86). A mechanical engineer with a passion for art, Myrtle was an honorary advisor on the Cooper collection, later serving on the Art Gallery's Board of Trustees (1963–76) and curating exhibitions of Chinese ceramics at the Art Gallery.[15] Objects from each of these formative gifts have a strong presence in the Asian Lantern galleries and across the campus, including in the new building, where strategic inclusions of historical art add depth and richness to presentations of contemporary art.

The Art Gallery also made occasional purchases. These include a gilded Thai Buddha from Sydney collector GJE Fombertaux in 1948, and in 1959 a group of Indian nineteenth-century Kalighat folk paintings, formerly owned by the Australian artist Hans Heysen.[16]

This purchase followed the Art Gallery's first donation of Indian art the previous year, a group of 1770s souvenir paintings believed to have been commissioned by Warren Hastings, a colonial administrator of Bengal and its first *de facto* governor-general.[17] These paintings, along with a Japanese bronze kangaroo made around 1900 and a watercolour of an emu painted in the Malay Peninsula about 1807, are among several eclectic works from the Asian collection included in the rehang of nineteenth-century art in the Grand Courts.[18]

From the 1940s to the 1970s, the Art Gallery hosted more than thirty exhibitions of Asian art. Most toured multiple venues, and many were remarkably timely. They included modern Japanese prints in 1946, just after the end of the Second World War; drawings by the Nobel Prize–winning Indian poet and philosopher Rabindranath Tagore (1861–1941) in 1947, the year of Indian independence; and *Chinese painting* in 1949, the year the People's Republic of China was declared. The 1950s saw twelve exhibitions of Asian art, among them two of Persian miniatures (1950 and 1957), three of Indian painting (1952, 1954 and 1959), and in 1958 a presentation of the Hiroshima panels painted by Maruki Iri and Akamatsu Toshiko in response to the United States bombing of Hiroshima on 6 August 1945.[19] Asian art exhibitions continued through the 1960s, with subjects spanning New Year folk prints from Vietnam and China, Indian paintings, Japanese prints, and the ceramics of Hamada Shōji and Bernard Leach, influential potters whose sustained intellectual exchange is particularly celebrated in Japan. International exhibitions were also presented, such as *Oriental Rugs from the Victoria and Albert Museum* (1964) and *5000 Years of Pakistan Art and Archaeology* (1969).

In 1977 the Art Gallery was among a number of state art museums to host Australia's inaugural Asian art blockbuster *The Chinese Exhibition: A Selection of Recent Archaeological Finds of The People's Republic of China*. The show, organised by the Australian Art Exhibitions Corporation and the Australia Council of the Arts with the support of Hepburn Myrtle, attracted 595,000 visitors across the country. It marked a beginning for the Art Gallery as one of few Australian institutions to regularly support the development, presentation and promotion of exhibitions of Asian art, especially ticketed shows in the popular summer period. Capon, who had been involved in planning *The Chinese Exhibition* from his base in London before being appointed director in 1978, was quick to curate a second Chinese blockbuster, *Qin Shihuang: Terracotta Warriors and Horses*. Unearthed in Xian in 1974, the sculptures were shown, for the first time outside China, at venues across Australia in 1982 and 1983. In Sydney alone, the exhibition attracted over 200,000 visitors.[20]

Subsequent major exhibitions generated by the Art Gallery include *Dancing to the Flute: Music and Dance in Indian Art* (1997), *Modern Boy, Modern Girl: Modernity in Japanese Art* (1998), *Buddha: Radiant Awakening* (2001), *Goddess: Divine Energy* (2006), *Kamisaka Sekka: Dawn of Modern Japanese Design* (2012), *Tang: Treasures from the Silk Road Capital* (2016), *Passion and Procession: Art of the Philippines* (2017) and, most recently, *Japan Supernatural* (2019).

Part of the Sydney International Art Series held each summer since 2010, *Japan Supernatural* attracted much the same number of visitors as those of the previous two years: *Rembrandt and the Dutch Golden Age: Masterpieces from the Rijksmuseum* 2017 and *Masters of Modern Art from the Hermitage* 2018. Crucially, more than half the visitors to *Japan Supernatural* were under the age of thirty-five, a demographic that the Art Gallery, along with many other art museums, has often found difficult to attract. The exhibition presented over 180 works of art from collections worldwide around the theme of the paranormal in Japanese art from the 1770s to now.

Japan Supernatural brought to life tales and representations of supernatural beings, in particular *yūrei* (ghosts) and *yōkai* (animate beings, from shapeshifting animals to household objects). Through narrative rather than chronology, the exhibition followed threads of connection from books and paintings of centuries past to contemporary sculptures and video, all drawing on the same stories and iconographical traditions. Works by some of the most admired artists of Japan's past, including Toriyama Sekien, Katsushika Hokusai, Utagawa Kuniyoshi, Tsukioka Yoshitoshi and Kawanabe Kyōsai, were shown alongside those by contemporary artists Chiho Aoshima, Fuyuko Matsui, Tabaimo, Miwa Yanagi, Yamamoto Tarō, Hideta Kitazawa, Mizuki Shigeru and Takashi Murakami. Murakami's vast painting *Japan Supernatural: Vertiginous After Staring at the Empty World Too Intensely, I Found Myself Trapped in the Realm of Lurking Ghosts and Monsters* 2019 was commissioned for the exhibition. Reflecting the artist's knowledge of Japanese art history, it derived its characters from Edo period handscrolls and woodblock prints of warriors and *yōkai* by Kuniyoshi and Utagawa Kunisada/Toyokuni III.

The project built on a legacy established with the *Buddha: Radiant Awakening* exhibition, signalling an increasing focus on community engagement and connections across media and time that is vital to our approach in the refreshed Asian Lantern galleries. Exhibition wall labels were in Japanese and English and the audio experience, also in both languages, incorporated music composed and performed by Australian-based musicians with Japanese heritage. The redisplay of the Asian Lantern galleries and opening of the Sydney Modern Project building give us further opportunities to present Asian art in new contexts relevant to diverse audiences, and to engage Asia-literate communities with displays of collection works across media and millennia.

Reconsidering the Asian galleries

The first Asian gallery at the Art Gallery of New South Wales opened in 1972 as part of the building extension designed by Andrew Andersons. A sleek modernist space located on the Art Gallery's upper level, it housed an assortment of historical and contemporary art from across Asia. A 1970s photograph of the gallery shows a painting on the back wall, *The beast*, which had been created by Teshigahara Sōfū in a 1976 performance at the Art Gallery; and a

Ming dynasty gilded figure of a Chinese Buddhist guardian in the centre of the space. Showcases on either side displayed objects including Chinese and Japanese ceramics, a Thai sculpture of the Buddha purchased in 1948, and a Gandharan hunting frieze donated to the Art Gallery by Aslam Malik, then High Commissioner for Pakistan.

A new gallery designed especially for Asian art opened in 1990. Designed by Esther and Trevor Hayter as part of the 1988 Australian Bicentenary extensions also led by Andersons, it features extensive use of timber, sympathetically proportioned spaces and ample showcases for scrolls, screens and ceramics, as well as a functioning tearoom provided by Japan's Idemitsu Foundation. Reflecting the strengths of the collection, the gallery was initially divided into the Kenneth and Yasuko Myer Gallery of Japanese Art, and the Edward and Goldie Sternberg Gallery of Chinese Art. Although together Chinese and Japanese art still represent about three quarters of the collection, exhibitions and acquisitions of art from South and Southeast Asia increased significantly in the 1990s and 2000s.[21]

Takashi Murakami at the *Japan Supernatural* exhibition with his painting *Japan Supernatural: Vertiginous After Staring at the Empty World Too Intensely, I Found Myself Trapped in the Realm of Lurking Ghosts and Monsters* 2019

In 2003, to accommodate the expanded collections and commitment to Asian art, a second gallery opened above the 1990 space. It was designed by Richard Johnson to show bronze, stone and ceramic objects from the South and Southeast Asian

Melanie Eastburn

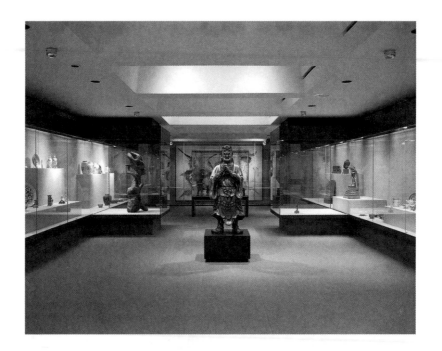

Top: The first Asian gallery at the Art Gallery of New South Wales in the 1972 extension designed by Andrew Andersons

Above: Art Gallery sponsors Kenneth and Yasuko Myer at the *Celebrity Choice* exhibition in 1983 with one of their favourite items in the collection, Maruyama Ōkyo's *Cranes* c1770

collections around its light-filled perimeter and host temporary exhibitions within. With an exterior of white glass panels linked by stylised lotus flowers in steel, the structure floats above the earlier gallery like a lantern, which now gives our two-level space for Asian art its name. The two Asian galleries are joined by a staircase with a window overlooking an impressive Moreton Bay fig tree.

The arrival of Michael Brand, a specialist in Indian art, as director in 2011 brought a fresh perspective to the institution and its collections. In a shift from almost twenty-five years of categorising displays according to geography and chronology, he championed *Conversations through the Asian Collections* (2014–16). Across both the upper and lower Asian Lantern galleries, the exhibition placed contemporary art in conversation with historical objects, showing visual connections between past and present. Subsequent exhibitions drawing on the depth and breadth of the collection include *Beyond Words: Calligraphic Traditions of Asia* (2016–17), *Glorious: Earthly Pleasures and Heavenly Realms* (2017–19), *In One Drop of Water* (2019–21) and *The Way We Eat* (2021–22).

For the Sydney Modern Project redisplay spanning both Asian Lantern galleries we built on those focused exhibitions, bringing together historical and contemporary objects from across the holdings. The spaces are considered in terms of the bodily (lower) and philosophical (upper) realms, recognising that the two are intertwined. The organising principle of the lower gallery is the concept of a world comprising five basic elements. These vary between cultures but include earth, water, fire, wood and metal in a Chinese context and earth, water, fire, wind and space in a South Asian setting. In the upper gallery, philosophical or political concerns permeate the works on display. These realms of the body and mind are connected through the reopened stairway which will be enlivened by commissioned works. The tearoom too is invigorated by a series of installations from the collection, and by invited artists.

The two levels incorporate a sense of movement through time – cyclical rather than linear, a culturally appropriate temporality – acknowledging the diversity of Asian culture and highlighting innovation alongside links between the past and contemporary worlds. The architectural integrity of each space has been retained, with adaptations made to ensure greater environmental control for the protection of vulnerable materials and to enable the display of a broader range of works from the collection – from time-based art and large installations to folding screens, prints and ceramics.

The works of art displayed present multiple histories and perceptions of time. These emphasise historical flashpoints and moments of significant change to the people and cultures involved, rather than according to a Gregorian calendar or what is often described as a Western hierarchy of world events.[22] The collection has deep holdings to support this conceptual framework, from historical Indian paintings and Japanese prints and ceramics made for trade to works by contemporary artists including Yasumasa

Morimura, Dadang Christanto, Eko Nugroho, FX Harsono, Xiao Lu, Guan Wei, Nalini Malani and Dinh Q Lê.

For the initial presentation, the centre of the upper gallery is wrapped in Jitish Kallat's *Public notice 2* 2007 (see p 24). This work marks a moment in March 1930 when Mahatma Gandhi gave his famous speech about salt tax as a symbol of the oppressive British Empire, but vitally about commitment to achieving change without violence. Against rich yellow walls, letter by letter, Gandhi's words are cast in bone-shaped resin for our sustained review.[23]

Similarly bringing historical events into the present through reflection are the works of two artists who migrated to Australia, Dadang Christanto from Indonesia and Xiao Lu from China. Christanto's *They give evidence* 1996–97 was originally exhibited as the central installation for the opening of the upper Asian Lantern gallery in 2003. It presents sixteen larger-than-life-size naked figures cradling the clothing of loved ones, much of which is made of batik-patterned cloth. Though the installation references widespread suffering and injustice, it is also personal – the artist's mother and grandmother were batik sellers; his father was abducted during Indonesia's anti-Communist purges of 1965–66 and never returned.[24]

Xiao Lu was among the artists who relocated to Australia in the aftermath of the Tiananmen Square massacre of 4 June 1989, changing the trajectory of contemporary art in Australia.[25] In her series *15 gunshots … from 1989 to 2003*, she presents framed photographs of herself holding a gun to the camera. To complete the work, Xiao Lu then shot at the framed images, puncturing the glass in reference to a performance at the *China Avant-Garde* exhibition in Beijing in February 1989, in which she had shot at a work created with

Xiao Lu *15 gunshots …
from 1989 to 2003*
2003, printed 2018

From here, south is north

her collaborator Tang Song. The exhibition was closed and the artists arrested. According to the critic Li Xianting, 'the fate of the exhibition was a precursor to the fate of the student movement at Tiananmen, marking the conclusion of an era's ideals.'[26] The work is equally relevant in the contexts of international contemporary art, Australian art and Asian art and has been included in the twentieth-century art displays curated by Nicholas Chambers.

Also vital are works by artists commissioned for the Sydney Modern Project. Among these are Japanese artist Yayoi Kusama's *Flowers that bloom in the cosmos* 2022 and Taiwanese–American artist Lee Mingwei's *Spirit House* 2022. Kusama's work comprises three vivid blooms located on an outdoor terrace overlooking Woolloomooloo and visible on entering the new building. In contrast, Lee's *Spirit House* is a space for reflection and gratitude, softly lit and built into a garden wall to be discovered almost by chance. Inside, a bronze Buddha created by treasured sculptor Huang Hsin Chung sits in meditation.

The presence of Asian art is pivotal across the Art Gallery's entire campus as part of the Sydney Modern Project transformation but finds its clearest voice in the intricate stories shared across the two levels of the Asian Lantern galleries. From here, where south is north.

Notes

1 'The view from Mumbai: a conversation with artist Reena Kallat', *Together In Art*, AGNSW, 22 Jun 2020, togetherinart.org/the-view-from-mumbai-a-conversation-with-artist-reena-kallat

2 The print is inscribed 'Picture of South Wales, New Holland', using an old European name for Australia, New Holland.

3 *Woven chronicle* was commissioned for *Fearless* at AGNSW (2018–19), an exhibition of contemporary art by South Asian women. For McArthur's map, see mapdesign. icaci.org/2014/02/mapcarte-38365-mcarthurs-universal-corrective-map-of-the-world-stuart-mcarthur-1979

4 Angus Lockyer, 'Japanese and international exhibitions, 1862–1910', in Ayako Hotta-Lister & Ian Hill Nish (eds), *Commerce and culture at the 1910 Japan–British exhibition: centenary perspectives*, Global Oriental, Leiden/Boston, 2013, pp 27–34.

5 'World population prospects 2019', United Nations, population. un.org/wpp

6 'Cultural diversity in Australia', Australian Bureau of Statistics, 2016, https://www.abs. gov.au/ausstats/abs@.nsf/ Lookup/2071.0main+features302016; 'A forgotten advantage: enabling Australia's Asian-Australian and diaspora communities', *Asia Taskforce Discussion Paper*, no 3, Oct 2020, asiasociety.org/ sites/default/files/inline-files/ Asia_Taskforce_Discussion_Paper_3_ Asian-Australian_Diaspora.pdf

7 Natali Pearson, 'Shipwrecked? The ethics of underwater cultural heritage in Indonesia', *TAASA Review: The Journal of the Asian Arts Society of Australia*, Jun 2016, pp 10–11.

8 Following the wreck's rediscovery in the mid 1990s, it was officially excavated later the same decade. All unique objects and a selection of representative types were kept for museums in Vietnam. The remainder was sold at auction in San Francisco with proceeds divided between the Vietnamese Government and the two salvage companies engaged in the excavation. The Art Gallery purchased one of three dragon ewers auctioned (the other two went to the British Museum).

9 See J Bennett (ed), *Crescent moon: Islamic art and civilisation in Southeast Asia*, Art Gallery of South Australia, Adelaide, 2006; Marshall Clark & Sally K May (eds), *Macassan history and heritage: journeys, encounters and influences*, ANU E Press, 2013, press-files.anu.edu.au/ downloads/press/p241301/html

10 For further information and an image of this print, see artgallery.nsw.gov.au/collection/ works/204.2007.5

11 Kavita Singh, 'For a place like India, art history is an urgent necessity', video lecture, posted 16 Jan 2019, youtube.com/ watch?v=BuHmYQC3Y2g

12 In addition to the Japanese vessels, more than thirty paintings, drawings and sculptures shown in the Sydney International Exhibition are now in the AGNSW collection.

13 Hixson was in command of the 1900–01 New South Wales Naval Brigade contingent to China but stayed in Hong Kong due to his age. The sculpture was taken from what was described as the Palace of Ten Thousand Years. Although the gift of the sculpture was legal at the time, under current ethical guidelines it would not have been accepted by the Art Gallery. This is indicative of a significant shift in approaches to collecting, especially in the last decade. See Lucie Folan and Natalie Seiz, 'Art crime and its aftermath: Australia's response to the Subhash Kapoor cases', *TAASA Review: The Journal of the Asian Arts Society of Australia*, Jun 2016, pp 4–7.

14 *Catalogue of the Eedy collection: to be sold by auction by James R. Lawson, James R Lawson*, Sydney, 1921. pp 57–76.

15 John Myrtle, 'Myrtle, John Hepburn (1911–1998)', People Australia, 2018, peopleaustralia. anu.edu.au/biography/myrtle-john-hepburn-31590; Jackie Menzies, 'Myrtle, John Hepburn (1911–1998)', orig pub in *Australian*, 3 Feb 1998, p 17, Obituaries Australia, oa.anu. edu.au/obituary/myrtle-john-hepburn-31590

16 Kate Brittlebank, 'Unexpected connections: an Australian Kalighat album reunited', *TAASA Review: The Journal of the Asian Arts Society of Australia*, June 2006, pp 4–5. The paintings were collected in India by Lucy Kealley Thompson, who worked in India from 1890 to 1913 and bought the paintings in Kolkata (Calcutta).

17 Fifteen of the pictures were donated by George Sandwith in 1957 and a further two from the same collection in 2008. Sandwith acquired the paintings in 1939.

18 The representation of exotic animals has a long history in Asian art. For instance, the Mughal emperor Jahangir (r1605–27) requested the artist Mansur to illustrate a North American turkey in his care, while in China the Qianglong emperor (1711–99) kept and recorded cassowaries, referred to as *emo*, from the Indonesian word *emeu*. See Yu-Chih Lai, 'Images, knowledge and empire: depicting cassowaries in the Qing court', *The Journal of Transcultural Studies*, vol 4, no 1, 2013, pp 7–100, doi.org/10.11588/ts.2013.1.10769

19 Barbara Hartley, 'The Hiroshima Panels are a remarkable artistic exploration of trauma', *The Conversation*, 4 Aug 2021, theconversation.com/the-hiroshima-panels-are-a-remarkable-artistic-exploration-of-trauma-164333

20 Caroline Turner, 'International exhibitions', National Museums Australia, nma.gov.au/research/understanding-museums/CTurner_2011.html; Katherine Russell, 'An immersive experience: innovative Asian art exhibitions in Australia', *TAASA Review: The Journal of the Asian Arts Society of Australia*, Dec 2011.

21 Many South Asian acquisitions were recommended by Pratapaditya Pal, a scholar and curator of South Asian and Himalayan art who had worked at the Museum of Fine Arts, Boston, the Los Angeles County Museum of Art, the Art Institute of Chicago and the Norton Simon Museum of Art.

22 How can we so comfortably continue to use 'Western' as shorthand when we would not consider using what was for so long its counterpart, 'Eastern', to categorise any kind of philosophical thinking or cultural coherence? 'Euramerican' was popular for a time, particularly in the 1990s, but it again is a simplification that doesn't take into account the intricacies of the world as it is now, or has always been.

23 Mahatma Gandhi, 'On the eve of Dandi March', transcript of speech, Ahmedabad, India, 11 Mar 1930, Mahatma Gandhi's writings, philosophy, audio, video & photographs, mkgandhi.org/speeches/dandi_march.htm. For details of the work see Chaitanya Sambrani, 'Of bones and salt: Jitish Kallat's *Public notice 2*' in *Jitish Kallat: public notice 2*, exh cat, AGNSW, Sydney, 2015.

24 Caroline Turner & Jen Webb, *Art and human rights: contemporary Asian contexts*, Manchester University Press, Manchester, 2016, pp 49–50; Vanessa Van Ooyen, 'Artist interview', in *Dadang Christanto: 1965*, exh cat, QUT Art Museum, Brisbane, 2015, p 55–56.

25 Other artists who migrated to Australia from China in the same period include Shen Jiawei, Guan Wei, Ah Xian, Liu Xiao Xian and Guo Jian.

26 Li Xianting, 'Major trends in the development of contemporary Chinese art', in Nicholas Jose (ed), *Mao goes pop: China post-1989*, exh cat, Museum of Contemporary Art, Sydney, 1993, pp 5–12.

Melanie Eastburn

Self-portrait: women artists and the twentieth-century Australian collection

Wayne Tunnicliffe

'Our displays ... now reinforce the central role of women artists throughout the development of Australian art and reveal how persistent narratives skewed towards the contribution of men are reductive, exclusionary and far less interesting than the actual art scenes of any period.'

THE ART GALLERY'S NEW BUILDING opened with gender parity in the collection and temporary exhibition displays, a commitment to art by women artists that should be the minimum for a twenty-first-century art museum.[1] The focused thinking and collection work for the Sydney Modern Project has also resulted in new approaches to the cultural and social narratives told in the collection displays in the original building. Works by women artists feature in the new exhibitions, notably in the twentieth-century galleries where the collection is most expansive, telling vital histories with women as leaders and central participants.[2] Australian art and international art are exhibited together in the original and new buildings and the art garden that connects them, presenting a vastly improved gender balance within an expansive worldview from the perspective of our remarkable location in Sydney.

The almost doubling of the Art Gallery's exhibition space with the Sydney Modern Project's completion has meant the galleries available for the display of our twentieth-century collection have also doubled. The largest part of the Art Gallery's collection is now exhibited over two floors of the 1972 wing, the modernist galleries immediately to the left of the neoclassical vestibule as you enter the original building. Designed by architect Andrew Andersons in 1968 and opened in 1972, these extensions are newly transformed with the removal of fifty years of incremental changes made to increase display space. Windows onto the surrounding landscape have been unblocked, divided rooms opened up, and sightlines between floors returned. The deliberate contrast between the minimalist architecture, which responded to the light and landscape of the site, and the grandly ornate, enclosed nineteenth-century galleries is heightened through these changes which bring the 1972 wing closer to the architect's original intent.

The Art Gallery's Australian art collection is one of the country's most significant and during the development of the Sydney Modern Project we closely examined it to determine priorities for growth, research, interpretation and display. Gender was one of the most important lenses we applied to guide our future approach, and it magnified the inequality already apparent to anyone visiting the Art Gallery's existing nineteenth- and twentieth-century Australian displays or the collection pages on our website. The statistics speak for themselves: only 18.4 per cent or 4020 of the Art Gallery's 21,895 Australian artworks are by women artists.[3] Of the 2686 Australian artists represented in the collection whose gender is known, 35.6 per cent or 957 are women.[4] These percentages are similar to, and surprisingly sometimes better than, those for most collections across the world that date from the nineteenth century or earlier, reflecting the gender inequality seemingly hardwired into art institutions through their most valuable asset. Greater parity has been achieved in the collection with works made in this century, and 47 per cent or 955 of the 2030 works in the collection made by Australian artists between 2000 and 2020 are by women.[5]

The Art Gallery began collecting art by women artists in the decade after it was founded in 1871, which coincided with rising numbers of professionally trained female artists in Australia.[6] Even though far fewer works by women than by men were acquired, recent research by art historian Lara Nicholls suggests work by women artists was more likely to be collected by the Art Gallery than in most art museums in Australia or the United Kingdom at the time.[7] This reflects the Art Gallery's relatively progressive trustees and their commitment to contemporary art during a time when women artists in Sydney had an active role and could not be ignored. But the works acquired were still a small percentage of what was exhibited. Today we heed the clarion call of art historian Joan Kerr, prompted by her observation of an enduring reality for women artists:

> As history repeatedly tells us, there is nothing new about a flourishing contemporary art scene filled with women. Decade after decade they appear and, with but one or two exceptions, are exiled to oblivion or the 'minor arts'. The moral is clear: past women artists have to be retrieved and reinstated to give their descendants a future.[8]

Joan Kerr's landmark book on women artists, with its numerous contributors, was published in conjunction with the Australia-wide

Tempe Manning
Self-portrait 1939

Violet Teague *Margaret Alice* 1900

Self-portrait: women artists

National Women's Art Exhibition in 1995, celebrating the twentieth anniversary of International Women's Day. The Art Gallery participated by rehanging its displays in the modern, Aboriginal and contemporary art galleries solely with works by women artists, curated by Sandra Byron, Deborah Edwards, Victoria Lynn, Margo Neale and Daphne Wallace.[9] Edwards led the significant reappraisal of the Art Gallery's collection of historical works, including commissioning extended labels from art historians that were often the first research on these works publicly available. This should have heralded a long-term revision of the collection displays and yet many of the featured works subsequently returned to storage when male-dominated art-historical narratives were reinstated.[10] However, this earlier work meant we had a significant base to build on as we began reassessing our collections and displays as the Sydney Modern Project was initiated and developed.

Our response to the Art Gallery's historic collection has focused on retrieval and significant growth. Retrieval has meant again bringing works by women out of storage and conserving, researching, documenting and displaying them publicly, a process accelerated with the complete redisplay of the Australian collections a decade ago.[11] Growth has meant adding many works, introducing new artists to the collection, or building on the holdings of artists we already have. Given the rarity of nineteenth-century art by women on the market and the now ferocious competition for these works, our focus for growth has been on the period 1900 to 1980.[12] Retrieval can be as satisfying as uploading images of works by sixty women artists to our website collection pages whose copyright owners could not yet be traced, giving their art presence while research continues. Growth can be as exciting as securing – from a private collection in New York – Violet Teague's *Margaret Alice* 1900, an exceptional and ambitious portrait of a sportswoman painted at the beginning of the new century which offered greater hope of rights for women as the suffragettes fought for social and political change. Repatriated to Australia, *Margaret Alice* has been a centrepiece of our nineteenth-century galleries since it was purchased in 2017.

Sometimes research on a single work can reveal much about the Art Gallery's history and attitudes to artists in the past. Tempe Manning's *Self-portrait* 1939 (see p 177) arrived at the Art Gallery on loan from a private collection in May 2021 and it was striking how fresh it seemed. The artist, half turned, looks at us as directly, just as she had scrutinised herself in a mirror while painting the work at the onset of the Second World War. Manning portrays herself in shirt and trousers as a confident working artist and modern woman, holding our gaze in an assured and compelling way. *Self-portrait* was first displayed at the Art Gallery in the 1939 Archibald Prize exhibition for portraiture, one of four works entered by Manning at a time when all entries were hung.[13] It was not the winner – that accolade went to Max Meldrum for a darkly tonal and unsurprising portrait of a bewigged male politician.

Meldrum had fiercely criticised the winning portrait the previous year, Norah Heysen's *Mme Elink Schuurman* 1938, the first time a painting by a woman had received the prize. Meldrum's view that women were incapable of being professional artists was extreme even for the period but sadly not unique, and the Art Gallery's trustees clearly listened, awarding the squeaky misogynistic wheel the prize oil the following year.[14] Manning's *Self-portrait* seems a knowing and quietly assertive riposte to the debates over the seriousness and significance of work by women artists. Seven decades later it found its time, when hung in a prime position in the first room of the exhibition curated by Natalie Wilson celebrating the centenary of the Archibald Prize, featured in the national marketing campaign and on the cover of the exhibition book and, most importantly, purchased for the Art Gallery's permanent collection. It has become an ambassador for the hidden history of women participating in the Archibald Prize and joined the two-year tour of the exhibition throughout Australia, reflecting our commitment to making art by women artists more widely available.[15]

A collection is shaped by its exclusions almost as much as by its inclusions and it has been important to understand the parallel history of works not acquired or perceived as no longer required. The Art Gallery has a long history of deaccessioning that has not favoured women artists. Tempe Manning never had the indignity of her work being deaccessioned, as her paintings had not been collected in the first place, despite thirty-four of them having been included in the Art Gallery's Archibald, Wynne and Sulman Prize exhibitions between 1931 and 1955. Her work *Portrait of a boy* c1916 was the first to be purchased, after it was exhibited in 2013 in *Sydney Moderns*, co-curated by Deborah Edwards and Denise Mimmocchi.[16] This painting is a fine example of the post-impressionist experiments in flickering colour and light produced by Antonio Dattilo Rubbo's talented group of students that led the development of modern painting in Sydney. Early modernist works by Manning's fellow students, female and male, such as Grace Cossington Smith, Norah Simpson, Roland Wakelin and Roy de Maistre, were not collected until decades later either.

Cossington Smith, now renowned as one of Australia's great modernist artists, did not have work acquired by the Art Gallery until 1940, when she was in her late forties, and even then this still life of Australian wildflowers in a jug was the 'gift of twenty admirers of the artist's work'.[17] During the 1940s and 1950s, still-life paintings and close-up views of the bush near her home in Sydney's northern suburbs were purchased, but the great 1920s and 1930s scenes of modern metropolitan Sydney did not begin entering our collection until the 1960s, when curator Daniel Thomas brought Cossington Smith's earlier achievements back into the public realm.[18] This culminated in the revelatory *Grace Cossington Smith* survey exhibition Thomas curated for the Art Gallery in 1973.[19] We now have arguably the finest collection of her work, though not the largest at just twenty-six paintings and drawings.[20] We continue to add judiciously to represent Cossington Smith in greater depth and have acquired

Self-portrait: women artists

Grace Cossington Smith
The window 1956

three more works in the past decade, including her major late painting *The window* 1956, one of her greatest room interiors looking out to the garden of her family home in Turramurra.

It is incorrect, though, to assume that the Art Gallery was not purchasing modern works by women artists in the first decades of the twentieth century. Two of the most prominent artists in Sydney, Margaret Preston and Thea Proctor, had forceful personalities that cut through the masculinist miasma at the Art Gallery and were the two most collected women artists in their lifetimes and subsequently. Proctor's work was first purchased in 1912 and nineteen works were acquired by the time of her death in 1966 and another thirty-eight since. Preston's work was first purchased in 1920 and thirty-three works were acquired before she died in 1963 and another eighty-six subsequently. For comparison, their contemporary Elioth Gruner, considered one of Sydney's great landscape painters during this

Wayne Tunnicliffe

period, had twenty works purchased during his admittedly shorter life – he died in 1939 – and we still only hold twenty-five works now. Preston was, however, the only woman the Art Gallery trustees invited to contribute a self-portrait when they commissioned a series 'perpetuating the names of Australian artists who have distinguished themselves in Art'.[21]

Other artists prominent at the time whose works were purchased include Florence Rodway, Janet Cumbrae Stewart and Hilda Rix Nicholas, and we have recently bought more works by all three. Stand-out among these is Rix Nicholas's landscape *Through the gum trees, Toongabbie* c1920, purchased in 2016. Rix Nicholas's career studying and exhibiting in France from 1907 to 1918, with sales to the French government, no doubt impressed the Art Gallery trustees on her return at the conclusion of the First World War, and a French subject oil and three pastel drawings with French or North African subjects were purchased in 1919. *Through the gum trees, Toongabbie* was painted soon after, in Rix Nicholas's Paris-influenced, simplified style, and it travelled to Europe for her well-received Australian life and landscape exhibition in Paris and London in 1925.[22] In the 1920s landscape painting was widely admired as a national art of the highest order, but no Australian landscapes by women artists were added to

Above: Hilda Rix Nicholas
Through the gum trees, Toongabbie c1920

Opposite: Clarice Beckett
Evening, St Kilda Road c1930

Self-portrait: women artists

the Art Gallery's collection in that decade. In an astonishing fact, from the Art Gallery's foundation in 1871 until 1940, only one Australian landscape oil by a female artist was acquired, Jessie Scarvell's brilliantly luminous study of sand dunes and shoreline *The lonely margins of the sea* 1894, donated to the Art Gallery by a benefactor in the year it was painted (see p 115).

Paintings and drawings by Rix Nicholas regularly appear on the market but works by many other female artists rarely or never become available and the mystery remains as to what became of their oeuvre.[23] The finding of more than two thousand paintings by Clarice Beckett in an open-sided farm shed in 1971 is one of the more famous rediscovery stories, though the Art Gallery's exceptional street scene *Evening, St Kilda Road* c1930, purchased in 2013, is one of the rare Beckett's which had been in private hands since it was painted.[24] The largest group of historical works by a woman artist to come into the collection recently is that of Anne Dangar's cubist decorated ceramics of the 1930s and 1940s made at Moly-Sabata, where she lived in France. Previously, the most important Dangar material we held was in our archive: letters, lessons and photographs from Dangar to her friend and fellow artist Grace Crowley in Sydney.[25] They reflected Dangar's vital role communicating her mentor Albert Gleizes's theories on cubism to Crowley, who shared them more broadly through the Crowley–Fizelle art school.[26] After several years of negotiation with the Albert Gleizes Foundation in France, the Art Gallery was able to acquire through purchase and gift twenty of Dangar's most significant ceramics. Supplemented with further purchases, the 'missing modernist' now has exceptional representation in our collection.

Crowley was vitally important in the second wave of modernism in Sydney, leading to pure abstraction in the 1940s. Due to her painting few works and relentless self-editing, there are only a small number of extant paintings and almost all are in public collections. In 2019 we were able to purchase from a long-term supporter of the Art Gallery one of the only abstracts still in private hands, *Abstract painting* 1950, a typically brilliant exercise in colour forms and linear energy fusing Crowley's cubist and constructivist interests. Three years after Crowley's death in 1979, her executor donated a large group of drawings to the Art Gallery. Many were notational but others were more developed and are an important part of her surviving oeuvre. At the time of donation, they were accessioned into our study collection, an offline resource which has proved useful when there has been directorial or trustee hesitation. When the painting was purchased, these drawings were reappraised by curator Anne Ryan and eighteen were given full collection status, enriching our formal representation of Crowley's practice.

With these recent acquisitions building on works already in the collection, the central role of women in developing modernism in Sydney will be amplified in the Art Gallery's new collection displays. The purchase of the Rix Nicholas landscape and other country and coastal depictions by artists including Adelaide Perry and Freda Robertshaw means the participation of women artists in Australia's evolving landscape tradition in the early to mid twentieth century will be apparent in our galleries for the first time. We have added many works by women depicting city life in the first half of the twentieth century. Augmenting Cossington Smith's great Sydney scenes and

Above, from left: Anne Dangar *Plate with cubist designs* c1938

Anne Dangar at work in the studio, 1940s

Opposite: Grace Crowley *Abstract painting* 1950

Self-portrait: women artists

Beckett's painting of St Kilda Road in Melbourne, for example, are works showing city streets and industrial sites by Aletta Lewis, Dorrit Black, Eveline Syme, Nancy Borlase and Ada Plante, among others. The existing collection strengths in still life, interiors and domestic scenes are all explored and include recent acquisitions amplifying the ways in which these subjects were approached and renewed through the century. The significant role of women artists as conduits for international developments in art into Australia – where they were often catalysts for change – is represented through the displays, as is their role in taking knowledge of Australian art out into the world. The inclusion of works by international artists makes the dialogue between Australian and international artists during these decades more readily apparent.

The years after the Second World War are associated with social conservatism and restricted roles for women, yet in the 1940s and 1950s the Art Gallery collected more art by Australian women artists than it had previously, across a wider range of subjects, including landscapes as well as social realist and surrealist works. Conversely, the Art Gallery's most extensive deaccessioning took place in 1946 and 1948 and while more works by men than women were deaccessioned, the percentage of the collection by women disposed of was much higher. Most works sent to auction were late nineteenth century, and it coincided with a simplification of the period's art history to focus on the male artists of the 'Heidelberg School' of

impressionism in Melbourne, and Julian Ashton and his male plein-air acolytes in Sydney. The roll call of women artists whose work was deaccessioned shows the extent of this rewriting of history: Evelyn Chapman, Edith Cusack, Hetty Dymock, Florence Fuller, Alice Hambidge, Millicent Hambidge, Alice Muskett, Alice Norton, Helen Peters, Jane Price, Ellis Rowan, Ethel Stephens and Mary Stoddard. For Dymock, Fuller, Millicent Hambidge, Muskett, Peters and Price these were the only works held in the Art Gallery's collection.[27]

After the Second World War, Australian artists returned to travelling, studying and exhibiting internationally. The still little-known Mary Webb had a career in Paris in the 1950s, where she also increased awareness of Australian abstract painters through advocacy on their behalf. The lyrically painted *art informel* abstraction, *Joie de vivre* 1958, is the most significant surviving work by Webb and it came to our collection in 2011 after rediscovery in Paris where it had been in storage for decades. Like the earlier generation of women in France, Webb was a source of information on international developments for artists in Sydney, including Crowley. Yvonne Audette left for New York in 1952 and then went to Italy in 1955–66, developing a measured abstraction melding the influence of both American and European schools with her own almost calligraphic mark-making and communicating her discoveries back to Australia. The Art Gallery was late to collect her work, acquiring by purchase

Above: Yvonne Audette *Italia benvenuto* 1957

Opposite: The Art Gallery acquired Lesley Dumbrell's *Solstice* 1974 in 2019, twenty years after the purchase of her painting *Spangle* 1977

Self-portrait: women artists

and gift two major paintings from the artist only in 2015. Seeing Audette's *Italia benvenuto* 1957 hang next to John Passmore's *Jumping horse-mackerel* 1959 reminds us of the proximity in their practices at that time and the likely never-to-be-resolved question of who developed this style first. The Art Gallery's strong past allegiance with Passmore may be one reason that Audette's work was collected so late.[28]

One of the most active areas of our collection and display revision is the 1960s and 1970s, which provides the additional reward of often working with artists who are still making and exhibiting. The Art Gallery's exhibition program in the 1970s included important surveys of earlier practitioners Grace Cossington Smith, Grace Crowley, Dorrit Black, Hilda Rix Nicholas and Bessie Gibson, and from the mid 1970s women artists were included in group exhibitions in much greater numbers.[29] The collection still lagged, however, and while high-profile male artists could expect multiple purchases, the Art Gallery tended to buy a single significant work by a female artist that stood in for their entire practice or even for the contribution of women to an art movement. Lesley Dumbrell's *Spangle* 1977 was purchased in 1979 and was often displayed as the only work by a woman in a room of male geometric abstractionists. We are building our holdings across all areas of practice from this period, though how we have approached abstract art and its hybrid variations is indicative, adding works on paper and paintings by Janet Dawson, Lesley Dumbrell, Virginia Cuppaidge, Bridgid McLean, Wendy Paramor, Normana Wight, and Margaret Worth. Many of these feature in our expanded opening displays, bringing greater gender balance to a prominent area of art practice in Australia at the time.

Artists reappraising their own earlier careers are enriching our understanding of this period and a recent example is a series of photographs by Helen Grace taken at the women-only Amazon Acres in northern New South Wales in 1978–80. The ethos of this rural, utopian, anti-capitalist commune was captured in the slogan 'no men, no meat, no machines'. Grace was an active participant rather than an observer and her photographs show an insider's perspective. The sense of optimism and liberation in exploring alternative ways to live in a patriarchal world is captured in Grace's titling of this series after a line in an Emily Dickinson poem 'And awe was all we could feel'. There was no context in which these photographs could be exhibited at the time they were taken, and Grace revisited her own archive and printed them only in 2020, for the exhibition *Friendship as a Way of Life* at UNSW Galleries.[30] As my colleague Isobel Parker Philip has written, 'the history her photographs trace is the history of feminism and queer politics in Australia. ... The photographs, then, appear to us – forty years after they were taken – as an honest and poignant record.'[31] Grace's photographs join the rich history of queer sexuality in the Art Gallery's collection, from Janet Cumbrae Stewart's and Dora Ohlfsen's sensuous female nudes in the early twentieth century when both were in long-term relationships with women, to the activist works that emerge as the lesbian and gay rights movements developed alongside second-wave feminism.

Self-portrait: women artists

Fourth-wave feminism, the #MeToo movement and other recent initiatives utilising social media continue to expose discrimination, highlighting how insidious the devaluing of women in our society remains. This has been reinforced by cultural institutions which have told histories that exclude or diminish the contribution of women and unreasonably value the contribution of men. Over the last ten years, as we prepared for the transformation of the Art Gallery through the Sydney Modern Project, 956 works by 339 women artists have been added to the collection. The earliest is dated 1888 and the most recent commissioned and completed in 2022. With gender parity underpinning our contemporary Australian collection, our focus on retrieval and building our holdings from 1900 to 1980 has allowed us to rewrite the art histories told in our displays from this period. These now reinforce the central role of women artists throughout the development of Australian art and reveal how persistent narratives skewed towards the contribution of men are reductive, exclusionary and far less interesting than the actual art scenes of any period. This revision is not ideology; it is a more truthful representation of the past that allows for a more inclusive and equal future for all of us.

Opposite: Dora Ohlfsen *Woman on a bear skin* 1920

Above: Helen Grace *And awe was all we could feel 11* 1978–80, printed 2020

Wayne Tunnicliffe

1 In this essay and in the AGNSW collection, the gender category 'woman' includes cis and trans women. 'Non-binary' has only recently been included as a gender category and statistics were not available when this essay was written.

2 The new displays also acknowledge the restricted opportunities for women throughout the period this essay covers, which are discussed in depth in the books cited in the bibliography.

3 These statistics were compiled in September 2021 and cover all works with full collection status. The AGNSW's Australian art collection has 21,895 works, with 4020 by women, 17,109 by men, 71 collaborative works by both women and men, and 694 for which the artist's gender is unknown.

4 1729 artists or 64.4 per cent are men.

5 The overall numbers of Australian works acquired continue to be disproportionately by men, because most earlier works coming into the collection – often by donation – continue to be by men. The Art Gallery is actively trying to balance this situation.

6 While there were earlier professional women artists, notably Adelaide Ironside, it was in the fourth quarter of the nineteenth century that women trained in the new art schools, participated in exhibitions, and self-organised for greater opportunities.

7 Lara Nicholls, email to the author, 21 Jan 2022, following previous discussions. Nicholls' extensive research forms the basis of her forthcoming PhD thesis. Due to deaccessioning in the mid twentieth century, the late-nineteenth-century collection no longer reflects the active role of women artists during that period, a point I return to later in this essay.

8 Joan Kerr, 'Introduction' in Joan Kerr (ed), *Heritage, the national women's art book*, Craftsman House, Sydney, 1995, p ix.

9 *Review: Works by Women from the Permanent Collection of the Art Gallery of New South Wales*, AGNSW, 8 Mar – 4 Jun 1995.

10 Edwards primarily curated temporary exhibitions rather than working on the permanent collection displays, which remained the purview of head curator of Australian art Barry Pearce and director Edmund Capon. The significance of the National Women's Art Exhibition in 1995 is discussed in Joanna Mendelssohn, Catherine De Lorenzo, Alison Inglis and Catherine Speck, *Australian art exhibitions: opening our eyes*, Thames and Hudson, Australia, 2018, pp 237–39.

11 Co-curated by Deborah Edwards and Wayne Tunnicliffe in 2012.

12 Our representation of women artists in the collection improved after the appointment of the first curator of contemporary art in 1979. The Aboriginal and Torres Strait Islander art collection is vital to the Art Gallery's identity and the focus for its growth is on supporting contemporary artists and communities and so little retrospective collection-building is undertaken. No works identifiably made by women artists prior to 1980 have come into the collection in the ten years of collection development prior to the completion of the Sydney Modern Project.

13 *Archibald Prize 1939*, AGNSW, 20 Jan – 20 Mar 1940. The Archibald Prize from 1921 to 1945, when all entries were displayed, is notable for the number of women artists who exhibited. The trustees began selecting finalists from 1946 onwards and there is an abrupt decline in the numbers of women artists whose work is displayed, from 26 artists in 1945 to 9 in 1946. These figures are researched but not definitive, as gender statistics were not collected, and the gender of some artists remains unknown.

14 Nora Heysen's painting was also criticised as some felt Mme Schuurman to be a socialite rather than someone 'preferentially distinguished in art, letters, science or politics', as the rules set out. A further subtext to the criticism is likely to have been racist attitudes towards Mme Schuurman's Eurasian background. Meldrum's choice of subject and titling of his work assertively states the type of person he thought distinguished: Hon GJ Bell, CMG, DSO, VD (Speaker, House of Representatives).

15 *Archie 100: A Century of the Archibald Prize* was scheduled for display at the Art Gallery of New South Wales from 5 Jun to 26 September 2021, with a subsequent tour to eight venues throughout Australia. Due to COVID-19 restrictions, the exhibition was open to the public at the Art Gallery only until 25 June. Max Meldrum's 1939 winning portrait was not included.

16 *Sydney Moderns: Art for a New World*, AGNSW, Sydney, 6 Jul – 7 Oct 2013.

17 Grace Cossington Smith, *Wildflowers* 1940, gift of twenty admirers of the artist's work 1940.

18 Thomas was alerted to Cossington Smith's practice by Bernard Smith, as noted in Mendelssohn, De Lorenzo, Inglis and Speck, 2018, pp 227–28.

19 *Grace Cossington Smith*, AGNSW, Sydney, 15 Jun – 15 Jul 1973, and touring.

20 The largest collection, with 123 works, is at the National Gallery of Australia in Canberra. It consists of sixteen paintings and the rest works on paper, including many fascinating sketchbooks. The Art Gallery's collection is twenty-one paintings and five works on paper.

21 AGNSW Board of Trustees, minutes, 24 Jun 1921, p 403, quoting an earlier Trust resolution from 23 Feb 1919. Artists were sporadically invited to contribute self-portraits during the 1920s and 1930s, with ten acquired in this manner. Preston's is the only painting from this group still regularly displayed. Margaret Preston *Self-portrait* 1930, gift of the artist at the request of the trustees 1930. See artgallery.nsw.gov.au/collection/works/937

22 *Exposition de tableaux d'Australie par Mme Hilda Rix Nicholas*, Galerie Georges Petit, Paris, 16–30 Jan 1925, *Hilda Rix Nicholas: Australian Life and Landscape*, Beaux Arts Gallery, London, 8–29 Oct 1925.

23 The estates of women artists have often not been as well-managed as those of male artists for a variety of reasons, including the lower financial value of works and because many women artists did not have a spouse or heirs, though when they did this did not always help.

24 *Evening, St Kilda Road* c1930 has the added rarity of being in its original frame so appears exactly as Beckett presented it.

25 The Crowley archive has been invaluable in providing a context for Dangar's works and some of the ceramics acquired appear in the photographs Dangar sent from France. The National Art Archive at the Art Gallery holds the archives of many women artists as well as gallery owners, critics, curators and academics.

26 Dangar's ceramics were exhibited in Sydney in the 1930s, but none were acquired by the Art Gallery. However, an extensive collection of Australian decorative arts, mostly by women, was built in the early twentieth century, encompassing all media shown at the annual exhibitions of the Society of Arts and Crafts of New South Wales from 1910 to 1934: painted porcelain, leather, metalwork, jewellery, wood carving, pyrography, textiles and needlework. After 1934 collecting in this field effectively ceased. See Deborah Edwards, *Australian decorative arts at the Art Gallery of New South Wales*, exh cat, AGNSW, Sydney, 1991.

27 The Art Gallery kept Julian Ashton's portrait of a young Alice Muskett, while deaccessioning her own work. Florence Fuller's work re-entered the collection when her most significant known early painting *Weary* 1888 was purchased in 2015. We are yet to obtain works by the other artists.

28 Dating Audette's paintings can be complex, with some dates added from memory later, a not uncommon practice with artists who did not date their works when they made them. The two in the Art Gallery's collection have early documentation which suggests the dates ascribed are accurate.

29 The Cossington Smith, Crowley, and Rix Nicholas exhibitions were curated by the Art Gallery; Black and Gibson were touring exhibitions. The inclusion of only three women in *The Field*, a survey of hard-edge abstraction by forty artists curated by John Stringer and Brian Finemore that opened the new National Gallery of Victoria building in 1968 and toured to the Art Gallery of New South Wales, is often cited as an example of the sexism prevalent at the time; another example is the exhibition *Recent Australian Art*, curated by Frances McCarthy and Daniel Thomas for the Art Gallery in 1973, with Ewa Pachucka the only woman among forty-six artists. The situation improved after the significant revisionist exhibition *Australian Women Artists: 100 Years 1840–1940*, curated by Janine Burke for the Ewing and George Paton Galleries in Melbourne, which toured to the Art Gallery in 1975. Fifteen of the seventy-one works were from the AGNSW collection, and its curators Daniel Thomas and Joanna Coleman (Mendelssohn) were members of the advisory group for this project. The genesis and context for this exhibition is discussed in Mendelssohn, De Lorenzo, Inglis and Speck, 2018, pp 227–28.

30 *Friendship as a Way of Life*, curators José Da Silva and Kelly Doley, UNSW Galleries, Sydney, 8 May – 21 Nov 2020. Helen Grace, *And awe was all we could feel* 1978–80, printed 2020.

31 Isobel Parker Philip, acquisition report for Helen Grace's *And awe was all we could feel* 1978–80 (printed 2020), viewed 16 Nov 2021, artgallery.nsw.gov.au/collection/works/12.2021.a-l

Wayne Tunnicliffe

From black box to white cube: moving images in the Art Gallery

Ruby Arrowsmith-Todd

'The art of mise-en-scène channels energy, concentrating viewers' attention in close-up focus while projecting out to expansive vistas. Cinema's pulse between stillness and energetic outburst manifests the Sydney Modern Project ethos: "From here. For all."'

9

WANDER INTO ANY INTERNATIONAL BIENNIAL, art fair or blockbuster and you'll likely encounter large-scale projections suffusing the space with electronic light. In the digital age, artistic practice reflects a new cultural obsession: taking and sharing videos. Cinema has migrated from the black box to the white cube. Museums have turned into stewards of screen culture at a historical juncture when moving images abound yet venues for their mass appreciation dwindle. This chapter is a meditation on the contemporaneity of moving images in the art museum.

To shed light on the current prominence of the moving image, I shall confine myself to one rather specific question. How has cinema moved from the edges to the centre of the Art Gallery of New South Wales in Sydney? This question might be rephrased in a variety of ways. Why was film ever in exile? What can we learn from the institutional lag in welcoming an artform with roots in popular entertainment? How can the present abundance of moving images draw upon the under-recognised recent past of cinema in our institution? After all, film has quietly thrived here for over twenty years: curated, tended and screened to hundreds of cinephiles every week in our underground theatre. Finally, what's different now? Across our campus, moving images spill out from the cinema onto our gallery walls, across immersive installations and tiny apertures. The art of mise-en-scène channels energy, concentrating the viewer's attention in close-up focus while projecting out to expansive trajectories and vistas. Cinema's pulse between stillness and energetic outburst manifests the Sydney Modern Project ethos: 'From here. For all.'

Take one: parallel beginnings

In spring 1896, the earliest reels of film reached Sydney Harbour aboard the French steamer *Polynésien*. In the nearby Domain, foundations for the Art Gallery's permanent new home were being laid. The neoclassical facade, pillared archways and neutral green walls of architect Walter Liberty Vernon's design for the Grand Courts were intended to create ideal viewing conditions for painting and sculpture. Down by the dock, accompanied by Lumière agent Marius Sestier, cargo containing the world's newest entertainment medium was destined for a less rarefied exhibition space: a converted shopfront at 237 Pitt Street. On 26 September, Sestier opened Australia's first cinema with hourly exhibitions of the Lumières' Cinématographe. Sydneysiders clambered to see the latest technological marvel in action, enjoying 'living pictures' of London and Paris. As the *Bulletin* noted, 'Sydney is gradually going mad over this new invention, and the signs are that the cinematograph is going to rage virulently for a time.'[1]

For most of the next century, fine art and film remained distinct spheres of culture in our harbour town. Theatres with neon facades bloomed across the city to satisfy locals' ongoing craze for the pictures. As the *Bulletin* had predicted, audiences flocked to novelty. When the talkies arrived in 1928, the average Sydneysider was

attending the flicks twenty-nine times per year.[2] Film was truly a *mass* medium. Picture palaces housed rowdy crowds, gun-toting villains and slapstick thrills. The art museum, by contrast, was an arena of quieter contemplation, aesthetic appreciation and civic uplift. Put simply, museums didn't need cinema and cinemas didn't need the museum. Film was flourishing elsewhere in the city.

To be sure, from the 1970s, video art would go on to make irregular appearances within the Art Gallery.[3] In 1976, a landmark Kaldor Public Art Project introduced local audiences to Nam June Paik's famous video sculptures including *TV Buddha* 1976, a work where a television set and a Maitreya Buddha sculpture face off in a feedback loop. From the late 1970s, alternating *Australian Perspecta* and Biennale of Sydney exhibitions also offered annual showcases of new multimedia works by artists including Joan Brassil and Jill Scott. However, gallery-based video practice and the film milieu remained largely siloed, with distinct practitioners and audiences. As Daniel Fairfax reflects of the era, 'the two worlds simply did not speak to each other. While moving-image work had a presence in the art world, notably with the video art of Nam June Paik, Bill Viola and Anthony McCall, cinema did not have the requisite cultural cachet to take its place in the museum.'[4] And despite wave after wave of twentieth-century art movements, from dada to pop art, whose representatives would enter the building to challenge ingrained divisions between high and so-called low culture, the unruly energies of cinema itself would not infiltrate the art museum until artist–filmmakers came knocking.

A Pierrot-costumed performer advertising the Salon Lumière on Sydney's Pitt Street in 1896

Take two: cinema in the underground

The year is 1988. Art school students and graduates of the Australian Film and Television Radio School form collectives and host pop-up screenings in artist-run spaces and squats. As part of the Art Gallery's 1988 Australian Bicentenary extensions, the Domain Theatre – a 339-seat auditorium – is built in the basement. Though it was initially intended to be a lecture hall, it isn't long before the city's experimental filmmakers seize upon this rare inner-city venue buried in the bowels of the Art Gallery. The Sydney Intermedia Network begins hosting occasional weekend programs such as the Matinaze series, featuring new work by artists including Barbara Campbell, Philip Brophy, Janet Merewether, Paul Winkler and Lisa Reihana, whose 16mm animation *A Māori dragon story* 1995 was first shown in this context.[5] Reihana's reimagining of Waitaha lore, with its jittery stop-motion, cellophane seascapes and plasticine figures, conveys the subversive lo-fi energies of these early screenings.

From this artist-led milieu, a crucial figure in our story emerged. Trained as a filmmaker, Robert Herbert singlehandedly turned ad-hoc screenings into a formalised, weekly offering.[6] In 2000, he launched the Art Gallery's film program with a free 'film study day' exploring the 'sexual politics of gay eroticism and desire'. It took a person with remarkable dedication to the medium to convince the

Above: Nam June Paik
TV Buddha 1976

Opposite: Lisa Reihana
A Māori dragon story 1995
(film still)

From black box to white cube

Art Gallery, after decades of institutional indifference, that moving images deserved permanent residence. Alfred Hitchcock, Yasujirō Ozu, Isaac Julien, Chantal Akerman: these were artists as worthy of exhibition as any other. Like painting or sculpture, film was a distinguished modern artform with a history to be shared with audiences. And for the next seventeen years, Herbert did just that, offering his encyclopaedic knowledge of film to Sydney audiences for free, three times a week, like clockwork.

Responding, often in wildly inventive ways, to the Art Gallery's major exhibitions, Herbert's curation ran the gamut from canonical classics and documentaries to avant-garde shorts sourced from archives across the globe. Titles by Bergman, Scorsese and Lubitsch arrived from the British Film Institute and Cineteca di Bologna, whereupon the 35mm prints were trolleyed down to the bio box, each reel cleaned, tested and threaded, ready for the show. Although his programming skewed to the Euro-American canon, Herbert was committed to screening the work of contemporary First Nations directors including Tracey Moffatt, Ivan Sen and Rachel Perkins, alongside new films by Indigenous-owned media organisations.

Yet while Australian film production flourished, the bricks-and-mortar infrastructure necessary to sustain film culture in Sydney was beginning to shrink. In 2005, the Chauvel Cinema in Paddington and Glebe's Valhalla Cinema – two mainstays of the independent cinema landscape – were the first casualties of the turn toward digital production, distribution and exhibition.[7] By the end of that

year, box-office admissions per capita in Australia had dwindled to four per annum.[8] In Sydney, as elsewhere across the world, the crisis of the digital was transforming the nature of film as a medium (from celluloid to 0s and 1s) and cinema as a social institution (from collective to individualised consumption).

Against a chorus of cries lamenting the 'death of cinema', Herbert tended the unfashionable: analogue media and the curated big-screen experience. He remained devoted to screening films in the formats intended by their creators (16mm, 35mm). This meticulous approach to projection was matched by a zeal for ensuring that each and every film was viewed in the best possible conditions. Mobile phones off! Latecomers not admitted! No talking during screenings! At first, such a purist commitment to celluloid (and notorious pre-show spiel) may have seemed outmoded, a dedication to the defunct. Gradually, however, the reputation of the program began to change. Growing audiences came to recognise the Art Gallery's cinema as a bastion for the kind of publicly accessible, critically engaged film culture on the brink of extinction. Here, in the basement of the Domain, was a free civic space in a city whose cinematic ecosystem continued to contract. The Art Gallery, which had for so long shunned film, was repositioned as a saving refuge.

Herbert's curation was adored by generations of students, casual visitors and die-hard regulars. Yet his work rarely had its praises sung within the building. Indeed, for most of his seventeen-year tenure at the Art Gallery, Robert was employed in the Public Programs Department rather than under the Curatorial umbrella. Film was *still* positioned as an educational adjunct to 'real' art. Until his premature death in 2017, Herbert's exceptional program remained peripheral to the Art Gallery's own self-assessment. An institution-within-an-institution was thriving in the underground.

Take three: cinema spills over

A recent video acquisition by Moroccan-born artist Meriem Bennani sets the scene for our current moment. *Guided tour of a spill (CAPS interlude)* 2021 takes place on a fictional island called CAPS, where troopers detain illegal teleporters trying to reach American shores. Against a backdrop of militarised borders, the work celebrates what can't be contained: bootlegged media, data leaks and viral videos. Bennani speaks to the proliferating forms of contemporary moving image on- and offline: YouTube meets CGI meets reality TV meets gifs meets CCTV meets cartoons. Her work distils the spirit of boundary crossings and cross-media convergences that characterise a new era for time-based art at the Art Gallery.

Both globally and within our own museum, the prominence of the moving image in contemporary exhibitions is hard to miss. Turn to the right, and you'll find a set of VR headsets; turn to the left, and you'll step into an installation unfurling across multiple screens. Since the digital wave of the new millennium, *what* we watch and *where* we watch have changed. Two tectonic shifts have shaken galleries' long-standing resistance to the form.

REMEMBER WHEN TELEPORTATION REPLACED AIRPLANES ?

Firstly, the means of film production is ever more democratic. Most readers would now have a smartphone-cum-filmmaking device in their pocket, and artists have always been drawn to explore the cultural materials of their time. Indeed, some of the most zeitgeist-defining works of the decade, such as Arthur Jafa's *The white album* 2018, have been remixes of found footage mined from YouTube and Instagram. Contemporary art is undergoing an audiovisual turn with artists exploring the interplay between old and new media. Cinema is both an archive to trawl and a frontier of technological innovation.

Secondly, the shuttering of cinemas and rise of digital streaming has led to a surrender of the movie theatre's privileged status as an arena of public assembly. From its highpoint as the mass artform of the twentieth century, analogue film has been increasingly 'culturally marginalised', assuming a place alongside other rarefied forms such as lyric poetry, opera and classical music.[9] At this historical juncture, teeming with moving images yet increasingly bereft of venues for their mass enjoyment, cinema has infiltrated the contemporary art museum. As the Art Gallery demonstrates, art museums are now providing forums for civic congregation, preserving cinema's past and offering encounters with contemporary artworks that push the medium forward. Across our campus, there are three spaces where this shift is most palpable.

Meriem Bennani *Guided tour of a spill (CAPS interlude)* 2021 (video still)

The Domain Theatre

Liberated from its 'commentary' role and untethered from the Art Gallery's exhibition schedule, our cinema is now curatorially autonomous. As film curator within the International Art Department, I'm committed to reorienting our program to the Southeast Asian and Great Ocean region, giving audiences access to new films from Indonesia, Taiwan, Thailand, Sāmoa and beyond. Audiences are keen to experience 'classics' reinterpreted for the present, and we frame historical series with an eye to emergent social and ecological transformations. How does cinema's obsession with doppelgängers and fakes resonate with the notion of a 'post-truth' society? How can the moving image channel more-than-human modes of perception? Such propositions now inform the discursive horizon of the Domain Theatre, which pulses to a regular beat of panels, introductions, commissioned live scores and performances by artists and critics.

The old silos that separated video art from art-house cinema are also tumbling down. In 2020 we launched *Projections*, a monthly showcase of contemporary artists' films. There was nowhere else in the city to regularly discover works by leading artists such as Lawrence Abu Hamdan and Basma Alsharif, who weave between the white cube and the black box. It's at this intersection where some of the most formally daring time-based artworks are being made. *Projections* takes stock of this era, when artists have entered the cinema, filmmakers have entered the art museum, and moving images are percolating up from the basement throughout our building.

From black box to white cube

The gallery walls

For the first time, film winds through our permanent collection displays. One of the major projects prior to the completion of the Sydney Modern Project was a comprehensive rehang of the collection in the original building. In the Grand Courts designed by Walter Liberty Vernon, visitors now experience early cinema from a Sydney perspective. Two installations draw on the Corrick Collection, a world-renowned archive of marvellous short films shown to rural and urban audiences in New South Wales at the turn of the twentieth century. While the Art Gallery's earlier trustees may have spurned the medium, the distinct aesthetic thrills which were once the preserve of a Pitt Street shopfront now exist alongside the sublime and picturesque pleasures of other arts of the period. Attention-grabbing shorts by directors such as Gaston Velle and Walter R Booth were created to elicit maximum delight, wonder and squirm. To the nearby nineteenth-century artworks in these courts, film's message is clear: loosen up, shift perspectives, spring into action! A kinetic modernity is on the horizon.

Moving from the Grand Courts to the two floors of twentieth-century art in the 1972 wing, filmmakers whose work had previously been screened in the subterranean Domain Theatre are now elevated to exhibition spaces. For instance, a film by German-born Australian bricklayer-turned-experimental-auteur Paul Winkler (a mainstay in early Matinaze programs) is shown alongside renowned works of industrial minimalism by Hilla and Bernd Becher, Richard Serra and Vik Muniz. Crunch, scrape, repeat: we hear the sounds of Sydney construction in his landmark film *Brickwall* 1975, a transcendent meditation on the most lumpen of materials. Moving images can modulate the intensity and mood of a space. They vivify gallery walls, and in this instance, appear to build them anew.

The light, sound and rhythmic flickers of film are changing the dramaturgy of our expanded campus. Consider how the presence of moving image in a gallery alters your apprehension of time. In one sense, when you see a painting, you see a time-based medium. A still image has taken time to be made, and that temporality is condensed within the work. Yet in a video or film, time unravels; you can experience the work and (some part of) the duration of its making in a single frame. Bringing cinema out of the black box means contending with new economies of attention. Where a film screened in the dark may hold a viewer transfixed for hours, films projected within an exhibition pull in and out of focus as the viewer wanders over to neighbouring works and back again.

Films were never meant to be unique objects: reels of celluloid travel, videos are copied, digital files transferred. In an exhibition context, the reproducibility of a medium for the masses challenges traditional notions of value based on the aura of a unique work of art. It also upends museological conventions of presentation and preservation. Installing a historical work across settings involves complex questions of translation and reinterpretation: should a 16mm flicker film be shown digitally? How can a CD-ROM

An audience in the Domain Theatre during a film screening

Ruby Arrowsmith-Todd

installation be exhibited if the original display carrier is now obsolete? As we develop our time-based art collection, the Art Gallery's conservators are at the forefront of ensuring that contemporary artists' intentions are well-documented for future iterations.[10]

A new home for moving image

While light-filled pavilions may seem an inauspicious home for cinema, SANAA's new building hosts numerous purpose-built zones for the moving image. Visitors to the Lewin Media Lab can not only watch new media works but also learn how to make their own. The Lab broadcasts beyond the four walls of the museum, beaming art and artist talks to phones, laptops and classrooms across New South Wales, Australia, and even internationally. Proceeding downstairs, the Neilson Family Gallery has been specifically designed to display time-based artworks. En route, visitors discover moving images in tiny peepshows. The fleshy protrusions of Mika Rottenberg's *Lips (study #3)* 2016 blow smoke and enjoin a single visitor to peer inside and watch a crude show, harking back to cinema's bawdy, vaudevillian origins. Moving from the intimate to the immense, visitors to the inaugural installation then encounter Howie Tsui's *Retainers of anarchy* 2017, a dizzying 27-metre animation uniting *wuxia* (martial arts) tales of outlaw warriors with views of everyday life in Hong Kong's notorious Kowloon Walled City. Powered by a live algorithm which means that scenes never repeat, this immersive environment invites viewers to sit down, move close and return to watch more than once.

I've often encountered the idea that film has entered the art museum as a 'dead' medium in need of preservation, per Adorno's well-known claim: 'Museum and mausoleum are connected by more than phonetic association. Museums are like the family sepulchres of works of art.'[11] Yet to frame the migration of moving images onto our walls simply as a rescue effort that shelters an endangered medium misses how the contemporary art museum has become fertile ground for the metamorphosis of cinematic tropes, conventions and modes of spectatorship. Far from a scene of necrophilic salvage, the art museum in recent decades is, as Erika Balsom argues, a 'primary site at which notions of cinema have been renegotiated and redefined'.[12]

With this renaissance comes risk. Gigantic projections have increasingly become avatars of what Rosalind Krauss has called the 'late capitalist museum', offering a shortcut to mass appeal, modishness and interactivity.[13] Wraparound screens can feel vertiginous, an unwelcome sensorial overload. Rather than engaging the visitor's intellect via the senses, moving images exhibited as special-effects spectacles alone can resemble luxury screensavers. While developing the Sydney Modern Project, we have privileged artists who cultivate the anti-spectacular. Hand-spun materiality and experiments which tie new technologies to anachronistic forms intervene in the slickness of contemporary screen culture and its incessant production of novel thrills.[14]

Radiating from an LED panorama installed in the central atrium of the new building, a new Lisa Reihana commission mobilises

cinema's capacity to dazzle and transport yet remains anchored to the cultural histories of our site. SANAA's building overlooks the once-bustling Finger Wharf at Woolloomooloo, a port steeped in stories of encounter and exchange between Pacific peoples, Māori, Indigenous Australians and settlers. From this vantage, Reihana forges a new story of trans-Tasman connection. Set in a post-apocalyptic future, *GROUNDLOOP* 2022 shows a cast of First Nations travellers boarding a *waka hourua* in Aotearoa New Zealand and heading toward Australian shores (see p 74). Along the way, Reihana's camera skims the ocean floor and surges through the sky, evoking shared Indigenous navigation systems of stars and songlines. The screen morphs from a vehicle for linear narrative into a surface for pulsing *tāniko* patterns, handmade sci-fi costumes spun from hydroponic plants, and animated spirits that seem to emerge from and dissolve into our building's limestone facade. Reihana's 16mm animations were first screened in our Domain Theatre. She is now an internationally renowned pioneer of monumental

Mika Rottenberg *Lips (study #3)* 2016/2019

Ruby Arrowsmith-Todd

Howie Tsui *Retainers of anarchy* 2017 (video still)

205

time-based installations. AR (augmented reality) allows visitors to stage one-on-one encounters with her virtual cast of characters. In *GROUNDLOOP*, grand-scale cinema for the digital age embraces both lo-fi animation and the personalised pleasures of watching media on your phone.

The kinetic force of the projected image is transforming the white cube. As miniature screens proliferate in individuals' pockets yet spaces of collective viewing become rarer, cinema finds its place in the houses of contemporary art. To conclude my examination of the moving image at the Art Gallery of New South Wales, it is worth returning to this chapter's beginnings. For twenty years, when many art institutions in Australia still ignored cinema, our art museum cultivated loyal audiences. From our inaugural film curator we learn that the vivacity of new experimentation can co-exist with respect for an old medium replete with storied movements and exemplary auteurs. Now that moving images burgeon across our campus, perhaps too we can learn something from still earlier decades, when cinema flourished elsewhere in the city. Sydneysiders have long loved film and flocked to watch it, at picture palaces in Parramatta and community halls in Chinatown. Today our institution feels enlivened and obligated by this inheritance. A once-booming film culture dispersed across Sydney finds a reimagined home: publicly accessible, culturally and linguistically diverse: each week a new artwork, a new reason to come and visit.

Notes

1 'Sundry shows (3 October 1896)', *Bulletin*, vol 17, no 868, pp 10.

2 Diane Collins, *Hollywood down under – Australians at the movies: 1886 to the present day*, Angus & Robertson, Sydney, 1987, p 17.

3 As Wayne Tunnicliffe notes, 'The first acquisitions of artists' films were made in 1972 and the first video was purchased in 1977.' For more information on this pre-history, see Wayne Tunnicliffe, 'After video', *Anne Landa Award for Video and New Media Arts*, AGNSW, 2004, pp 7–9.

4 Daniel Fairfax, 'Cinema and the museum: introduction,' *Senses of Cinema*, no 86, Mar 2018, sensesofcinema.com/2018/cinema-and-the-museum/introduction-8, accessed 15 July 2021.

5 This work was acquired by the Art Gallery in 2020.

6 From 1972, the Art Gallery's Education Department organised occasional Thursday night screenings of films about artists and art movements.

7 Venues that couldn't afford to upgrade their 35mm equipment to DCP projectors shut as studios converted to digital-only distribution. Widespread digitisation steered audiences toward home-viewing as DVDs and internet downloads proliferated.

8 'Top 10 countries ranked by number of cinema admissions per capita, 2005–2010', Screen Australia, screenaustralia.gov.au/fact-finders/international-context/world-rankings/in-the-archive/admissions-per-capita, accessed 1 Aug 2021.

9 Kent Jones, 'The marginalization of cinema', *Film Comment*, Nov–Dec 2016, p 54.

10 The Art Gallery now employs a dedicated time-based art conservator.

11 Theodor W Adorno, *Prisms*, trans Samuel and Shierry Weber, Neville Spearman, London, 1967, p 175.

12 Erika Balsom, *Exhibiting cinema in contemporary art*, Amsterdam University Press, Amsterdam, 2013, p 11.

13 Rosalind Krauss, 'The cultural logic of the late capitalist museum', *October*, no 54, 1990, pp 3–17, viewed 3 August 2021, doi:10.2307/778666. Cited in Balsom 2013, p 19.

14 For the notion of an 'antispectacular turn', I am indebted to Erika Balsom. See Balsom 2013, pp 65–106.

Making space: performance at the Art Gallery

Lisa Catt with Jonathan Wilson

'We must work together to create a space of care, seriousness and possibility for the rebellious kind of art that we call performance.'

10

PERFORMANCE HAS NOT TRADITIONALLY been part of the institutional narrative of the Art Gallery of New South Wales, though it is very much part of its history. Peel back the sandstone facade, with its layers of blockbusters and masterpieces, of the publicised and promoted, and you will find that it has long been a place where art has crossed disciplines, where liveness has lived. Indeed, the history of performance, understood here in the broadest sense of live artistic practice, spans back to the foundation years of the Art Gallery. Then known as the New South Wales Academy of Art, it first took up residence in a dance hall where, from 1875 to 1879, concerts, rehearsals and other forms of music-making occurred alongside displays from the nascent art collection.[1]

That the Art Gallery has long housed the visual arts together with the art of other disciplines is worthy of reflection. Over time, these disciplines have been regarded in different ways and with differing favourability by the institution. For example, during the 1870s many of those in the Academy saw music as a disruption to the 'primal objects' of the art collection.[2] In 2020 a curator of music was appointed, a first for the institution but also for any art museum in Australia. As late as 1974 the trustees questioned whether staging 'an unpublicised, unannounced dance sequence' would be appropriate in an art gallery.[3] In 2021, the Art Gallery became a partner in an international research project committed to better understanding choreographic practice.[4]

Though performance has had to navigate this shifting and debated terrain, the relationship between objecthood and liveness, permanence and ephemerality has been central to the institution from its very beginning. The notion of the Art Gallery as a shared space where disciplines can comingle is built into its very DNA. And indeed, the Gadigal history of the Art Gallery's site and its proximity to areas of ceremonial import to local Indigenous communities, locate the institution within a much greater lineage of performative practice.

To look at the history of performance at the Art Gallery is to cross a gamut of artforms and a range of presentation contexts: from performance art and dance to music and poetry; from exhibitions and commissions to digital projects and public programs. It is a history that speaks to the passion and advocacy of individual curators who have brought new forms of art into the institution, particularly through initiatives such as *Australian Perspecta* and *The National: New Australian Art*. It is also a history that speaks to the extraordinary opportunities offered by partnerships with contemporary art organisations such as the Biennale of Sydney and John Kaldor Public Art Projects, and performing arts organisations such as Sydney Dance Company, the Australian Chamber Orchestra and Sydney Festival. Most importantly, it is a history that speaks to the incredible community of artists who have created it, who have made art *happen* at the institution.

And yet, this history is not written into the Art Gallery annals.

What follows is not an attempt to do so comprehensively. Instead, as part beginning and part provocation, it takes us from

the late-nineteenth-century Grand Courts to the galleries of the new building – the centrepiece of the Sydney Modern Project. It is a start at bringing performance into our narrative: understanding how it has occupied, contested and reframed our spaces; exploring how it has opened new perspectives on process, spectatorship and display within the museum; and recognising how it has tested institutional assumptions and mechanisms. It is also a start at considering how we can best take up this history, heeding what the artists and their artworks have taught us, and making *real* space for performance within the institution.

With the Art Gallery on the precipice of opening a new building as we write, it is perhaps unsurprising that the construct of space sits front of mind, both architecturally and metaphorically. What does it mean to have more space? What will the institution give space to? And what might it create space for?

Art engaging with the live and the ephemeral becomes entangled in such musings. As articulated by American artist Senga Negudi: 'I like to dance with the spaces I occupy ... Partnering, we show each other what we have to offer.'[5]

Holding such an intimate and contingent relationship with space, performance is often indelibly linked to a particular *where*. Though it trades in impermanence, performance can still leave a lasting imprint on the spaces it passes through. Indeed, to find the history of performance at the Art Gallery, one should not solely rely on the collection database, for performance works are largely not (yet) part of the museum's art repository, nor is their documentation made readily visible by its catalogue. But if you were to take a walk through the various spaces of the original building, where these histories are held through a mixture of collective memory, mythology and documentation, an incredible performance archive reveals itself. Our spaces have collected this history.

And now, next door, stands a new building, waiting to collect new histories. What will be witnessed? What will be felt? What will be remembered? From the open volumes of the main galleries to a series of curious interstitial spaces and expansive outdoor terraces, from the dedicated performance hall to the enigmatic Tank – the spaces of the new building are poised for partnership. And an incredible community of artists are too.

To be a genuinely good partner, however, the Art Gallery's offer to artists must go beyond the architectural. We must make space for performance within our institutional structures and prise open the way we think about acquiring and collecting art. How might we move beyond processes wedded to nineteenth-century principles of medium specificity, permanency and perpetuity? How might we find new methods, and indeed attitudes, that are not conditional on objecthood, to assign value and significance to artworks?

The Art Gallery must reconsider the way in which it conserves. How might we expand our notions of preservation and care to accommodate not just objects but also embodied practice; that is, people, relationships and networks of knowledge? How might we think about conservation not as something the institution prescribes on its terms but which can be led by the artist and the specificities of their artwork?

The Art Gallery must also expand its exhibition frameworks. How do we move performance from event listings to focused artistic programs within our exhibition schedule? How do we shift the emphasis from a performance simply 'happening' in the moment, and recognise the entire process – all the conversations, nurturing and testing that come before it happens, and the archiving, documenting and approaches to collecting that follow it?

It is up to us: the curators, the producers, the conservators, the archivists, the registrars, the installers, the hosts and the security guards. We must work together to create a space of care, seriousness and possibility for the rebellious kind of art that we call performance.

Because what would a twenty-first-century art museum be without:

Art that embraces the unforeseen

5 DECEMBER 1923

This afternoon visitors to the Art Gallery become both viewers and listeners. The Sydney Conservatorium Ladies String Quartet is performing in the Grand Courts. Behind it hangs the Art Gallery's prized nineteenth-century painting by Alphonse de Neuville, *The defence of Rorke's Drift 1879* 1880 (see p 131). The stage is set.

As these 'bright young players' move through compositions by Haydn and Mozart, the concert begins to spread to the adjoining courts. The exceptional acoustics have sent the music outwards, to an audience out of sight.[6] What was planned as a discrete pairing of quartet and painting turns into something much more expansive, a kind of incidental sound installation.

The concert had been considered an experiment. Though the Art Gallery had long served as a venue to musicians, this time music and art did not simply occupy the same space: the two forms were intended to interact. It marked the first time the Art Gallery officially programmed music. And the experiment paid off. The Conservatorium Ladies String Quartet would go on to perform regularly at the Art Gallery for the next ten years.

Art that bemuses

16–21 AUGUST 1973

Two tweed-suited men stand atop a table in the Art Gallery's entrance court. They have brought with them a transistor radio, from which they play a single song, the 1932 track 'Underneath the arches' by British comedy duo Flanagan and Allen. Over and over the song plays. And over and over the two men sing and dance along. Like two figurines in a music box.

Gilbert and George embodied contradiction: they sang about homelessness but presented as conservative British middle-class men;

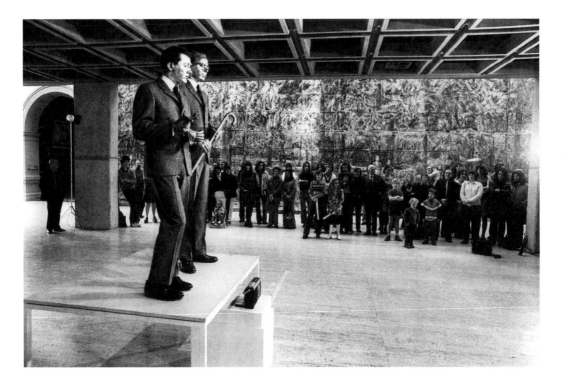

they painted their faces and hands in bronze to reference what sculpture had been, but used themselves to posit what sculpture could be – dancing, singing, living. People were fascinated. Across six days, visitors to the Art Gallery stopped, sat and watched. The performance, *The singing sculpture* 1969–91, would become a flashpoint in changing perceptions of the institution.

Art that is transparent

22 SEPTEMBER 1967

A reverential hush falls across Art Gallery goers as a bespectacled Japanese man in a cream coat and yellow gloves is seen walking across the entrance court. He is accompanied by his wife and an impressive entourage of assistants. The man is Teshigahara Sōfū – painter, sculptor and master of the Sogetsu School of Ikebana. He stops in front of a large blank canvas laid flat on sheets of old newspaper spread out on the floor. He removes his gloves and coat. With the slightest gesture, he cues an assistant to pass him a bottle of ink. Pouring the ink directly onto the canvas, closely watching the ways in which it pools and runs, Teshigahara proceeds to '[dance] around with broom-sized brushes making a huge, wildly gestural black calligraphy painting'.[7]

Teshigahara came to the Art Gallery as part of an ikebana conference and was lauded by the local press as the 'Picasso of flower arrangers'. But what he demonstrated to the public on this day is not just about arrangement but also the tension between process and production. Here, the ceremony and

Gilbert & George perform *The singing sculpture* for the third Kaldor Public Art Project, August 1973, with their 1972 'charcoal-on-paper sculpture' *The shrubberies number 1* and *The shrubberies number 2* 1972 on the rear wall

immediacy of art-making is made equivalent to the traces left behind. The artwork reveals itself: it is a profound act of transparency in place of grand facades.

Art that destabilises

4 APRIL 1976

The artist and experimental musician Charlotte Moorman climbs along a sandstone ridge on the exterior of the Art Gallery, carefully shepherded onto the roof by a group of assistants. Here, she sits above the portico at the apex of the neoclassical facade. (The safety precautions of the time extend to a rope tether and her assistants hiding behind the parapet, holding her in place.) From a bamboo pole, she dangles her cello over the side of the building to perform *Cello sonata* 1972, by her Fluxus peer, the composer Mieko Shiomi.

Presented as part of an exhibition by Moorman and her acclaimed collaborator Nam June Paik, organised by John Kaldor Public Art Projects, this performance revelled in spectacle, but was also loaded with consequence. Here was a woman artist at the highest point of the Art Gallery, gleefully teasing the museum, making a statement about art-making, art-makers and the art institution. The names of venerated male painters and thinkers inscribed on the facade below her served only to reiterate the point. These names had been considered to exemplify the highest realm

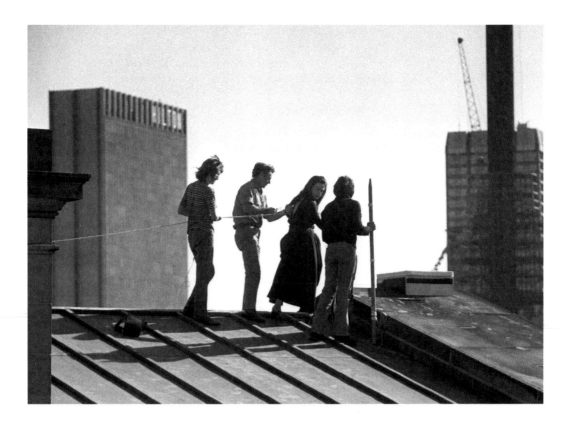

Making space

of creative greatness imaginable – a kind of aspirational declaration by the institution when it was first built. But on this day, Moorman and her cello went higher.

Art that is slippery

28 NOVEMBER 2020

The artist Angela Goh creeps across the parquetry floor of the Grand Courts in a movement so strange that you could swear her body was moving backwards and forwards at the same time. Part-reptile, part bot, part-dancer, she begins to examine her surrounds, her fingers extending around architraves, columns, picture rails and archways. With each grip, she seems to gather more information: 'I can reach my hand there ... I can extend my foot here ...' And so, she reaches higher and scales the walls of the Grand Courts. Meeting the lofty heights of the gilt-framed paintings, she hauls her body upwards and outwards and backwards. All the while, her voice, layered and looped, fills the space with a ghostly siren song. Visitors from all corners are drawn in.

In this work, *Body loss* 2017–, Goh emphatically engaged with the architecture of the museum but evaded its context. She turned the Grand Courts into a kind of threshold space where timescales

Opposite: Charlotte Moorman being secured by rope to the roof of the Art Gallery of New South Wales prior to performing Mieko Shiomi's *Cello sonata* 1972, April 1976

Above: Angela Goh performing *Body loss* 2017– in the Grand Courts, 2020

Lisa Catt with Jonathan Wilson

and meanings became unsettled and detached. And in this space of something else, the artist moved between and around the structures of histories, canons and institutional traditions – and then simply walked away.

Art that continues on

4–19 JULY 1981

Marina Abramović and Ulay have been invited to make a new work at the Art Gallery. This would be their second time performing at the institution within two years, following their presentation for the 1979 Biennale of Sydney. They first spend five months travelling across the country. The experience of their travels – the expansive landscape, the periods of solitude and the opportunity to learn about Indigenous Australian culture – would remain with them upon their return to Sydney. Here they present the performance *Gold found by the artist*. For seven hours a day over sixteen days, they sit at opposite ends of a long table, facing each other in complete silence and stillness. A collection of gold nuggets, a boomerang, and a live diamond python sit on top of the table. Throughout this time, they also fast. The artists are no strangers to pushing their bodies to the extreme, but the duration of the work, its sustained physical intensity, could be considered, at this time, unprecedented in their practice.

Above: Marina Abramović and Ulay performing *Gold found by the artists* 1981

Opposite: Dancers performing for Amrita Hepi's *The tender* 2019

Making space

The work evidently lingered in the artists' minds. It was to become the seed that generated the series of performances presented across the world between 1981 and 1987, *Nightsea crossings*. Thereafter, it continued to manifest in their *The Great Wall walk* 1988 in China and in Abramović's *The artist is present* 2010 in New York – a testament to the bold and experimental commissioning traditions of the Art Gallery.

Art that is in a constant state of becoming
31 MARCH AND 24 APRIL 2019

In the entrance court, three dancers move on all fours, flicking back their heads, jerking and curving their bodies in a physical expression of defiance and play – a reflex to the museum space, perhaps? Throughout the work, each of them uses a single prop, a length of orange rope. Twirling, whipping, lassoing and binding, the rope becomes both rhythm and metaphor. It is there to slow and to quicken. To connect and to control. To resist and to release. Indeed oppositional forces structure the work's entire cycle of movement – it is a choreography that never chooses a side.

The tender, by choreographer Amrita Hepi, placed dance at the centre of a provocation: about the ways in which bodies are woven together; about the ecologies of support, care, cooperation and collaboration that bind us. It affirmed our interdependence, with all its inherent tensions. It reminded us that we are all part of a tender, to each other. (The Art Gallery included.)

Lisa Catt with Jonathan Wilson

Art that interrupts time

24–29 MAY 2000

There is a horse in the Grand Courts. And on the horse sits a naked woman. They are modelling for three painters who have taken up residence at the Art Gallery for Cai Guo-Qiang's *Still life performance*, part of the 2000 Biennale of Sydney. Stationed at their easels, brushes at work, the artists turn the historic European paintings of the Grands Courts inside out, extracting the act of painting from the canvas and into performance.

Restaging the tradition of a studio painting circle as a kind of art historical readymade, Cai mashed up contexts, timescales and expectations to rousing effect. The performance was reported to have elicited anything from a giggle and curious glance to a scream from visitors who came in expecting the nineteenth century, only to be confronted by the twenty-first.[8]

But there was another, quieter provocation at play. Cai had specified the artist participants for the performance be 'a Westerner, a person of Chinese descent, and a woman'. And while each artist worked side-by-side, in the same room, with the same model, the images they created were far from the same. Art is a process, Cai revealed, but also a matter of perspective and experience. Whose take does art history let live on in the museum?

Art made of constellations of people

7 APRIL AND 8 APRIL 1982

Maurice Jupurrula Luther, Ronnie Jakamarra Lawson, Thomas Sampson, Bobby Japaljarri Leo, Willy Jupurrula Hudson, Dick Japalajarri Raymond, Lindsay Jungarai Herbert, Peter Jangala Ross, Joe Jangala and Abie Jangala gather on a vast blanket of red sand that buries the Art Gallery's travertine floor. On the sand, the men create an image using red and white ochre, depicting the tracks of snakes moving between two waterholes on Jundu Country. The men then move through a cycle of song and dance that tells the story of Werril Werilpa, who broke sacred law and was subsequently punished.[9] This is not performance as typically categorised or staged by the Art Gallery. It is an extraordinary demonstration of ceremony and culture, of embodied teaching and learning, of understanding one's place in the world and the value systems that shape that world.

Members of the Warlpiri community, these men had travelled to Sydney from Lajamanu, a town in the Northern Territory, to participate in the 1982 Biennale of Sydney. Bringing dance, song and image-making from Country into an institutional context, they finely calibrated the public and the sacred, theatre and ritual, art and cultural practice, to generously share with Art Gallery visitors the stories of their ancestors. They showed how their practices and knowledges are lived outside of linear chronologies and objects stamped in time.

Opposite: Installation view of Cai Guo-Qiang's *Still life performance* during the 12th Biennale of Sydney in 2000

Above: Warlpiri artists performing a Snake Dreaming Ceremony at the 4th Biennale of Sydney in 1982

Lisa Catt with Jonathan Wilson

Art that spreads out

2 MAY 2020

Lebanese Australian artist and vocalist Maissa Alameddine is in a building full of art but empty of visitors. The Art Gallery is closed indefinitely due to the COVID-19 pandemic and awhirl with existential angst: What is an art museum without a public, without a physical space?

Alameddine stands in front of Lesley Dumbrell's vibrant op art painting *Solstice* 1974, a work that appears alive with the shimmer of sound waves. She is singing 'Hal Asmar el Lon', a traditional Arabic song about yearning for a loved one, passed down through families over generations – from grandmothers to mothers, from mothers to daughters.

Her performance, recorded and presented in digital space for audiences at home on their phones and computers, was a timely reminder that art can travel far and has long connected us irrespective of bricks and mortar.

Alameddine was one of several musicians commissioned for the Art Gallery's Together In Art project. This not only opened a new space for performance to exist at the Art Gallery – that is, online – but also marked a starting point for the broader inclusion of music in the Art Gallery's programming.

Above: Maissa Alameddine performing for Together In Art in 2020 in front of Lesley Dumbrell's *Solstice* 1974

Opposite: Eunice Andrada reading poetry in the exhibition *Passion and Procession: Art of the Philippines* in 2017

Making space

Art that speaks back

5–26 AUGUST 2017

> If you tell your children
> the story of how you came here
> in a language they don't understand
> did you arrive at all?

The question hangs in the air as poet Eunice Andrada performs her spoken word piece *Last days of rain* in front of three paintings by fellow Filipino artist Marina Cruz. These paintings, of dresses made by Cruz's mother, are so vividly rendered, so full of knowing and character, that they slip into the genre of portraiture. Here, against Andrada's words, experiences of migration, displacement and matrilineal kinship emerge from the burrows and folds of the dresses' fabric.

Andrada, along with poets Gloria Demillo and Merlinda Bobis, was commissioned to write new works for the exhibition *Passion and Procession: Art of the Philippines*. This collection, titled *Harana* after a Tagalog word meaning 'to serenade', was performed weekly within the exhibition as a kind of poetry tour.

The Art Gallery has often drawn upon the poetic form as an aid to interpreting the art on the walls. But Andrada put forward a different proposition – that poetry has a rightful place as an independent artform within the museum. An artform that can allow communities to gather and tell their own stories – to 'speak back', as she likes to say.

Lisa Catt with Jonathan Wilson

Art that wrestles with expectations

18 JULY – 1 SEPTEMBER 2013

The shadow of a dancing body is projected across two suspended screens. This body belongs to the artist Agatha Gothe-Snape, and she is dancing a score created by collaborator Brooke Stamp. She will perform this score live at the Art Gallery twice – once in private and once in public. As the artist wishes, these performances are not documented. Instead, a brass plaque mounted in the exhibition space, inscribed with the work's title and performance times, serves as a quiet memorial.

Inexhaustible present asked an overdue question of the Art Gallery – how might the complexities of embodied, collaborative, live practice translate into the traditional parameters of a museum exhibition? What is to happen when an exhibition is not a group of objects, on display and constantly available to visitors, across a three-month duration? Gothe-Snape posited that until performance can enter the museum and be free of these parameters, until it can be there without always being there, we are only ever watching shadows.

Art that revels in collective experience

10–12 JANUARY 2019

As a summer night begins to take hold, a low-end rumble extends down the front steps of the Art Gallery, lulling the vestibule into a trance and awakening the entrance court. This is the sound of American composer Dean Hurley as he opens Masters of Modern Sound, a durational music and performance program with the Festival of Sydney that consumes the Art Gallery for three nights.

Italian composer Caterina Barbieri performing at Masters of Modern Sound in 2019

Making space

Music and recorded audio compositions are performed by sound artists throughout the building, creating a textured cacophony of sound. Each act is then connected through a series of improvisations by the experimental dance studio Force Majeure. People lie down on the entrance court floor, listening and watching.

The program was much like a film score, providing a compositional and auditory arc to the art and building itself. It opened up a new plane of feeling in the museum – the usual norms of hushed tones and silent contemplation were temporarily suspended, replaced by complete sensory engagement.

The Sydney Modern Project has offered an incredible opportunity for the Art Gallery to establish itself as an art institution that celebrates and supports the live and the ephemeral; that works across, within and between disciplines; that embraces the full spectrum of contemporary art. As these performance vignettes reveal, the beginnings of a cross-disciplinary approach to contemporary art are already part of our history. Now it is time to make it a cornerstone of our story.

Notes

1 Steven Miller, *The Exhibitionists: a history of Sydney's Art Gallery of New South Wales*, AGNSW, Sydney, 2021, pp 38–49.

2 Miller 2021, p 199, quoting letter from Joseph Rubie to Frederick Eccleston Du Faur, 26 Nov 1878.

3 AGNSW Board of Trustees, minutes, 26 Jul 1974.

4 The research project, entitled *Precarious movements: choreography and the museum*, is supported by an ARC Linkage Grant and hosted by the University of New South Wales with partner organisations Art Gallery of New South Wales, Monash University Museum of Art, National Gallery of Victoria, Tate UK, as well as independent artist Shelley Lasica.

5 Senga Negudi, artist statement, sengasenga.com/statement, accessed 17 Aug 2021.

6 'Music in the Art Gallery', *Sydney Morning Herald*, 5 Dec 1923, p 10.

7 Daniel Thomas, 'Rhythm and lift-off', in *Rosalie Gascoigne: plain air*, City Gallery & Victoria University Press, Wellington, NZ, 2004, republished in Steven Miller & Hannah Fink (eds), *Recent past: writing Australian art*, AGNSW, Sydney, 2021, p 214.

8 Jane Albert, 'Gallery trots out an old idea for the manestream', *Australian*, 24 May 2000, p 7.

9 Artist names and work details sourced from 'Aboriginal Artists at the Biennale of Sydney 1982', typescript, National Art Archive, AGNSW.

Our house is open

Paschal Daantos Berry

'We who work within the world of public programs and creative learning see ourselves as companions or collaborators who create access points for audiences to step into an artist's world. An encounter with art should be memorable. It should delight, disarm, inspire, shock, raise critical questions or elicit joy and excitement.'

THE WORLD OF PUBLIC PROGRAMS AND ART PEDAGOGY has significantly changed since 7 August 1871, when a 'brilliant assembly including most of the principal personages of Sydney and its vicinity' came together for the first *conversazione* of the New South Wales Academy of Art, an organisation which evolved into the Art Gallery of New South Wales.[1] Consistent with its time, this first public program of the nascent Art Gallery constructed rigid parameters for participation – it was an offering for the privileged, for the colony's elite and in celebration of the 'Triumph of Art'. In 1994 the Yiribana Gallery opened, embedding into the history of the building the inherently interdisciplinary nature of Indigenous art and cultural practices. Public programs for children and families became integral activations and important immersions into culture, bringing new knowledges and experiences to the Aboriginal and Torres Strait Islander collection.

Historically education and public programs have played an important role in shifting public perceptions around art and the Art Gallery's collection. From the late 1970s there was a significant focus on expanding the role of art educators to support interpretation and develop new audiences. While deeply informed by this history, we seek to imagine the future with our community of audiences and artist collaborators.

Our house is open

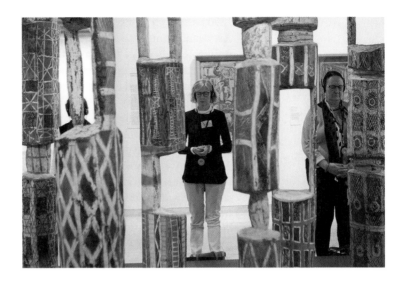

In 2015 the education, public program and visitor experiences teams were repositioned under the banner of Learning and Participation. Frameworks around *learning* and *participation* can be interpreted through multiple lenses. At this juncture our team views these terms as provocations for whomever is in the room: Who is teaching? Who is learning? Who is participating?

Gatherings within the context of art have thus shifted even further from that first *conversazione*. Our central philosophy during the Sydney Modern Project has been to metaphorically remove the facade of our building, to create an 'open studio' experience that welcomes the participation of our audiences and lay bare the creative process. Ambitiously, we give ourselves the task of creating life-changing moments, to spark epiphanies and to dare propose that we are all important contributors in the creation of culture and a robust Australian identity.

The original Art Gallery building is a place that's familiar, like a scholarly aunt who is at once warm but opaque enough to hold some mystery. Tongan Australian artist Latai Taumoepeau remembers the exterior in relation to the grassy hills of the Domain, where in the 1980s her father used to take her and her siblings while they waited for her mother to join them. They would roll down the hill and play in the greens but would never step into the Art Gallery. With its imposing entrance of neoclassical columns, it suggested an alien world, one that was vastly different from where her family lived in Marrickville, a suburb built by the labour of generations of colonists and migrants, from the Greeks to the newly arrived Vietnamese refugees and a large Chinese community.

For Lina Ishu, a youth worker at the NSW Service for the Rehabilitation and Treatment of Torture and Trauma Survivors (STARTTS), the most vivid memory of the Art Gallery was finding solace and a sense of belonging in Sir Edward John Poynter's beloved

Opposite: Students in the Djamu Indigenous art education program viewing Yhonnie Scarce's *Death zephyr* 2017 in *The National 2017: New Australian Art*

Above: Visitors experiencing a mindful tour of the Art Gallery in front of the *Pukumani grave posts* commissioned in 1958

1890 painting *The visit of the Queen of Sheba to King Solomon*. The Assyrian antiquity that sets the scene connected her, as an Assyrian refugee, to a heritage that has withstood centuries of violent acts of erasure, and to an identity that exists in fragments in museums, in artists' renderings of bible stories, in family stories and in flesh and blood. She remembers her mother standing under the painting on another visit and quietly whispering '*We are here.*'

Artist Sarah Houbolt, who describes herself as partially sighted, created an audio experience that chronicled her journey from the National Art School in Darlinghurst to the Art Gallery. As part of her participation in Brook Andrew's *NIRIN*, the 22nd Biennale of Sydney, she described the textures of the walk, the sound of traffic lights and her ability to navigate the Art Gallery's entrance court through a familiar welcoming voice that greeted her by name. Her understanding of the interiors of the building is built on her existing relationships with staff and her connection with our access programs.

We who live here locate the Art Gallery in our own unique maps, drawn from memory and experience, often involving transformative encounters with art, sometimes inspiring, sometimes alienating. In an Australia that oscillates between valuing the work of artists and criticising their role in society, it feels urgent to have an honest conversation with the public about where they place art in their hierarchy of priorities, by creating a space for reciprocal exchange between artists, institutions and audiences. As Alison Croggon expresses it: 'Culture works in complicated and often untraceable ways. But the core of culture is artists: they are the source of the vitality, richness and innovation.'[2]

We who work within the world of public programs and creative learning see ourselves as companions or collaborators who create access points for audiences to step into an artist's world. An encounter with art should be memorable. It should delight, disarm, inspire, shock, raise critical questions or elicit joy and excitement. It is an active experience that provokes a spectrum of emotional and cerebral responses – a call and response between artists and audiences, if you like.

At the Art Gallery we are always working to improve the rigour of all programs, but it helps to be guided by an ethos that puts the encounter between artists and the audience at the centre. As we develop ideas to strengthen this relationship we consider multiple viewpoints, diverse cultural and canonical contexts, histories and philosophical perspectives.

A person's earliest encounters with art inform their future engagement. Our collective endeavour is to ensure that our exhibitions and programs are accessible for all, and for all offerings to reach a wide audience. We do this through hospitality, with our team creating a welcoming space that respects all abilities and removes obstacles for participation. It is our responsibility to create a place that considers how audiences interpret what they are seeing, and which provides opportunities for audiences to encounter each other, both organically and as the result of the conscious design of an inclusive space for discursive interaction.

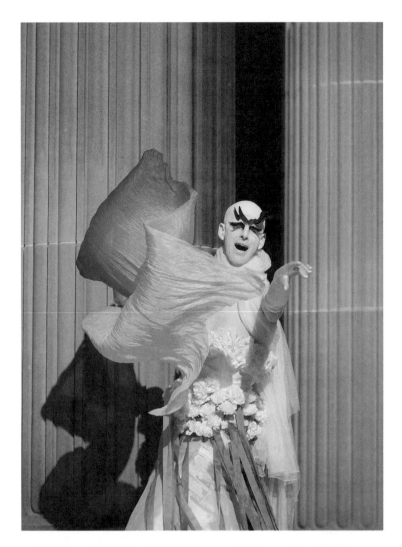

Top: Brendan De La Hay
welcomes visitors to
Queer Art After Hours
with performance piece
The Bleeding Bride

Right: Singer Zaya Barroso
entertains a crowd at
Queer Art After Hours

Paschal Daantos Berry

As we consider the immense responsibility of introducing the public to the Art Gallery's new building, it is important to remember that transformation is the acknowledgement of a past that's both worthy of pride and worth recontextualising, while we bravely face an imperfect future. Change is about people finding common ground and celebrating and defending difference and cultural specificity. Being connected to the world means that institutions like ours must respond to global phenomena – the ambiguity of a post–COVID-19 world, the continuing fallout of colonisation and, importantly, our climate emergency and environmental crisis.

The fears and aspirations associated with these issues are within the hearts and minds of our audience members and are also of primary concerns for artists. They are things we consider when we create safe spaces for participation and when we offer an open house that is centred on people and reciprocal learning. Though we value our institutional scholarship, we also acknowledge that we have much to learn from our audience and our diverse communities.

Above: A community group making art in an access workshop

Opposite: Primary school students in an Art Pathways program viewing Brett Whiteley's *The balcony 2* 1975

To imagine the future, we can take inspiration from the past and the things we already do in creating stepping-stones to transformation. Our relationship with Indigenous communities and artists is the starting place. This is best exemplified in our program Home, which connects students and teachers to local Aboriginal

Our house is open

artists and communities. With a current focus on Wiradjuri, Kamilaroi/Gomeroi, and Gathang, Biripi/Worimi Country, culture and language, the program repositions the country now known as south-east New South Wales as a vibrant and interconnected rhizome of Indigenous practices and knowledges. We respond to the needs of the communities through periodical reassessments of the program, which is a collaboration between the Art Gallery, local Aboriginal artists and communities and our organisational partners.[3] From 2015 Home has engaged with over 100 schools and has worked closely with regional centres across New South Wales, including Wagga Wagga Art Gallery, Bathurst Regional Art Gallery, Murray Art Museum Albury and Tamworth Regional Gallery.

The Djamu Program for Indigenous Art Education provides an opportunity for Indigenous students in Greater Sydney and regional New South Wales to learn about art, culture and career pathways. In 2020, as part of Djamu's regional program, artist and Barkandji Elder Badger Bates cut a canoe from a red gum sourced from the waterway of his birth, the Baaka/Darling River. The first canoe in 70 years to be made on Barkandji Country, it was a stark reminder of Indigenous cultural practices that were outlawed for decades, and the critical work needed to revitalise them. Led by an artist who has personified

Our house is open

the voice of the Baaka through decades of environmental activism, students from Wilcannia engaged with cultural memory, rigorously supported by the Art Gallery's team on Country. As one student responded: 'It was special to sit and listen to Uncle Badger and learn about how our old ancestors would build canoes and other objects needed to live on the river.'[4] The importance of their engagement was palpable.

Children and young people working in proximity with artists is also central to our Art Pathways program. Engaging with Western Sydney schools and art centres since 2017, Art Pathways has created opportunities for students in the region to experience first-hand the practice of culturally and linguistically diverse artists who work and live in their neighbourhoods and whose perspectives and identities are like their own. During the first three years of the program, Western Sydney artists Louise Zhang, Marian Abboud and Marikit Santiago developed activities with the Art Gallery that encouraged students to connect with their own cultural identities and diverse histories: 'We could connect with students and make them feel welcome, understanding that the Art Gallery of New South Wales is their place and open them up to the possibilities of art, as well as being honest about what being an artist means.'[5]

For teachers, this offered new ways to work directly with artists and to connect with institutions and their collections through an infrastructure of local arts organisations, and the resources to transport their students to the Art Gallery:

> Our communities have always given us glimpses of how we should transform, in the way they respond to our exhibitions, and the manner in which they hold themselves within our galleries and interstitial spaces.

In 2017 at the launch of the Bayanihan Philippine Art Project, artist Alwin Reamillo led a procession through the Art Gallery's Grand Courts, carrying fragments of a bamboo house he had built with the participation of the Filipino community. The scene, witnessed by the Art Gallery's weekend audience, was a live manifestation of Ian Fairweather's 1957 painting *Anak Bayan*, representing Fairweather's recollection of the busy streets of Manila in the 1930s. Such engagement with a collection work that understands the cultural nuances of the diaspora, by people from the community it depicts, points to possibilities for recontextualising other existing works. Through participating in the work of a contemporary Filipino artist who looks like them, people could write themselves into our building. Reamillo, who relates to Joseph Beuys's utopian idea of social sculpture, where 'EVERY HUMAN BEING IS AN ARTIST', would have consciously connected his collaborative house with the Beuys tree planted just outside the Art Gallery building.[6] The Filipino community responded in a way that shifted the rhythm of an art gallery, one that's often wedded to the precision of time and schedules. For those who were there, a twenty-minute fashion parade expanded to an hour, a choir sang more folk songs than

Opposite, from top: Indigenous educator Wesley Shaw leads a virtual art lesson based on the art of Karla Dickens with Gundagai South Public School as part of the Home program in 2020

Shanaha Clayton from Wilcannia Central School floating a tree canoe on the Baaka/Darling River during the Djamu Regional Program led by Barkandji artist and elder Badger Bates in December 2020

Paschal Daantos Berry

programmed and the kinetic blur of people through the Grand Courts manifested a delightful demonstration of Beuys's social sculpture.

A 2017 collaborative project with Parramatta's Information and Cultural Exchange (ICE) titled *Manifesto for tomorrow* provides a compelling foreshadowing of what may exist in the Art Gallery's expanded campus. Art Gallery staff with artists Marian Abboud, Marilyn Schneider and Amrita Hepi posed a question to students from Auburn High School: 'What should an art museum be like?' The students responded in simple, short statements that declare what the next generation wants from its cultural institutions – a manifesto of their collective vision:

> I want permanent digital art.
> [I want] a better multisensory experience.
> I want clearer architecture.
> I want to experience each artwork with sounds related to the work's heritage.
> [I want] information that interacts with you.
> I want the gallery to bring nature inside.
> I want to see through the artworks.

If there was a time to respond to the provocations from the students who participated in *Manifesto for tomorrow*, it was in the shaping of programs leading to the opening of the Art Gallery's new building.

Our house is open

I WANT TO EXPERIENCE EACH ARTWORK WITH SOUNDS RELATED TO THE WORK'S HERITAGE.

Opposite: Artist Alwin Reamillo leads a procession though the Art Gallery as part of the Bayanihan Philippine Art Project in 2017

Above: Easha Mohammed Ghouseddin from Auburn Girls High School working on the *Manifesto for tomorrow* project as part of a partnership with Information and Cultural Exchange (ICE) in Parramatta

The new expanded campus provides opportunities to create meaningful art encounters through newly designed spaces that encourage exchange and immersion in practice.

Student and community participation play an important role in a new commission by artists Isabel and Alfredo Aquilizan, a work that is part of *Dreamhome*, one of the opening exhibitions in the new building. For this iteration of the work, the Aquilizans constructed a city of cardboard, an immersive architectural world in which each individual dwelling was made by workshop participants in collaboration with the artists. Each home represents an ideal, a personal symbol of safety and comfort during a time of universal uncertainty. The artists worked with students participating in our Art Pathways program in various Western Sydney schools, and with community groups who had participated in the Bayanihan Philippine Art Project, who were able to reconnect with the Art Gallery through another ambitious large-scale project.

The interaction between artists and an intergenerational audience can be further developed through the new Paradice Learning Studio in the new building. It is a kind of open studio, primarily a space for students and teachers to engage with our education program, it will also be the home for our partner community and arts organisations such as STARTTS, Asylum Seekers Centre and Story Factory. The Art Gallery is developing a robust relationship with these diverse stakeholders by ensuring that the process-centred work that we do in

Paschal Daantos Berry

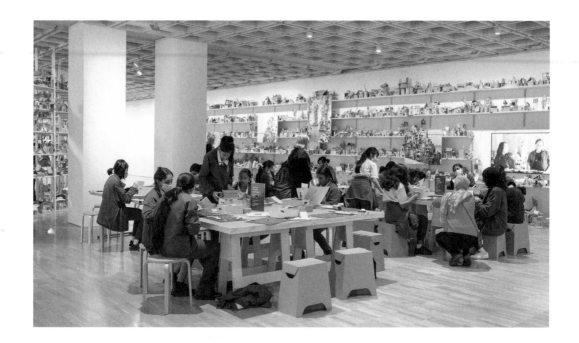

communities can also thrive within our building – through regular workshops and artist-led learning in this adaptable, purpose-built space.

This open studio approach is also the focus of our Lewin Media Lab where we can host residencies for artists working within the digital realm and making time-based art. The lab provides an opportunity for us to consolidate everything we have learnt from the digital program we developed intensively during COVID-19 restrictions. As we watched young people master digital content-making through new app developments and the creative use of social media, we saw the potential for combining digital experience with live and immersive interactions in our future learning and public programs. Developments within augmented-reality technologies also throw open an exciting world where virtual interactions can enhance the live experience and play a vital role in the interpretation of art.

As part of the 2021–22 exhibition *Family: A Vision of a Shared Humanity*, curated by Franklin Sirmans, director of the Pérez Art Museum Miami, Barkandji artist Emily Johnson connected with the curatorial vision of a post–Black Lives Matter world, through content specifically designed for social media. Her work, presented on her popular TikTok account, is a humorous take-down of racism against Aboriginal people, in short-form exchanges between Johnson and her racist detractors in a way that implicitly understands its audience and the efficacy of this format in reaching a diverse demographic.

The Lewin Media Lab gives us the opportunity to work closely with artists such as Johnson in bringing their practice to students who are familiar with these communication tools. It opens their perception of what art can be and redirects and recalibrates their use

Students from Blacktown Girls High School participating in an Art Pathways program making cardboard 'dream homes' that may become part of Isabel and Alfredo Aquilizan's sculpture to be displayed in the *Dreamhome* exhibition when the new building opens

Our house is open

of technology to encompass creativity and expression. Artist Adrián Villar Rojas has described such support as a kind of 'housekeeping':

> Housekeeping is a type of labour that enables other types of labour (and life) to happen, and when it's well done, nobody sees it. And this is a quality I'm interested in, committed to and that I want to embody. I want to cooperate with my hosts and allow them to use me as a platform for transformation.[7]

The Sydney Modern Project's other exciting commissions and exhibitions provide the opportunity for deep dives into the idiosyncratic worlds of artists and the urgency of the messages within their works. We are finding space for children and young people to encounter artworks by inviting them into earlier conversations with artists or introducing them to artist projects at their inception. A close collaboration between the curatorial and learning and participation teams, as well as other staff within the Art Gallery, is key to developing a robust art gallery culture. More importantly, through our regional and in-school exchanges as well as our work with communities, we give space for longitudinal relationships to develop, to ensure that our future as an institution flourishes in the voices of the people we serve.

Notes

1 'New South Wales Academy of Art', *Sydney Morning Herald*, 8 Aug 1871, p 2, cited in Steven Miller, *The Exhibitionists: a history of Sydney's Art Gallery of New South Wales*, AGNSW, 2021, p 181.

2 Alison Croggon, 'The desertification of Australian culture', *The Monthly*, October 2019.

3 The Home program was founded through a partnership between the Art Gallery; The Arts Unit, NSW Department of Education; Wiradjuri community at Wagga Wagga; and Wagga Wagga Art Gallery.

4 Student, Wilcannia Central School, 2020.

5 Artist–educator for Art Pathways, 2019.

6 A fig tree was planted in 1984 on behalf of Joseph Beuys as part of an environmental art project initiated at Documenta7, 1982.

7 'In conversation: Adrián Villar Rojas and Hans Ulrich Obrist', The Phaidon Folio, *Artspace*, 25 February 2020, artspace. com/magazine/interviews_features/ book_report/in-conversation-adrian-villar-rojas-and-hans-ulrich-obrist-56474, accessed 10 March 2022.

Embracing the changing needs of art

Steven Miller and Carolyn Murphy

'The Sydney Modern Project has not only been about the development and expansion of the Art Gallery's physical spaces; it has also provided the opportunity to rethink what a museum might be in the twenty-first century.'

If your work will change, then the entire structure of the museum should change as well ... I think that communication is necessary between living artists and museums that have works in their collection. It has to become a constant dialogue.

—Marina Abramović[1]

FIFTY YEARS AGO, IN MAY 1972, the Art Gallery of New South Wales opened a new wing. It was the first major addition to occur since 1909 and gave a permanent face to the Art Gallery's northern elevation. Architecture, however, was not the focus of the press in reviewing this extension. The *Sydney Morning Herald* titled its feature piece 'The Art Gallery of New South Wales: a new lease of life',[2] noting that the new building gave the Art Gallery an opportunity to rethink its role in a world that had changed radically since its establishment in 1871. An imposing new building has now opened alongside the original building and its extensions. Expanded exhibition and educational spaces, an art garden and wonderful terraced views over the harbour, all delivered through the elegant architecture of Kazuyo Sejima and Ryue Nishizawa and their team at SANAA, are only part of what this development means for the Art Gallery in 2022. This moment of transformation – a new lease of life – is even more far-reaching than what was experienced fifty years ago.

Transformation is occurring at all levels of Art Gallery life, from the public-facing activities of collecting and exhibiting to the less visible areas of conservation and research. The parliamentary Act that governs the Art Gallery defines its two major purposes as developing and maintaining a collection of works of art and increasing knowledge of art.[3] Conservation and research have always been at the core of the Art Gallery's mission. The conservation department and the library and archive have contributed to a distinctive institutional culture and make a significant and lasting contribution beyond 'the old triad of success factors that continue to plague most museums – the number and marketability of exhibitions, the number of visitors, and the number of members'.[4]

Both departments received new facilities as part of the Art Gallery's physical expansion: an additional conservation studio in the new building and an entire new library and archive as part of the refurbishment of the lowest level of the original building. This physical expansion has been accompanied by a broadened approach to conservation that moves beyond a narrow focus on the physical integrity of the artwork to encompass its conceptual integrity and the values and meanings ascribed to it by artists and communities. Conservation now values the intangible values and meanings of artworks. This shift has framed approaches to conserving time-based art and managing installation and performance works, for instance, as well as to archiving and giving research access to these artforms. Through research and practice the Art Gallery is also developing its expertise in digital preservation and aims to become a national leader in this specialist field that is now essential for the care of digital art and archives. The opportunity offered by this exciting moment in

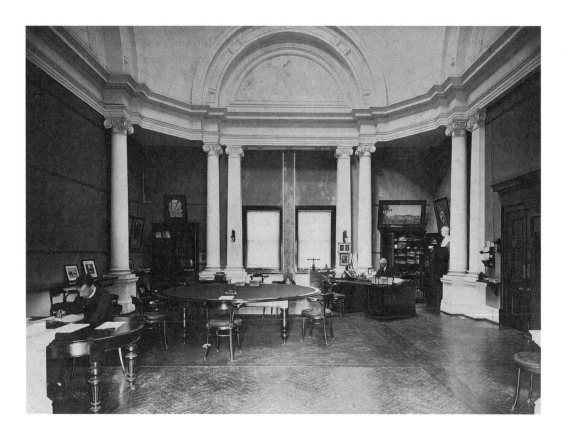

the Art Gallery's 150-year history, at the completion of the Sydney Modern Project, has encouraged us to meet the changing demands of art, artists and the digital world as we build on our shared history.

Freelance 'restorers', along with artist–creators, worked on deteriorating works in the Art Gallery's collection from the first decade after works were acquired in 1874. It was not until 1899, when the Art Gallery was officially incorporated, that a permanent conservator was appointed. And although book acquisitions were made from 1884, the first professional librarian was appointed only in 1959. By this time, the Art Gallery's professional staff comprised merely the director and his deputy (both artists), a curator (designated as a professional assistant), a conservator and a librarian.

The Art Gallery of New South Wales was established as the first freestanding public art museum in Australia exclusively devoted to art. Although the National Gallery of Victoria had been founded ten years earlier in 1861, it was part of a multi-part institution encompassing a science museum, a 'national' gallery and a library, a structure followed in all colonies apart from New South Wales. Such independence played some part in the vigorous establishment of the museological functions of conservation and research at the

The boardroom, director's office, archive and library were all housed in one room of the Art Gallery when this photograph was taken in 1914

The Art Gallery of NSW:
A new lease of life

Souvenir

This cut-away drawing of the Art Gallery shows the new wing and the renovated front section of the building. The extension has doubled the gallery's hanging space. The layout is described on the next page: see "New approach in Captain Cook wing."

Art Gallery in Sydney. In 1899, when the Art Gallery was officially incorporated, a permanent conservator was appointed. In 1933 a conservation laboratory was built at the back of the Art Gallery, the first of its kind in Australia. Refitted several times, this remained in use for thirty-five years.

Since that time, and following the passionate support of early board members, Art Gallery directors have shown strong personal interest in developing the Art Gallery's conservation department and library. When he began as director in 1945, Hal Missingham appointed William 'Bill' Boustead, a key figure in the establishment of art conservation in Australia. Establishing a 'first class art library' was another of Missingham's priorities.[5] An artist himself, he was sensitive to the desire of fellow artists to access up-to-date publications and periodicals. In the mid 1950s a gallery adjacent to a prints and drawings study room was converted into a library.[6] Artist Judy Cassab noted in her diary that it was 'open every Thursday. I look at art magazines from New York, Belgium, France, Germany and Japan.' It was here that she came to see that 'the whole world has turned abstract expressionist'.[7]

When Bill Boustead returned from a period of training in England in 1952, he introduced the application of scientific principles and materials analysis to the discipline of art conservation at the Art Gallery.[8] By 1958 the Art Gallery had hired additional conservation staff and upgraded its conservation facilities to include new microscopes and other technical equipment, a darkroom and a studio for prints and drawings (as well as paintings).[9] The conservation department had the support of a Scientific Advisory Council and was

Above: A *Sydney Morning Herald* article from 3 May 1972, illustrating the Art Gallery's new wing designed by Andrew Andersons

Opposite: The Art Gallery conservation laboratory, with Bill Boustead using micro-photography equipment (right), and an intern at the vacuum hot-press table (left), c1960

Embracing the changing needs of art

selected as a provider of training for overseas students. Boustead also managed a cadet restorer program at the Art Gallery with state government support, providing an important training program for conservators in Australia.[10]

Several decades later, a committee of inquiry concerning national collections chaired by the Sydney businessman Peter Pigott noted that of the seventy collecting institutions it had visited, in most the collections were poorly stored and conserved, 'except at the Art Gallery of NSW and a few other institutions'.[11] At that time there were only ten conservators working for these institutions who could be considered properly trained. The Art Gallery was one of the few institutions where 'scientific conservation' was seen to be practised.[12] The report could have also noted that the Art Gallery had been advanced in developing research resources. As the Melbourne art historian Franz Philipp had noted when researching his book on artist Arthur Boyd, 'there is no systematic collection of art exhibition catalogues ... to compare with that of the Sydney Gallery'.[13]

Before coming to Sydney in 1978, Edmund Capon (director 1978–2011) had been assistant keeper of far eastern art at London's Victoria and Albert Museum. He claimed that his office there was originally a cupboard, a circumstance that led him to decamp to the National Art Library, which was housed in a magnificent nineteenth-century reading room at the museum. His curatorial reliance on

library collections from that time convinced him that no art museum could achieve excellence in collections and programming without such a resource, a point also made on numerous occasions by his successor Michael Brand (director 2012–). The library doubled in size under Capon, took on new permanent staff, and moved twice. Under Brand it has moved again and further increased in size as part of the Sydney Modern Project.

In the 1980s and 1990s the conservation department also expanded to include conservators specialised in the care of paintings, frames, objects and works on paper, and a scroll-mounting studio was established for the treatment of Asian screens and scrolls.[14] In 1987 the increasing professionalisation of conservation was recognised in a cultural institutions agreement in New South Wales that stipulated that conservators should either have relevant tertiary qualifications or a minimum of five years' experience without formal qualifications.[15]

Above: In 1994 the Art Gallery's research library and archive were made fully accessible to the public in a repurposed grand basement court

Opposite: Conservators Analiese Treacy (left) and Sarah Bunn in the paper conservation studio of the original building preparing artworks for display

To further develop its technical capabilities for the examination of artworks, the conservation department began to purchase analytical equipment with the support of the Conservation Benefactors. This group of Art Gallery of New South Wales Foundation members was established in 1993 to support conservation programs, research and projects. In 1994 the group made its first significant purchases – a stereomicroscope and X-ray equipment – and in 1995 purchased an infrared reflectography vidicon system to detect underdrawings

Embracing the changing needs of art

on paintings.[16] It also supported the department's purchase of a Fourier-transform infrared spectrometer,[17] which enabled the analysis of organic materials such as paint binders and plastics, improving the department's ability to undertake detailed technical analysis.[18] In 2003 the Art Gallery designed and built an expanded suite of conservation studios on its upper level, with space for each area of specialisation and facilities for the technical examination of artworks.

Conservation science at the Art Gallery has continued to develop in recent years to address the challenges posed by new art materials. The increasing use of plastics by artists during and since the twentieth century means that there are hundreds of installations and sculptures in the Art Gallery's collection with plastic components. Margel Hinder's *Revolving construction* from 1957 is currently identified as the earliest example. In 2017, the Art Gallery partnered with the University of Melbourne and other collaborators on the Polymuse project to develop a national framework for the management of malignant plastics in museum collections.[19] This project recognised the challenge confronting museums with increasing plastic or polymer-based materials in their collections but inadequate research to support the development of approaches to their preservation. Focused on the scientific analysis of plastic collections to identify materials and develop approaches to their care, this project has made a significant contribution to the care of at-risk artworks in the Art Gallery's collection.

Traditionally libraries and archives have stored knowledge in analogue formats. While the Art Gallery's library and archive supports the conviction that meaningful interaction with physical objects remains essential to human flourishing, its new facilities have been developed at a time when the digital age has brought new tools for collecting, researching, managing and accessing resources, as well as a proliferation of digital artforms.[20] Thousands of items from the Art Gallery's archive have been made available online for the first time. To achieve this, extensive work was required to adapt object-based collection management and develop a robust digital preservation system to ensure the long-term care of the collections. Between 2020 and 2022 several appointments were made in recognition of the significant growth of the Art Gallery's digital art and archive collection: an archivist of digital and special collections, and a digital preservation manager and assistant. The Art Gallery is committed to making its digital archives the richest and most accessible in Australia.

Twentieth-century collection management proceeded from the idea that artworks are physical objects created by artists. In the twenty-first century, the increasing collection of installation, time-based art and performance art with ephemeral and variable elements meant that this assumption no longer provided a sound foundation for collection care. The Art Gallery's growing collection of time-based art (TBA) – durational works including film, video, kinetics, software-based works, slide and sound installations as well as iterative and performance works – needed specialist attention.[21] The Art Gallery had been accumulating such works since the 1970s, in parallel with artists' use of ever-changing technologies, but their care had not been the subject of focused conservation projects or research and the skills to undertake this work were not available on staff. To address this gap, and with more such works coming into the collection during the Sydney Modern Project, the Art Gallery, with support from the Conservation Benefactors and the Women's Art Group, embarked on a TBA conservation project in 2015.

This project led to a complete rethinking of collection management, which had seen artworks as physical objects. The new approach recognised that works of art are increasingly flexible, variable, ephemeral and reproducible and that contemporary art, which includes traditional media alongside time-based, installation and performance works, requires new thinking from conservators and collection managers.[22] The project developed the practice of time-based art conservation at the Art Gallery and more generally made a significant contribution to the development of this specialised field in Australia. This work culminated in the creation in 2018 of the first TBA conservation position in an art museum in Australia. In 2019, to share our work with the museum community, the Art Gallery, in collaboration with Tate in London, designed and hosted the symposium and workshop 'Towards a flexible future: managing time-based artworks in collections'. With delegates from fifteen cultural institutions from Australia, New Zealand and Hong Kong, this workshop 'represented the largest gathering in Australasia to

A visitor interacting with
teamLab's digital work
Flowers and people – gold
2015 during the exhibition
*Time, Light, Japan: Japanese
Art 1990s to Now* in 2017

date of professionals from within the sector dedicated to the care, management and future of TBA works and collections'.[23]

Following from this work, and in acknowledgement of the increasing importance of live art practice in the programming associated with the Sydney Modern Project, in 2021 the Art Gallery became a partner in an international research project committed to better understanding choreographic practice within museums.[24] This allowed the Art Gallery to take the process of change further: to interrogate conservation in relation to choreography, to look at how this might be similar to – or differ from – managing installation, time-based and other performance works. It involves reviewing our approach to all live practice across all contexts – events, programs, exhibitions and acquisitions. It involves looking at how we support the precarity or instability of live art and how we care for and support the people associated with a work. It involves developing new processes to ensure we manage and document such works in a sustainable and appropriate way. The overarching aim is to ensure that we better serve and represent artists and their work.

The shift away from defining artworks simply as physical objects is also significant to ensuring the appropriate care of art practices embedded in communities and cultures. An increasing focus on the 'social process' of conservation ensures that multiple stakeholders are consulted and that cultural conservation is integral to the care of collections.[25] In 2022, in accordance with the Art Gallery's

Objects conservator Kerry Head
cleaning Michael Parekōwhai's
sculpture *The English Channel*
2015 in the Grand Courts

Embracing the changing needs of art

Aboriginal and Torres Strait Islander Action Plan, the Art Gallery employed an Indigenous conservator to contribute to the conservation of its Aboriginal and Torres Strait Islander collections and projects, to collaborate on the development of a cultural conservation framework for the Art Gallery and to advocate for the importance of cultural conservation in the Australian conservation community.[26]

The way archival holdings are collected, managed and accessed has also undergone a radical transformation in the last ten years. Archives are now included within an expanded idea of what constitutes the Art Gallery's collection. Their capacity to broaden art-historical narratives, document movements and artforms that are poorly represented in curatorial collections and challenge the magisterial voice of the institution is a great strength. This was recognised when the Art Gallery became the first public art museum in Australia to appoint a professional archivist in 1995 and a dedicated archivist of Aboriginal and Torres Strait Islander collections in 2016.[27]

The Art Gallery's original building with its extensions has become a shared responsibility in recent years, with conservation, building services and other departments working together to ensure its heritage value is preserved while at the same time facilitating its role in providing spaces for the public enjoyment of arts and culture. The development of the Art Gallery's approach to using the huge underground Tank space in the new building (one of the naval oil tanks from the Second World War) has highlighted the importance of documenting and managing heritage sites that also serve as contemporary cultural spaces.

In 2022 an additional conservation studio was created in the new building. This space was designed with the changing needs of the Art Gallery's collections in mind: its open plan, higher ceiling and improved access make it better able to accommodate large contemporary works. A hoist-rail system, as well as ceiling rigging to enable the installation of audiovisual hardware, will facilitate the conservation of large heavy artworks as well as time-based and installation works.

As part of the Sydney Modern Project, the original building was also revitalised, with the library and archive rehoused in beautiful new facilities designed by the architectural firm of Tonkin Zulaikha Greer in Andersons' 1988 extensions. This move, and the rethinking of the role, services and collections which it occasioned, was the most important transformation of the Art Gallery's library and archive in its history.

Many aspects of this transformation were informed by current reflection upon the evolving role of museums in the wider cultural landscape. A surprising omission from both the theory and practice of museum design – an otherwise vibrant area of architecture over the last thirty years – has been the physical presence and accessibility of libraries and archives. Even when institutions proclaim the centrality of these collections, such a mission is usually not reflected in their buildings.[28] In contrast, the Art Gallery's expanded library and archive facility reflects the significant thinking and financial and physical investment it has made to honour their important role.

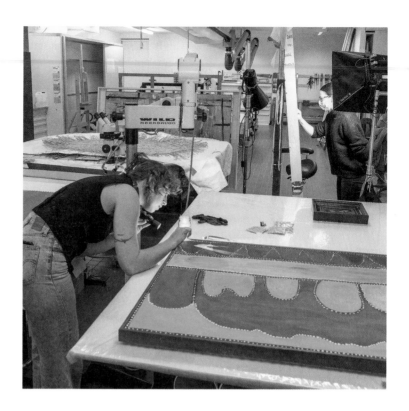

The capacity for visitors to browse the book and periodical collections on open shelves is an important feature of the Art Gallery's new library, named in honour of Edmund Capon and his wife Joanna. This emerged as a top priority from wide consultation with artists and researchers in the planning stages. More than a few noted that creativity often involves the serendipity and chance discoveries that open shelves facilitate. Over a hundred thousand books and twenty thousand periodicals are consequently available for browsing. One in every five items is in a language other than English and many more are bilingual. Open access is a departure from current trends, where the cost of space has seen collections put into storage, to be accessed only on request. The open-access model, however, supports recent museological thinking about the strategic role of space in shaping the visitor experience, promoting an interactive model of encounter that sees learning arising from meaningful experiences.[29]

The Art Gallery's new library and archive is adjacent to the Domain Theatre, the refurbished Art Gallery Society's Members Lounge and a new Volunteers Hub – part of a zone of encounter with a wide range of visitors. From a shared lobby linking the facilities, the library and archive are always visible through glazed walls. The library entrance is designed to encourage casual visits. No reader's card is required. An information desk is located at this point, with the more traditional reference desk at the impressive double-height reading room at the southern end of the library.[30] A works-on-paper study

The Art Gallery's first Aboriginal and Torres Strait Islander conservator Juanita Kelly-Mundine, a west Bundjalung and Yuin woman, treating Queenie McKenzie's *Untitled* c1994, and paintings conservator Madeleine Ewing

Embracing the changing needs of art

room overlooks the reading room, creating a visual link between all the Art Gallery's research facilities.[31]

To reach the reading room, a visitor must pass through the archives and rare collections housed at the centre of the new facilities. These are enclosed for security but still visible, and have their own smaller reading room. Incorporating these collections at the heart of the new research facilities reproduces in Sydney what has been done so spectacularly at the Beinecke Rare Book and Manuscript Library at Yale University and at the British Library. The Art Gallery has the largest holdings of art-related archives in Australia.[32] Director Michael Brand launched these collections as the National Art Archive in 2015. The new facilities give them a concrete physical presence for the first time.

The Art Gallery was famously described by artist Arthur Streeton in 1920 as a 'temple' of art.[33] Today it aims to be more like a forum, promoting reflection and dialogue while also keeping in mind the broader responsibilities and powers of museums as social, inclusive and accessible institutions. One of the most exciting ways the Art Gallery is extending access is by providing a dedicated children's art library, supported by trustee Ashley Dawson-Damer – the first such library in Australia and one of the few in the world.

The Sydney Modern Project has not only been about the development and expansion of the Art Gallery's physical spaces; it has also provided the opportunity to rethink what a museum might be in the twenty-first century. This has led to significant changes to the ways in which research and collection care are thought about and managed. Physical and digital objects as well as flexible, variable, ephemeral, reproducible and live art practices all need to be considered. Through the development of new spaces, new staff roles and new policies and procedures, this transformative project is ensuring that the Art Gallery maintains its reputation as a forward-thinking, collaborative participant in the preservation and understanding of Australia's art and culture.

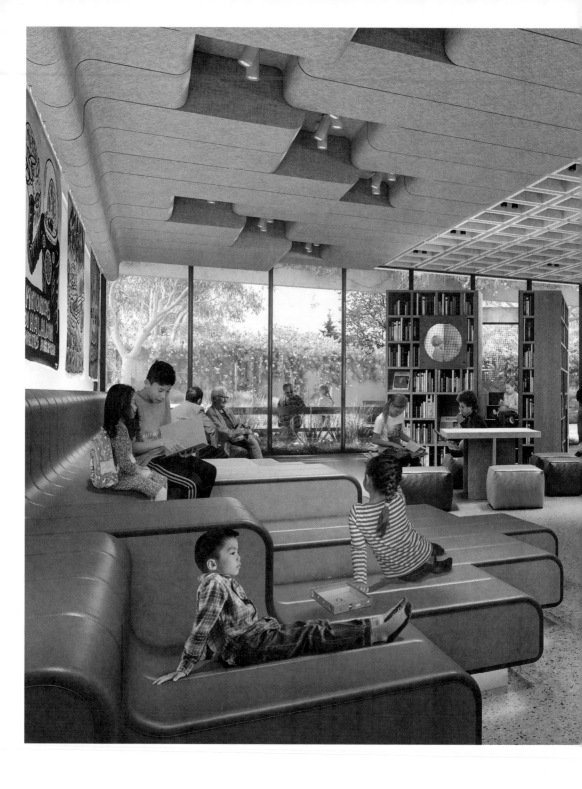

Architectural render of the new
children's art library designed by
Tonkin Zulaikha Greer Architects

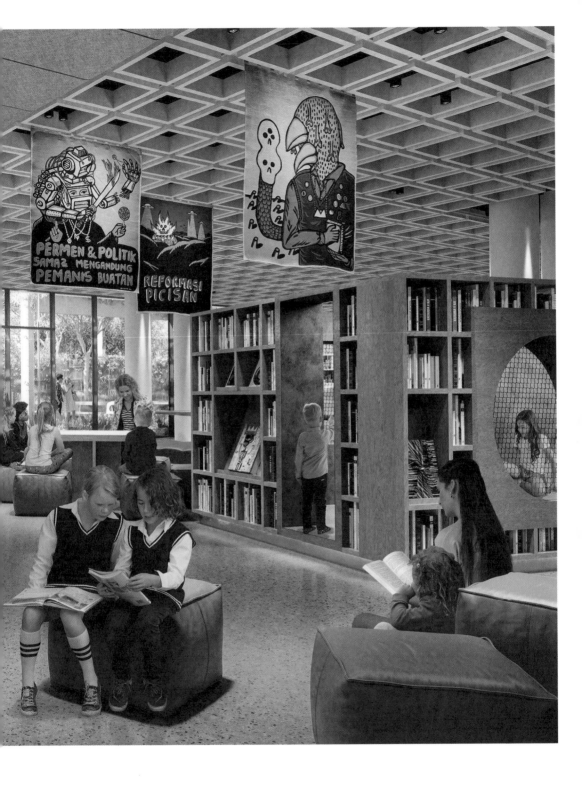

1 Marina Abramović, quoted in Frederika Huys, 'Keeping performances alive: Marina Abramović's views on conservation and presentation' in Lydia Beerkens et al, *The artist interview: for conservation and presentation of contemporary art: guidelines and practice*, Jap Sam Books, Heyningen, 2012, p 63.

2 *Sydney Morning Herald*, 3 May 1972, p 13.

3 *Art Gallery of New South Wales Act* [1980], no 65, clause 7, Principal objects of the Trust.

4 Robert R Janes, *Museums in a troubled world: renewal, irrelevance or collapse?*, Routledge, London, 2009, p 132.

5 Harry Tatlock Miller [?], 'A breeze blew into the Gallery', *The Sun* (Sydney), 9 Sep 1945, p 4.

6 This library was in the original 1885 AGNSW building designed by Horbury Hunt.

7 Judy Cassab, *Judy Cassab diaries*, Alfred A Knopf, Sydney, 1995, entry for 31 May 1957, p 75.

8 The scientific approach to conservation had developed internationally in the years after the Second World War. See, for instance, Paul Philippot, 'Restoration from the perspective of the humanities', in Nicholas Stanley-Price et al, *Historical and philosophical issues in the conservation of cultural heritage*, Getty Conservation Institute, Los Angeles, c1996, p 217.

9 William Boustead, 'The conservation department of the New South Wales Art Gallery, Australia', *Studies in Conservation*, vol 5, no 4, 1960, p 121.

10 Alan Lloyd, 'The Boustead years 1946–1977', in Carl Villis and Alexandra Ellem (eds), 'Paintings conservation in Australia from the nineteenth century to the present: connecting the past to the future', contributions to the 11th AICCM Paintings Group Symposium, National Gallery of Victoria, Melbourne, 2008, pp 59.

11 Australia. Committee of Inquiry on Museums and National Collections; PH Pigott; Australia. Planning Committee on the Gallery of Aboriginal Australia; Gallery of Aboriginal Australia: report of the Planning Committee, *Museums in Australia 1975: report of the Committee of Inquiry on Museums and National Collections including the report of the Planning Committee on the Gallery of Aboriginal Australia*. Australian Government Publishing Service, Canberra, 1975, p 64.

12 *Report of the Committee of Inquiry on Museums and National Collections, including the Report of the Planning Committee on the Gallery of Aboriginal Australia (the Pigott Report)*, AGPS, Canberra, 1975, p 64.

13 Franz Philipp, letter to Paulette Jones, 14 Mar 1966. National Art Archive, AGNSW.

14 See Malgorzata Sawicki, 'New challenges for frames conservation in Australia: a pragmatic vision of future hands-on training, *AICCM Bulletin*, vol 41, no 1, 2020, pp 61–68 and Rose Peel, 'Sun Yu obituary', *AICCM National Newsletter*, no 114, Mar 2010, p 5.

15 Public Service Board of NSW and the Public Service Association of NSW, *Conservators, cultural institutions agreement No 2504*, 1987, p 3, viewed 28 August 2021, psa.asn.au/wp-content/uploads/2017/11/AG87_2504.pdf

16 In 1999, AGNSW partnered with National Gallery of Australia, Artlab Australia, National Gallery of Victoria, Queensland Art Gallery and the University of Canberra in an Australian Research Council collaborative research project on the use of infrared reflectography to examine artworks. This project ensured that partner organisations were equipped with infrared imaging analytical equipment and contributed to the development of skills and experience across the Australian art-conservation sector. This project culminated in the exhibition *Seeing Red: The Art and Science of Infra-Red Analysis* in 2001–02 at the National Gallery of Australia and a dedicated issue of *The Melbourne Journal of Technical Studies in Art* in 2005.

Embracing the changing needs of art

17 The Conservation Benefactors supported the purchase of a Fourier transform infrared spectrometer in 2002 and then again in 2019 when a new FTIR was purchased to replace the superseded 2002 model.

18 This equipment enabled AGNSW to partner with University of Melbourne, University of Queensland, Art Gallery of New South Wales, National Gallery of Victoria, Artlab Australia, Queensland Art Gallery, Tasmanian Museum and Art Gallery, Getty Conservation Institute, National Art Gallery of Malaysia, Jorge B. Vargas Museum at the University of the Philippines, Silpakorn University Thailand, Southeast Asian Regional Centre for Archaeology and Fine Arts and Tate for *Twentieth Century in Paint*, in an Australian Research Council Linkage Project. This project examined new media, pigments, dyes and additives used by artists in the twentieth century in Australia and Southeast Asia. At AGNSW a major study was undertaken on the work of Sidney Nolan, using the materials archive acquired from Jinx Nolan in 2006.

19 For further details on the Polymuse project see polymuse.net.au/the-project, viewed 29 Aug 2021.

20 Oliver Grau, Wendy Coones and Viola Rühse, *Introduction to museum and archive on the move: changing cultural institutions in the digital era*, De Gruyter, Berlin, 2017, p 9.

21 Asti Sherring, Carolyn Murphy and Lisa Catt, 'What is the object? Identifying and describing time-based artworks', *AICCM Bulletin*, vol 39, no 2, 2018, pp 86–89.

22 Carolyn Murphy, 'Physical object or variable, flexible, ephemeral and reproducible: the management and care of contemporary art collections in 2020', *AICCM Bulletin*, vol 41, no 1, 2020, pp 49.

23 Asti Sherring, 'Divergent conservation: cultural sector opportunities and challenges relating to the development of time-based art conservation in Australia', *AICCM Bulletin*, vol 41, no 1, 2020, pp 71–72.

24 The research project, entitled *Precarious movements: choreography and the museum*, is supported by an ARC Linkage Grant and hosted by the University of New South Wales with partner organisations AGNSW, Monash University Museum of Art, National Gallery of Victoria, Tate UK, as well as independent artist Shelley Lasica.

25 On social process, see Jane Henderson, 'Beyond lifetimes: who do we exclude when we keep things for the future?', *Journal of the Institute of Conservation*, vol 43, no 3, 2020, p 196; on cultural conservation see Lily Bennion and Juanita Kelly-Mundine, 'Clashes in conservation: First Nations sites, communities and culture in Australian cultural heritage management', *Journal of the Institute of Conservation*, 2021, vol 44, no 3, p 171.

26 The appointment of Juanita Kelly-Mundine to the role of Indigenous conservator was initially funded by the Conservation Benefactors. It was made an ongoing Aboriginal and Torres Strait Islander identified position in July 2022.

27 Shari Lett was appointed archivist of Aboriginal and Torres Strait Islander collections with the support of Geoff Ainsworth and Jo Featherstone.

28 The libraries and archives of many museums rehoused as part of a new build or extensions – for instance, those at the Museum of Modern Art and Whitney Museum in New York, SFMOMA in San Francisco and the Stedelijk Museum in Amsterdam – are clinical, office-like spaces.

29 See, for instance, Andrea Witcomb, *Re-imagining the museum: beyond the mausoleum*, Routledge, London, 2003; GE Hein, 'Museum education' in Sharon MacDonald (ed), *A companion to museum studies*, Blackwell, Oxford, 2006, p 348.

30 For many years the AGNSW library has also offered online reference services. A typical year would see around 1200 of these requests, 30 per cent from metropolitan Sydney, 20 per cent from regional New South Wales and the remaining half from interstate and overseas.

31 This reading room continues a traditional nineteenth-century connection between a library and a 'cabinet' of prints and drawings, maintained at the Rijksmuseum in Amsterdam and the Royal Collections at Windsor.

32 Although the archive of Max Klinger was offered to the Art Gallery in 1955, it is the bequest of Margaret Preston's library and archive in 1963 that is considered foundational. Desiree Klinger, the daughter of Max Klinger, offered her father's archive to the Art Gallery. Deputy director Tony Tuckson advised that copies be made to be kept in the Art Gallery's library and that the originals be donated to the Archiv für Bildende Kunst in Nürnberg

33 Arthur Streeton, 'National art collections. A breezy criticism. Melbourne and Sydney compared', *Argus*, 21 Aug 1920, p 6.

Looking forward: contending with the contemporary

Isobel Parker Philip

'To collect and to display contemporary art is to move *with* mutability and flux. It is to participate in an unfolding.'

13

THE TERM 'CONTEMPORARY' HAS BEEN ANALYSED in art historical discourse again and again. When does the 'contemporary' start? Does this date need to be reconsidered? Does the contemporary constitute a discrete art movement? Does it have unique aesthetic or conceptual attributes? I'm less concerned with justifying nomenclature or demarcating artistic categories than I am in the *state* of the contemporary. The state of the just surfacing, of the urgent, of the in-step-with-the-world. Because it's here that we locate the vitality: the opportunity to challenge and to change.

The Sydney Modern Project calls forth such vitality. It invites and invokes change. The singular and purpose-built architectural space of the Art Gallery of New South Wales' new building – designed to accommodate the breadth, nuance and experimental impulse of contemporary practice – presents us with a chance to reflect on what it means to collect and display contemporary art. It offers us, that is, both the momentum and the context to attend to, and interrogate, the elastic and generative qualities of the contemporary.

To collect and to display contemporary art is to move *with* mutability and flux. It is to participate in an unfolding. Indeed 'contemporary' itself can only ever be a provisional label. At the Art Gallery, the contemporary collection will eventually become absorbed into the historical one, carrying with it the nuances and felt reality of the times in which it was formed.

In adopting flux and change as a lens through which to frame an institutional approach to the contemporary, it might seem as if we're abandoning core principles. A collecting institution's primary purpose is to preserve things for posterity. To conserve an artwork against the threat of deterioration and change. While by and large this may be true, for an institution is always accountable to the items in its care (excepting works that intentionally invite entropy), the collection itself is neither inert nor fixed. After all, the Art Gallery saw itself as participating in 'contemporary' practice in the nineteenth century, with its first director Eliezer Levi Montefiore laying the foundations of the institution's collecting practice by insisting that the limited acquisition funds be spent on works by living artists. His engagement with the contemporary looks very different to that of today. But so it would. History does not stand still. Defined by the artworks it contains, a collection is in a perpetual state of motion. It is an active organism.

Turritopsis dohrnii is a species of jellyfish that is thought to be biologically immortal. Colloquially known as the immortal jellyfish, *T. dohrnii* begin life as tiny larvae that settle on the sea floor to form a cluster of polyps. Multiple jellyfish emerge from these polyps to become free-floating organisms that retain the ability to revert to the polyp stage if exposed to environmental change, age or physical threat, through a process of cellular transdifferentiation in which the cells themselves transform completely. This ebb and flow between different states can go on indefinitely.

Perhaps there is room to think of a similar ebb and flow taking place in the way the contemporary as an idea functions within an

institution. Like the jellyfish, the contemporary can take us back to first principles. It's cellular: the contemporary can ask us to rethink patterns of growth and propagate entirely new clusters of thought. Because, we might remind ourselves, contemporary art is not just about the shiny and the novel; it is about opening up new ways of thinking, about contending with the past while engaging with the present.

To commit to the contemporary is to commit to change. For an institution to genuinely engage with contemporary art it must allow the immediate – the instant, the present tense – to inform its methodology. This is not a question of progress or efficiency. It is an ethical imperative. The critical discourse that shapes society at large should find itself reflected in the questions that an institution asks itself: questions around whose art it represents, whose voices it profiles and what image of the world it projects. A contemporary collection, then, should be capacious and expansive, encompassing multiple ideas and histories. It should speak of, and to, different lived experiences while being attentive to the specificity of context. To the inheritance of colonisation and the ongoing structural inequalities that disenfranchise and endanger First Nations peoples, culture and Country. To the marginalisation of people and communities who have been left out of the histories told by institutions such as this one in the past, among them people of colour, women, the LGBTQIA+ community or those with a lived experience of disability. A contemporary collection has an obligation to everyone.

A collection that embodies these ideals would not dovetail neatly. It would amplify difference. It would sprawl and spread, never aiming at coherence or comprehensiveness. Not an inventory, but a scattered network.

The collective noun for a large group of jellyfish is a bloom. This seems an apt analogy when one thinks of the hypnotic choreography through which these organisms move, billowing and contracting like a blossoming bulb, flowering at high speed. Such poetic terminology also lends nuance to the proposition being gently offered here. It's perhaps useful to consider the sprawl of the contemporary collection as akin to expansive pollination. Because even though there is scatter and dispersal, there are still points of connection: instances of exchange where one thing precipitates another.

In the context of a collection, artworks sit in dialogue with each other. They rebound and reflect ideas, as if to form their own narrative. This is a narrative that changes as the collection grows and comes to encompass more and more voices. A narrative, then, that ebbs and flows; that remakes itself over and over by responding to its context, to what feels urgent or critical. The amassed artworks create their own environment, a field of ideas, images and concepts that is always expanding. An ecology of exchange that is always in motion.

With all this in mind, when interpreting or describing a collection it is imperative to resist any attempt to ascribe a singular story. Instead, we might look to moments of connection between works as eruptions of vitality and as a window into growth as it happens. For in looking at instances of connection or dialogue mapped across a collection,

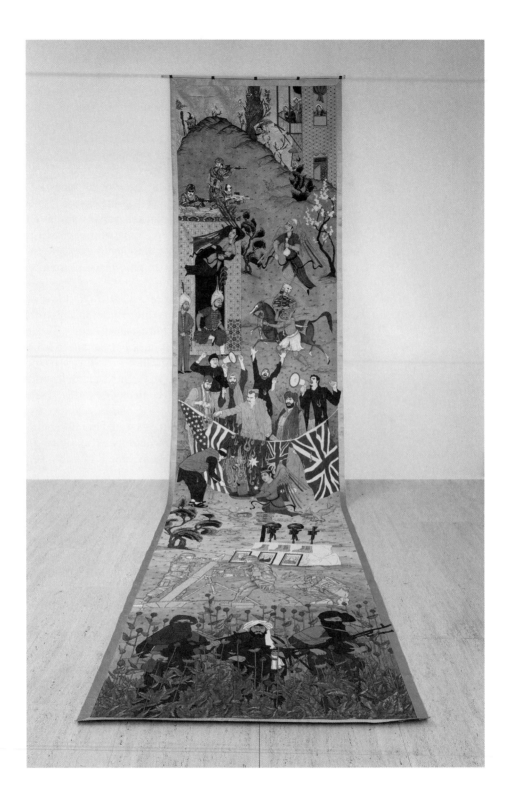

Khadim Ali *Untitled* 2019 from
the series *Flowers of evil*

Looking forward

we can locate a pathway while also recognising that it is still in the process of being formed. That the collection remains, and will always be, in a state of bloom.

The artworks explored here, many of which will be debuted during the opening of the new building and all being acquired with this context in mind, are not representative of the Art Gallery's contemporary collection in its entirety, nor do they constitute a list of its most significant works. Drawing on concrete and legible examples will inevitably contradict the very terms outlined here; terms we rely on in our approach to collecting and displaying contemporary work in new, reconceived spaces: namely flux, sprawl and irreducibility. But this is the inherent paradox of exhibiting and collecting contemporary art in a museum. In illustrating how a sense of urgency binds and shapes the contemporary collection – and thus revealing the collecting strategies at play – we risk making things look neater than they are. This text offers one framework, one pathway, through the ever-expanding field. By making connections between works, it plots a course that makes sense of material that is mutable. There is tension here, for the institution and the text, in trying to contain the uncontainable. Yet it is only through actual examples that we can appreciate how the present tense can come to animate a collection and a place.

If urgency is a metric that inflects the collection and shapes how it speaks to us, it's worth noting that I'm writing this just days after the Taliban seized control of Afghanistan, in August 2021. Against this devastating backdrop, Khadim Ali's mesmeric portrayal of the complex history of violence in the Afghan region in his epic textile work *Untitled* 2019, from the *Flowers of evil* series, assumes a newfound resonance. An Afghan Hazara artist born in Pakistan and based in Sydney, Ali uses history and fable to anchor an incisive commentary on contemporary life in Afghanistan and Pakistan. His work is a compelling example of the indivisibility of the categories of 'Australian' and 'international' art – a condition that underpins all the new displays conceived for the Art Gallery's transformed campus. In *Untitled*, demons and winged figures populate the same elaborately detailed pictorial field as patent allusions to contemporary conflict: Taliban fighters wade through poppy fields; United States, British and Australian flags burn; Western soldiers load ammunition. This densely layered storyboard, whose composition derives from that of Persian miniatures, is a pointed indictment of the mythology of heroism and its deployment to justify war, firmly positioning the West as culpable and complicit in this cycle of violence. Much of Ali's work draws reference to the tenth-century Persian epic poem the *Shahnameh* (literally 'book of kings') c977–1010 CE by the poet Firdawsi. Ali is attentive to the way the poem has become symbolically charged, with its hero Rostam co-opted by the Taliban as an allegorical figurehead. In response, Ali has often inverted the hero/villain binary, using the image of the demon to represent displaced peoples like the minority Hazara community. In this work, mythological creatures look out from their perch onto a war zone.

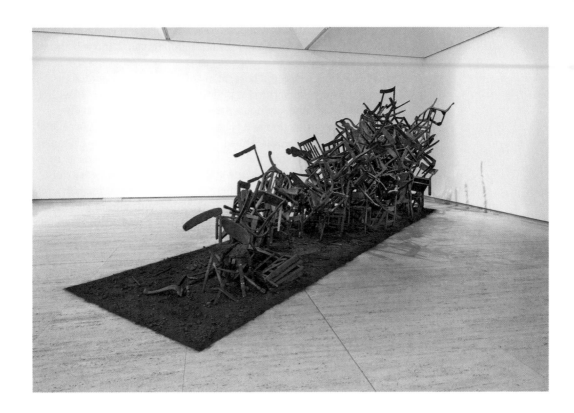

Violence sprawls, aided by more mythic figures. A pair of cupids carries a combat boot and a helmet. The deification of violence and the saviour complex is here exposed and undone.

Elsewhere in the collection we find works that remind us of the lived impact of such conflict. Rushdi Anwar's *Irhal (expel), hope and the sorrow of displacement* 2019 offers us a memorial to dispossession and displacement. Domestic wooden chairs are piled perilously high in an installation that surges off the gallery floor. But the chairs have been rendered utterly useless. They've been burnt to a crisp, some becoming little more than fragments of charcoal. Amassed, they form a monument to denied domesticity. An elegy to Anwar's own experience of exile as a Kurdish refugee living between Australia and Thailand, *Irhal* presents an image of collapse that is not without strength. Amid the chaotic, precarious tangle of fragmented forms, the chairs rise out from the charcoal-carpeted ground like a wave. This is a portrait of resilience as much as it is a study of destruction.

Consider this work alongside the haunting photographic portrait of Kurdish Iranian journalist and human rights defender Behrouz Boochani from Hoda Afshar's series *Remain* 2018 (opposite and p 33). Boochani stares out at us intently, set against a depthless black backdrop. To his left, flames lick the edge of the image, sending plumes of smoke into the nondescript space behind him. As in Anwar's work, fire here becomes allegorical. It is a potent agent of destruction but also renewal.

Above: Rushdi Anwar *Irhal (expel), hope and the sorrow of displacement* 2019

Opposite: Hoda Afshar *Behrouz Boochani – Manus Island* 2018 from the series *Remain*

Looking forward

In Afshar's photograph, the stark simplicity of the composition is a political act. Nothing eclipses, nor detracts from, the subject's presence. It is an assertive reaction against the insidious objectives of Australia's offshore detention policies, which render individuals invisible. The photographs and video work that constitute the *Remain* series were made with a group of stateless men, including Boochani, who remained on Manus Island, Papua New Guinea, after the Australian-run immigration detention centre closed in October 2017. In the film, through episodic fragments, these men recount their experiences in roving voice-overs that are by turns lyrical and brutal. Some recite poetry, some sing, some remember the riots and the suicides. As their stories unfold, the camera pans over a picturesque landscape of lush foliage and crystal-clear water. A 'green hell' as one man describes it. The abrupt collision of these two registers, the harrowing oration and the idyllic imagery, uproots the viewer. Though made in 2018, this work remains urgent today.

Pulling us into the past, Shireen Taweel's *tracing transcendence* 2018–21 maps lines of movement and migration that sit in direct dialogue with those explored by Anwar and Afshar. In this

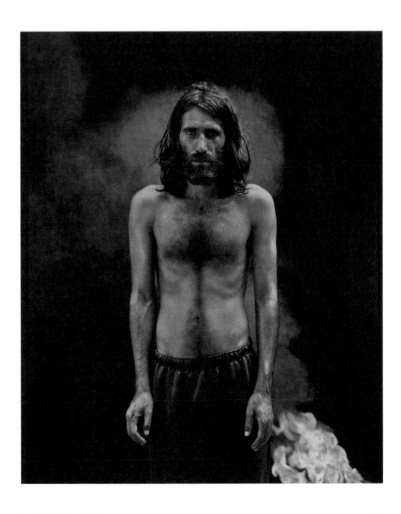

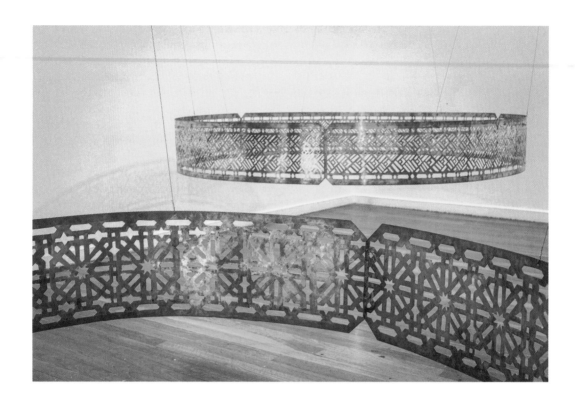

installation, three large copper rings, ranging in diameter from 180 to 240 centimetres, hang suspended from the ceiling. Each band of copper, a material commonly used in Islamic decorative arts, has been intricately hand cut. The motifs that pierce the copper, sending shadows skidding across the floor when the work is spot-lit, carry distinct cultural and symbolic weight. The designs etched into the smallest ring pay homage to the mosque built by cameleers from Afghanistan and elsewhere, in Broken Hill, on Wilyakali Country, New South Wales, in 1887. These cameleers transported supplies from cities to regional towns before the introduction of road and rail infrastructure in the 1920s. Though their history has been too often forgotten, the cameleers were integral to the survival of many colonial Australian townships and to the operative function of mines and goldfields. Taweel references this history, reinterpreting the patterns on the pressed tin that lines the interior walls of the mosque. Another of her copper bands features motifs derived from a cameleer's coat now held in the collection of the Migration Museum in Adelaide.

The mosque in Broken Hill is the only one built by the cameleers to have survived. The first mosque to be constructed in Australia, in Marree, on Dieri Country, is now an eroded ruin in the South Australian desert. The soundscape that accompanies Taweel's installation features field recordings taken at both sites, anchoring

Above: Shireen Taweel *tracing transcendence* 2018–21, at the 4A Centre for Contemporary Asian Art, Sydney, September 2020

Opposite: Marlene Gilson *Ballarat, my Country* 2020

Looking forward

the work in the historical past. But it is the third copper band that teleports us forward, representing an as-yet-unfixed site. It evokes what Taweel refers to as a future Australian mosque, a salute to the strength of community and a call to action.

In these four works, we're able to trace *one* through-line that animates the present era. There are innumerable such pathways we could take when mapping the collection and its sprawl. Pathways that illuminate other stories and reframe other histories. There's a pathway, for instance, that can be traced among works on display in both buildings around the time of the Sydney Modern Project's completion, which extends out from Taweel's tribute to the cameleers who transported goods to the goldmines and lands us at Marlene Gilson's painting *Ballarat, my Country* 2020, an exquisitely detailed tableau that depicts the goldmining township on Wadawurrung Country in Victoria and positions Aboriginal people as central to the scene. Murnong yam daisies are shown being harvested by an Aboriginal woman, an important reference to Indigenous farming practices. From here we can continue to Eugenia Lim's *New Australians (welcome stranger 1869/2015)* 2015, from the series

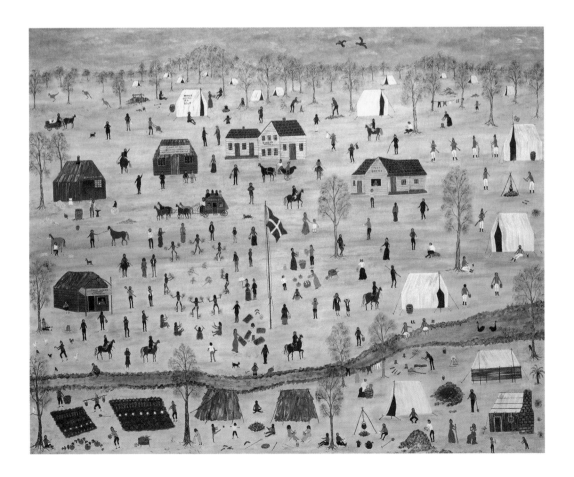

Yellow peril. In this photograph printed on gold foil, Lim appears in character as the Ambassador, a performative alter ego she often channels to explore identity and stereotype. Wearing a gold lamé Mao suit, the Ambassador poses for the camera in the mock nineteenth-century photography studio at the Sovereign Hill theme-park in Ballarat. Via this avatar, who sits holding a replica of Welcome Stranger, the 72 kilogram gold nugget discovered on the Victorian goldfields in 1869, Lim inserts herself into this historical episode to draw attention to the significant, yet overlooked, presence of Chinese migrants during the Australian gold rush, counteracting the whitewashing of this nation-building narrative.

From Lim's historical role-play, a thread extends to Simryn Gill's *Eyes and storms* 2012, a series of aerial photographs of open-cut mines that read as deep scars in the landscape, and then onto other works that contend with myriad ways in which the land has been extracted and exploited. There are James Tylor's daguerreotypes from the series *Terra botanica II* 2015 that draw a poignant analogy between botany and imperialism, showing native plants stripped from their natural environment and turned into specimens, their Latin names eclipsing their Indigenous ones. Then there is Yhonnie Scarce's *Death zephyr* 2017, a vivid evocation of the poisonous clouds that rained down on the land during the nuclear tests carried

James Tylor *Banksia ericifolia* 2015, from the series *Terra botanica II*

Looking forward

out by the British and Australian governments in Maralinga, on Pitjantjatjara/Yankunytjatjara Country, South Australia, during the 1950s and 1960s (see p 226). The same clouds whose fallout has had catastrophic consequences for the Aboriginal communities to whom the land belongs and who were displaced from Country because of this noxious undertaking. Scarce's cloud is made from a swarm of suspended glass yams, each one representing a person. The two arresting and monumental paintings by Betty Muffler and Maringka Burton that were included in the 2021 edition of *The National: New Australian Art*, both titled *Ngangkari ngura (Healing Country)* 2020, relate to the healing of Country and of the Anangu in the aftermath of this weapons testing. Ever outwards, the threads extend.

These lines of exchange pulsate through the collection, connecting disparate works across different spaces. It is through these instances of exchange that the collection's reach is made manifest. This notion of the sprawl also governs the way in which the contemporary appears within the display context of the Art Gallery itself. For there is no one space that is dedicated to exhibiting contemporary art. It bleeds into all areas of the museum, and across its campus – from the neoclassical Grand Courts of our original building to the modernist 1972 extensions that house the twentieth-century collection and into the epic open possibility of the new SANAA structure, with its expansive column-free space where large installations can stretch out (the Isaac Wakil Gallery), its intimate enclosures for video works, and the subterranean wonder of the Tank. Wherever we find it, contemporary art reorients us and shifts our perspective. Though the contemporary has always animated the Art Gallery, with the introduction of the new building, it will feel as if written into the architecture, in sync with the building itself. We may look to a recent project for a precursor to the kind of expansive impulse that the Sydney Modern Project invites. In 2020, the collaborative mural *Love owls and mermaids singing in the rainbow pop* by Mathew Calandra, Emily Crockford, Annette Galstaun, Lauren Kerjan, Jaycee Kim, Catherine McGuiness and Meagan Pelham of Studio A exploded across the facade of the Grand Courts. Occupying the single largest wall in the Art Gallery, this artwork transformed the entrance court into an electric field of colour and energy. Commissioned in response to the turmoil of 2020, the mural gave each artist a platform to portray a person or being who supported and inspired them during the pandemic. Responses ranged from portraits of fellow artists and writers to friends, family and pets alongside imaginative companions: a mermaid and an angel. All these figures congregated together on the wall amid the giant embrace of Pelham's 'love owls', icons of devotional and unconditional love. Emerging from a time of isolation, this work offered an image of care which felt as radical as it did ebullient.

As a testimony and tribute to compassion, and as an insistent response to the present moment, this mural is an object lesson in the possibilities of the contemporary. Not simply because it stood as a timestamped testament to the pandemic, but because it was so

Betty Muffler and Maringka Burton
Ngangkari Ngura (Healing Country) 2020

Mathew Calandra and Meagan Pelham working
on the collaborative mural *Love owls and mermaids
singing in the rainbow pop* 2020 by Mathew
Calandra, Emily Crockford, Annette Galstaun,
Lauren Kerjan, Jaycee Kim, Catherine McGuiness
and Meagan Pelham

assertively multi-authored. Though occupying the same pictorial landscape, each artist's voice and story spoke on its own terms. The painted vignettes were all anchored in the joyful expanse of Pelham's backdrop – the text that danced across the wall operating like connective tissue – yet remained distinct. It was, patently, a polyphonic chorus.

A contemporary collection should strive for the same dynamic – profiling many voices and accommodating many melodies, whether harmonious or dissonant. More than this, though, it should be attentive and responsive to who is speaking; questioning which stories and histories have been given airtime in the past and which have been ignored. It should tip the balance. This is what a commitment to the contemporary looks like. It is a commitment to change, born out of the act of listening.

Such change is totalising and slow work, for it relates to the way an institution operates, as much as it does to the artworks it collects and displays. To be truly contemporary, an institution must challenge its own history. The Sydney Modern Project – itself an act of change and an opportunity to reflect on the past – has prompted the Art Gallery to do just this, to become more generous and inclusive in the image of the world it reflects. It must, like the jellyfish, constantly rethink and renew itself, creating new forms, new environments, new ecologies.

This process has no end point. There is no marker of completion because a sprawl or a bloom has no boundary line. The aim is capaciousness; not simply in terms of the growth of the collection but in terms of who it serves and speaks to. When we think of collection growth, we should think not only of entries in a database, but of narrative tendrils and connective threads. This kind of growth is not linear. Rather than using a compass, we must equip ourselves with a sense of speculative openness towards what is an ever-unfolding endeavour. A project in perpetual motion, with change its only constant. For there is always more ebb and more flow. We're left then, with an ellipsis rather than a full stop ...

Something always not seen

Justin Paton

'With its uncanny echo, its connection to conflict, its scars of use and disuse, and its changing physical state, the Tank is a remarkable location from which to contemplate what art museums will be – what they will hold, how long they will last, what they'll keep doing and what they'll relinquish.'

A LIGHT-DRENCHED DAY IN A SUN-WORSHIPPING CITY. The harbour glitters expensively. It's peak hour in the Sydney leisure-scape. Lunchtime joggers stampede past the Art Gallery. Down through the Royal Botanic Garden and Wahganmuggalee, where the Gadigal who have lived here for thousands of years gathered for ceremonies, cicadas chirr in the trees. Out at Yurong, where the joggers turn and pant back towards their offices, the view arranges itself obligingly: Bridge, Opera House, blue sea and sky, thrusting city ...

Today, however, I've joined colleagues nearby to visit a lesser-known location. We're on the outer edge of the Domain, just off the path down to Woolloomooloo from the Art Gallery, on a scruffy field whose sunburnt grass doesn't see much lunchtime activity. This, we know, is the site where the Sydney Modern Project building will soon be rising: a new art museum on Gadigal Country. Yet our focus today is not the building to come but something already beneath us. After pulling on gumboots and receiving a safety briefing, we gather around a strange sight. A hatch has been opened in the surface of the world. We climb down out of the light.

This sounds like the stuff of fantasy – of fables, myths, science fiction. Think of all the stories of transformation in which the main characters *descend*, dropping below the ground-plane of the known to somewhere below and within. Think of Alice tumbling down the rabbit hole to a Wonderland where everything grows 'curiouser and curiouser', or the grieving Orpheus descending into the underworld 'through the shadowy tribes and the ghosts of the buried' to rescue

his wife Eurydice. Think of the sun in Yolŋu tradition who travels through the earth at night to her camp, the warmth from her extinguished torch nourishing growth above.

Our descent into the Tank is, admittedly, less mythic. No payments to Charon – just a form to sign and those gumboots for protection in the disused space. But by the standards of an average workday, the experience is wondrously dislocating. The sudden drop from daylight to darkness makes it hard to see. What strikes us instead is *atmosphere* – a heavy coolness and stillness in the air. Columns march for what feels like miles in every direction, their forms doubled in the rainwater that's pooled here. Sound travels weirdly as we descend the scaffold; the smallest 'clink' hangs in the air. Then, as we slosh our way to the walls, comes the revelation of time and texture: oil-stains, clay-streaks, time-scars. Though human-made, this underland seems organic, even animate. Its richness makes the world above feel glary and insubstantial.

All of this happened in 2017 but the memory of the experience is strong. Architecture in its most predictable form announces its importance from afar. An 'iconic' building offers itself up as an image for rapid digestion and distribution. The Tank, by contrast, was thrilling to visit because there was no forewarning, no preamble. Climbing down, we entered a space we had hardly known was there, and which was, in its darkness and sensory intensity, impossible to capture photographically. We knew it would become a space for art – the fourth and lowest level of the museum that SANAA was designing. But because the space was pre-existing, it felt less like anyone's 'achievement' than a common gift or a shared secret – 'the treasure', as SANAA architect Ryue Nishizawa called it on his own first visit in 2017.

As we know from fairytales and fables, treasures come with obligations. It is not enough just to receive or 'discover' the gift. The receiver must also recognise its value, and prove themselves deserving. Appreciating the stupendous atmospherics of the Tank is part of that recognition. But the encounter also demands that we reckon with what the Tank *was*. For the 'treasure' and its astonishing properties are products of a specific history, one that formed our present but which is, like the Tank, easy to overlook. To descend into the Tank is also to descend into a space of twentieth-century conflict.

Plans to build the Tank in this location took shape in a flurry of secret government correspondence in May 1942. Following the fall of the British naval base in Singapore to Japanese forces earlier that year, an urgent need arose for sites to fuel and repair Allied war vessels in the Pacific. The scale and speed of the resulting build can be glimpsed in a notice in the *Sydney Morning Herald* on 11 July 1942, calling for the delivery of 2260 tons of cement and 10,000 cubic yards of gravel to the Domain within four days.[1] By August of 1942 the site was swarming with labourers, working to create what was, effectively, a war machine: two connected bunkers holding around 19 million litres of oil that would be pumped to ships across the bay.[2]

The temporary staircase leading into the Tank in September 2018

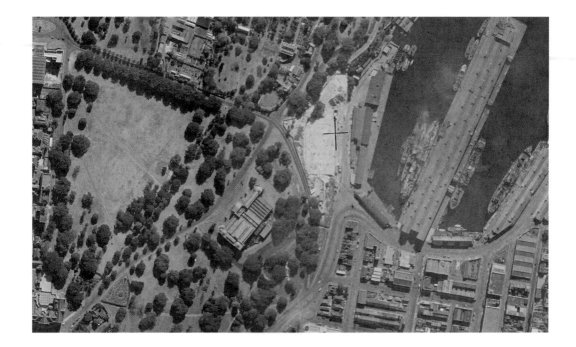

With its mighty expanses of formworked concrete and forest of more than one hundred precast columns, the Tank belongs to a worldwide network of bunkers and defences created during the Second World War – an architecture of crisis that reached from the Nazi fortifications on France's north-west coast to coastal gun emplacements in Aotearoa New Zealand. Constructed not long after submarines of the Imperial Japanese Army attacked Sydney Harbour and bombed Sydney and Mulubinba/Newcastle, the Tank, which was decommissioned in the 1980s and has lain unused since, is an unseen yet imposing reminder of Australia's involvement in a new kind of war that was capable of reaching anywhere (the page of the *Herald* mentioned above features advertisements for 'AIR-RAID SHELTERS, factory or home').

It is not unexpected to see art now arriving in a space vacated by war and industry. Through the 1990s and 2000s many semi-ruinous industrial spaces have been repurposed for the display of contemporary art and in aid of civic regeneration, among them the Casula Powerhouse Arts Centre in Sydney in 1994, the Hamburger Bahnhof in a Berlin railway terminus in 1996, MASS MoCA in a Massachusetts factory complex in 1999, Tate Modern in a London power station in 2000, and Dia Beacon in a box-printing factory in upstate New York in 2003. Schooled by minimalist and post-minimalist art to admire built structures of a massive and functional kind, commissioned architects began renovating such spaces to hold examples of those very artistic styles, creating a mode of art display that might be termed the gentrified-industrial sublime. The refurbished wartime bunkers of Berlin's Boros and Feuerle collections provide the most discomforting examples of the style.

Above: Aerial view from 1943 showing the Art Gallery and Woolloomooloo Bay, and the not-yet-turfed roof of the two oil tanks

Opposite: The construction of the oil tanks in 1942

Something always not seen

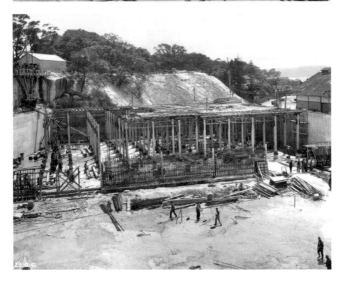

Justin Paton

Art has a hard time not seeming trite in settings where trauma still hangs heavy.

As important as these international echoes are, the differences are at least as compelling. If there is one word that distils the Sydney Tank's unique character, it is *locatedness*. Built into the curve of a quarried hillside, with sandstone at its back and ocean adjacent, the Tank is an aggressively human, wartime structure that feels powerfully dug in, embedded. The sense of architecture infiltrated by nature was acute on our first visit, when we marvelled at the slender stalactites of sand in one corner and the tree roots that had grown downward in another, their blind tips webbing out to soak up available moisture. Even now, with those 'growths' removed, the Tank's material life is insistent. Salts and minerals bloom on the walls. Horizontal accretions mark tidelines. And every vertical surface in the space carries a petroleum patina.

This patina, more than anything else, discloses the Tank's unusual history and paradoxical character. For the oil that was held here to fuel a war was itself an extracted product – a dark substance formed of the altered bodies of ancient organisms, drawn up through the earth. And the fossil fuel, having filled this container for decades, has impregnated its concrete interior, so that the Tank possesses, in low light, the leathery glow of a Rembrandtesque chamber. So, the accidental monument to war is also, now, an oil-stained memorial to the fossil-fuel era, while having additionally become an unlikely nursery for peculiar and persistent natural forms. Histories of human labour and extraction merge disorientingly with 'biological' incursions, leaving an onlooker wondering how, and even if, the natural and cultural can be separated.

The challenge for art in the Tank is to surface these contradictions rather than leaving them buried. How to recognise, without trying to resolve or reconcile, the turmoil of histories and existences in this location? And how, in the process, not to be overwhelmed by the presence of the Tank itself? Art is often enlisted to bring interest and texture to architecture that has been disinfected of context – the ubiquitous 'white cube' of the contemporary art-system. But the Tank is a found object so charged with history and irony that it scarcely needs art's assistance. The art it does need will have to be ambitious but also, strangely, humble – more interested in channelling the power that is already there than in asserting its own unique presence.

All good stories of descent into the underworld involve a main character, and so it is in Sydney. Argentinian Adrián Villar Rojas is the first artist to present a project in the Tank – though the anodyne language of 'presenting projects' does no justice to what he is undertaking. Curious by temperament and committed to what he calls a 'bodily investment' in the places he works, Villar Rojas spent many hours, in the era before COVID-19, getting to know the Tank physically: absorbing its atmosphere, pacing it out, meeting acoustics experts in situ. He stared at the roots that grew down the walls. He swung torches to explore the movement of shadows. He ran sound

The interior of the Tank before its conversion
into a gallery, with tree roots descending from
the grounds above, February 2018

Justin Paton

from his phone through a mobile speaker and felt the whole space reverberating. He witnessed many fugitive effects of light and sound that will never be repeated.

But, as rich as these visits were, the most galvanising insights emerged above ground during discussions with staff, particularly archivists and Aboriginal curators and educators, about the history of the Art Gallery and its site.[3] A self-described 'housekeeper' who has created assumption-testing projects at The Met in New York, MOCA in Los Angeles, and Kunsthaus Bregenz in Austria, Villar Rojas works always from the understanding that 'the container is the content' – that the institutional frame (its walls, its workings, its workers) is as charged and expressive, as capable of 'meaning', as the art within it. During conversations with the Art Gallery's head archivist Steven Miller, Villar Rojas was especially struck by aerial views of the evolution of the Art Gallery 'container'. From its neoclassical facade to its modernist 1972 extension to the addition and renovation of Asian and contemporary galleries, the museum unfolded down the hill like a surrealist exquisite corpse, an architectural collage expressing the Art Gallery's evolving identity (and occasional identity crisis). Looking down at all this from above was, Villar Rojas said, like looking into someone's brain.[4]

The new building, as Villar Rojas observed, would update and reset that history, exchanging the imposing monumentality of Walter Liberty Vernon's Greco-Roman facade for the lightness of SANAA's slender columns and glazed facades. But the dialectical key to the

expanded art museum was provided, unexpectedly, by the Tank. If looking at the Art Gallery from above was like looking into someone's brain, then descending to the Tank and walking among its forest of columns was like entering the museum's architectural unconscious – a mirror space, an upside-down, that reflected the museum back at itself unexpectedly. Looking back up through the layers of the museum from the vantage provided by its war-era basement, one registers afresh the shocking recentness of Western art's arrival in this place, and how that category has itself been churned and changed within larger movements of war, empire, exploitation, extraction, trade and labour.

Of course, the Tank will primarily be a space for the art called contemporary. As I write, it is being fitted with the services that will make it exhibition-ready: lighting tracks, floor boxes, service boards, air registers, data cables and so on. The space eventually encountered by visitors will surely earn those words so prized in the 'experience economy': spectacular, immersive, multisensory. But Villar Rojas's provocations also make me hope that the Tank will be – a very different word – *haunting*, and that, in the process, it will test and unsettle the way we use the word contemporary. Today 'contemporary art' is a historical term, associated with the emergence of a market and a field of study and institutional attention in the 1960s and 1970s (the Art Gallery appointed its first curator of contemporary art in 1979). The defining expression of the contemporary in museum architecture is the impeccable white cube or art fair booth, a space that does not smell or sweat and which declares itself perpetually ready for the *now* and the *next*.

In every way, the Tank denies this dream of neutrality and nowness. Those marks on the wall – are they chemical or mineral? Natural seepage or recent intervention? The acoustics, geometry and even smell of the Tank amplify and accelerate that confusion. The space holds and uncannily prolongs any noise you make. The column grid creates, as you move, a constant flick-flack of lateral perspectives. The sheer size of the Tank, combined with its darkness, makes the space, though vast, feel elusive. It's hard to photograph; it won't be held in one view. Something is always not being seen.

Here lies the Tank's potential as a space for what I'll call constructive haunting. It is, as we've seen, a matchless space in which to be haunted by what has happened – to feel the layering of lives, thoughts, work and matter since its construction.[5] But it is also – and this is where things get heady – a fitting place to be haunted by the future. For if there is one thing that distinguishes the art museums of now from those of, say, a century ago, it is a sense of their own precariousness and mortality. Museums, traditionally seen as safe houses for vulnerable objects, now strike us as vulnerable objects too – the improbable adornments of a civilisation that is rapidly consuming the world that sustains it. We are conscious not just of the futures we dream of but of the futures we have already lost – the future in which, say, the Great Barrier Reef is not dying, and Canada

Adrián Villar Rojas testing sound in the Tank in September 2018

Justin Paton

281

is not enduring freak heatwaves. The rhetoric of *newer* and *better* needs to be countered by a chastened sense of roads no longer able to be taken.[6]

What kind of ancestors will we be? asks philosopher Roman Krznaric.[7] With its uncanny echo, its connection to conflict, its scars of use and disuse, and its changing physical state, the Tank is a remarkable location from which to contemplate what art museums will be – what they will hold, how long they will last, what they'll keep doing and what they'll relinquish. Excitingly, these are philosophical questions that we're now working through in practical ways. With Villar Rojas as a kind of spatial dramaturge, the Art Gallery's conservators, curators, designers, installers, educators and front-of-house teams are, so to speak, down in the basement together with the artist discovering what kind of space it can be. The Tank is now characterised, in the words of head conservator Carolyn Murphy, as 'a space alive', a site whose specialness lies precisely in the fact that it is changing and will keep doing so.[8] Preservation and control, the reflex responses of institutions accustomed to collecting precious objects, are being replaced by an ethos of active observation and 'working with', as the Tank's new tenants learn to live in a space hat's still breathing, seeping, drying, reverberating.

At present, for instance, the Art Gallery's conservators are attending closely to the Tank walls and their rich confusion of industrial stains – the aim being to understand how Villar Rojas can create new markings that collaborate with 'the walls as something active'.[9] A related conversation has unfolded around the now-demolished northern Tank. On learning that this adjacent space was to be removed to make way for a loading dock, conservation lab and other facilities, Villar Rojas immediately asked if he could salvage some of its remnants. Columns, plinths and other offcuts now lie under tarpaulins at the Art Gallery's offsite storage, ready to return to the southern Tank as part of Villar Rojas's work. This act of recycling will also be an exceptionally visceral form of haunting – the 'bones' of the gone Tank cradled within the standing columns of its twin. What an image this is, of the art museum as a self-conscious, self-critical and sometimes self-consuming organism – feeding off its own losses and gains, swallowing and trying to digest its own history.

In the time between his last visit to Sydney in 2019 and his imminent return, Villar Rojas's relationship with the Tank has deepened in remarkable ways. Prevented from visiting in 2020 and 2021 by the global pandemic, Villar Rojas and his collaborators found another way to be local, using gaming software to create a lovingly detailed version of the Tank that permits them to dwell in it fully – testing the fall of light, the swing of shadows, the roll of sound, the movement of people. From their distant yet connected spaces in New York, São Paulo and Villar Rojas's hometown and studio base in Rosario, Argentina, he and his team began to occupy and populate the Tank's mighty volume with what he calls 'receptive forms': sleepers, monsters, collisions, depositions, irruptions, grafts, broken marvels.

Top: A screenshot of the digital modelling process for Adrián Villar Rojas's Tank project, with renders created by Matheus Frey, Francisco Castells and Luke di Rago

Above: Adrián Villar Rojas and part of his workshop team discussing plans for his sculptures in Rosario, Argentina, in November 2021

Justin Paton

Then, as if mimicking the way the Tank itself has been altered by time during its years of disuse, they subjected those forms to a kind of temporal sculpting – sending them virtually to distant times and places to endure whatever awaits them, and then retrieving them to observe what remains. It is these forms – troubled, wondrous, non-Euclidean, incommensurable – that are now being made real in the large and bustling workshop Villar Rojas has established for this project in Rosario.[10]

But I am, I fear, getting ahead of myself, and giving too much away. The final contours of Villar Rojas's project are not fully known at the time of writing, and, even when they are, the unknown will remain an essential element – a quality, a pressure, that Villar Rojas will work with as physically as he does any of his real materials. In a world where experience is increasingly pre-named, observed, tracked, quantified and instrumentalised, our dream is to offer to visitors some version of the wondrous disorientation that overcame us on first visiting the Tank. And the deeper dream, as those visitors gain their bearings, is to make that disorientation productive – to open a space where anyone is free to contemplate what they had not seen, what they did not know, what they had never realised or anticipated.[11] This freedom has value anywhere, but one could argue that it has special value in a new art museum on Gadigal Country, on a storied site whose Indigenous history precedes beaux-arts temples and wartime fuel-bunkers by millennia. Perhaps the most important moment will not be when we descend into the Tank but when we come back up from it, newly conscious of all there is to see and know in the ground beneath our feet.

Installation of the SANAA-designed spiral staircase in September 2021

Something always not seen

Notes

1 Thanks to Eric Riddler, visual resources librarian in the National Art Archive, AGNSW, for locating and sharing this Tenders notice, from *Sydney Morning Herald*, 11 Jul 1942, p 15. Thanks also to Emily Sullivan, assistant curator contemporary international art, for assistance with research, and to Lisa Catt, curator contemporary international art, for support and dialogue in her role as co-curator of the inaugural Tank project.

2 For historical background on the construction, I have referred to the 'Art Gallery of New South Wales expansion: heritage impact statement: report prepared for the Art Gallery of NSW, April 2018', compiled by GML Heritage, section 5.1.6, p 88, majorprojects. planningportal.nsw.gov.au/ prweb/PRRestService/mp/01/ getContent?AttachRef=SSD-6471%2120190227T065444.261% 20GMT

3 In addition to the support and guidance generously offered to Adrián Villar Rojas by Cara Pinchbeck, Coby Edgar, Wesley Shaw and the Art Gallery's Indigenous Advisory Group, I acknowledge, for their perspectives on art and living memory on and around the site occupied by the Art Gallery's expanded campus, Hetti Perkins's essay 'Indigenous voices telling untold stories in the public domain: the Eora journey and *Yininmadyemi thou didst fall*', in *Civic actions: artists' practices beyond the museum*, Museum of Contemporary Art, Sydney, 2017, pp 49–59; and Emily McDaniel's 'Eora journey: harbour walk storytelling report', City of Sydney, Nov 2019, link to pdf on cityartsydney.com.au/city-art-public-art-strategy/yananurala, accessed 28 Feb 2022.

4 In Steven Miller, *The Exhibitionists: a history of Sydney's Art Gallery of New South Wales*, AGNSW, Sydney, 2021, p 264.

5 For an incisive and useful discussion of layered time in museums of contemporary art, see Claire Bishop's commentary on anachronism, presentism and 'where we should be heading' in *Radical museology, or, what's 'contemporary' in museums of contemporary art?*, Koenig Books, London, 2013, pp 19–23.

6 For a rousingly ambivalent dialogue on the importance and longevity of museums, see 'Housekeeping: a conversation between Helen Molesworth and Adrián Villar Rojas, in *Adrián Villar Rojas: the theater of disappearance*, exh cat, Museum of Contemporary Art, Los Angeles, 2017, pp 98–119. Sample sentence (Molesworth): 'I feel like I am at the end, that my generation is the last generation to even believe in this project of the museum, and that your project encounters this almost as an inevitable failure of the idea of the museum to move forward into the twenty-first century' (p 107).

7 Roman Krznaric, *The good ancestor*, WH Allen, London, 2020.

8 Carolyn Murphy, 'Gallery 8: a living space: cultural significance and preservation of the oil tank gallery, Sydney Modern Project, Art Gallery of NSW', internal draft paper, Jul 2020. Thanks to Carolyn Murphy and Sofia Lo Bianco of the Art Gallery's conservation department for their advice on the Tank's patina and material condition.

9 Villar Rojas in conversation with the Art Gallery's conservators in a project team meeting on 9 July 2021.

10 I borrow the word 'incommensurables' from Venezuelan American art historian and curator Luis Pérez-Oramas's paper 'Towards a museum of incommensurables'. The incommensurables of his title are 'objects for which we might not find a common measure that could regulate their significance or meaning, and therefore objects that cannot occupy a fitting location within the conventional geometry of museum representation: objects that are fundamentally disproportional'. Presented as part of the Contemporary and Modern Art Perspectives (C-MAP) conference, Museum of Modern Art, New York, 2017.

11 This disorientation will, I hope, be akin to the 'defamiliarisation' and 'strangemaking' that Alex Kitnick describes when he writes that 'the strangemaking device par excellence may be the museum itself. And this strangeness, my substitute word for autonomy, is what grants the museum a position not outside, but adjacent to, life – a place where life might be seen, queried, and discussed.' 'In 'Point of no return: Alex Kitnick on the discontent with museums', *Artforum*, vol 59, no 4, Jan/Feb 2021, pp 55–56. Kitnick's conclusion includes the arresting suggestion (especially arresting for anyone involved in the development of a new museum) that the modern museum's 'incessant territorial expansionism may be one of its most colonial traits' (p 56).

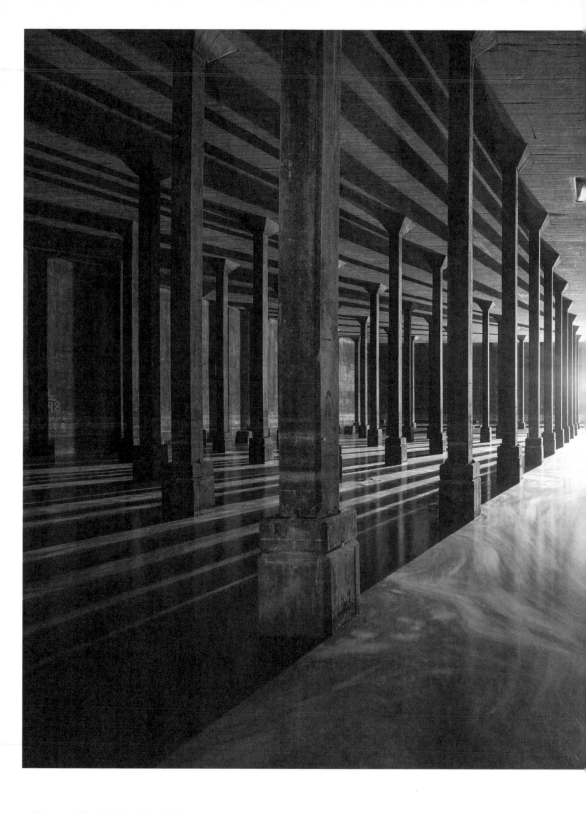

The empty Tank in 2018, with residual water
reflecting the light from above ground

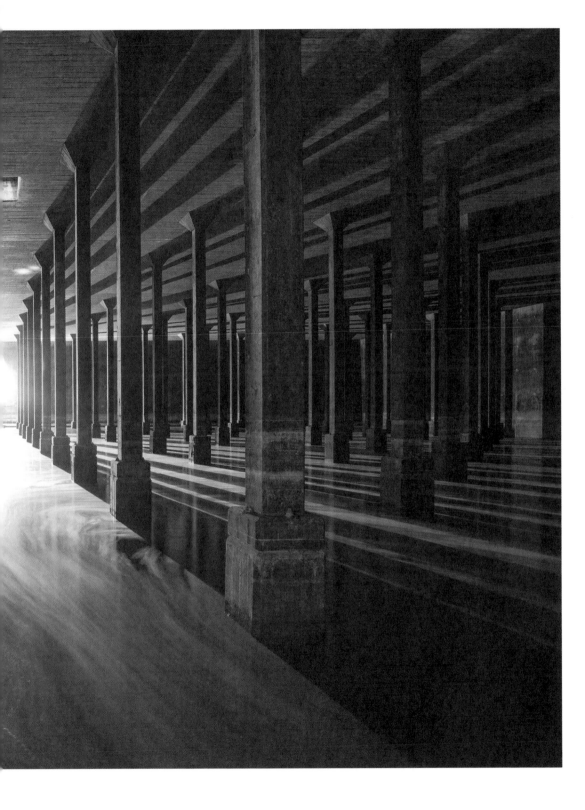

Further reading

Antoinette, Michelle & Caroline Turner (eds). *Contemporary Asian art and exhibitions: connectivities and world-making*, Australian National University Press, Canberra, 2014

Balsom, Erika. *After uniqueness: A history of film and video art in circulation*, Columbia University Press, New York City, 2017

Bishop, Claire. *Radical museology, or, what's 'contemporary' in museums of contemporary art?* Koenig Books, London, 2013

Blau, Eve. 'Inventing new hierarchies', The Pritzker Architecture Prize essay on Kazuyo Sejima and Ryue Nishizawa, 2010 laureates, The Hyatt Foundation/The Pritzker Architecture Prize, Chicago, 2011, pritzkerprize.com/2010/essay

Bond, Anthony. *The idea of art: building a contemporary international art collection*, NewSouth Publishing / Art Gallery of New South Wales, Sydney, 2015

Brüderlin, Markus. *Ornament and abstraction: the dialogue between non-Western, modern and contemporary art*, Fondation Beyler, Basel, 2001

Bullock, Natasha, Kelli Cole, Deborah Hart and Elspeth Pitt (eds). *Know my name*, National Gallery of Australia, Canberra, 2020

Cull, Tamsin. 'Public programmes at the Art Gallery of New South Wales: education, access and interpretation', MA thesis, University of New South Wales, Sydney, 2002

Cuno, James (ed). *Whose muse?: art museums and the public trust*, Princeton University Press, Princeton, NJ, c2004

Edwards, Deborah (ed). *Review: works by women from the permanent collection of the Art Gallery of New South Wales,* Art Gallery of New South Wales, Sydney, 1995

French, Blair & Anne Loxley (eds). *Civic actions: artists' practices beyond the museum*, Museum of Contemporary Art, Sydney, 2017

Glissant, Édouard. *Poetics of relation*, University of Michigan Press, Ann Arbor, 1997

Greiner, Catherine. *Multiple modernities, 1905–1970*, Editions du Centre Pompidou, Paris, 2014

Hammond, Victoria & Juliet Peers, *Completing the picture: women artists and the Heidelberg era*, Artmoves, Melbourne, 1992

Hasegawa, Yuko. *Kazuyo Sejima + Ryue Nishizawa: SANAA*, Phaidon Press, New York City, 2012

Kazuyo Sejima & Ryue Nishizawa. *Kazuyo Sejima Ryue Nishizawa SANAA 1987–2005 vol 1 / 2005–2015 vol 2 / 2014–2021 vol 3*, TOTO Publishing, Tokyo, 2019

Kerr, Joan (ed). *Heritage: the national women's art book*, Craftsman House, Sydney, 1995

Kitnick, Alex. 'Point of no return: Alex Kitnick on the discontent with museums', *Artforum*, vol 59, no 4, Jan–Feb 2021.

Macgregor, Neil. *À monde nouveau, nouveaux musées: Les musées, les monuments et la communauté réinventée*, Éditions Hazan, Paris, 2021

McLean, Ian. *Rattling spears: a history of Indigenous Australian art*, Reaktion Books, London, 2016

Mendelssohn, Joanna, Catherine De Lorenzo, Alison Inglis & Catherine Speck, *Australian art exhibitions: opening our eyes*, Thames and Hudson, Melbourne, 2018

Miller, Steven. *The Exhibitionists: a history of Sydney's Art Gallery of New South Wales*, Art Gallery of New South Wales, Sydney, 2021

Mimmocchi, Denise (ed). *Tony Tuckson*, Art Gallery of New South Wales, Sydney, 2018

Molesworth, Helen & Bryan Barcena. *Adrián Villar Rojas: the theater of disappearance*, exh cat, Museum of Contemporary Art, Los Angeles, 2017

Murphy, Carolyn. 'Physical object or variable, flexible, ephemeral and reproducible: the management and care of contemporary art collections in 2020', *AICCM Bulletin*, vol 41, no 1, 2020

Nelson, Amelia & Traci E Timmons (eds). *The new art museum library*, Rowman & Littlefield Publishers, Lanham, MD, 2021

O'Callaghan, Genevieve. *Jonathan Jones: barrangal dyara (skin and bones)*, exh cat, Kaldor Public Art Projects, Sydney, 2016

Pascoe, Bruce. *Dark emu: Aboriginal Australia and the birth of agriculture*, Magabala Books, Broome, WA, 2018

Pérez-Oramas, Luis. 'Towards a museum of incommensurables', *Post: notes on art in a global context*, Museum of Modern Art, New York City, 3 Oct 2018, post.moma.org/toward-a-museum-of-incommensurables

Perkins, Hetti & Margie West. *One sun, one moon: Aboriginal art in Australia*, Art Gallery of New South Wales, Sydney, 2007

Pinchbeck, Cara (ed). *Tradition today: Indigenous art in Australia*, Art Gallery of New South Wales, Sydney, 2013

Pinchbeck, Cara, Lindy Allen & Louise Hamby. *Art from Milingimbi: taking memories back*, Art Gallery of New South Wales, Sydney, 2016

Richmond, Alison & Alison Bracker. *Conservation principles, dilemmas and uncomfortable truths*, Elsevier in association with the Victoria and Albert Museum, London, 2009

Reed, Stuart. 'Policy, taste or chance? Acquisition of British and foreign oil paintings by the Art Gallery of New South Wales from 1874 to 1935', MA thesis, University of New South Wales, Sydney, 2013

Scholte, Tatja & Glenn Wharton (eds). *Inside installations: theory and practice in the care of complex artworks*, Amsterdam University Press, Amsterdam, 2011

Smith, Bernard. *Place, taste and tradition: a study of Australian art since 1788*, Oxford University Press, Melbourne, 1979 (1945)

Smith, Linda Tuhiwai. *Decolonizing methodologies: research and Indigenous peoples*, Zed Books, London / New York, 2012

Stefanovich, Andy. *Look at more: a proven approach to innovation, growth, and change*, Jossey-Basse, Hoboken, NJ, 2011

Thomas, Daniel. *Recent past: writing Australian art*, Art Gallery of New South Wales, Sydney, 2020

Thomas, Nicholas. *The return of curiosity: what museums are good for in the 21st century*, Reaktion Books, London, 2016

Topliss, Helen. *Modernism and feminism: Australian women artists, 1900–1940*, Craftsman House, Sydney, 1996

Turner, Caroline & Jen Webb. *Art and human rights: contemporary Asian contexts*, Manchester University Press, Manchester, 2016

Villis, Carl & Alexandra Ellem (eds). 'Paintings conservation in Australia from the nineteenth century to the present: connecting the past to the future', contributions to the 11th AICCM Paintings Group Symposium, National Gallery of Victoria, Melbourne, 2008

Wasson, Haidee. *Museum movies: the museum of modern art and the birth of art cinema*, University of California Press, Berkeley, 2005

Waterfield, Giles. *The people's galleries: art museums and exhibitions in Britain 1800–1914*, Yale University Press, New Haven, CT, 2015

Wilson, Natalie. *Archie 100: a centenary of the Archibald Prize*, Art Gallery of New South Wales, Sydney, 2021

Acknowledgements

This book, much like the Sydney Modern Project itself, would not have been possible without the expert input of a great many people. First among them are my Art Gallery colleagues whose compelling and considered essays form the basis of this publication, and whose hard work and commitment continues to transform our institution for the future. I would also like to make a heartfelt acknowledgement to academic, essayist and collaborator Ross Gibson, whose foreword sets the scene for what follows.

Throughout the writing and editing process we have all relied upon the expert editorial guidance of Faith Chisholm and Linda Michael and the feedback of our readers Stephen Gilchrist, Chris McAuliffe and Joanna Mendelssohn. For his design of the book, I thank Dominic Hofstede, partner at the international design studio Mucho, who also designed the Art Gallery's new visual identity released on the occasion of our 150th anniversary in 2021. Thanks to the Gordon Darling Foundation for its financial support of the publication.

For their design of our wonderful new building at the heart of the Sydney Modern Project, I thank Kazuyo Sejima and Ryue Nishizawa, the Pritzker Prize–winning architects and founders of the Japanese architectural studio SANAA, along with their team, and in Sydney, executive architect Architectus. For the revitalisation of our existing building, I thank Tonkin Zulaikha Greer. For landscape design I thank Kathryn Gustafson – who was also among the jurors for our international architecture competition in 2014 – along with GGN in Seattle, and in Sydney, McGregor Coxall. And for building our new home for art notwithstanding the challenges of bushfires, a pandemic and torrential rains, I thank Richard Crookes Constructions and Infrastructure NSW.

The completion of the Sydney Modern Project has been delivered by my brilliant executive team, comprised of deputy director and director of collections Maud Page, director of public engagement Miranda Carroll, chief operating officer Hakan Harman and director of development John Richardson. Without their experience and energy we might never have achieved all we set out to accomplish, especially during two COVID-19 lockdowns. I also acknowledge with deep admiration Sally Webster, our head of the Sydney Modern Project, and her team, for keeping our complex architectural expansion aligned with our institutional transformation along with Infrastructure NSW project director Andrej Stevanovic. Research for this book was tirelessly supported by our senior librarian and archivist Steven Miller and his team. I thank my office manager Michelle Raaff for helping me balance my work on this book with all my other responsibilities, and Simone Bird for her considered advice along the way.

The Art Gallery's trustees, past and present, with current president David Gonski at the helm, deserve special thanks for their unswerving support of our endeavours at every turn. I am also deeply grateful to the NSW Government for supporting the notion of a public art museum by providing such significant funding for our expansion. The Art Gallery has received extraordinary support throughout the course of the Sydney Modern Project from Premier Dominic Perrottet, and his predecessors Gladys Berejiklian, Mike Baird and Barry O'Farrell, and Minister for the Arts Ben Franklin, and his predecessors Don Harwin, Troy Grant and George Souris. In addition, I want to acknowledge and thank Treasurer Matt Kean and Minister for Infrastructure Rob Stokes, as well as all our colleagues in a range of government departments and agencies.

I am also filled with gratitude for the many generous benefactors, inspired by capital campaign chair Mark Nelson, who have made our transformation possible as part of the largest government and philanthropic partnership in the arts in Australia to date. The continuing development of our collection is entirely supported through philanthropy and I want to acknowledge and thank in particular our Foundation led by Kiera Grant for the largest art commissioning project in the Art Gallery's history.

It is a great pleasure to acknowledge the entire staff at the Art Gallery of New South Wales who have all contributed to this transformation in their own way, right across the institution. Ditto, our dedicated volunteers, celebrating their fiftieth year of service this year.

Finally, I would also like to salute the exceptional and inspiring work of all the artists we have the honour to work with, and whose creativity we have the pleasure of sharing with our audiences here on Gadigal Country in Sydney.

Michael Brand
Director, Art Gallery of New South Wales

We thank the NSW Government and our Sydney Modern Project campaign supporters* for their generosity and vision in funding the Art Gallery's expansion.

Lead donor
Susan and Isaac Wakil Foundation

Leadership donors
The Ainsworth Family
Aqualand
The Lee Family
The Lowy Family
The Neilson Foundation
Mark and Louise Nelson
Oranges & Sardines Foundation
Gretel Packer AM

Anonymous
Mark Ainsworth and Family
Valeria and Paul Ainsworth
Guido and Michelle Belgiorno-Nettis
Anita and Luca Belgiorno-Nettis Foundation
The Chen Yet-Sen Family Foundation in honour of Daisy Chen
Andrew and Jane Clifford
John Grill AO and Rosie Williams
The Medich Foundation
Nelson Meers Foundation
Paradice Family Foundation
Dr Gene Sherman AM and Brian Sherman AM

Founding donors
David Baffsky AO and Helen Baffsky
Andrew Cameron AM and Cathy Cameron
Ian Darling AO and Min Darling
Ashley Dawson-Damer AM
The Douglass Family
Ari, Daniel and David Droga Families
John Gandel AC and Pauline Gandel AC
David Gonski AC and Orli Wargon OAM
The Grant Family in memory of Inge Grant
Ginny and Leslie Green
The Hadley Family
Susie Kelly
Gary and Kerry-Anne Johnston
Elizabeth and Walter Lewin
Andrew and Paula Liveris
Catriona Mordant AM and Simon Mordant AO
Hamish Parker
The Pridham Foundation
Bee and Bill Pulver
Ruth Ritchie Family Fund

Andrew and Andrea Roberts
Rothwell Family Foundation
Penelope Seidler AM
Charles and Denyse Spice
John and Amber Symond
Will and Jane Vicars
Lang Walker AO and Sue Walker
Philippa Warner
Peter Weiss AO

Major donors
David Khedoori and Family
Joy Levis
The Lippman Family
Jillian Segal AO and John Roth
TLE Electrical
Tee Peng Tay and Family
Turnbull Foundation

Visionary donors
Russell and Lucinda Aboud
Geoff Alder
Ainsworth Herschell Family
Hayley and James Baillie
Georgina Bathurst and Richard McGrath
Ellen Borda
Drew and Alison Bradford
Jillian Broadbent AC
Bella and Tim Church
Clitheroe Foundation
Ken Coles AM and Rowena Danziger AM
Patrick Corrigan AM
Judy Crawford
Anna Dudek and Brad Banducci
Jane and Richard Freudenstein
Chris and Judy Fullerton
Kerry Gardner AM and Andrew Myer AM
Maurice Green AM and Christina Green
Fiona Martin-Weber and Tom Hayward
Robert and Lindy Henderson
Sally Herman
Roslyn and Alex Hunyor
Peter Ivany AO and Sharon Ivany
Ann and Warwick Johnson
Simon Johnson and David Nichols
James Kirby and Claire Wivell-Plater
Anne and Mark Lazberger
John Leece AM and Anne Leece
Paula and Andrew Liveris
Juliet Lockhart
Amanda and Andrew Love
Michael Martin and Elizabeth Popovski
Andrew Michaels and Michele Brooks
Justin Miller AM
Edwin Mok and Rina Mok

Alf Moufarrige AO
The Papas Family
Bill and Karen Robinson
Justine and Damian Roche
The Quick Family
Edward and Anne Simpson
Rae-ann Sinclair and Nigel Williams
Jenny and Andrew Smith
Allan and Helen Stacey
Colin Tate AM and Matthew Fatches
Georgie and Alastair Taylor
Victoria Taylor
Alenka Tindale
Eleonora and Michael Triguboff
Mark Wakely in memory of Steven Alward
Barbara Wilby and Christopher Joyce
Ray Wilson OAM in memory of James Agapitos OAM
Jane and Rob Woods
Sharne and David Wolff
Helen Changken Wong
Bing Wu Family
Carla Zampatti Foundation

* As of August 2022

Image credits

Foreword

p 10
David Moore
Sydney Harbour from 16,000 feet 1966,
printed later
gelatin silver photograph, 30.3 x 21.2 cm
Art Gallery of New South Wales,
purchased 1976
302.1976
© Lisa, Michael, Matthew and
Joshua Moore

Introduction

pp 18–19
Photo: Craig Willoughby,
SKYview Aerial Photography

p 20
The final stone about to be placed
in the pediment above the entrance
portico of the Art Gallery of
New South Wales' sandstone
building, 24 March 1902
gelatin silver photograph,
18 x 24 cm image
National Art Archive, AGNSW
ARC2.2.5

p 22
Image produced by Kazuyo Sejima +
Ryue Nishizawa / SANAA © AGNSW

p 24
Jitish Kallat
Public notice 2 2007
resin, 4479 letters: installation
dimensions variable
Art Gallery of New South Wales,
gift of Gene and Brian Sherman
2015, donated through the Australian
Government's Cultural Gifts Program
232.2015
© Jitish Kallat

p 27
Clifford Possum Tjapaltjarri and
Tim Leura Tjapaltjarri
Warlugulong 1976
synthetic polymer paint on canvas,
168.5 x 170.5 cm
Art Gallery of New South Wales,
purchased 1981
321.1981
© Estate of the artists. Licensed by
Aboriginal Artists Agency Ltd

p 30
Brook Andrew
Tombs of thought 2017–18
mixed media, dimensions variable
Art Gallery of New South Wales,
purchased with funds donated by
Geoff Ainsworth AM and
Johanna Featherstone 2018
442.2018.5-9
© Brook Andrew. Courtesy the artist
and Tolarno Galleries, Melbourne

p 33
Hoda Afshar
Remain 2018
dual-channel digital video, colour,
sound, 23:33 min, dimensions variable
Art Gallery of New South Wales,
purchased with funds provided by
the Contemporary Collection
Benefactors 2020
161.2020.a-b
© Hoda Afshar

p 35
Charlotte Moorman performing
Mieko Shiomi's *Cello sonata* 1972
on the roof of the Art Gallery of
New South Wales, 1976
gelatin silver photograph,
19.8 x 24.6 cm
National Art Archive, AGNSW
ARC30.1098.1
© AGNSW, Kerry Dundas

Chapter 1

p 39
Exterior view of the Fine Arts
Annexe to the Sydney International
Exhibition 1879
wood engraving, printed in black ink
on paper, 12.5 x 20 cm
National Art Archive, AGNSW
ARC2.2.1

p 40
Conrad Martens
Apsley Falls 1874
watercolour, opaque white, gum
on paper, 54.2 x 76.9 cm
Art Gallery of New South Wales,
commissioned by the Board of
Trustees and purchased 1874
117

p 42
View of the Art Gallery of New South
Wales showing the junction between
the original building designed by Walter
Liberty Vernon and the wing designed
by Andrew Andersons, November 1972
gelatin silver photograph, 16.5 x 25.8 cm
image; 18 x 25.8 cm sheet
National Art Archive, AGNSW
ARC2.4.17
Photo © AGNSW, Max Dupain

Photo © AGNSW, Eric Sierins

p 47
Image produced by Kazuyo Sejima +
Ryue Nishizawa / SANAA

p 48
Photos: Luke Johnson

p 51
Image produced by McGregor Coxall

pp 52–53
Image: bloomimages
Berlin GmbH © AGNSW, 2021

pp 56–57
Image produced by Kazuyo Sejima +
Ryue Nishizawa / SANAA © AGNSW

p 58
Interior view of the new Australian
courts 1972
gelatin silver photograph, 19.5 x 25.7 cm
National Art Archive, AGNSW
ARC2.4.38
Photo © AGNSW, Max Dupain

p 60
Image © Mogamma

pp 62–69
Photos © AGNSW, Rory Gardiner

Chapter 2

p 73
Photo: Andrew Curtis

p 74
Production stills for Lisa Reihana
GROUNDLOOP 2022
© Lisa Reihana

p 77
Photo: Lane 216, East Production

Photo: LEE Studio

p 78–79
Kimsooja
Archive of mind 2017
participatory installation with clay,
wooden table and stools, 16-channel
sound, display dimensions variable
Art Gallery of New South Wales,
purchased with funds provided by
the Art Gallery of New South Wales
Foundation 2018
82.2018.a-s
© Kimsooja

Rodel Tapaya
Do you have a rooster, Pedro?
(Adda manok mo, Pedro?) 2015–16
acrylic on canvas, 300 x 700 cm
Art Gallery of New South Wales,
gift of Geoff Ainsworth AM and
Johanna Featherstone 2016
308.2016
© Rodel Tapaya

Imants Tillers
Counting: one, two, three 1988
synthetic polymer paint, gouache,
oilstick on 162 canvas boards,
251 x 639 cm overall
Art Gallery of New South Wales,
gift of the artist 2006
92.2006.a-ffffffff
© Imants Tillers

p 80
Photo: Daniel Mazza

pp 84
Photo: Lisa Sorgini

p 85
Image created by Alessandro Mucci,
© Jonathan Jones

Chapter 3

p 91
Destiny Deacon
Dreaming in urban areas 1993
4 colour Polaroid laser copies,
62.5 x 56.5 x 2.5 cm
Art Gallery of New South Wales,
purchased 1993
393.1993
© Destiny Deacon/Copyright Agency

p 92
Elaine Russell
Inspection day 1994
synthetic polymer paint on cardboard
73.5 x 99.9 cm sight; 94.8 x 120.8 x 2.1 cm
frame
Art Gallery of New South Wales,
purchased with funds provided by the
Australian Collection Benefactors 1995
19.1995
© Estate of Elaine Russell

p 93
Jack Yarunga with
Bob Apuatimi working on Pukumani
post with Dr Stuart Scougall and Tony
Tuckson and filmmaker Bill Dalzell,
Milikapti, Melville Island 1958
Photo: Margaret Tuckson
colour slide, 2.4 x 3.6 cm
Margaret Tuckson archive, gift of the
artist's son, Michael Tuckson 2014
National Art Archive, AGNSW
ARC398.1.219
© Estate of Margaret Tuckson

p 94
John Mawurndjul
Mardayin ceremony 2000
natural pigments on eucalyptus bark,
170 x 78 cm (irreg)
Art Gallery of New South Wales,
Don Mitchell Bequest Fund 2000
538.2000
© John Mawurndjul, Maningrida Arts
and Culture/Copyright Agency

Lin Onus
Fruit bats 1991
polychromed fibreglass sculptures,
polychromed wooden disks, Hills Hoist
clothesline, 250 x 250 x 250 cm
Art Gallery of New South Wales,
purchased 1993
395.1993
© Lin Onus Estate/Copyright Agency

Rover Thomas
Two men dreaming c1985
natural pigments on canvas board,
91 x 61 cm
Art Gallery of New South Wales,
purchased 2000
37.2000
© Estate of Rover Thomas, courtesy
Warmun Art Centre/Copyright Agency

p 95
Binyinyuwuy Djarrankuykuy
Trees and flying fox camp c1950s
natural pigments on bark,
48 x 29.5 cm (irreg)
Art Gallery of New South Wales,
purchased 1962
IA10.1962
© Binyinyuwuy Estate. Licensed by
Aboriginal Artists Agency Ltd

p 96
Mary Thomas
Dawoorrgoorrima 2010
natural pigments on composite board,
80 x 121.5 cm
Art Gallery of New South Wales,
purchased with funds provided by
the Aboriginal Art Collection
Benefactors 2010
302.2010
© Mary Thomas/Copyright Agency

p 97
Reko Rennie
No sleep till Dreamtime 2014
44 panels; birch plywood, metallic
textile foil, synthetic polymer paint,
diamond dust, gold leaf,
310 x 1030 cm overall
Art Gallery of New South Wales,
purchased with funds provided by
the Art Gallery Society of New South
Wales Contempo Group 2014
173.2014.a-rr
© Reko Rennie

p 100
Genevieve Grieves
Picturing the old people 2005
five-channel digital video, colour,
sound, 12:55 min
Art Gallery of New South Wales,
gift of the artist 2009, donated through
the Australian Government's Cultural
Gifts Program
245.2009.a-f
© Genevieve Grieves

pp 102–03
Brook Andrew
AUSTRALIA VI Theatre and
remembrance of death 2014
mixed media on linen, 200.2 x 300 cm
Art Gallery of New South Wales, gift of
Geoff Ainsworth AM 2014
91.2014
© Brook Andrew. Courtesy the artist
and Tolarno Galleries, Melbourne

Chapter 4

p 109
Frederick McCubbin
On the wallaby track 1896
oil on canvas, 122 x 223.5 cm
Art Gallery of New South Wales,
purchased 1897
572

Arthur Streeton
*'Still glides the stream, and shall
for ever glide'* 1890
oil on canvas, later mounted on
hardboard, 82.6 x 153 cm
Art Gallery of New South Wales,
purchased 1890
859

p 111
Southeast region artist
Australia
Sydney shield 1800s
natural pigments on wood, cane
handle, 82.5 x 31 cm
Art Gallery of New South Wales,
purchased with funds provided by
the Art Gallery of New South Wales
Foundation 2018
236.2018

p 112
Eugene von Guérard
*A fig tree on American Creek near
Wollongong, NSW* 1861
oil on canvas, 83.7 x 66.1 cm
Art Gallery of New South Wales,
purchased 1996
398.1996

p 114
WC Piguenit
The flood in the Darling 1890 1895
oil on canvas, 122.5 x 199.3 cm
Art Gallery of New South Wales,
purchased 1895
6015

p 115
Jessie E Scarvell
The lonely margin of the sea 1894
oil on canvas, 76.2 x 108 cm
Art Gallery of New South Wales,
gift of H Bush 1894
6020

p 116
E Phillips Fox
Art students 1895
oil on canvas, 182.9 x 114.3 cm
Art Gallery of New South Wales,
purchased 1943
7319

p 117
Hugh Ramsay
A lady in blue 1902
oil on canvas, 172.0 x 112 cm
Art Gallery of New South Wales,
presented by the family of
Hugh Ramsay 1943
7317

p 120
Charles Conder
*Departure of the Orient –
Circular Quay* 1888
oil on canvas, 45.1 x 50.1 cm
Art Gallery of New South Wales,
purchased 1888
829

Mildred Lovett
*Vase with pastoral design of dancing
figures by Sydney Long* 1909
hand-painted porcelain with overglaze
decoration, 26.4 x 14 cm diam
Art Gallery of New South Wales,
purchased 1909
2223
© Estate of Mildred Lovett

Chapter 5

p 128
Ford Madox Brown
Chaucer at the court of Edward III
1847–51
oil on canvas, 372 x 296 cm
Art Gallery of New South Wales,
purchased 1876
703

p 131
Alphonse de Neuville
The defence of Rorke's Drift 1879 1880
oil on canvas, 181.4 x 301.5 cm
Art Gallery of New South Wales,
purchased 1882
735

p 132
Edward John Poynter
*The visit of the Queen of Sheba to
King Solomon* 1881–90
oil on canvas, 234.5 x 350.5
Art Gallery of New South Wales,
purchased 1892
898

p 133
Camille Pissarro
Peasants' houses, Éragny 1887
oil on canvas, 59 x 71.7 cm
Art Gallery of New South Wales,
purchased 1935
6326

p 134
Claude Lorrain
Pastoral landscape 1636–37
oil on copper, 27.9 x 34.7 cm
Art Gallery of New South Wales,
gift of James Fairfax AC 1992
208.1992

p 136
Jusepe de Ribera
Aesop c1625–31
oil on canvas, 125 x 92 cm
Art Gallery of New South Wales,
purchased in 2021 with funds provided
by the Art Gallery of New South Wales
Foundation and the Art Gallery of
New South Wales 2019 Gala dinner
168.2021

Chapter 6

p 142
Plan of the Art Gallery's ground floor
from the *National Art Gallery of New
South Wales illustrated catalogue* 1926
soft-bound book, 22 x 14.5 x 2.3 cm
NSW Government Printing Office,
Sydney
National Art Archive, Art Gallery
of New South Wales
ARC11.3.4

pp 144–45
Pascale Marthine Tayou
Colonnes Pascale 2012
found Arabic pots with metal
support, display dimensions variable
Art Gallery of New South Wales,
purchased with funds provided by
the Art Gallery Society of New South
Wales and the Jim and Mollie Gowing
Bequest 2021
194.2021.a-e
© Pascale Marthine Tayou

p 147
John Constable
*Landscape with a goatherd and
goats (after Claude)* 1823
oil on canvas, 53.3 x 44.5 cm
Art Gallery of New South Wales,
gift of the National Art Collections
Fund 1961
OB1.1961

Kent Monkman
The allegory of painting 2015
synthetic polymer paint on canvas,
122.0 x 96.5
Art Gallery of New South Wales,
purchased with funds provided by
Atelier and the Mollie and Jim Gowing
Bequest 2020
2.2020
© Kent Monkman

p 149
Grace Crowley
Portrait of Lucie Beynis 1929
oil on canvas on hardboard,
79.7 x 64.5 cm
Art Gallery of New South Wales,
purchased 1965
OA14.1965
© Reproduced with permission of
Grace Crowley Estate

p 150
André Lhote
House in Tunis (Maison à Tunis) 1929
oil on paper mounted on cardboard,
64 x 49 cm
Art Gallery of New South Wales,
purchased with funds provided by
Guy and Marian Paynter 2020
11.2020
© André Lhote/ADAGP.
Copyright Agency

p 151
Yahia Turki
The blue door Sidi Bou Said 1929
oil on panel, 41 x 33 cm
Art Gallery of New South Wales,
purchased with funds provided by
Meredith Paynter 2020
10.2020
© Estate of Yahia Turki

p 153
Kamrooz Aram
Nocturne 3 (departing nocturne) 2019
oil, oil crayon, wax pencil and pencil
on linen, 193 x 152.4 cm
Art Gallery of New South Wales,
purchased with funds provided by the
Roger Pietri Fund and the Asian Art
Collection Benefactors 2019
135.2019
© Kamrooz Aram

pp 154–55
Frank Stella
Khurasan Gate variation II 1970
from the series *Protractor*
synthetic polymer paint on canvas,
304.8 x 914.4 x 7.6 cm
Art Gallery of New South Wales,
purchased with funds provided by
the Art Gallery Society of New South
Wales 1977
420.1977
© Frank Stella/ARS. Copyright Agency

p 156
Kaapa Tjampitjinpa
Wartunuma (Flying ants) 1977
synthetic polymer paint on canvas,
160 x 180 cm
Art Gallery of New South Wales,
donated by Katherine and Christopher
Goodnow through the Australian
Government's Cultural Gifts Program,
in memory of Professor Jacqueline
Goodnow AC 2015
14.2015
© Estate of Kaapa Tjampitjinpa
Licensed by
Aboriginal Artists Agency Ltd

Michael Johnson
Anna 1965
PVA on canvas, 218 x 417 cm
Art Gallery of New South Wales,
Purchased with funds provided by
the Patrick White Bequest 2018
528.2018
© Michael Johnson/Copyright Agency

William Turnbull
8-1965 1965
synthetic polymer paint on canvas,
256 x 142 cm
Art Gallery of New South Wales,
gift of Edron Pty Ltd 1995 through
the auspices of Alistair McAlpine
262.2002
© Estate of William Turnbull/
DACS Copyright Agency

Chapter 7

p 160
Tsukioka Yoshitoshi
*Picture of the country of New Holland
South Wales (Shin Oranda Minami
Waruresukoku no zu)* 1866
woodblock print; ink and colour on
paper, triptych, 36 x 75 cm
Art Gallery of New South Wales,
Yasuko Myer Bequest 2020
194.2020.a-c

p 161
Reena Saini Kallat
Woven chronicle 2018
circuit boards, speakers, electrical
wires and fittings, sound component,
dimensions variable
Art Gallery of New South Wales,
purchased with funds provided by the
Roger Pietri Fund and the Asian Art
Collection Benefactors 2018
88.2018.a-g
© Reena Saini Kallat

p 162
Matsumoto Hōen
Jar with design of sea creatures
late 1870s
enamelled porcelain, 37.8 x 22.8 cm
Art Gallery of New South Wales, gift
of the Japanese Commissioners at the
Sydney International Exhibition 1879,
accessioned 1889
2439.a-d

p 163
Vietnam, Hội An
Dragon ewer mid 1400s
stoneware; moulded, with
underglaze blue and white
decoration, 22.3 x 17 x 7.8 cm
Art Gallery of New South Wales,
purchased 2000
523.2000

p 167
Takashi Murakami
*Japan Supernatural: Vertiginous
After Staring at the Empty World Too
Intensely, I Found Myself Trapped
in the Realm of Lurking Ghosts and
Monsters* 2019
acrylic, gold leaf and glitter on canvas,
300 x 1000 cm
Art Gallery of New South Wales,
purchased with funds provided by
the Art Gallery of New South Wales
Foundation 2019
191.2019.a-j
© 2019 Takashi Murakami/Kaikai Kiki
Co., Ltd. All Rights Reserved.

p 168
Installation view of the Art Gallery
of New South Wales Asian collection,
November 1972
monochrome 120-format negative,
5.3 x 6.9 cm
Douglas Thompson Archive
National Art Archive,
Art Gallery of New South Wales
ARC474.370.58
Photo © AGNSW, Douglas Thompson

Maruyama Ōkyo
Cranes c1770–72
pair of six-panel screens (*byobu*);
colour and gold leaf on paper, right
screen 169.5 x 373 cm, left screen
169.5 x 373 cm
Art Gallery of New South Wales,
purchased with assistance from
the Japanese Society of Sydney, the
Japan Chamber of Commerce and
The Sidney Myer Charity Trust 1981
109.1981.a-b
Photo: John Nobley/Fairfax Media

pp 170–71
Xiao Lu
15 gunshots … from 1989 to 2003 2003,
printed 2018
15 black-and-white digital prints,
framed and punctured by bullets,
each 100 x 45 cm
Art Gallery of New South Wales,
purchased with funds provided by
the Asian Collection Benefactors
and the Photography Collection
Benefactors 2019
188.2019.a-o
© Xiao Lu

Chapter 8

p 177
Tempe Manning
Self-portrait 1939
oil on canvas, 76.0 x 60.5 cm
Art Gallery of New South Wales,
purchased with funds provided by the
Art Gallery Society of New South
Wales 2021
65.2021
© Estate of Tempe Manning

p 178
Violet Teague
Margaret Alice 1900
oil on canvas, 193.2 x 91.5 cm
Art Gallery of New South Wales,
purchased 2017 with funds provided
by the Australian Masterpiece
Fund, including the following major
donors: Barbara Gole (in memory of),
Antoinette Albert, Anita &
Luca Belgiorno-Nettis AM,
Andrew Cameron AM & Cathy
Cameron, Krystyna Campbell-Pretty
& the late Harold Campbell-Pretty,
Rowena Danziger AM & Ken Coles AM,
Kiera Grant, Alexandra Joel & Philip
Mason, Carole Lamerton & John
Courtney, Alf Moufarrige AO, Elizabeth
Ramsden, Susan Rothwell, Denis Savill,
Penelope Seidler AM, Denyse Spice,
Georgie Taylor, Max & Nola Tegel,
Ruth Vincent
192.2017

p 181
Grace Cossington Smith
The window 1956
oil on hardboard, 121.9 x 91.5 cm
Art Gallery of New South Wales,
gift of Graham and Judy Martin 2014,
assisted by the Australian
Masterpiece Fund
607.2014
© Estate of Grace Cossington Smith

p 182
Hilda Rix Nicholas
Through the gum trees,
Toongabbie c1920
oil on canvas, 65.7 x 81.9 cm
Art Gallery of New South Wales,
acquired with the support of the Art
Gallery Society of New South Wales
through the Dagmar Halas Bequest
2016
323.2016
© Estate of Hilda Rix Nicholas

p 183
Clarice Beckett
Evening, St Kilda Road c1930
oil on board, 33.8 x 39.5 cm
Art Gallery of New South Wales,
purchased with funds provided by
the Australian Art Collection
Benefactors 2013
197.2013

p 184
Anne Dangar
Plate with cubist designs c1938
glazed earthenware, 4.4 x 34.5 cm diam
Art Gallery of New South Wales,
purchased with funds provided by the
Mollie Douglas Bequest 2017
84.2017

Anne Dangar at work in the
studio, 1940s
gelatin silver photograph, 14.8 x 10 cm
National Art Archive, Art Gallery of
New South Wales, bequest of
Grace Crowley 1979
ARC106.23.7

p 185
Grace Crowley
Abstract painting 1950
oil on hardboard, 59.5 x 74.5 cm
Art Gallery of New South Wales,
purchased with funds provided by
the Art Gallery of New South Wales
Foundation 2019
192.2019
© Reproduced with permission
of Grace Crowley Estate

p 186
Yvonne Audette
Italia benvenuto 1957
oil on hardboard, 123.2 x 151 cm
Art Gallery of New South Wales,
purchased with funds provided by
the Wendy Barron Bequest 2015
238.2015
© Yvonne Audette

p 187
Lesley Dumbrell
Solstice 1974
synthetic polymer paint on canvas,
173 x 296 cm
Art Gallery of New South Wales,
purchased with funds provided by the
Patrick White Bequest 2019
3.2019
© Lesley Dumbrell

p 188
Dora Ohlfsen
Woman with bear skin 1920
bronze on stone base, 47.5 x 18 x 26.8 cm
Art Gallery of New South Wales, gift
of Michael Cain and Ian Adrian 2019
211.2019.a-b

p 189
Helen Grace
And awe was all we could feel 11
1978–80, printed 2020
12 gelatin silver photographs,
display dimensions variable
Art Gallery of New South Wales,
purchased with funds provided by
the Photography Collection
Benefactors 2021
12.2021.a-l
© Helen Grace

Chapter 9

p 195
Photo: Marius Sestier

p 196
Nam June Paik
TV Buddha 1976
television monitor, video camera,
painted wooden Buddha, tripod, plinth,
installation dimensions variable
Art Gallery of New South Wales, gift
of the John Kaldor Family Collection
2011, donated through the Australian
Government's Cultural Gifts Program
342.2011.a-f
© Nam June Paik Estate

p 197
Lisa Reihana
A Māori dragon story 1995
16mm animation transferred to
single-channel digital video, colour,
sound, 15 min
Art Gallery of New South Wales,
purchased with funds provided by
the Friends of New Zealand art 2020
16.2020
© Lisa Reihana

p 199
Meriem Bennani
Guided tour of a spill (CAPS interlude)
2021
single-channel digital video, colour,
sound, 15.49 min
Art Gallery of New South Wales,
purchased with funds provided by
Danny Yap, Emily Fan and Harvey Yap
2021
90.2021
© Meriem Bennani

p 203
Mika Rottenberg
Lips (study #3) 2016/2019
mixed media, single-channel video
installation, colour, sound, 1:28 min
Art Gallery of New South Wales,
purchased with funds provided by
the Art Gallery of New South Wales
Foundation 2019
218.2019
© Mika Rottenberg

pp 204–05
Howie Tsui
Retainers of anarchy 2017
algorithmic animation sequence,
five-channel video projection, six-
channel audio, dimensions variable
Art Gallery of New South Wales,
purchased with funds provided by the
Asian Art Collection Benefactors 2018
136.2018
© Howie Tsui

Chapter 10

p 213
Photo: Roderick MacRae /
The Sydney Morning Herald and
The Age Photos

p 214
Charlotte Moorman being secured by
rope to the roof of the Art Gallery of
New South Wales prior to performing
Mieko Shiomi's *Cello sonata* 1972,
April 1976
gelatin silver photograph,
19.8 x 24.6 cm
National Art Archive, Art Gallery
of New South Wales
ARC30.1098
Photo © AGNSW, Kerry Dundas

p 215
Angela Goh *Body loss* 2021,
performance documentation, Art
Gallery of New South Wales, Sydney,
© Angela Goh, photo: Hospital Hill

p 216
Marina Abramović and Ulay
Gold found by the artists 1981
from the series *Nightsea crossing*
1981–86
16 Cibachrome photographs,
each 23.5 x 34.5 cm
Art Gallery of New South Wales,
purchased 1981
211.1981.5.a-p
© Marina Abramovic & Ulay,
1981/Bild-Kunst. Copyright Agency
Photo: John Lethbridge

p 217
Amrita Hepi
The tender 2019
performance, decal, ramp, linoleum
flooring, rope, 60 min
Commissioned by the Art Gallery of
New South Wales for *The National
2019: New Australian Art*
© Amrita Hepi

p 218
Installation view of Cai Guo-Qiang's
Still life performance during the 12th
Biennale of Sydney, 2000
Courtesy Cai Studio

p 219
Warlpiri artists performing
a Snake Dreaming Ceremony at the
4th Biennale of Sydney in 1982
colour slide, 2.5 x 3.5 cm image
National Art Archive,
Art Gallery of New South Wales
ARC40.3.20
© The artists/Copyright Agency

p 220
Photo © Matthew McGuigan,
Hospital Hill

p 221
Marina Cruz
Blush fibres and bed sores 2016
oil on canvas, 244 x 183 cm
Private collection

When Sonia was four (1958) 2017
oil on canvas, 191 x 261 cm
Private collection
Courtesy of the artist and A3
© Marina Cruz
Photo: ABC RN, Teresa Tan

Chapter 11

p 226
Yhonnie Scarce
Death zephyr 2017
hand-blown glass yams, nylon and
steel armature, dimensions variable
Art Gallery of New South Wales,
purchased with funds provided by
the Aboriginal Collection Benefactors
Group 2017
14.2017.a-c
© Yhonnie Scarce

p 227
Bob Apuatimi, Don Burakmadjua,
Charlie Kwangdini, Laurie Nelson
Mungatopi, Jack Yarunga, Tiwi artist
Pukumani grave posts 1958
natural pigments on iron wood,
274 × 250 × 250 cm overall
Art Gallery of New South Wales,
gift of Dr Stuart Scougall 1959
IA1.1959.a-q
© The artists/Copyright Agency

p 231
Brett Whiteley
The balcony 2 1975
oil on canvas
203.5 × 364.5 cm
Art Gallery of New South Wales,
purchased 1981
116.1981
© Wendy Whiteley/Copyright Agency

p 232
Photo: Greg Appel and Liam Keenan,
Spontaneous Films

p 235
Photo: Marian Abboud

p 236
Photo: Penelope Clay

Chapter 12

p 241
The boardroom and director's office
of the National Art Gallery of
New South Wales, 1914
gelatin silver photograph, 15.5 x 20.5 cm
Photo: Gother Victor Fryers Mann
National Art Archive, Art Gallery of
New South Wales
ARC2.1.1

p 242
Image courtesy Nine Publishing

p 243
The conservation laboratory at the
Art Gallery of New South Wales, c1960
gelatin silver photograph, 22 x 29 cm
National Art Archive,
Art Gallery of New South Wales
ARC5.5.1
Photo © Estate of Max Dupain/
Copyright Agency

p 247
teamLab
Flowers and people – gold 2015
3–8 channel interactive program,
colour, sound, motion sensors,
continuous, 120.1 x 548 cm overall
Art Gallery of New South Wales,
purchased with funds provided by
the David George Wilson Bequest for
Asian Art and the Asian Collection
Benefactors 2015
406.2015
© teamLab, courtesy Martin Browne
Contemporary, Sydney

p 248
Michael Parekōwhai
The English Channel 2015
stainless steel, 257 x 166 x 158 cm
Art Gallery of New South Wales,
purchased with funds provided by
Peter Weiss AO 2016
432.2016
© Michael Parekōwhai

p 250
Queenie McKenzie
Untitled c1994
natural pigments on linen, 80 x 100 cm
Art Gallery of New South Wales, gift of
Christopher Hodges and Helen Eager
2002
192.2002
© Queenie McKenzie Estate, courtesy
Warmun Art Centre/Copyright Agency

pp 252–53
Image © Mogamma

Chapter 13

p 260
Khadim Ali
Untitled 2019
from the series *Flowers of evil*
acrylic paint, hand and machine
embroidery stitched on fabric and dye,
667.8 x 153.2 cm
Art Gallery of New South Wales,
purchased with funds provided by
the Contemporary Collection
Benefactors 2020
147.2020
© Khadim Ali. Courtesy Milani Gallery

p 262
Rushdi Anwar
*Irhal (expel), hope and the sorrow
of displacement* 2019
burnt wooden chairs, black oxide
pigment, charcoal and ash, display
dimensions variable
Art Gallery of New South Wales,
purchased with funds provided by
the Contemporary Collection
Benefactors 2019
164.2019.a-p
© Rushdi Anwar

p 263
Hoda Afshar
Behrouz Boochani – Manus Island 2018
from the series *Remain*
inkjet print, 130 x 104 cm
Art Gallery of New South Wales,
purchased with funds provided by
the Contemporary Collection
Benefactors 2020
162.2020.2
© Hoda Afshar

p 264
Shireen Taweel
tracing transcendence 2018–21
hand-pierced copper, single-channel
sound file, display dimensions variable,
duration: 3:51 min
sound composer: Spencer
Anthony Reid
Art Gallery of New South Wales,
purchased with funds provided by
the Contemporary Collection
Benefactors 2021
67.2021.a-d
© Shireen Taweel, photo courtesy
4A Centre for Contemporary Asian
Art, Sydney

p 265
Marlene Gilson
Ballarat, my Country 2020
synthetic polymer paint on linen,
120 x 150 cm
Art Gallery of New South Wales,
Mollie Gowing Acquisition Fund for
Contemporary Aboriginal Art 2020
77.2020
© Marlene Gilson

p 266
James Tylor
Banksia ericifolia 2015
from the series *Terra botanica II*
Becquerel daguerreotype, 24 x 19 cm
Art Gallery of New South Wales,
purchased in memory of Reginald
John Vincent 2016
246.2016.1
© James Tylor

pp 268–69
Betty Muffler and Maringka Burton
Ngangkari Ngura (Healing Country)
2020
synthetic polymer on linen,
289 x 490 cm
Art Gallery of New South Wales,
purchased with funds provided by
the Aboriginal Art Collection
Benefactors and Atelier 2021
66.2021
© Betty Muffler & Maringka Burton/
Copyright Agency

p 270
Mathew Calandra, Emily Crockford,
Annette Galstaun, Lauren Kerjan,
Jaycee Kim, Catherine McGuiness
and Meagan Pelham
*Love owls and mermaids singing
in the rainbow pop* 2020
site-responsive painted mural,
dimensions variable
Commissioned by the Art Gallery of
New South Wales for *Archie Plus* 2020
© the artists

Chapter 14

p 276
Aerial view from 1943 showing the
Art Gallery and Woolloomooloo Bay
1943 AUSIMAGE © Jacobs Group
(Australia) Pty Ltd

p 277
Photos: Naval Historical Society of
Australia

p 283
A screenshot of the digital modelling
process for Adrián Villar Rojas'
Tank project, with renders created by
Matheus Frey, Francisco Castells and
Luke di Rago
© Adrián Villar Rojas
Photo: Mario Caporali

pp 286–87
Photo: Ben Campbell

Index

Page numbers in **bold** indicate illustrations. Page numbers including 'n' indicate chapter endnotes.

Contributors

Ross Gibson
Centenary professor in creative and
cultural research, University of Canberra

**Art Gallery of
New South Wales staff**

Ruby Arrowsmith-Todd
Curator of film

Paschal Daantos Berry
Head of learning and participation

Michael Brand
Director

Lisa Catt
Curator of contemporary
international art

Melanie Eastburn
Senior curator of Asian art

Steven Miller
Manager of the Edmund and
Joanna Capon Research Library and
National Art Archive

Denise Mimmocchi
Senior curator of Australian art

Carolyn Murphy
Head of conservation

Maud Page
Deputy director and director of collections

Isobel Parker Philip
Senior curator of contemporary Australian art

Justin Paton
Head curator of international art

Cara Pinchbeck
Senior curator of Aboriginal and
Torres Strait Islander art

Peter Raissis
Senior curator of historical
European art

Wayne Tunnicliffe
Head curator of Australian art

Jonathan Wilson
Music and community curator

Published by Art Gallery of New South Wales
on Gadigal Country
Art Gallery Road, The Domain
Sydney 2000, Australia
artgallery.nsw.gov.au

A catalogue record for this book is available from the National Library of Australia
ISBN 9781741741568

Managing editor: Faith Chisholm*
Text editor: Linda Michael
Design: Dominic Hofstede (Mucho)
Rights & permissions: Michelle Andringa*, Clara Finlay*, Megan Young*
Photography: Jenni Carter*, Felicity Jenkins*, Diana Panuccio*,
Christopher Snee*, Mim Stirling*; additional photographers indicated
in captions or image credits list
Proofreader: Kay Campbell, The Comma Institute
Production: Cara Hickman*
Prepress: Spitting Image, Sydney
Printing: Printed in China by Australian Book Connection
* Art Gallery of New South Wales

The Art Gallery of New South Wales is a statutory body of
the NSW Government

Distribution:
Thames & Hudson Australia
Thames & Hudson UK
University of Washington Press USA

This publication was supported by the Gordon Darling Foundation

GORDON DARLING
FOUNDATION